| DATE | | | |
|---|---|---|---|
|  |  |  |  |
|  |  |  |  |
|  |  |  |  |
|  |  |  |  |
|  |  |  |  |
|  |  |  |  |
|  |  |  |  |
|  |  |  |  |
|  |  |  |  |
|  |  |  |  |
|  |  |  |  |
|  |  |  |  |
|  |  |  |  |

# CARL SANDBURG
## His Life and Works

# CARL SANDBURG
## His Life and Works

North Callahan

THE PENNSYLVANIA STATE UNIVERSITY PRESS
University Park and London

Library of Congress Cataloging-in-Publication Data

Callahan, North.
Carl Sandburg: his life and works.

Bibliography: p.
Includes index.
1. Sandburg, Carl, 1878–1967—Biography.
2. Poets, American—20th century—Biography.
I. Title.
PS3537.A618Z5378   1986       811'.52 [B]        86–43031
ISBN 0-271-00486-X

*A biography, Sirs, should begin with the breath of a man when his eyes first meet the light of day—then working on through to death when the light of day is gone.*

—Honey and Salt

# Contents

Pictures follow pages 66 and 152

# Acknowledgments

*A*ppreciation is expressed to the Sandburg Family Trust for permission to use relevant materials in this biography; to Harcourt Brace Jovanovich, Inc., for the excerpts from various Sandburg works that it published; and to other publishers, organizations, and individuals as cited specifically in the Notes at back of the book.

# Preface

During the whole of a quiet, balmy Saturday afternoon in Texas, I was seated at a typewriter in a newspaper office, pecking away at an equally unexciting feature story for the Sunday edition. Suddenly, from nowhere it seemed, a big man bounded into view, a white mane of hair hanging down over one eye. He flung himself into the chair beside my desk, stuck out a huge hand and boomed, "Sandburg's my name!"

So Carl Sandburg came into my life, just as he did into countless others. To say that my world was different after meeting him might be an exaggeration; but certainly anyone who met him even once was conscious of him ever afterward.

The next time I saw him, some fifteen years later, was on the edge of the Great Smoky Mountains in western North Carolina. Here he lived in a huge house called "Connemara," now a National Historic Site, but at that time the center of a serene and secluded estate, so fitted to the evening of his fruitful life. My own home, at one time near the Smokies, was now New York City, and members of the Civil War Round Table there had just elected me president. One of my goals was to get Carl Sandburg, who had completed his great biography of Abraham Lincoln, to speak to our organi-

zation. I had been told that this was impossible; that he had stopped appearing before such groups, had slowed down because of his age and was confining himself to his woodland farm.

But I did not accept this as a positive fact and was determined to seek him out and somehow persuade him to come and speak. It would have been useless to write or telephone. The answer would surely have been no, and he probably would not even have given that answer personally. So along with my cousin, Milton Callahan of Chattanooga, I drove to Connemara, slowly easing the car up the last bit of winding, tree-lined road to his large white house for fear that we would be sighted and shooed away.

In front of the impressive residence, we paused. I was on the point of getting out of the car when a huge, muscular black dog appeared beside it and sobered this thought to a dim wish. The dark animal came closer, stopped, and looked at us with questioning eyes. My heart sank. But not for long. If it required being mangled to get to the Sandburg doorway, it might as well be now, I muttered as I slowly opened the car door and ventured out. The dog stood his ground. Somehow I found the courage to reach out a trembling hand and pat him on the head, half expecting part of the hand to disappear. The dog turned up his mouth—I was near paralysis—but then a warm red tongue emerged and licked my hand. Relief verged on collapse as I made my way to the front door.

After I had rung the doorbell three times, a trim lady with gray hair and sharp but kindly eyes came to the door and asked what I wished. Quickly I spoke the names of mutual friends of Mr. Sandburg's and mine—Allan Nevins, Carl Haverlin, and John C. Pemberton—and was pleased to note that she recognized them. I was just passing by, I added, simply wanted to shake the hand of the poet-biographer and to present him with a book of mine that he might find appropriate because it was titled *Smoky Mountain Country*. Mrs. Sandburg nodded very slowly, asked me to wait a moment, and then faded back into the recesses of the house.

By this time Milton had joined me on the porch, and we both stood and waited hopefully in silence. After what seemed a long time, although actually it wasn't, I saw a white-haired figure, staring blinkingly from under an old green eyeshade, make his way to the front door. As he opened the door, I repeated my introductory words. We shook hands and I reminded him we had once met at the newspaper office in Texas. He nodded and seemed to remember, and I handed him the copy of my book, for which he thanked me.

"Mr. Sandburg," I said, "the next time you are in New York, would you please come to our Civil War Round Table and receive an award?"

"An award for *what?*" he roared.

It was a pretext to which I had given little thought, but I managed to reply that it would be set forth on the plaque. He mumbled a kind of assent and, before he could say more, I added that of course we hoped he would say a few words on the occasion.

Months later, Carl Sandburg did appear before our Round Table in New York. I spent half a day with him before the meeting, having been warned that if one did not keep an eye on him, he might well forget an occasion and not show up. After he had been interviewed by a young reporter from the *New York Times*—during which he admonished him, "Young man, now don't you put words in my mouth"—Sandburg and I stood for twenty minutes in the rain at Madison Avenue and 54th Street, trying to get a taxicab. Finally, the historian himself nabbed one and we rode down to the New York University Faculty Club at Washington Square, where the meeting was to be held.

As we moved slowly along through the rain, I asked, "Mr. Sandburg, why of all those people on national television last night dedicating the Overseas Press Club did you alone *read* your remarks?"

He paused for a moment and replied, "Well, Lincoln *read* his Gettysburg Address."

At the Civil War Round Table meeting, Sandburg spoke to a capacity crowd about Abraham Lincoln and the Civil War. When I presented him with a scroll, he looked at it and exploded, "Now that's a fine piece of calligraphy! If I were a dentist, I could hang it on my wall and it would do me some good."

Among those at the head table that evening was Professor Oscar Cargill of New York University, head of the American Civilization Program. The idea of my writing a biography of Carl Sandburg did not occur to either of us on that memorable occasion. Yet when Dr. Cargill later asked me to do just this, the Round Table meeting came vividly to mind.

A biography of Carl Sandburg is plainly no easy task. He was such a many-faceted man—poet, musician, journalist, biographer, historian, writer of children's stories, and novelist. Even so, it is a challenge to set forth the story of his unique life, to recall the manner in which he strode so flaringly across our land, and to examine the effects upon his wide audience. Time is determining his place in the hierarchy of human greatness.

In January 1978 an elaborate and extensive commemoration of the 100th birthday of Carl Sandburg was held at his birthplace in Galesburg, Illinois. Academic and other persons familiar with his life delivered speeches on various aspects of his remarkable career, I among them. A national postage stamp was issued in his honor. Knox College, which the young Sandburg attended when it was Lombard College, was the hospitable host for the occasion, and for a week, considerable national attention was focused on this small midwestern city.

Many subsequent interviews with people who knew Carl Sandburg, as well as much additional intense research in his voluminous papers, have added much to my concept of this great and versatile man. To all of those who have been of help in this immense undertaking, I am grateful, and trust that in these results the efforts are justified.

North Callahan
New York University

# 1

## The Young Idea Takes Shape

The contrast of the seasons in which Carl Sandburg entered upon this earth and took his departure from it was no sharper than that of the circumstances. He was born on a cold morning, January 6, 1878, in Galesburg in northwestern Illinois, the son of an illiterate blacksmith, and died, world-famous, eighty-nine years later in July at his North Carolina mansion home.

Sandburg once wrote, "My father and mother left Sweden before its modern awakening; my father could read but not write; he made his mark when signing documents; the mother could both read and write, had a wide acquaintance with books and often amazed us with her English vocabulary."[1]

Carl described his father, August Sandburg (originally Sandberg), as a "black Swede," having straight black hair with eyes black and a hint of brown, deep-set in the face. His skin crinkled when he smiled. He was below medium height, weighed around 150 pounds, and was well muscled. "No sports interested him, though he did make a genuine sport of work that needed to be done."

Carl's mother, Clara Mathilda, had fair hair, "the color of oat straw just

before the sun tans it—eyes light blue, the skin light as fresh linen by candlelight, the mouth for smiling. She had ten smiles for us to one from our father."

In his life, covering nearly a century, Sandburg led at least three lives, and if one counts carefully, several more. He made his slow, struggling way along the main roads but loved to go off at unexpected times into intriguing byways. Until his last years he was always on the move, either in external travels or striving for literary achievement inside his home or office. And even when age and weariness forced him to slow down, he relived in his warm memory the travels made by his active body and ebullient mind.

There was, when Carl Sandburg was born, a significant Swedish community in Galesburg, which had been there for over a quarter of a century. This group was to prove influential in the development of Swedish-American institutions. The local Lutheran church, led by a colorful minister, Tufve Nilsson Hasselquist, was a prime force behind the national organization of Swedish Lutherans, the Augustana Synod. Here also was established the first Swedish-language newspaper in the United States, the *Hemlandt*, which August Sandburg read every week, and this was about the only other thing he did read except the Swedish Bible.

In his autobiography, *Always the Young Strangers*, Sandburg expressed regret that he never learned from his parents much about their Swedish ancestors.

The Swedish population comprised about a third of the inhabitants of Galesburg. There was even a store on Main Street known as the "Swede Grocery" and a school generally identified as "the Swede school." A local bank was mainly patronized and managed by Swedish citizens, and one of the fire-fighting companies was Swedish. Civil War veterans claimed that they belonged to Swedish units of the Union army. The Sandburg family attended the Swedish Lutheran Church but later went most often to the Swedish Methodist Church. The son who was to become famous never positively identified himself with any particular denomination.

The delineation in the town was so strong during these years that the Galesburg postmaster published the names on the letters that had not been called for at the post office under three headings: "Gents," "Ladies," "Swedes."

According to Professor Hermann R. Muelder of Knox College, Galesburg was then

a thriving little city which was a division point on a transcontinental railroad and the location of several railroad dependent industries. Railroad activity dominated the life of the town in a variety of ways now difficult to appreciate. It was a major source of conversation—of news. The leading local paper had a regular column devoted to railroad events, not merely to the rather frequent accidents to workmen, to wrecks of equipment and to other causes of irregular service, but also to more ordinary matters, such as bridge construction, mechanical improvements, changes in job assignments, tramps expelled from the trains, a ticket office robbery, changes in the life of the railroad men, such as marriages.[2]

The story of the birth with which we are concerned began just after midnight in the Sandburg home on Third Street in Galesburg, beside the Chicago, Burlington and Quincy Railroad, for which his father worked. In the three-room frame home, the Sandburg's first baby, a girl named Mary, had been born three years earlier. Carl was the first son and therefore especially welcome, as he was to concede later.

The baby was put into a cradle his father had made for Mary. It had three legs on each end. A year and a half later, Carl was in turn displaced by a new brother, Mart.

Carl Sandburg always loved to recall his boyhood days; in fact, in many ways he never outgrew them. One of the saddest things to him was that growing up was necessary in this life; yet to the end of his long span of years, he was to recount the charms of his golden days, and if now and then he threw in a sad note, he usually made it disappear with a great burst of laughter that sounded down the intervening time.

He was christened Carl August Sandburg, but he himself decided in his first years in school to use the name Charles instead, believing that it sounded less Swedish. He kept this first name for thirty years. About the same time, he and his brother and sister began to spell their last name "burg" instead of "berg."

Among Carl's many early memories was that of carrying pails of water from a cistern in the yard to fill washtubs, one having warm water and a washboard for soaping and rubbing, the other, with a wringer attached to it, holding cold rinsing water. He often turned the wringer handle and later carried the washing to a clothesline in the backyard. When the weather was cold—and in Galesburg it gets very cold in the winter—Carl would often have trouble when the clothes froze and slapped against his head in the wind. When bath time came, often at the urging of a discerning mother, the same washtubs were filled with warm water, soap was fur-

nished, and the boys took over the kitchen for scrubbing, while the sister waited and took turns shortly afterward.

Many years later, Carl's granddaughter, Paula Steichen, recalled that he helped each year with the cleaning of the cistern in the yard. Barelegged, Carl was let down by a rope to the bottom, where he shoveled the mud and silt upward. In addition to his other duties, which included carrying the ashes from the household stoves, getting in the coal, and spading the garden, the young Carl often at night held a lantern for his father when he made repairs on the house.[3]

Once the social-reformer-to-be was put in jail for four hours when he and some of his friends were caught swimming naked in an old pond on the edge of Galesburg. As a sort of contrast, at about this time Carl Sandburg bought a guitar from a local pawnshop for two dollars and learned to play simple chords on it. This rudimentary music was to come in handy in his later life when he spiced up his platform lectures around the country with his singing of folk songs and accompanying himself on the banjo or guitar.

In his autobiography, *Always the Young Strangers*, published over a half a century later, Sandburg remembered:

> Once on a rainy Sunday, I stopped under a culvert to read in the Chicago-Inter-Ocean magazine section about a boy who had a visit with the poet, Oliver Wendell Holmes. Holmes talked with the boy about how, why and when he wrote his poems. I read the article twice and came away from it feeling that I myself had had a visit with the famous poet and I would have to read his writings because I liked him as a man.

The one thing Carl knew by then was that "to all the best men and women I had known in my life and especially all the great ones that I had read about, life wasn't easy, life had often its bitter and lonely hours, and when you grow with new strengths of body and mind it is by struggle."

On November 11, 1887, four radical agitators in Chicago were executed for their alleged complicity in the infamous Haymarket Massacre, in which a bomb had killed seven policemen and wounded many others. Carl vividly recalled that he was coming home from school that afternoon when he saw walking toward him a railroad man who called out to a friend, "Well, they hanged 'em!" Carl could tell by his tone of voice that the man was glad. "Something tight in me came loose and it was the same with the other kids. We looked into each other's faces and said, 'They had it comin' to them and we're glad they're dead.'" The Sandburg family also approved

of the hangings, but a few years later when Illinois Governor John Peter Altgeld condemned the execution as unjust, the fifteen-year-old Carl read the long account in which the governor explained his pardon of the three men who had been imprisoned in connection with the crime and the boy was persuaded that Altgeld was right. Altgeld soon became one of his heroes, not only for this act but for similar liberal leanings.

Carl Sandburg was never a stickler for food yet always seemed to appreciate good edibles. Perhaps this was because his earliest meals consisted mainly of the Swedish dishes of boiled herring and boiled potatoes. Even in his last years, his menus at Connemara were simple ones, with boiled potatoes again forming a sturdy adjunct. Cabbage heads were heaped in the early Sandburg cellar in October to be used during winter. As to another source of sustenance, Carl himself reminisced:

> In the triangle closet under the stairs from the first floor to the cellar, Papa used to keep a barrel of apples in winter months, when he could afford it. He put a lock on the door and hid the key. He had seen that when a barrel of apples stood where everyone could get at it, we would soon be at the barrel bottom. He would have put a board over the gap above the door had he known what Mart and I were doing. By hard wriggling, our boy bodies could squeeze through the gap and drop down to the apple barrel. We took two apples at a time and only every other day. What we stole wasn't noticed and we said, "When two of us steal two apples and divide them, that's only stealing one apple apiece and stealing one apple isn't really stealing, it's snooking."[4]

Life picked up somewhat for the family when the elder Sandburg bought a larger house, on Berrien Street in Galesburg. It had ten rooms with a long garret running the length of the house. There were four rooms in the cellar, two of them having floors. Behind the house stood the usual two-section privy, with a henhouse behind it. The big lot on which the house stood had a spacious garden containing gooseberry bushes and a front yard with maple trees bordered by a picket fence and a brick sidewalk. Over the front door of the house a small tin sign read "Etna Fire Insurance Company" to show that the house was insured.

Two lots down the street in front of a small barn, Carl saw his first hog killing. The hogs' bodies were lowered into a huge tub of hot water, where the hair was removed. Then they were strung up on poles, sliced open, next lowered, and cut into sections. The Sandburg family took part in this and in the winter would have pork chops, pork loins, side meat, spareribs, cracklings, pigs' knuckles, and sausage.

But the payments seemed bigger than the house, especially when they came at the same time as those on the parcel of farmland the father had also bought in this sudden splurge. For a while, the family dreamed of leaving Galesburg and moving onto the farm. There were visions of big crops of wheat and corn, apples and pears. Tradition pictured the farmer as independent, living off what he raised on his land; he was his own boss and could not be discharged. But then came the Panic of 1893, when the New York stock market collapsed and the price of gold fell, followed by business failures, unemployment, strikes, and a depression. Corn dropped to ten cents a bushel in Kansas and land went down in price. As a sad consequence, August Sandburg sold his land. In 1894 Coxey's Army marched on Washington. Hard times harried Galesburg, as they did other communities. Work on the railroad dropped from a ten-hour to a four-hour day and the Sandburg paycheck, like others, was less than half what it had formerly been.

None bore the depression with more spirit, however, than the Sandburgs. They ate bread spread with lard; sometimes even the lard ran out and molasses was substituted. Fortunately, the potato crop was good, and this welcome staple helped them ride out the crisis. Occasionally neighbors banded together and killed hogs, dividing up the carcasses—succulent spareribs, loins, chops, and all the other delectable parts—which added variety to the plain, drab diet to which they had become accustomed.

Powdered coke was used for fuel instead of the better lumps. Young Carl learned to break big lumps of coke small enough to fit into the coal bucket and the stove. He found this to be hard work but consoled himself that many miners he had read about went through more hardships than he did. Only a small part of the house was heated in those cold winter nights in Galesburg, and Carl and his brother, Mart, who slept in the third-floor garret, used to stand before the kitchen stove in their underwear, get real warm, then dash upstairs and into bed before the cold could close in on them. Later, when the family had acquired a gasoline stove for cooking and a heating stove with an isinglass door and an ashpan at the bottom—which Carl emptied endless times on the outside ash pile—memories remained of the cherished old kitchen stove before which they had so delightfully warmed their haunches on icy winter nights before jumping into bed.

The Sandburgs must have spent much time in the kitchens of their earlier homes, for Carl recalled the scenes as long as he lived. There they were crowded into a kitchen twelve by fifteen feet, with cupboard, sink, stove, table, and chairs. It was not only a kitchen, he recalled, but a dining

room, study-playroom, and workshop. There Carl's mother mixed bread and oven-baked the dough into savory brown loaves. There clothes were patched, the boys' hair was cut by their father, and their shoes were half-soled. Corn was popped, taffy made, and nuts were cracked on flatirons and eaten voraciously.

Carl remembered:

> Papa shaved at the kitchen sink before a small looking glass. A serious father with lather over cheeks, chin and neck looks less serious to his children. The sound of the scraping razor mowing down the three days' growth of whiskers had a comic wonder for us. He couldn't shave without making faces at himself. There were times when his face took on so fearful and threatening a look we were a little scared. We saw his razor travel over cheeks, chin, upper lip, below the jaws, everywhere except a limited area under his chin. There he left a small tuft of hair. At intervals over a few weeks, we could see him take scissors and trim this goatee.[5]

Though much of Carl's boyhood centered about play, work of various kinds made impressions more lasting than those of the indelible pencil his father used on special occasions to record something of importance. There was a pump in the backyard with a personality of its own, a demanding one when his father wanted fresh water and Carl had to go out and pump it. In summer the pump needed to be primed, and he would have to go back into the house and fetch a pail of water to pour into the reluctant conveyor. On winter mornings, the pump handle often would not move, so Carl had to douse it with hot water until it was thawed. Its two-way stretch had a rhythm similar to some lines of the Sandburg poetry.

As time went on, the appearance of the houses in the neighborhood changed. For years, all the residences had been fenced in on the sides, back, and front. This apparently was because of numerous horses, cows, pigs, and chickens belonging to virtually all the families around; it was necessary to protect one's property as well as one's safety. But as the numbers of the livestock dwindled, the fences began to disappear—first the front ones, then the sides and back. The wealthier families got rid of them first and the less affluent followed suit until, finally, all the fences were gone.

At the age of six, Carl Sandburg saw his first political meeting. Down on Seminary Street a crowd of men had gathered under torchlights for a Republican rally. As they began to march, a brass band led the procession, and to this sound was added those of extra horns blowing and drums

beating. All his life, Carl seemed to hear the sound of drums of some kind, whether real or in fancy; it reminds one, in recounting his far-reaching life, that the poet and biographer, like Thoreau, must have heard "a different drummer."

One group at this rally yelled rhythmically, "Blaine, Blaine, James G. Blaine!" while across from them, with equal fervor, a competing crowd screamed, "Hurrah for Cleveland!" In return, the opposition retorted that they thought Cleveland should be hanged, but instead, a few months later, Cleveland was elected President, a great disappointment for the elder Sandburg, who was a rabid Republican.

Ulysses S. Grant, another Republican, died when Carl was seven years old, and Galesburg held a sort of collateral funeral for him, which made a strong impression on the youngster. Local stores closed for this July afternoon in 1885 and a parade began on Seminary Street, moved along Main Street, and ended in the public square. Crowds lined the sidewalks, and Carl and his father had trouble seeing what was going on in the streets. Finally the boy was placed on his father's shoulders and he could see that a marshal on a sorrel horse headed the parade, resplendent with shiny bridle and saddle. Police marched two abreast and a fife-and-drum corps followed. Grant had been the most famous general in America, if not the world, and members of his old ranks, the Grand Army of the Republic, marched there, a few of them escorting a symbolic black box on a black cart pulled by eight black horses. Then came a procession of Negroes pacing to slow and sad music, for Grant had led the armies that set them free. This event lingered in the memory of Carl Sandburg, as did most military spectacles, and it fired his imagination as to what was the real significance of the death of a man who had fought for a cause that came to mean so much to so many.

This early interest in history was widened by reading especially by the time Carl was in the fifth grade. With avid interest, he devoured John S. C. Abbott's *History of Napoleon Bonaparte*, both volumes. The boy learned not only that Napoleon was a great soldier but also that, despite his autocratic career, he accomplished some good things for his people and set a colorful example the world will never forget. Carl was so impressed with the emperor that he put a leather strap around his waist and a wooden sword inside it and strutted around the house like the "Little Corporal" himself. Other volumes he read thoroughly included J. T. Headley's *Napoleon and His Marshals* and *Washington and His Generals*; also *Boy Travellers* by Thomas W. Knox, Hezekiah Butterworth's *Zigzag Journeys*,

*The Life of Munson Long, Gambler*, *A Brief History of the United States*, and *Civil Government in the United States* by John Fiske. But Carl recalled:

> Best of all was the American history series by Charles Carleton Coffin. *The Boys of '76* . . . made me feel I could have been a boy in the days of George Washington and watched him on a horse, a good rider sitting easy and straight, at the head of a line of ragged soldiers with shotguns. I could see Paul Revere on a horse riding wild and stopping at farmhouses to holler the British were coming. I could see old curly-headed Israel Putnam, the Connecticut farmer, as the book told it: "Let 'em have it!" shouted Old Put, and we sent a lot of redskins head over heels into the lake. . . . A few days later . . . the French and Indians ambushed us. We sprung behind trees and fought like tigers. Putnam shot four Indians. . . . One of the Frenchmen seized Roger's gun, and the other was about to stab him, when Put up with his gun and split the fellow's head open.[6]

Other books by Coffin that Carl enjoyed were *Old Times in the Colonies*, which related how the pioneers built cabins, cleared the timbers, and shoved crude plows into new ground while watching out for the Indians, and *The Story of Liberty*, which revealed what attracted people to Europe and described tyrants, who intrigued the curiosity of the young Sandburg. Strangely, Carl found *The Boys of '61* by Coffin not nearly so interesting as his volume on the Revolution, yet Coffin was supposed to have been a correspondent in the Civil War.

In studying Sandburg's career, one wonders how much he might have been influenced by Mark Twain, especially since Twain lived until Sandburg was thirty-two years old. They had some similar qualities, but Sandburg appears to have been little conscious of any influence of Twain. This may have been partly because the first of Twain's books that Sandburg read, *Huckleberry Finn* and *Tom Sawyer*, made little impression upon him. But there is definitely one quality the two had in common—wishing to make people happy and rejoicing in it when they did. While Twain made people laugh, Sandburg made them laugh and cry. Even the crying usually had a twinge of joy. And helping folks to feel better lay deep in the roots of Sandburg's boyhood.

The first biography Carl ever owned was an accidental but significant discovery. He found it lying on a sidewalk on his way to school, and when he had picked it up and cleaned the dirt off, he discovered a very small book with a glossy paper cover and a color picture of Major General P. T. Beauregard of the Confederate Army. It had only thirteen pages of text, but this was enough to enhance his curiosity about the Civil War and the men

who figured in it. In the back of the book was a list of other such volumes, which came in the packages with a certain brand of cigarettes. Carl persuaded two older friends of his to purchase some of these and eventually he became the owner of biographies not only of Beauregard but of Cornelius Vanderbilt, Sarah Bernhardt, George Peabody, Robert Ingersoll, and John Ericsson, who invented many features on the Union ship *Monitor*. Through these books Carl became entranced with history, especially the period of the Civil War. His mother was glad that he had the history books; but his father was skeptical and wondered out loud what good it would do. Such taunts hurt Carl, though he did not say so. They doubtless drove him to prove later on just how much good could come from them.

In 1891, when Carl Sandburg was thirteen and had finished the eighth grade, he dropped out of school and temporarily stopped his studies. His education for almost a decade came from experience and occasional contacts with newspapers, magazines, and a few random volumes, but mostly, as always, from people. He was still a boy, however, and no one ever savored the keen delights of boyhood more than he, when he had the chance. He and his friends played the ageless game of mumblety-peg, trying to flip an open knife from the hand so as to stick the blade in a particular spot of ground. Or, on the wooden sidewalks of Berrien Street, they flung tops in gay abandon, the radish-shaped forms landing with a whining hum on their metal tips, sometimes upright and correct, sometimes at a dizzying angle that could not be sustained and ended in a flip-flop across the walk, coming to rest as still as young death. There was the gratifying game of two-eyed cat, in which two batters stood facing each other, a catcher-pitcher behind each one. When the ball was hit, the batters ran and changed sides until scores piled up and young muscles finally gave out. Sometimes a good batter would just stand up and knock mighty fly balls toward eager outstretched arms away out in the cow pasture. When the hit was wide, one of the boys running to catch it would at times slip and fall ignominiously in a fresh puddle of soft cow manure. This they called "third base."

When the players stayed so late that dusk fell as they journeyed home, they would pass the lamplighter at his work. He carried a small ladder that he would set against the lamppost. Slowly he would climb up and open the door of the glass compartment that held the gas burner. He would reach in and turn the gas on, then with a lighted taper he would put flame to the gas escaping from the tiny outlet in the center of the lamp. This aroused the poetic sense of young Carl, who later described with such vividness the

glories of the night world. Soon the gas lamps were replaced by the more mundane electric lights, which brought into bright focus the raw ugliness of Galesburg.

The hometown team aspired to more than sandlot baseball. Galesburg played teams from Peoria, Chillicothe, and Rock Island on the campus of Knox College. Named for General Henry Knox of Revolutionary War fame, it was a nonsectarian, coeducational institution opened by Congregationalists and Presbyterians and chartered in 1837. It was to be combined with Lombard College in the years to come, and both Knox and Lombard had a part in the life of Carl Sandburg. When the town baseball teams played on the campus, the kids from Berrien Street, who usually lacked the price of admission, watched through knotholes in the fence or climbed a tree not too far from the diamond and saw the game almost as well as those close by.

Baseball, with its heated activity and competition, most probably influenced young Sandburg, for in many ways the game remained with him to the end of his life. At one point he wanted to be a professional, and at times in the summers he played from eight in the morning until it was too dark to see the ball, only chasing home at noon for a bite of lunch and racing back. His head was filled with baseball names and stars, and he knew the names of the teams of both the National League and the American Association, including the players who led in batting and fielding and the pitchers who won the most games.

An abrupt end came to Carl's baseball ambitions. Early one afternoon in October 1894, he took his secondhand fielder's glove to a pasture to practice catching fly balls. A friend hit a high ball and Carl ran headlong for it. As he raced along, he later recalled, he had visions of making a great catch in the style of big-league baseball. This dream was interrupted when his right foot went into a hole and he found himself face down on the ground. His foot hurt and when he looked at it, blood was oozing from his sock, and a broken beer bottle which had cut him lay nearby. He managed to make his way to the home of a nearby doctor and have the cut dressed and four stitches taken, before he limped home. His mother was sorry, his father disdainful, and the combination of all factors completely ended Carl's ambitions for big-time baseball. But he never lost his love for it and it colored his mature vocabulary.

Between the age of nine and twelve, Carl Sandburg experienced one of the pleasures boys fortunate enough to live in that day had: along with his friends he attended the county fair. That this required almost a five-hour

walk each way to reach the fair grounds just outside Knoxville, Illinois, was simply part of the pleasure to him. Usually the roads were dusty. For barefoot boys this provided a delightful powder to squish up between the toes and splash gently over the balls of the feet in soft rhythm as they plodded joyously along, the fair already in their nostrils, the thrill of the crowds already sounding in their young ears. They had shoes, not to waste on the dust of the road, but to carry in their hands until they reached the fair and there proudly put on to keep bare toes from being stepped on and skinned by the crowd.

Most things at the fair cost a nickel then. Carl and the Larson brothers, his friends, invested one each in the new Edison Talking Phonograph. They had to put on earphones to listen while other people stood around awaiting their turn to "take in" the great new wonder which brought so near the sound of words and music from far-off places. In later years, Carl always seemed fascinated with sound reproduction. He was to make resonant sounds of his own, especially on records that, fortunately for posterity, hold his warm folk singing and his poetry recitation to this day. He never seemed happier than when he was in some big-city studio, singing or speaking into a microphone for radio or recording for television or films. When work was over, he often joshed with the studio personnel and often said things as priceless as those he produced for formal occasions.

At the county fair, Carl saw slices of midwestern life that were always to be part of his own nature and expression—horses and cows, hogs and chickens, ducks and sheep. These were only part of the panorama of the prairie farms on display, their red and blue ribbons bright evidence of prizes won in sweating competition between ardent but fair-minded farmers from the surrounding countryside. Not only did the farmers compete, but they learned from example how to make the land produce more each year in crops and profits, until finally the system would develop that gave a small percentage of people sway over a powerful kingdom of mechanical giants, wresting from the soil its rich fruitfulness. Carl saw the rawboned farmers in their crude but clean clothing, muscles prominent underneath, sturdiness plain in their earnest faces. Their women, who should have retained their beauty, were all too much like the Grant Wood painting that reveals femininity worn and wearied by toil and inexorable demands of family life on the prairie.

On one visit to the fair, Carl hitched a ride home in a hayrack, a comfort and joy to his aching feet and exuberant heart. The smell of the hay as the horses jogged along caught in his nostrils and never left him when he

came to write about his Middle West and its people, who turned to the great cities to compete in a harsh industrial system that this Swedish-American never quite accepted. The luxuriant grass, as thick as his own hair, was a symbol to him of the surface of the prairie. Although he never gave the grass the prominence in his titles that Walt Whitman did, Sandburg, whom Whitman influenced, was just as conscious of it and vastly more familiar with this hirsute adornment of rural nature than his earlier Brooklyn counterpart.

Another strand in this youthful experience that bore so strongly upon the sensitive mind of young Sandburg was the Barnum and Bailey Circus. When it came to town, he was up early to watch the unloading of the animals down by the railroad tracks, and hear the man who rode ahead of the elephants announce in exaggerated but beloved tones that the great beasts were coming down the street—something he could hardly have concealed had he tried. Once Carl even saw Mr. Bailey himself, in a long black coat with tails, noisily supervising the setting up of the circus in a large field outside Galesburg. Characteristically, the boy wondered where Barnum was, not realizing that it was unusual for even one of the owners to appear at such a comparatively small place on the circus itinerary.

Carl got a job carrying water for the elephants, and this was not a small task, for the pay involved a ticket for the day's performance. But he considered the show a rich reward, with its grand march of all the performers around the spacious interior of the great tent, the antics of the acrobats, the hilarious carrying-on of the clowns, and—the climax that forever remained with him—the hippodrome chariot race lavishly presented as it had been, at least in the words of the master of ceremonies, in the time of the Roman Emperor Nero. Other features that stuck in the fertile Sandburg mind were the spieler with the long mustache and stentorian voice, the inevitable wild man of Borneo, the world's smallest dwarf and tallest giant, a man-eating python, a dog-faced boy, an unbelievably fat woman, and the tattooed man who had fish, birds, girls, and boats all over his skin. Carl felt sorry for the freaks because he sometimes felt like a freak himself and sympathized when they were stared at. Yet the time was to come when he would feel inadequate in public unless he himself was stared at. Indeed he cultivated a colorful appearance for the very purpose of bringing this about, particularly when it meant success on the stage or in front of the microphones.

Not long afterward—perhaps the influence of the circus was to blame—Carl went into Olson's store and made his first purchase on credit. It was a

stick of licorice and it cost only a nickel, but that was more than Carl possessed. He thought that this was a marvelous way to get something for nothing; but he did not reckon with his thrifty mother. When he arrived home with the dark and sticky candy showing on his face, she inquired how he came by it and he told her. Whereupon she slapped him and admonished him never to abuse the family credit again on peril of a real licking.

Such episodes were exceptional, however, for Carl's recollections were mostly pleasant, especially the occasions of his first singing. The local cigar store was the scene of gatherings of his boyfriends between work and play times. On balmy nights, and on Sunday when the little store was closed, he and his friends would gather on the sidewalk for a session of youthful harmony. Among the participants were tall and skinny John Hultgren, a Swedish boy who worked in a local broom factory, and stout, bright-cheeked John Kerrigan, a young Irishman who worked as an apprentice plumber, both of whom sang tenor. Willis Calkins and Carl Sandburg sang baritone and bass interchangeably, which they considered quite accept-able, but since there were no demanding critics, it made little difference. Examples of their musical offerings were "In the Evening By the Moon-light," "Carry Me Back to Old Virginny" in its original version, and the popular "Swanee River."

Such sentiment fused into the religious when Carl watched the local cobbler do his work and philosophize at the same time. The cobbler would cut his leather for a half-sole and fill his mouth with wooden pegs for the job, meanwhile trying to talk. The boys watched with fascination as he proceeded, and remembered his mouth as much as his words. But they knew that he worked from early morning until early evening each day and that he liked his work, something that made a special impression on Carl as he huddled around the cozy little coal stove on chilly winter days. But memorable also were the cobbler's devout words. He made it clear that he had Jesus in his heart, that he prayed to him day and night, and that the boys would never go wrong if they followed Jesus, for He was the light of the world and if one believed in Him, one should never be afraid. The cobbler emphasized that this is a short life, and he proved it by dying early from consumption. This experience made a sharp impression on the young Sandburg, although even now it is hard to estimate just how re-ligious he ever became. But it is certain that in later years he often made reference to God, especially in some of his writings. One has the feeling

that Carl Sandburg, like Jefferson and Lincoln, was religious in his own special way.

In his teens, Carl heard one of the foremost speakers of the day, William Jennings Bryan. The "Great Commoner" arrived in Galesburg by train, and from a platform on Mulberry Street next to the railroad tracks he made one of his eloquent speeches. The boy has not recorded what impression the famous orator made the first time he heard him, but evidently it had a definite impact, for not long afterward, when Bryan was speaking in Monmouth, a town some sixteen miles from Galesburg, Carl and some of his friends rode the cowcatcher of a train on a cold October night to hear him again. Whatever the orator said this time must not have made much impression on Sandburg; nor did his principle of abstinence from the bottle make much of a dent, for one of the boys bought a pint of blackberry brandy, which was sampled by the group and found to bring marked relief from the cool weather. In what appears from his own reminiscing, Carl was equally unimpressed with a speech by Robert Ingersoll, who appeared that fall in a tent on the Knox College campus and delivered an excoriation of the Democrats and Free Silver, which the local boys listened to obligingly. Meanwhile the blackberry brandy had apparently not become habit-forming, for the boys had decided they would leave booze alone thereafter. Instead, their main dissipation, for a time at least, consisted of walking the main street of the hometown and voraciously eating cream puffs.

Of more import was the first musical instrument that Carl Sandburg played. It was a willow whistle, which he cut out himself, and putting it between his teeth, he rapped out the tune against his teeth with his right thumb. Next came a comb with a paper over it on which he tried to vocalize, but without much success. With a dime sweet-potato-like kazoo, Sandburg could imitate large musical instruments or the sounds of chickens. Then he tried a tin fife, a flageolet, and the octarina, but none to much effect. His first string instrument was a banjo he made himself from a cigar box. He never learned to play any instrument very well, but from his success in singing folk songs and strumming a guitar or banjo later on, it seems that few minded.

Whether by performing musically or by writing or speaking, Carl Sandburg always had a knack for making money, even though he made so little at times that it seems a wonder that it was sufficient to sustain him. His first regular paid job, following a series of odd assignments such as hunting for rags, bones, iron, and bottles to sell, was with the local real-estate firm of

Callender and Rodine, located in the main part of town. His task was to open the office each morning before the owners arrived and sweep it from end to end. There was dust all over the wooden floor and in the cracks and corners; Carl dealt with it by the simple method of sweeping it out into the hall and down the stairs into the street. Also part of the daily stint was cleaning the spittoons of both Mr. Callender and Mr. Rodine. Carl carried the heavy, smelly brass receptacles to a nearby faucet, where he emptied them, then washed and rinsed them. Every few weeks, the lad polished the spittoons until they shone like a brass tuba. For this chore, which really required only a few minutes each morning, Carl received the sum of twenty-five cents a week.

Inevitably for an American boy growing up in that era, Carl carried newspapers. This he did for the *Galesburg Republican-Register*. The papers came off a flatbed press and the carrier boys, who gathered right after school each day, took them to a table where they folded and counted them. Carl learned how to fold the papers so they could be thrown sharply against the front doors. With a bundle of them under his arm, he dashed downstairs to Main Street and turned north. Most of the houses were near enough to the sidewalk so that, without stepping off the walk, he could fire the papers smack against the door bottoms on the wooden porches. Now and then he would find a big house set back so far from the walk that he had to go into the yard to make his pitch. Possibly here at this early age began Carl Sandburg's resentment of those who had what seemed to him too much, as opposed to his own class, which had too little. Especially, he became unpleasantly conscious of the local Republican Party boss of the county, a fat man who often waddled out to meet him and take the paper from his hand, so greedy, thought Carl, was the roly-poly one to read the news of the world, particularly one that fed his own likes and dislikes. The great three-story stone house, the biggest in town, seemed to the boy to have a particularly forbidding appearance of wealth, with its towers and fancy curvatures. When he had finished his two-mile delivery rounds— greeting friends, shyly looking at girls now and then—he turned south again, with one copy of the newspaper left over for himself. In addition, the *Republican-Register* paid him one shiny and appreciated silver dollar a week.

This typical American Midwest landscape that young Carl saw as he delivered his papers made a deep impression on him, leaving a kind of Gothic etching in his mind that later was to appear in the vivid images of

both his poetry and prose. The trees stood out in bold relief, stark and bare against the winter sky, lush and green in spring and summer days. In autumn some of the apple trees were too beckoning for him not to pause and partake of their fruit; for surely no one was ever hungrier than a schoolboy carrying newspapers. Carl, in contrast, also got to know the sizes and shapes of the backhouses or privies; every yard, rich or poor, had one, only varying from elegant lattice-fronted structures, spacious and containing soft paper, to dinky and broken ones with apertures open to the elements and catalogs the mainstay of their equipment.

On these rounds came the inspiration that was to stay with Carl until the end of his long life and mark him in many primary ways, a journalist at heart and in much practice and association. He saw the reporter for the newspaper going along the street and getting personal items from the most prominent people, who were either coming or going, expecting company or a baby, or perhaps had had a sickness or a death in the family. It was a leisurely process then, and a pencil was used on the copy paper instead of a typewriter. The sight of this working journalist thrilled Carl and filled him with an admiration that spurred him to eventual emulation.

In fact, he got deeper into the newspaper field even then by carrying a morning route of Chicago papers. This required diligence, and every morning he found himself on the railroad platform when the fast mail train from Chicago came in soon after seven. From the depths of the mail car as the train rolled to a stop came hard, fat rolls of the city papers, the boys grabbing them and quickly sorting them out for their routes. The newspapers included the *Chicago Tribune*, *Chicago Times*, *Chicago Herald*, and *Chicago Chronicle*. On Sunday mornings, Carl would pull a small wagon filled with the Chicago newspapers and sell them for five cents a copy, making a penny for himself. All in all, he came to make about twelve dollars a month—to say nothing of the invaluable experience he received in his varied contact with all kinds of people, the feeling he acquired for the business, and his hearty absorption of the joys and sorrows he encountered.

Of equal interest and value were his days peddling milk from a wagon, although this episode in his life was a rather brief one. Carl was nearly fifteen years old when a dairyman hired him to help deliver milk to the local residents. The milk barn was two miles away and instead of riding this distance, which cost a nickel, the young man walked. He had hardly begun work when he and his family came down with diphtheria, and Carl

was kept from his job for some time. The dairyman held little attraction for Carl, so when he paid him for his work, the boy told him he wished to quit and this was mutually agreed upon.

After a short period of working for a drunken tinner, and another of washing bottles in a pop bottling plant, where Carl drank so much free pop that he felt he had had enough to do him the rest of his life, he quit this for still another job, this time in a drugstore. He had the key for opening the store, and at seven in the morning he appeared and diligently swept the floor, then took a chamois skin and wiped off the showcases. Carl quickly learned how to fill bottles with wine and whiskey, as well as those labeled sulphuric and muriatic acid, wood alcohol, turpentine, and other kinds of medicine. Mr. Hinman, the pharmacist, reminded Carl of Edgar Allan Poe, being slim, dark-skinned, and wearing a neat little mustache. He had a frequent smile and an ever-present sense of humor.

Perhaps no boy ever had such varied jobs as Carl Sandburg. For weeks he worked nights in what was called an ice harvest on a nearby lake when the thermometer was near zero. Carl walked from home for several blocks, then caught a streetcar that ran for over a mile out to the lake. The ice was thick, up to eighteen inches, and men worked over it at first with ice cutters. Large blocks from ten to fifteen feet in size were cut and moved to the icehouse at the edge of the lake. The ice was then cut up into smaller cakes and these were stored in rows with sawdust sprinkled in between to keep them until the warm weather came, when they were greatly cherished.

"I had overshoes and warm clothes and enjoyed the work," Carl reminisced in later years:

> The air was crisp and you could see a fine sky of stars any time you looked up, sometimes a shooting star and films of frost sparkles. I never had a night job that kept me til the sun came up. I got acquainted with a little of what goes on over the night sky, how the Big Dipper moves, how the spread of the stars early in the night keeps on with slow changes into something else all night long. I did my wondering about that spread of changing stars and how little any one of us is, standing and looking up at it.[7]

When soon afterward Carl was put in the icehouse to work, he found that the chutes fed him so many cakes of ice that it was a cold, hard struggle to keep up with them. As he did in his life to come, he adjusted his efforts and strength and handled the ice cakes well. Throwing iron tongs into these heavy blocks and maneuvering them into proper position

proved to be heavy work, straining the muscles in his back and shoulders. Doubtless such labor added to the size of his huge hands, which were always conspicuous whether he was typing out a newspaper story or plunking on his guitar. He found that like many beginners he went at the work too diligently and unskillfully. Now and then he would try to rest a few minutes, but evidently the foreman did not relish this, for he would walk over and tell the young man to get busy. At least he called him by his name, and this helped. Carl was just about ready to quit when the foreman kindly reminded him that in only a few more days the ice-gathering job would be over. This gave Carl a second wind and he tore into the task with new vigor. He worked harder, slept better, and best of all his taut muscles relaxed. He found that if he relaxed, he could work better and last longer. This was a lesson he never forgot.

All his life too he relished sports. A year after his experience with the ice, he worked for a time at the local racetrack, carrying water and helping to dry and sponge the tired horses after their runs. This was interesting, but best of all to him was being near some of the best racehorses in the world. Here was competition at its keenest; he learned what it took to win. Yet some days were wet and then the horses and trainers and riders had to wait for the weather to change, something none could control but all complained about just the same. Over them all, however, there was a complacency, which was a good example to the young man who was to express man's struggle in song, poetry, and prose and to show the lasting influence of such molding experiences.

At the Galesburg grammar school one night, Carl saw a diorama of the Battle of Gettysburg, and even this simple portrayal etched itself permanently in his mind. Admission to the show was five cents. Succeeding curtains revealed the unfolding events of the great battle as a man with a long pointer explained the struggle. Although the man's voice was squeaky and monotonous, Carl absorbed the spirit of the presentation and remembered details that in later years he was to convey not only in writing but to interviewers who walked with him across the battlefield itself as he reflected on the image of Abraham Lincoln.

John L. Sullivan, the heavyweight boxer, also came to Galesburg. He played in a skit that had little relation to athletics but did give the audience an opportunity to see and hear this strong man who had won the admiration of boxing fans of the world. Sullivan whetted the appetite of the young Sandburg for sports, as did "Gentleman Jim" Corbett, who appeared soon afterward with his punching bag. But Carl got little thrill out of seeing

Fridtjof Nansen, the adventure-story writer, or Henry M. Stanley, the African explorer, with whom he had less familiarity.

Some of Carl Sandburg's first stage experience came when he helped backstage with the play *The Count of Monte Cristo*, which came to town with James O'Neill as the star. In fact, the young man helped roll the canvas sea that O'Neill swam in when he made his escape. *Uncle Tom's Cabin* also played the town, and Carl remembered long afterward how disappointed all the local people were at not seeing two of each character in the play as had been advertised. Carl even had a small part in a Civil War play, *Shenandoah*, by Bronson Howard. A favorite was Al Field's minstrel show, for here was a rousing display of the art of banjo-playing by Field himself. Carl usually saw these shows from the balcony known as "Nigger Heaven," a cheaper and noisier part of the auditorium where the cracking of peanut shells mingled with sounds from the stage.

Despite the interest and variety of Carl's many jobs, he began to realize that he was not getting anywhere and decided that he wanted to learn a trade. But he found no opportunities among the plumbers, carpenters, painters, or machinists. Then he heard of an opening for a porter at the Union Hotel barbershop. By this time, he felt some desperation and rationalized that here was a real opportunity for work, travel to other towns, and possible openings into more promising fields of endeavor. So he went down and got the job. The barbershop was under a bank—in a basement with large windows through which he could see the feet of pedestrians on the sidewalk. These feet were of special interest to Carl because he was to shine the shoes of many of them and the result would be a few welcome tips to add to the slender coffer. Later when he was to write of the lowly, he knew the lowly.

In the barbershop Carl met the so-called upper crust of Galesburg and he was not overly impressed with them. The barbershop was not always busy, and Carl found that at early noon he could go up a back stair to the main office of the hotel and through it to the bar (although he was too young to be admitted legally) into the swanky saloon. There he found a brass rail and a long mirror with fancy wood carving around it. At the end of the bar was the proverbial free lunch of those days, ham and cheese and pickles. There Carl got his lunch, without buying a drink—for which he was duly thankful. The most prominent people who passed through Galesburg usually appeared at the hotel, and Carl learned who they were by reading the *Police Gazette* in the barbershop, so he recognized many of them when he saw them. A high spot in Carl's barbershop job came when

on the death of the local congressman he took to his shoeshine stand and there brightly shined the shoes of four senators, eight congressmen, and two majors, as well as two pairs of knee-high boots such as Lincoln wore. Their wearers had of course come for the funeral, and that day Carl made an unprecedented $1.40.

Saturday was a special day in the barbershop. It was bath day. Next to the shop was a bathroom with tubs that cost a quarter to use. Some of the customers would call Carl in to scrub their backs, for which he usually received a quarter. Often he would compare notes with other barbershop porters on what was the best polish for shoes and how to wheedle the biggest tip out of a customer. Sometimes some of the shine boys would go to the hotel on Sundays and order the best dinner, just so they could say they had associated with the bon ton of the town and did not have to be lackeys all week long. The barbershop fascinated Carl, but by spring of 1893 he was ready to leave it. He felt he was not cut out to be a barber.

Serious thoughts were besetting him. He observed:

> Every morning for sixteen months or more I walked from home at half-past six, west on Berrien Street, crossing the Q. Switchboard tracks, on past Mike O'Connor's cheap livery stable, past the Boyer broom factory, then across the Knox College campus and past the front of the Old Main Building. Every morning I saw the east front of Old Main where they had put up the platform for Lincoln and Douglas to debate in October, 1858. At the north front of Old Main many times I read on a bronze plate words spoken by Lincoln and Douglas. They stayed with me and sometimes I would stop to read these words only, what Lincoln said to twenty thousand people on a cold, windy October day: "He is blowing out the moral lights around us, when he contends that whoever wants slaves has a right to hold them." I read them in winter sunrise, in broad summer daylight, in falling snow or rain, in all the weathers of a year.[8]

It was probably at this point in the young man's life that he began to ally himself with Lincoln as a force, an unknown quantity, an enigma—having no notion that one day he, Carl Sandburg, would be moved to write the world's most spectacular biography of the Civil War president.

This was on Carl's second milk-route job; also on this job he found his first romantic love. Once he saw her face, it stayed with him day and night. She lived in a home that required a quart of milk each day, so he would pour it into the crock waiting on the porch, knowing that usually, through the window above him, she was looking. Sometimes when there was no message in the crock, she would come out and smile at him and ask him to

leave the milk. He left his heart also. But this did not last long. One night he had the opportunity to walk home with her from the Knox Street Congregational Church and found she had little to say and less to offer, so he shied away from her from then on, a disillusioned but not too downcast boy.

But girls had a very small part in Carl's early life. He did not understand them or know what to say to them. Now he was nineteen years old and restless. His jobs had led nowhere and his frustration often depressed him. He began to feel that, though his hometown had many shortcomings, he did too—and so he blamed himself for his uneasy state of mind. He realized, however, that it was up to him to do something about this restlessness. So he decided to head west, having heard from hoboes that anyone could wander about without money or job and get along alright, at least in their demi-world. His family had not favored the idea—his mother burst into tears and his father scowled. But Carl was determined, and there was little they could do but let him go. He had no valise, just his clothes and a few toilet articles in his pockets, plus $3.25 and anticipation.

# 2

## Early Wanderings

""What came over me in those years would not be easy to tell," Sandburg later recorded. "I hated my hometown and yet I loved it. And I hated and loved myself about the same as I did the town and the people. I knew then as I know now that it was a pretty good home town to grow up in. I came to see that my trouble was inside of myself more than it was in the town and the people."

In June 1897 he headed west to work in the Kansas wheat fields. He would beat his way on the railroads and, early showing that wanderlust that was to stay with him all his active life, he was determined to see what would happen. He would be a hobo. The young Sandburg had talked with hoboes enough to know that one type was the professional tramp who never worked and another type the "jaycat," who looked for work and hoped sometime to land a job that would suit him.

Traveling was not entirely new to Carl. When he was eight years old he was a member of the Junior Epworth League and a delegate to a convention in Monmouth, Illinois. Six years later he and some other boys chipped in and bought one bony horse for two dollars and another for three. They hitched these nags to some light wagons and drove fifty miles to the

Illinois River, where they camped, fished, and went swimming. At this time the three-dollar horse died and they buried him, but with little respect. They had to buy another horse for the trip back home to Galesburg.

Not until he was sixteen did Carl ride a railroad train as far as fifty miles. His father obtained a pass for him to Peoria, and he rode the train alone to that city, feeling important and independent. There he saw the state fair and steamboats on the Illinois River. There he drank the "sulphur water" and felt he was a traveler seeing the world. He liked Peoria and never could accept the slighting references to it by New York theatrical producers, who have at times regarded it as a rustic testing place for their plays.

Carl Sandburg was eighteen when he made his first trip to Chicago. He had saved up one dollar and fifty cents, and his father, with much difficulty, secured him another railroad pass. As the train rattled along, Carl put his head out the car window at each stop and marveled at seeing for the first time such towns as Galva, Kewanee, Mendota, and Aurora. In Chicago Sandburg saw the Eden Museum, variety shows, Marshall Field's big store, gaped at the buildings of the *Chicago Daily News* and the *Chicago Tribune* and felt closer to these newspapers that he had sold in Galesburg. He watched with wonder the elevated trains and walked out to Lake Michigan, across which he was later to live, where he saw "water stretching away before his eyes and running to meet the sky." For miles he walked and never tired of the roar of traffic in the streets, the streetcars, the horses and wagons, buggies, surreys, and occasionally a man on horseback.

"It is clear," wrote Hazel Durnell, "that his reaction to the country and the aspects he seized on show unmistakable signs of keen sensitivity and a pictorial imagination that fixed scenes in his mind for years to come, together with a lyrical appreciation and gifts of expression, a sharp gift for the observation of life and a keen sense of the pathos of the human situation."[1]

Sandburg noted that the country was emerging from its hard times. He noticed that more factory chimneys were smoking and that the prosperity promised by President McKinley was on the way. Yet as he was always to discern, there were still many men out of work. Many had gone away from their homes hoping to get jobs elsewhere, and these men could be seen riding boxcars and sitting around in hobo jungles.

As Richard Crowder commented on Sandburg's autobiography, "The young Sandburg had surely learned something from every experience. The fact that he was now remembering vividly the details of his early life at

60 to 70 years before, show not only his capacity for recollection, but also his ability to remember particularly; to recall the special sights and sounds that made his experiences his own."[2]

Carl left on a bright afternoon when a Santa Fe Railroad freight train was standing near the station. He hopped into a boxcar and was soon a considerable distance from Galesburg, crossing the Mississippi River and jumping off at Fort Madison, where he procured a nickel's worth of cheese and crackers and felt more uncertain about his mission than he had thought he would. At Keokuk he met a real tramp who told him how he filched food from gullible housewives and proved it by showing Carl several sandwiches he had so obtained. Using his own initiative, Carl found an old tin can, bought a cheap brush and some liquid asphalt, and went from house to house getting jobs blacking rusty stoves. He earned a little money this way, enjoyed some good meals, and learned that housewives were the same as in Galesburg—credulous when a young man told them he was working his way through college.

In Keokuk the young Sandburg landed a job as waiter in a tiny restaurant, whose owner was evidently a drunk who came and went as the drinking notion struck him. But Carl did not leave this job until he had learned some of the art of waiting on hungry customers—and how to feed himself and fix a batch of hearty sandwiches for the road. Then he boarded another freight car, which took him into the center of Missouri. In a little place called Bean Lake, he worked for a few weeks on the railroad, tamping cross-ties and cutting weeds. But he tired of the monotony, the rigidity of the boss, and the endless diet of pork, potatoes, and coffee, so he soon departed for Kansas City. There he worked again briefly in a restaurant, mostly washing dishes. This naturally grew tiresome, so in keeping with the pattern he had already set, he quit and moved on. The freight train this time did not turn out to be such an easy ride. A brakeman spotted him and ordered him off the train, and when Carl did not readily comply, he struck the young man in the mouth with his fist, but allowed him to remain on board.

Carl remembered getting off the train in Emporia, Kansas, and walking past the office of the *Emporia Gazette* but not having the courage to stop in and see the editor, William Allen White. What good it would have done for the youth to have seen him under the circumstances is not clear from the later reminiscences, but apparently even at that age Carl realized who the "Sage of Emporia" was and how significant it was to be in his locality.

On to Hutchinson, Kansas, where Carl learned that by calling at houses

that were not too near the railroad tracks he stood a better chance of getting food handouts, although at times he had to work for them. By now he was getting used to the hand-to-mouth life, but one day he was shocked to hear some Swedes on a farm where he was working refer to him as a "bum." He asked himself if this was true—and concluded that it was. Even so, he apparently derived a bizarre enjoyment from his contacts with the other hoboes, and it is certain he learned from them some of the elementary facts of life he would never have absorbed anywhere else. He was meeting fellow travelers, and though they were rough, they were Americans. Even if he was not climbing upward conventionally in the social scale, he was gaining respect for his own ability to make a go of things. His open road was even more raw and revealing than that of Walt Whitman. Such feelings he later expressed in his poem "Slabs of the Sunburnt West."

> Into the night, into the
>     blanket of night
> Into the night rain gods, the
> night luck gods.
> Overland goes the overland
>     passenger train.
>
> Stand up, sandstone slabs of red,
>     tell the overland passenger who
>     burnt you . . .
>
> Sleep, O wonderful hungry people
>     take a shut-eye, take a long
>     snooze,
> and be good to yourselves.[3]

By degrees, Carl made his way across the Great Plains. He was stirred by the Rocky Mountains and saw Pikes Peak with pride. In Denver, he washed dishes at a hotel for two weeks. But time had brought some homesickness, so when he contemplated either going on to the West Coast or returning, it did not take him long to decide. He hopped a Pullman train, lay on the top of a car until he reached McCook, Nebraska, and there paused for a few days to eat and to wash his grimy clothes. He chopped wood and picked apples in return for some warm clothing, and on his way eastward in the cool fall weather, he asked to spend one night in a city calaboose so as to keep warm. Carl reached Galesburg in mid-October. As he was welcomed by his relieved family, he realized that he had at last grown up in many ways.

"What had the trip done to me?" he asked himself. "I couldn't say," he answered. "It had changed me. I was easier about looking people in the eye. When questions came I was quicker at answering them or turning them off. I had been a young stranger meeting many odd strangers and I had practiced at having answers. Away deep in my heart now, I had hope as never before. Struggles lay ahead, I was sure, but whatever they were I would not be afraid of them."

Reminiscent of his hobo days, in April 1952, when Sandburg won the gold medal of the National Institute of Arts and Letters, Harvey Breit of the *New York Times* asked him what he was going to do with the award. Carl answered, "I'll wear it on the inside of my coat and when a railroad dick stops me and flashes his badge, I'll flash my gold badge right back at him."[4]

Sandburg always remembered his hobo days. In a poem he wrote:

> I waited today for a freight train to pass
> Cattle cars with steers butting their
>   horns against the bars, went by
> And a half dozen hoboes stood on bumpers
> between cars.
> Well, the cattle are respectable, I thought.

He was not to remain idle long. Work on a farm some three miles east of Galesburg appealed to him, and he began a routine of arising at four-thirty in the morning and currying two horses, then milking eight cows while the owner milked fourteen. The milk was put into large cans and Carl drove into town with it, pouring out pints and quarts for the customers. He bought a Chicago newspaper regularly and on his way back to the farm read a series of lectures on history and government by University of Chicago professors. His intellect was beginning to be whetted. After leaving the farm work, Carl hired out to a Swedish painter in order to learn the trade. But mostly he scraped old paint off buildings and sandpapered the surface in preparation for the real painting by more experienced men.

In 1898 the United States was drifting toward war with Spain over conflict in Cuba. At first diplomacy was tried, but this failed, with the help of the yellow press in the nation and a group of young Republicans, including Theodore Roosevelt and Henry Cabot Lodge. They regarded Cuba as the key to domination of the Caribbean and favored expansionism. President William McKinley, a devout Methodist, at first was reluctant to declare war but finally capitulated and said that "God told me to take the Philippines from Spain."

The planned invasion of Cuba got off to a slow start, partly because of the poor condition of the Regular U.S. Army, which embarked from Tampa, Florida. The embarkation was delayed by the ineptitude of General William Shafter, who weighed about 300 pounds and faced difficulty from the heat and in mounting a horse. (His headquarters was in the old Tampa Bay Hotel, now the University of Tampa.) For some reason, the general took with him only three ambulances and one scow for landing his 16,000 men. Of the 275,000 soldiers who served in our army during the Spanish-American War, fewer than 400 were killed, while more than 5,000 died of wounds, disease, neglect, and spoiled food.

In February 1898 Carl heard of the sinking of the battleship *Maine* in Havana harbor and, like most other uninformed Americans, believed the propaganda—that the Spaniards who had killed thousands of Cubans who wanted a republic had also had a hand in blowing up the ship. Though Carl was as aroused as most of his countrymen, he went on with his sandpapering for a time. But he knew what he was going to do. On April 26 he enlisted for two years in the Sixth Infantry Regiment of the Illinois Volunteers. He was acquainted with most of the men in his company, for they were from Galesburg and its vicinity, and they were proud that no regular army personnel were part of the organization. The Sandburg family took the matter soberly. They did not try to keep Carl from going but did let him know that they fervently hoped he would return alive—to which he answered that most soldiers did return.

The local company of troops was quartered in a big brick building on the fairgrounds in Springfield, Illinois. Carl Sandburg could not have been unaware that here in this land of Lincoln, he too was serving in a local military outfit, as did the illustrious late President in another war. The fact that the men were staying in a building that ordinarily housed livestock did not diminish their sense of historic importance. Carl was given a heavy blue uniform and a Springfield rifle (named for the Massachusetts city where they were manufactured). He learned that these were the same uniforms worn by Grant's and Sherman's men some thirty-five years earlier. Carl recorded that he felt honored to wear the uniform, but for some reason he had a mistrust of it.

During a few leisure hours, Carl and his companions had an opportunity to walk around the capital grounds and past the home of Abraham Lincoln. But soon they were in train coaches headed southward. Their food consisted mainly of canned beans, canned salmon, bread, and coffee. Canned goods were not yet taken for granted; and it was well that these men did

not know that before this short enlistment was over, more men were to die from the effects of "embalmed beef" than from enemy bullets.

The train made its slow way to Washington, D.C., then on to Falls Church, Virginia, where the men bivouacked temporarily. From May to June the company drilled and the recruits became familiar with army equipment and its use in the field. About a fifth of the company had relatives in the Civil War, a fact that made a lasting impression on the young Sandburg. He learned that men join the military for various reasons: love of country, often vaguely felt; desire for adventure, sometimes soon regretted; troublesome wives, who doubtless live to be remorseful; and hope of pensions, which usually is rewarded.

On leave one day, Carl made a trip to Washington and for the first time saw the Capitol and Ford's Theater and the Peterson House across the street. Soon the regiment was on the Atlantic Coast Line train en route to action, making its way across Virginia and North Carolina to Charleston, South Carolina. There the men in Yankee blue were surprised by the friendly treatment accorded them by the local people. The cotton-plantation life was still evident, but the Negroes took off their hats to these soldiers, who to them represented their emancipators.

The Illinois men boarded a captured Spanish freighter, were issued more canned rations, and in due time landed at Guantanamo Bay, Cuba. There the ship lay at anchor—because of confusion in the orders from Washington, and because there were several hundred cases of yellow fever ashore. Finally the ship got underway, putting its soldiers ashore at Guanica, Puerto Rico.

Carl's dream of getting into action was frustrated by lack of action to get into, and by uncertainty as to the future. Mostly the fight was with mosquitoes and land crabs. About the latter, correspondent George Kennan, on the scene, observed, "They are the most disgusting and repellent of all created things."

Although some shooting could be heard in nearby towns, it did not affect the Illinoisians, and they continued to march, eat their canned rations, fight insects, and endure the heat, which was exacerbated by the heavy underwear, wool pants, shirts, and socks that had been worn by the Army of the Potomac in 1865. The Puerto Ricans appeared glad to be taken over by the Americans after four hundred years of Spanish rule. They were gladder than the American soldiers, who were each bearing, besides a heavy uniform, a cartridge belt, a rifle, bayonet, blanket roll, half of a canvas pup tent, haversack, and rations. Some of the men, including Private

Sandburg, tore off part of their blankets and threw them away to lighten their load.

Camping above a town called Ponce, the Americans were sleeping one night when shrieks rang out in the darkness and hundreds of men dashed from their sleeping places down a slope, sure that the enemy was in hot pursuit. True, it was hot and there was pursuit by mosquitoes, but the disheveled and bruised men soon learned that the commotion was caused by the bulls used for hauling carts. One animal had accidentally trampled on a sleeping soldier, who let out a blood-curdling yell. The men called this their "First Battle of Bull Run."

Carl observed that, even though it was a small war, it was the first in which our country had sent troops to fight on foreign soil and acquire island possessions. Soon it was over and a transport took the Americans back to New York. Our "hero" bought on the docks a loaf of white bread and a quart of milk and thought he was dining on nectar and ambrosia. It was not long before he was welcomed back in Galesburg, this time with the feeling that even though he had been away for only five months, he had gone "somewhere."

The homecoming was heartening to the young soldier. In the late summer days of September 1898, Carl marched with his company through the streets of Galesburg to the cheers of the welcoming homefolks. He felt additional pride from the fact that he drew $122 in discharge pay from the army. He gave part of this to his father in repayment of a loan. On the honorable-discharge document of Private Carl Sandburg were the words, "A good soldier, service honest and faithful."

# 3

# Lombard College and Sequel

Within easy walking distance from the Sandburg home in Galesburg was the campus of Lombard College. When Carl was a boy, he went to the commencement exercises of the college, the influence of which extended into his own neighborhood through a Sunday School Mission. The teachers of the institution were mostly college students. The president of the college from 1874 to 1892 was Newton Bateman, who had been Illinois Superintendent of Public Instruction during the last years of Abraham Lincoln in the state. Bateman and Lincoln became good friends, and Bateman composed a popular lecture centered around Lincoln's departure from Springfield for Washington. Now and then on campus the young Sandburg would see this short but distinguished-looking college president.[1]

After returning from the Spanish-American War, the sobered Sandburg decided he had better get down to business and pursue something with a future. So he decided to enroll at Lombard College. One reason for this was an individual who later was to become a mighty influence in Sandburg's life. The best introductory description of him is in the autobiography, *Always the Young Strangers*:

If we saw a man of slight, wiry build, a light-brown silken beard over his face, his head held high and bent forward peering through spectacles, a small tan valise in one hand, walking east as though his mind was occupied with ideas a million miles from Berrien Street and Galesburg, we knew it was near eight o'clock, when Professor Philip Green Wright would take up a class at Lombard University some six blocks away. We didn't know then his grandfather was Elezur Wright, a radical and an agitator who had a stormy career as secretary of the American Anti-Slavery Society and who later worked out and compiled the first dependable actuarial tables used by large life insurance companies. We didn't know that the funny-looking fellow would become a truly Great Man and forty years later I would write the sketch of him for the *Dictionary of American Biography*. As a boy I didn't have the faintest dim gleam of a dream that this professor would in less than ten years become for me a fine and dear friend, a deeply beloved teacher. He walked with queer long steps, stretching his neck to peer away past the next corner. We would imitate his walk and we didn't know in the least that he had streaks of laughter in him and in time to come would write one of the funniest musical comedies ever seen on the local auditorium stage even though he was a mathematician, an astronomer, a historian, an economist, a poet, a printer and a book binder, a genius and a marvel. All we knew then was that his figure and walk were funny and we liked to watch him and it was near eight in the morning.[2]

The Universalist Church founded Lombard College. The members of this liberal church did not believe that only a few people would obtain salvation but felt that God would save everyone. The college consisted of a department of liberal arts, the School of Music and Art, and the Ryder Divinity School.[3]

Carl had not been to high school but was admitted to the college, which offered him free tuition for the first year "in recognition for his valorous service in the late war." (He was awarded a diploma from Galesburg High School in 1963 on his eighty-fifth birthday.) He could have been at a disadvantage because he lacked the customary twenty-one credits needed for admission, including those in mathematics, English, natural science, and six language credits. Even so, he was to compress eight years of academic work into four.

Early in his freshman year, Carl became secretary of the college literary society, and in March of that year the *Lombard Review* published the first of numerous articles he was to contribute to this student magazine. The editor commented that "though lacking in experience, Sandburg was a man of indomitable will and [had] an insatiable desire to succeed which will doubtless carry him over every difficulty."[4] How prophetic this com-

ment was the college editor could not know. As a harbinger of his combining mental and physical activities, Carl became a member of the basketball team and when a junior was captain of it. He edited the college yearbook, won first prize in the oratorical contest, and later was elected editor-in-chief of the *Lombard Review*. Meantime, he rang the college bell, which summoned the students to classes and signaled their ending. This job paid his tuition. It is significant that he did not belong to one of the Greek-letter fraternities. (Years afterward, he was elected an honorary member of Phi Beta Kappa.)

In his writings for the *Lombard Review*, Carl Sandburg began to formulate his commitment to economic justice and social change. While he was a junior he wrote an eloquent defense of socialism. The essay began: "Twenty years ago, a socialist was often defined as a bombthrower and an opponent of law. In this day, however, most people have a dim, hazy idea that a socialist is a meek sort of fellow who has under his hat a theory which in politics is as opaque as theosophy is in religion. The strongest and most bitter opponents of socialism are business men, men whose occupation is mainly buying and selling."

Professor Philip Green Wright, as one author has said, seemed to his worshipful students to be a latter-day Leonardo. "Wright was a disciple of William Morris, the English poet and designer who had died in 1896 at sixty-four, and who had sought to promote the image of the well-rounded man. Morris, in addition to writing poetry, had been interested in medieval arts and crafts, helped spur the Gothic Revival, founded the famed Kelmscott Press, for which he had designed and printed lovely books, and had written utopian romances."[5]

Wright had come to Lombard in 1892, having been graduated Phi Beta Kappa from Tufts University with a degree in civil engineering. He earned a Master's degree from Harvard, where he studied economics and English literature, did some college teaching, helped build a bridge across the Mississippi, and worked as an actuarian. His formal academic title at Lombard University was Professor of Mathematics, Astronomy, and Economics. Said Sandburg about Professor Wright, "I had four years of almost daily contact with him at college, for many years visited him as often as possible, and there never was a time when he did not deepen whatever reverence I had for the human mind. . . . He was a great man and teacher."

During these days, Carl read a book by Edward Eggleston entitled *How To Educate Yourself.* In this volume were posed the questions: What does a person do when he thinks? Can one's thinking fool a person? One

sentence in the book set Carl to pondering: "An unreasoning skepticism is as bad as the unreasoning credulity, but the habit of holding the mind open to conviction and the habit of questioning everything for the sake of learning more about it, are certainly exceedingly valuable ones."

Letters that some of his fellow students wrote to Carl "had paragraphs and sentences moving in fine personal style. I don't feel it important that they should have written books. I know they would all have explanations of why they didn't write books. Like millions of good people they each made a pretty good life of it without the drudgery or anguish that comes with writing books worth readers' interest or laughing or crying from page to page. They didn't care to go through the loneliness, the experimentation, the practice, the writing and the rewriting, over and again, usually required to bring a book through to a good finish."[6]

Sandburg and the other students of his classes read *Pastels in Prose*, which included works by Baudelaire, Mallarmé, and Turgeṇev, and discussed how a mood or story could be told in a few well-chosen words. The students wrote criticism of these books, which was followed by a general discussion. In his classes Professor Wright would at times look over and beyond all those facing him and then "come up with something new, pat, and pertinent to what had gone before." After demonstrating on the blackboard with figures and equations, he would smile and tell a class as he finished, "And the beauty of it is that it is of no use whatsoever."[7]

The young Sandburg was impressed by how old the earth was and all the living things in it, "and what a long, crooked, wild and wasteful climb upward it had been from the early men to the latest." He was haunted by the words of William James: "How inessential in the eyes of God must be the small surplus of the individual's merit, swamped as it is in the vast ocean of the common merit of mankind, dumbly and undauntedly doing the fundamental duty, and living the heroic life."

At Lombard Carl found time to read Kipling and some of Mark Twain. His membership in the "Poor Writer's Club" brought him in contact with writers who had made some progress in their work. Evincing his flair for dramatics early, the young Sandburg appeared in a musical play entitled *The Cannibal Converts*, which was written by Professor Wright and produced at the local opera house. The plot concerned an imaginary aerial trip to some Pacific island by a group of Lombard students. Carl played a blackened character who talked in a strange tongue and was involved in successful efforts to prevent the students from being eaten by cannibals.

The students at Lombard College were mostly from the working and

middle classes. Some were children of merchants and bankers, farmers and mechanics. Both young men and women dressed plainly, and the girls were discouraged from using too much powder and rouge. Young Sandburg fell in love with one of them, if a brief infatuation could be so called. In apparent references to other such instances, Sandburg later recalled, "I would be smitten with a girl and after awhile I would find I wasn't smitten any more—and the thing to do when you no longer are smitten, is to call it off. Calling it off comes easy enough if you haven't told the girl you are smitten with her."

During his four years at Lombard, Carl never knew of a student getting drunk. There was very little liquor and very little talk about it. For one thing, the students did not have time or money to indulge in drinking or wild parties. In his later years, Sandburg often took a social drink, but he never came close to the stereotype of the soused newspapermen. Even his smoking was mainly confined to a cigar stub, usually unlighted, or a friendly pipe at times of relaxation.

It was at Lombard that Carl came under the influence of Walt Whitman. Professor Wright whetted his interest in this informal, bearded poet who was close to the Civil War and Lincoln and who, in contrast to Sandburg, had led a single, somewhat mysterious life that contained an avid physical interest in men rather than women. But Whitman's free, unrhymed, uninhibited style of writing poetry especially appealed to Sandburg, and he began to imitate him. Sandburg was to have a more wholesome, conventional influence on America, both by personal example and diverse literary contribution, than Whitman.

Before he grew Whitmanesque in his poetry, the young Sandburg tried rhyme. At Lombard he wrote pessimistically:

> Was the wind only jesting last night when it said,
> "The days are not long from the quick to the dead."
> For the house-windows shook and the tree branches tossed;
> The rain-bells rang for the souls that are lost.

Carl early developed some wily characteristics that often verged on the humorous. He wrote some poems and when he sent them off to editors, he purposely included, as his own, two free verse poems of Stephen Crane and a poem of Emily Dickinson. *All* of the poems were rejected and Carl showed the results to some friends, who laughed with him over the subterfuge. At least, the budding poet reasoned, his rejection was in good company.

In his sophomore year at Lombard, Carl was offered, to his surprise, an opportunity to apply for entrance to the United States Military Academy at West Point. He passed the physical examination without difficulty, but when it came to the mathematics examination, he failed. Apparently this was not his only difficulty, because years later Sandburg said, "I always thought it was just arithmetic I failed. But not long ago I came on the West Point letter. It was arithmetic and grammar." So ended, ironically, his military career.

At a rather early age, despite his good health report from West Point, Sandburg showed the first signs of physical strain. Perhaps it was because of so much reading in dim light or his irregular habits, or a combination of both, but his eyes began to bother him. In June 1901, he visited Galesburg's best eye man, a Dr. Perry, and had a thorough examination. He was shocked to learn that there was a growth in both eyes called a pterigium, which was moving toward the pupils, and if it reached them, there was danger of blindness. So Sandburg was placed in the local hospital, where he was operated on for removal of the films. For ten days he lay in bed in darkness except when the nurse removed the bandages at intervals and put drops in his eyes. He emerged from the hospital wearing dark glasses. "As I lay in total darkness day after day never seeing daylight, I did more thinking than ever in my life about what it is to go blind or to be born blind. I thought of the blind men and women I had heard about, so many of them heroic and fine, making more out of life than many who see and know not how precious is sight."[8]

When he wrote this in his late years, he doubtless had in mind such persons as the incomparable Helen Keller, who was to become a good friend. The two had a warm, mutual admiration for their respective literary efforts, as well as their work for social betterment. Carl found that later in life he needed to take more than usual care of his eyes, especially when he wrote most of the night, and he often wore a green eyeshade to ward off the bright light.

Despite any physical weakness, the Sandburg eyes could see more than most people, especially in discerning the extraordinary in the ordinary. For example, he remembered that in his last weeks at Lombard he went into the college museum and stood before a tall human skeleton. The skeleton seemed to whisper, "Whither goest thou?" and Sandburg whispered back, "I can't tell you but I know that if you could tell me you would." From that time on he was quite respectful of such bony remains,

imagining then that the Lombard one said, "I am the mute and incommunicable. I am not. I was."

It is not clear why Carl Sandburg dropped out of college before graduation. The idea that a diploma represented to him something of a capitalist symbol seems invalid, for he later accepted many honorary degrees and awards. His own words came closest to giving the reason why he concluded his formal education: "I was happy yet restless with an endless unrest," he wrote in *Ever the Winds of Chance*,

> editing and writing on the college paper ... speaking orations in contests, playing roles as an actor ... every day having fellowship with young men and women who were a stimulus to me ... What was going on inside of me? What was I headed for in the big world beyond the college days? I puzzled and wondered about it till I actually enjoyed the puzzlement and wondering. I was only sure that in the years ahead I would read many books and I would be a writer and try my hand at many kinds of writing.... I'm either going to be a writer—or a bum!

When I asked Margaret Sandburg why her father did not graduate, she replied, "It is difficult to explain. He didn't believe much in degrees. He didn't think a degree would be of any use to him as he didn't intend to teach or anything like that. And to get the degree, I think he would have had to go into other subjects that would have taken up his time that he thought would be better spent in writing or something else."

In 1928 Lombard College awarded Sandburg the honorary degree of Doctor of Literature. On that morning, he dashed into the president's office and demanded, "Where do I get the Ku Klux Klan regalia?" The same year Knox College awarded him an honorary degree, and in 1930 the two colleges united under the name of Knox College, named after Henry Knox, the noted American soldier and statesman.

Something got into Carl Sandburg in the year 1902, something that made wanderlust stronger than the desire for academic advancement, so he left the town of his birth and spent two years seeking an answer to whatever it was that impelled him. He sought and found jobs, tried to write some, and found that most of his companions were bums—and that was what he was too. Carl made his way east via the railroad freight cars and found himself in New York.

Across New Jersey he went, selling stereopticon pictures door to door, then to Philadelphia en route westward. The money from the sale of these

Underwood & Underwood photographs fed and clothed him. Asked by his teacher, Philip Green Wright, if he became discouraged, Carl replied:

> When one has the right swing and enthusiasm, selling is not unlike hunting, a veritable sport. To scare up the game by preliminary talk and to know how long to follow it, to lose your gain through poorly directed argument, to hang on to game that finally eludes, to boldly confront, to quickly circle around, to keep on the trail, tireless and keen, till you bagged some orders, there is some satisfaction in returning at night, tired of the trail, but proud of the day's work done.

This trait, Karl Detzer wrote, is shown in his tracing of elusive facts for biography, searching dusty files, and demonstrating that sturdy, persistent spirit for eminent success. The early Sandburg grasped for ideas, felt for words, seeking a cure for the injustices he had seen on his hobo wanderings.

As a salesman, Sandburg learned more about human nature. He found that with ordinary people it was better to say "views" than stereoscopes because the former word was easier for them to understand. Sometimes when pronouncing "stereoscopic photographs," he would look a man in the eye and would catch him looking back as if asking, "Is something wrong with this fellow's face or is he trying to sell me something?" A wife would say to her husband, "Are you letting one of those agents hook you again on something you don't want after you get it?" If the time were near noon, Sandburg would offer fifty cents off from whatever they bought to pay for his dinner with them and in this way spent many pleasant hours at their tables.

Sandburg had managed to get a pass on some of the railroads. As he traveled, he wrote and wrote, anything that came to his mind—poems, essays, just sentences. He listened to the heartbeat of the nation from an odd and elemental angle and tried, amateurishly, to reproduce it.

On August 2, 1904, Sandburg wrote to Professor Wright: "At Pittsburgh, I was captured by railroad police and sent to the Allegheny County jail where I put in ten days. The warden gets 50 cents per day for each prisoner he is (supposed to be) feeding; and as said feeding does not entail an expense of 5 cents per day, if only enough prisoners that can't make a howl may be obtained, why he can shake the plum tree and fill his own pockets. The charge against me was 'riding a freight train without paying fare.' And the car had not even moved."

While Sandburg was wandering in the East from 1902 to 1904, he and

Wright wrote to each other, exchanging experiences and poetry. From this correspondence emerged two small books, *In Reckless Ecstasy*, for which Wright wrote the introduction, and a ten-page essay, *The Plaint of a Rose*, a sentimental story of an undernourished flower trying to grow in the shadow of a healthy and beautiful one. Both were published by the Asgard Press, which Wright operated in his basement. In his introduction to *In Reckless Ecstasy*, Wright wrote:

> He had seen a great deal of the world; some of it, I believe, from the underside of box cars, traveling via the Gorky Line to literary fame. The boys called him the "terrible Swede"; not such a bad characterization, after all; for it is a quality of this old Viking blood that it enables its possessor to land on his feet in any and every environment, and this the students found out, perhaps a little to their surprise. The "terrible Swede," as captain of the basketball team, led them to a series of remarkable victories, and when the time came for electing the editor-in-chief of the college paper, then also, for this most coveted honor in their gift, they could find no one more fitting than this young descendant of the Norsemen. My own association with him was on the literary side. He, together with two other incipient geniuses, Brown and Lauer, constituted an extremely informal organization which met Sunday afternoon in my study for literary refreshment. At these meetings we read, for our mutual edification and criticism, our own productions in prose and verse and any other sports of the spirit which we happened to run across during the week. Very delightful, very innocent and refreshing were these meetings, where our minds wandered the free fields of fancy and imagination.[9]

In *In Reckless Ecstasy* there appears already some of the philosophy and outlook of Carl Sandburg: "It is often the case that ideas which cannot be stated in direct words may be brought home by 'reckless ecstasies of the language.' It is fear of the accusation of obfuscation that drives writers to the reckless ecstasy. There are some people who can receive a truth by no other way than to have their understanding shocked and insulted."

Even a poem included in the booklet shows Carl's early thinking:

> The cogs and the wheels, they hum and whirl
> Paying their bond to human brain;
> They card the wool, they hammer the steel,
> They utter no cry of joy or pain.

The *Mobile (Alabama) Register* reviewed *In Reckless Ecstasy*, saying, "There is a vital spirit and an original touch in every word of this little

book." The edition of 100 copies sold out at $1.00 per copy. Single copies have since sold for $500.

The Asgard Press also published *Incidentals*, a booklet of thirty-two pages containing some short pieces on such topics as "The Pursuit of Happiness," "Failure," and "What is a Gentleman?" Wrote Sandburg, "Life is more vast and strange than anything about it—words are only incidentals."[10]

On the cover of *Incidentals* was the verse:

> Yesterday is done. Tomorrow
> never comes. Today is here. If
> you don't know what to do, sit
> still and listen. You may hear
> something. Nobody knows.
>
> We may pull apart the petals of
> a rose or make a chemical anal-
> ysis of its perfume, but the mys-
> tic beauty of its form and odor
> is still a secret, locked in to
> where we have no keys.

Inside, Sandburg philosophized:

> Back of every mistaken venture and defeat is the laughter of wisdom, if you listen. Every blunder behind us is giving a cheer for us, and only for those who were willing to fail are the dangers and splendors of life. To be a good loser is to learn how to win. I was sure there are ten men in me and I do not know or understand one of them. I could safely declare, I am an idealist. A Parisian cynic says, "I believe in nothing. I am looking for clues." My statement would be: I believe in everything—I am only looking for proofs.[11]

Strenuously and consciously, the young Sandburg was analyzing himself in a remarkable manner. Already he had learned that the tree is not strong that has not weathered the storm, and thereby he had developed a toughness of mind and body that was to sustain him well in the even tougher struggles ahead.

# 4

## Maturing and Marriage

The winds of change were blowing for Carl Sandburg. They came out of the western prairies and sang in his mind and heart and would not let him rest. He came to know that he would have to respond to these strong forces so surging in his life and destiny. He was faced with a vital decision, but he had learned not to shrink from such. Suddenly it came.

He decided to leave Galesburg for good.

Or was it for good or bad or whatever? Only time, about which he had already written so philosophically, would tell. But leaving Galesburg for him was not like a disillusioned native departing from Gopher Prairie, Minnesota, or Winesburg, Ohio. He loved many things about his hometown. If it could hold all those things in the world that he held most essential to life's fulfillment, he would doubtless stay. But larger things beckoned, things that he had already sampled and liked the taste.

It was not easy for Carl to leave Galesburg. He never really left it, for it was a microcosm of America, exemplifying to him especially its sturdy, earthy, and burgeoning Middle West. He was to express this in the meat and meter of his poems, in the nasal but pleasant timbre of his songs, and in the bigness of his Lincoln biography. He was now twenty-seven years

old, time for him to set about whatever he was going to pursue in life, something he had not yet found at home or in his travels. Yes, he had received good advice; but he knew deep down that regardless of how well meant the advice was from parents, teachers, and friends, there was only one voice to obey—the voice of Carl Sandburg.

He caught the train for Chicago and there wandered down to Haymarket Square, where years before the famous riot had taken place in which both police and rioters were killed. Also in this city, which Sandburg was to celebrate in a new kind of poetry, the Pullman Strike occurred. This was broken up by thousands of troops, and Sandburg's future friend, Eugene V. Debs, was arrested. It was a time of The Progressive Era, of the muckrakers, one of whom, Upton Sinclair, had just published his sensational exposé of filth and corruption in the Chicago meat business, a book appropriately entitled *The Jungle*.

Carl had been in touch with Parker Sercombe, publisher of *Tomorrow* magazine, which was printed in a rundown Prairie Avenue mansion. He looked up Sercombe, who offered him room and board, without salary, in exchange for help in editing, proofreading, and handling manuscripts for the small publication. Carl accepted and saw some of his own poems and sketches published. To the young Sandburg, more impressive than *Tomorrow* were the visitors who came to see Sercombe. These included Jack London, H. G. Wells, and Edwin Markham.

Obviously this situation was short-lived. So one day Carl walked into the office of *The Lyceumite*, a trade journal of the International Lyceum and Chautauqua Association. Its editor, Edwin Barker, offered Sandburg $25 a week to be advertising manager and assistant editor. "Into this office came scores of travelers, fresh from their platform tours. If they were already advertising, I pointed them to space for larger ads. If they were not advertising, I told them that among our subscribers were all the bureaus who booked talent and all the local committeemen and Chautauqua managers who picked for next season's course the lecturers, elocutionists, quartets, solo star singers, violinists, pianists and chalk talkers."[1]

Sandburg wrote a series of sketches entitled "Unimportant Portraits of Important People." These were half biographical, half comment mixed with foolishness, insults, and high praise. In the bottom corner of one page, Carl had written this:

> I want to do the right thing, but often I don't know just what the right thing is. I am making mistakes and expect to make more. Every day I know I have

bungled and blundered and come short of what I would like to have done. Yet as the years pass on and I see the very world itself, with its oceans and mountains and plains as something unfinished, a peculiar little satisfaction hunts out the corners of my heart. Sunsets and evening shadows find me regretful of tasks undone, but sleep and the dawn and the air of the morning touch me with freshening hopes. Strange things blow in through my window on the wings of the night-wind and I don't worry about my destiny.[2]

The young writer was also learning something about public speaking. He listened to these Lyceum speakers carefully and noted their voice techniques—how they rose and fell, the inflection, the crescendos and dramatic whispers. In later life, when complimented on his own resonant and eloquent voice, Carl Sandburg replied, "I worked hard to make it like that. No one knows how hard."

He wrote to his sister from Chicago, "Everything is coming along as well as I could wish here. . . . Have gained six pounds in weight. Have met a number of men pretty well known over the whole country and almost believe that the nearer you get to a Great Man the smaller he looks. A Great Man is like a mountain and looks grandest from a distance."[3]

This lecture business was catching. Sandburg wanted to enter it himself. So he put together a lecture on Walt Whitman that he had been working on off and on for three years. He entitled it "An American Vagabond" and tried it out on a college professor, a Negro literary club, some guard-house military prisoners, and some bureau managers of the Lyceum. Nobody wanted it.

In Chicago this ambitious young man got rid of much of his energy by walking. He found that the city streets were generally smoother than country roads and the people there more interesting than rows of cornstalks and acres of cabbage heads. Wrote his daughter Helga later, "He would be a walker all his life, roaming city blocks in areas where many hesitated to go, and down dark alleys and sidestreets. He has told me how he would keep his hand in his pocket sometimes in more risky places, so that someone desperate might think he had a weapon. He never carried anything more dangerous than the slim small pocketknives he fancied to cut his cigars in half or to slit out newspaper items. He was mostly a night walker and carried a flashlight, using it sparingly."[4]

It may be that in his mind Sandburg was conscious of pitfalls along the streets and highways he was to traverse for many eventful years, but he did not allow the obstacles to stop him. He became interested in Elbert Hub-

bard, a retired businessman who had established a small press in East Aurora in upstate New York. He sent Hubbard some of his writings and there developed a mutual interest. Hubbard had written an essay about the Spanish-American War, "A Message to Garcia," which sold 40 million copies. A convention was held in East Aurora during July 1907, and Hubbard, who sponsored it, invited Sandburg to give some talks. For these lectures he was offered, besides expenses, a few dates to speak elsewhere.

Sandburg spoke on Walt Whitman, and this time it was successful. Hubbard said, "Sandburg knows his Whitman as very few men do." The embryo orator wrote to Professor Wright, "They are sort of crazy here about the lecture I gave. They drew out of me my best. Mr. and Mrs. Hubbard say I have 'a world-beater.' The crowd caught things right on the wing all the way through and when I was done and had seated myself and was talking nothings with somebody, Hubbard grabs me by the arm and pulls me to the front again—they were clapping and yelling for an encore."

The *Lyceumite* folded and Sandburg moved over to *Billboard*, a theatrical publication. Things did not go too well there either. Then one day Winfield Gaylord dropped in. He was a fiery Socialist organizer in Wisconsin and he talked to Sandburg about the Socialist movement there. The Social-Democratic Party in Wisconsin was then the forerunner of the Socialist Party in the United States and Sandburg liked its philosophy of a better life for the average man. Gaylord offered him a job to organize the Fox River district of his state, and Sandburg asked him how one went about organizing. Gaylord then described meetings in halls and homes, the work of soapbox orators, the visiting of local branches, the enrolling of new members and collection of dues. "So that's how you organize?" Sandburg asked. Replied Gaylord, "Yes, if you are good at it, all you do is work morning, afternoon and night." The neophyte was to learn that this was all too true.

In 1908 there was great social ferment in Wisconsin. Milwaukee was the capital of liberal ideas and Carl Sandburg entered into the spirit of this with gusto. He planned meetings and made speeches, arranged for the distribution of party literature, and helped the organization obtain new members and friends. This was not too difficult since there was then, as now, much sympathy in Milwaukee for the underprivileged. Carl worked also as a reporter and editorial writer. He went from the *News* to the *Sentinel* to the *Journal* and then to the *Leader*, somewhat in the haphazard manner of a waterbug. The immigrant Germans of Milwaukee at that time were influenced by Carl Schurz, who fled to America after the Revolution

of 1848 in Germany and who had become a friend and supporter of Abraham Lincoln. Theodore Roosevelt was now President, Robert M. La Follette was U.S. senator from Wisconsin, and a group of Socialist city officials were pushing and getting reforms in local government. Fresh in the minds of the people were the works of the muckrakers, such as *The History of the Standard Oil Company* by Ida M. Tarbell, *The Shame of the Cities* by Lincoln Steffens, *The Jungle* by Upton Sinclair, and *The Pit* by Frank Norris. Carl Sandburg must have read and absorbed these works, for he reflected their philosophy in his own endeavors. In his reading, speaking, and writing, Sandburg plunged ahead to the drive for clean government and the recognition of individual rights.

Sandburg went to Manitowoc, Wisconsin, for a lecture. There he had a talk with Chester Wright, editor of *The Manitowoc Tribune*, who was an intellectual man but a socialist. Going back soon afterward to Wisconsin, Carl next went to Oshkosh, the district headquarters of the Social-Democratic Party. He wrote to Philip Green Wright that the Wisconsin socialists were different from others he had known: "They have very little use for the theory of a social and industrial cataclysm, the proletariat stepping in and organizing the co-operative commonwealth. They know that a collapse is ultimately inevitable, but they know that a genuine democracy will not follow unless they have been trained and educated by actual participation in political and industrial management before the crisis arrives."

In 1908 Sandburg was on a train known as the "Red Special" as it crossed Wisconsin. The group of propagandists onboard were supporters of the Socialist platform, which called for the "eight hour day, old-age pensions, unemployment insurance, industrial accident insurance, a guaranteed annual minimum wage, higher wages, abolition of child labor, laws to protect union organization, and free textbooks for public schools."[5]

As a sequel, Sandburg wrote a pamphlet, *You and Your Job*, which was published by the Socialist Party and sold for five cents. In it he wrote: "I believe in obstacles, but I say that a system such as the capitalist system, putting such obstacles as starvation, underfeeding, overwork, bad housing and perpetual uncertainty of work in the lives of human beings, is a pitiless, ignorant, blind, reckless, cruel mockery of a system. If the capitalists will not provide, the Government must."

In Milwaukee in June, Sandburg participated in a large rally of the Wisconsin Socialist Party. He spoke on the subject of organizing people for this cause, and in the evening a dinner was served at thirty-five cents a plate with a 100-voice Socialist choir and orchestra performing.

Meantime something happened to Carl Sandburg that was to be the most important thing in his personal life: he met his future wife. He was in Milwaukee and went to see Victor Berger, the Socialist leader, in his office. Carl waited in the reception room and no doubt was thumbing through the magazines and newspapers, probably surreptitiously tearing out some articles and stuffing them into his pocket, as was his custom. When Berger came out, he was accompanied by a young woman, who was introduced to Carl as Miss Lilian Steichen. She had blue-gray eyes, dark brows, and was about five and a half feet tall. Carl is described as having at that time "hazel eyes with brown flecks in them, cropped dark hair and was thin and tall." She wore her black hair around her head in a simple braid, and when she learned that Sandburg was working for the Socialist cause, her eyes lighted with enthusiasm.[6]

How fortunate Carl was in meeting this young woman only the next sixty years could tell. She was to be truly a guiding light, a helpmate, and inspiring companion throughout his illustrious career, choosing voluntarily to stay in the background.

On this fateful day of meeting, Lilian had come from her home in Menomonee Falls, Wisconsin, where she had been spending a short vacation from her teaching position in the Princeton, Illinois, Township High School. She was a graduate of the University of Chicago, among the top three in her class, a member of the scholastic fraternity Phi Beta Kappa, and herself an enthusiastic convert to socialism.

Lilian had originally been named Mary Ann Elizabeth Magdalen, but her mother found a character in a book named Lilian and changed her daughter's name. She had attended Ursuline Academy in London, Ontario, where she was said to have read everything she could get her hands on. She had been well described as "a beautiful woman of grace and simplicity . . . with seemingly endless energy. Her intellect had been well disciplined by university mathematics and the classics. She was indeed a godsend to the thirty-year-old idealist who had not yet actually found his place in the work of the world."[7]

Lilian was once asked by her daughter Margaret what the first impression of Carl Sandburg had been. Lilian replied, "Of course, I was interested in him as the new organizer, but I felt sorry for him—he looked gaunt and worn, as if he worked too hard." He wanted to know more about her, and later saw her to the door and asked her if she would have dinner with him. Her mother refused, saying that she had an engagement for dinner and a concert later with some old friends of the family. She said to me of this,

"That was true, we were going out to dinner. But even if I had been free, I wouldn't have accepted. In those days things were different; no really nice girl would have dinner with someone she had just met. Your father didn't think of that at the time."[8]

Soon the two began to exchange letters. The first letters were not preserved, but one that was, dated January 17, 1908, is enlightening:

> Dear Mr. Sandburg, I have your leaflets "Labor and Politics" and "A Little Sermon." Do tell me how you contrive to be a moral philosopher and a political agitator at one and the same time—and especially how you contrive to write such Poet's English one minute and the plain vernacular the next. The combination is baffling! Artist, poet-prophet on the one hand; man of action on the other. You must explain yourself else I shall "have such misery" trying to crack the hard nut myself. Thank you for the leaflets. And good luck to you in all your work. Yours cordially, Lilian Steichen.

Later Lilian informed Carl that she would be spending her spring vacation at home in Menomonee Falls, and she indicated that she would be glad to see him there and he could meet her mother and father. Her vacation began on March 27, which also happened to be the birthday of her brother, Edward Steichen, later to become a world-famous photographer. Actually the Steichen home was called "The Little Farm," although it was only three-and-a-half acres.

Sandburg accepted the invitation and met Edward Steichen as well as the parents, but he did not make a tremendous impression at first. After all, he did not have a steady job; he carried around with him books by Whitman, Emerson, and Shakespeare; he read and wrote poetry; and he was somewhat careless in his dress. Besides Lilian, Edward seems to have understood this eccentric and odd-looking Swede better than the others.

After Lilian returned to Princeton, she and Carl corresponded for about six months, seeing each other only twice during this period. But that was enough. Carl sent Lilian some of his writings on labor and politics and a few of his poems. His letters to her were lyrically romantic and his poetry evidently had an effect. She told him that her brother's little daughter had called her "Paula." Carl liked this name and said to Lilian, "That's what I am going to call you."

Here is his letter to her written on March 21, 1908, from Manitowoc, Wisconsin:

> Dear girl:—I will look for you on the 4:45 p.m. at the C. M. and St. Paul station on Friday the 27th. I expect to have everything cleared up and be

ready for anything that can happen, gallows or throne, sky or sea-bottom! Yours Thoughtfully alias Paula will be dictator and mistress of ceremonies. You will announce the events and the gladiators will gladiate like blazes! The joy-bells on high will clang like joy. Motley will have bent and psalms will be sung and three or four paeans will go up to the stars out of pure gladiosity.—I believe you asked about my cussedness. This is some of it. I am cussedest when I am glad, and so are those around me. Admonish me gently to behave and I may or may not. For whatever is in must come out. That is the snub and sumstance of expression and great is expression.[9]

Another example of Carl's letters to Lilian was that penned from Two Rivers, Wisconsin, on April 23, 1908:

Back from a long hike again—sand and shore, night and stars and this restless inland sea—Plunging white horses in a forever recoiling Pickett's charge at Gettysburg—On the left a ridge of jaggedly outlined pines, their zigzag jutting up into a steel-grey sky—under me and ahead a long brown swath of sand—to the right the ever-repelled but incessantly charging white horses and beyond an expanse of dark—but over all, sweeping platoons of unguess-able stars! Stars everywhere! Blinking, shy-hiding gleams—blazing, effulgent beacons—an infinite, travelling caravanserie—going somewhere! "Hail!" I called. "Hail!—do you know? do you know? You veering cotillions of worlds beyond this world—you marching imperturbable splendors—you serene, everlasting spectators—where are we going? do you know?" and the answer came back, "No, we don't know and what's more, we don't care!" And I called, "You answer well. For you are time and space—you are tomb and cradle. . . ." There—it's out of me, Pal. It was a glorious hike. I shall sleep and sleep to-night. And you are near to-night—so near and so dear—a good-night kiss to you—great-heart—good lips—and good eyes—My Lilian—Carl . . . P.S.P.S.S.!—No, I will never get the letter written and finished. It will always need postscripts. I end one and six minutes after have to send more. All my life I must write at this letter—this letter of love to the great woman who came and knew and loved. All my life this must go on! The idea and the emotion are so vast it will be years and years in issuing. Ten thousand lovebirds, sweet-throated and red-plumed, were in my soul, in the garden of my under-life. There on ten thousand branches they slept as in night-time. You came and they awoke. For a moment they fluttered distractedly in joy at stars and odors and breezes. And a dawn burst on them—a long night was ended.[10]

Carl's postscript must hold some kind of record for a modern poetic expression of romantic love. One does not need to question his sincerity in such effusiveness to conclude that, among other things, Carl Sandburg was a great salesman!

And so it logically came about that Carl proposed and Lilian accepted.

The wedding was to be in June. He called their forthcoming union the "S-S," after their last names. "The S-S stands for two souls," he said, being ever the poet. "The hyphen means they have not met and are. S-S stands for poise. It means intensity and vibration and radiation but over and beyond these, it places harmony and equilibrium . . . But we'll remember that the life we live is more important than the works we leave . . . We will do good somehow . . . The poems of the S-S will be written by the Sand-burg-S tho the Steichen S will help with inspiration and love."

In the middle of May, the two met in Chicago to plan their wedding. At the depot they talked of where they would spend the night. Lilian thought of separate rooms, but he said they would share one and save money. So they slept together in a double bed for two nights, "and while they were in love," Helga recalled, "my mother said they didn't have intercourse. When I asked her why, she said they wanted to wait until their wedding, which was to happen soon. They lay in each other's arms and it seemed enough, she said. They were totally content."[11]

He sent her another poem:

> You are slanting sun across the dark,
> You are dew and calm and fragrance,
> You are fire and gold and sunset peace . . .

The wedding was at first to be held at the little farm of Lilian's parents, but the National Socialist Convention was to be held in Milwaukee, so Carl felt they must be there. The nuptial date was set for June 15, 1908. It was a simple affair in the home of Reverend Carl D. Thompson, a Socialist minister. There was no ring and little more money. Lilian did not believe in such adorn-ments as rings. She explained to Carl, "I gave up wearing rings about ten years ago because they seemed to me relics of barbarism on a level with earrings and nose-rings." The small son of the minister ran upstairs and took some artificial flowers from his mother's hat, came downstairs, and gave them to Lilian, who, although she disliked imitation flowers, did not have the heart to refuse them, so she held them throughout the ceremony.

A honeymoon was planned for Green Bay, but a telegram from Chester Wright changed things. He was being sued for libel and wanted Carl to come to Manitowoc to help with the *Tribune* while the lawsuit was in progress. Carl could not refuse his friend, so he went. Lilian then returned to her parental home at Menomonee Falls. After helping Wright, Carl joined her on the little farm three weeks later. This was a foretaste of his

many absences from home in most of the years that followed, but always to return and always to be warmly welcomed at their domestic hearth by a loving and understanding wife.

Soon after Carl's return to the family farm, the newlyweds were aroused one night by a great cacophony outside. The neighborhood farmers and their hired hands had gathered with cowbells, horns, and tin cans. They called for the bridegroom to come out with money for beer and cigars. Finally Sandburg sheepishly appeared. "You work hard all your lives," shouted Sandburg. "You are victims of a system which cheats you out of the time that should be yours to use for play and development and all the better and higher things of life." Came cries from the crowd, "Three cheers for Sandburg! Hurrah for the Social Democracy! How about those cigars?" The newlywed was ready with an answer. "If I had a million dollars, I would not give a cent for beer and cigars. A Socialist gives his money to the cause he is fighting for." Then Sandburg passed the hat. Some paid and others walked away.

Carl and Lilian went to Appleton to look for a place to live. They found rooms in a house and started out with bare essentials of furniture. The typewriter stood on an apple box, and two apple boxes covered with cretonne served as a dressing table. The pantry consisted of other boxes with cheesecloth curtains in front. There was little else except a cot and a bed.

Carl then joined the Wisconsin Anti-Tuberculosis Society and lectured on the disease in forty-five cities throughout Wisconsin, accompanying his lectures with steropticon slides. Meanwhile, they found a little house in Wauwatosa and moved in. It was much more of what they had been looking for. Carl, who had missed his music for some time, was able to find a good secondhand guitar for a low price. But his music was soon overcast by a sad tone. His father, August Sandburg, while trimming a tree in the backyard of his Galesburg home, fell from a ladder and seriously injured himself. He never recovered, developed pneumonia, and died in March 1910. In his autobiography, Carl wrote of his father: "No glory of any kind ever came to him. I am quite sure his name was never printed until he died and there was a brief obituary—and in the paragraph about his funeral his name was spelled 'Andrew' instead of 'August.' Yet there is an affirmative view that can be taken of his life, not merely affirmative but somewhat triumphant. August Sandburg had found life satisfying. He had enjoyed good health until the accident, and he was never dishonest."

In this early home, Lilian Sandburg began one of her nondomestic

activities designed to supplement the small family income. It was that of raising chickens. She bought a secondhand incubator and brooder and by summer, cute little chickens appeared in the yard. Three hundred of them reached broiler size. Some were sold, and others furnished eggs and chicken for the family table.

The mayoralty campaign in Milwaukee was sensational that year. Charges of corruption were brought against the city government and there was much opposition to the regular political candidates. As a result, Emil Seidel, a Social-Democrat, won the election and swept his ticket in with him. Sandburg campaigned for Seidel and as a reward was appointed secretary to the new mayor. Edward Steichen wrote his sister, congratulating her on both the chickens and the election. "And of course the chickens are all Socialists," he added. Carl's new job kept him busy with such activities as representing the mayor at city functions, attending conventions, and presiding over the opening of a new library. Lilian was also active, joining the suffragettes who marched down the Milwaukee streets carrying flags, urging votes for women.

After eight months, Sandburg became restless with so much public-relations activity. The party leaders felt that a new editor was needed for the *Social-Democratic Herald* and that Sandburg was just the man for the job. He eagerly agreed, for he felt the *Herald* had been weak and was not presenting the strongest Socialist viewpoints. He also wanted to do more writing. In addition to being editor, he wrote a page and two columns a week for the publication.

In the early part of the twentieth century, as Professor Frederick I. Olson has pointed out, Milwaukee had a strong ethnic quality:

> Most numerous were the Germans and Poles, who had substantially diminished the original Yankee cast to the community, but many other nationalities were well represented. The city's social and cultural life, its press, its schools, its politics reflected the diverse origins of its people. Its most prominent political feature was the Socialist movement, strongly German in its membership, its philosophy, and its program, and destined to gain momentary control of the local government in 1910. Milwaukee's Socialists strongly attracted Carl Sandburg by their idealism and their vision of a better world, and welcomed him as an active participant of their affairs.[12]

Fred W. Emery, editor of the *Galesburg Labor News*, recalled: "Great social changes were taking place during Sandburg's young manhood. Labor unions were being formed as the workers revolted against the virtual

slavery in the workplace.... The rapidly developing transportation and manufacturing technology was changing the nation from a predominantly agrarian society to a more urban and industrial society. The immigrant workers who came here to find a new life were not satisfied to remain as underpaid laborers and this created class struggle between the worker and owner management class."[13] Emery also recalled that in one article Sandburg advocated preventing further development of a privileged ruling class by the establishment of stiff inheritance taxes. In another article he revealed himself as a temporary pacifist, saying the workers were fighting the wars for business interests, and suggesting that if all workers would refuse to produce the tools and weapons of war, there would be no wars.

Lincoln's birthday in 1911 gave Sandburg an opportunity to write about the martyred President. In the *Social-Democratic Herald*, he wrote:

> Abraham Lincoln was a shabby, homely man who came from among those who live shabby and homely lives—the common people—the working class. Let us not forget—this man who was gaunt and sad and lean came from the masses of people whose daily lives are gaunt and sad and lean. His picture now adorns the wall of palace and mansion and gallery. His statue stands in parks and public buildings. And his name is spoken as a magic name by rich men who dwell amid perfumed and panoplied luxury. Among those who give praise and pay tribute to Lincoln today are grafters, crooks, political pretenders, and two-faced patriots who dine and wine and fatten on the toil of workingmen they sneer at on every day except election day.[14]

Soon a less somber note crept into the lives of Lilian and Carl Sandburg. Their first baby was born on June 3, 1911, and was named Margaret. Carl was happy but, like many fathers, admitted to a friend he would have been glad to have a boy, something that would be denied him. Sandburg was now contributing an occasional article to *La Follette's Weekly Magazine*. A week after Margaret's birth he wrote an article for it entitled "My Baby Girl." It included this sentence: "And when I walked away from the hospital in early gray daylight with a fresh rain smell in the air, treading the blown-down and scattered catalpa blossoms under my heels, I had above all a new sense of the sacredness of life."

What seemed to be a present for the young daughter came in the mail soon after from *La Follette's Weekly Magazine* to the father. A letter from the managing editor began, "I have directed the Business Manager to mail you a check for $10 for your splendid little article, 'The Man, the Boss, and the Job.'"

An article that drew considerable attention was one on Professor John R.

Commons, entitled "Making the City Efficient." It concerned an alliance between the City of Milwaukee government and professors at the University of Wisconsin. Commons would later become the outstanding authority on American labor relations.

Again, the attention of Sandburg was drawn to Abraham Lincoln. He wrote an editorial for the *Milwaukee Daily News* for February 12 that combined low finance and high emotion:

### LINCOLN ON PENNIES

The face of Abraham Lincoln on the copper cent seems well and proper. If it were possible to talk with that great good man, he would probably say that he is perfectly willing that his face is to be placed on the cheapest and most common coin in the country.

The penny is strictly the coin of the common people. At Palm Beach, Newport and Saratoga you will find nothing for sale at one cent. No ice cream cones at a penny apiece there.

"Keep the change," says the rich man. "How many pennies do I get back?" asks the poor man.

Only the children of the poor know the joy of getting a penny for running around the corner to the grocery.

The penny is the bargain-counter coin. Only the common people walk out of their way to get something for 9 cents reduced from 10 cents. The penny is the coin used by those who are not sure of tomorrow, those who know that if they are going to have a dollar next week they must watch the pennies this week.

Follow the travels of the penny and you find it stops at many cottages and few mansions.

The common, homely face of "Honest Abe" will look good on the penny, the coin of the common folk from whom he came and to whom he belongs.

The patience of Lincoln, however, did not always abide with the Sandburg family. Daughter Helga recalls that during the difficult times when her father worked at odd jobs and found it hard to make ends meet, there was some unrest in the family. "Perhaps it was now that my mother thought of leaving my father.... She reminded him that they'd had a pact from the first that if one wanted to go, the other would consent freely."[15] But they stuck it out and never exercised the pact.

It may well have been that such unrest, caused mainly by the lack of steady work and a good income, influenced the Sandburgs in thinking of greener fields. Both became convinced that Milwaukee was not the place for advancement for Carl. He wanted to write poetry, and that was one of the last things the labor leaders were interested in. Lilian particularly liked

living near her parents, but this had to be of secondary importance. So in the summer of 1912 they cast their hopeful eyes toward Chicago.

The time Sandburg spent in Wisconsin, from 1907 until 1912, is looked upon as an era in which he marked time until some mystical force compelled him to leave in search of inspiration and a new lifestyle. In Milwaukee he became familiar with the problems of governing an industrial town. He wrote, "It is here that we have one of the terrific mockeries of capitalism. The army of unemployed men is of about the same number as the army of child slaves. If the boys and girls today shut out from the schools and toiling away for their wage pittances were enjoying the companionship of books and music and flowers and thoughtful teachers, as they of right ought to be, there would be a world of work open for the down-and-outs of the unemployed army."

Sandburg found that the effort of the Socialists to gain public ownership of the utilities and transportation was an impossible task. Said he, "In addition to my disillusionment over office seeking, I began to see what political dogma does when it has to be applied. It hamstrings the official who is charged with the responsibility and walls the individual away from his right to think."

It was in Wisconsin that Sandburg had the opportunity to view the harsh realities of the political bureaucracy from the inside as well as from the outside. But most important of all, it was here that he matured.

# 5

## City of the Big Shoulders

Carl Sandburg came home from work one day excited. He told his wife that he had good news; that a big opportunity had come and they must not miss it. He explained that in Chicago a strike of pressmen, drivers, and newsboys on the major Chicago newspapers had put them all out of production and as a result, the circulation of the *Chicago Daily Socialist*, which was still operating, shot up to 600,000. Now to be called the *Chicago Daily World*, it would be a great socialist newspaper and was predicted to have wide influence. Friends and associates of the Sandburgs were going to join this newspaper in Chicago, and this helped to make up their minds.

So Carl hurried to the "Windy City" in August 1912. He had been invited to join the staff of the new paper and was delighted. Lilian and little Margaret repaired to the family farm temporarily but soon joined Carl in Chicago to help look for an apartment. They found one on the northwest side, but as Editor William Adelman has pointed out, "Carl was now thirty-five years old and completely broke. This happened before but now he had a wife and child to support."[1]

It happened that those in charge of the new newspaper were overoptimistic. The strike was settled and the big papers began publishing again.

The circulation of the *Chicago Daily World* dropped, and by December the newspaper had folded. Sandburg was again out of a job. He walked the streets looking for another and eventually was taken on the staff of *The Day Book*, a liberal, adless Scripps newspaper, small in size, published six days a week and sold for one cent a copy. Said Carl, "It takes no advertising, and therefore tells the truth. Chicago, however, is unfamiliar with the truth, cannot recognize it when it appears, so the paper is having a steady, quiet growth and seems to have large destinies ahead."

Unfortunately the destinies of this publication were not represented by a high enough salary, so Sandburg left it. He landed a job with *System*, a management magazine, for which he wrote under the pseudonym R. E. Coulson. This job paid $35 a week. He wrote to a friend, "You might say at first shot that this is a hell of a place for a poet but the truth is it is a good place for a poet to get his head knocked when he needs it." In November his employer at *System* wrote to Carl, misspelling his name: "Dear Mr. Sandberg: I want to put our relations on paper so that we both can consider them thoughtfully.... Observation leads me to believe that you have not the habit of thought nor the method of approach to work which would enable you to develop fully in this organization of ours." So again Sandburg was out of a job. He tried the *Chicago Tribune*, but with no results.

Sandburg walked the streets. The *American Artisan and Hardware Record* had an opening, which he eagerly grabbed. It was published on Saturdays and the masthead stated that it was "Representative of the Stove, Tin Hardware Heating and Ventilating Interests." Writing under the pseudonym "Sidney Arnold," he did a column called "Random Notes and Sketches." He obtained most of his material from clippings, articles, and notes stuffed into the big pockets Lilian had sewed into his coat. He was described at that time as cumbersome and gloomy but fine and sincere. Ben Hecht said Sandburg resembled a cowhand.

Meanwhile Sandburg had written his Chicago poems, later to become famous. He had submitted them to *The American Magazine* and they had been rejected. By this time the Sandburgs had moved to a house in suburban Maywood. Just across the nearby Des Plaines River, young Ernest Hemingway was attending Oak Park High School. In later years Sandburg and Hemingway were to become friends and mutual admirers. Not far away was a Jewish market area where Arthur Goldberg and Paul Muni were growing up. This neighborhood was the inspiration for Sandburg's poem "Happiness."

Sandburg liked to stroll in Oak Park, "where no saloons were allowed

and in Forest Park where there were more saloons than churches." It was in a Forest Park bar that Vincent Starrett first heard from him some delightful children's stories that Sandburg was planning to write after he had tried them out on his children, another daughter, Janet, having been born on June 27, 1916. As the two companions sat and nursed beers beside a big potbelly stove, Sandburg described Henry Hagglyboogly, who played the guitar with his mittens on, and Bimbo the Snip, whose thumb got stuck to his nose when the wind changed. Starrett mentioned the criticism of Sandburg's poem. The reply, "A man was building a house. A woodchuck came and sat down and watched the man building the house."

Carl had written much poetry but had sold none of it. This was soon to change. In the fall of 1913, he decided to drop in at the office on Cass Street of *Poetry: A Magazine of Verse*. This publication was only a year old and Lilian had already submitted some of his poems, but they had been returned. As assistant editor, Eunice Tietjens, described the poet-to-be as "lanky, warm and human, slow-spoken and witty." "I was not prepared," she wrote, "for the sweep and vitality of the Chicago Poems which he brought into the office the first day I met him. They quite took us off our feet and it was with much pride that we introduced this new star in the firmament. . . . We adopted Carl at once and loved him."[2]

The poems had been passed on to the editor of the magazine, Harriet Monroe. "Carl was a typical Swedish peasant of proletarian sympathies in those days, with a massive frame and a face cut out of stone. His delicate-featured very American wife told me that ours was the first acceptance of Carl's poems, although for two years she had been collecting rejection slips."

At last, the voice of Sandburg was heard through a respectable medium. The poem "Chicago" unveiled a new poetic idiom in America. It begins:

> Hog Butcher for the World,
> Tool Maker, Stacker of Wheat,
> Player with Railroads and the Nation's Freight Handler;
> Stormy, husky, brawling,
> City of the Big Shoulders.[3]

These lines shocked many readers, who were accustomed to more elegance. Some were outraged by Sandburg's use of slang and the earthy idiom of the common man. But with his increase in output there also came acceptance by many readers, if not by all critics.

More of the startling new poet was revealed in paeans to the people:

### Masses

Among the mountains I wandered and saw blue haze and red crag and was
 amazed:
On the beach where the long push under the endless tide maneuvers, I stood
 silent;
Under the stars on the prairie watching the Dippers slant over the horizon's
 grass, I was full of thoughts.
Great men, pageants of war and labor, soldiers and workers, mothers lifting
 their children—these all I touched, and felt the solemn thrill of them.
And then one day I got a true look at the Poor, millions of the Poor, patient and
 toiling; more patient than crags, tides, and stars; innumerable, patient as the
 darkness of night—and all broken, humble ruins of nations.

Sandburg seemed to possess an affinity with water, even if it was repre-
sented only by Lake Michigan. That lake mirrored for him the local human
misery:

### The Harbor

Passing through huddled and ugly walls
 By doorways where women
 Looked from their hunger—deep eyes,
 Haunted with shadows of hunger-hands,
 Out from the huddled and ugly walls,
 I came sudden, at the city's edge,
 On a blue burst of lake,
Long lake waves breaking under the sun
 On a spray-flung curve of shore;
 And a fluttering storm of gulls,
 Masses of great gray wings
 And flying white bellies
Veering and wheeling free in the open.

Perhaps Sandburg never loved the city. At least, after many toilful years,
he fled from it, even as he had fled from his smalltown home on the
prairie to wander the country and finally come to a restless stop in the
metropolis. At times he surely detested what he saw:

### They Will Say

Of my city the worst that men will ever say is this:
You took little children away from the sun and the dew,
And the glimmers that played in the grass under the great sky,
And the reckless rain; you put them between walls

To work, broken and smothered, for bread and wages,
To eat dust in their throats and die empty-hearted
For a little handful of pay on a few Saturday nights.

Beneath the ground, where ran the roaring trains, he saw a symbolic comparison to the depths of human endeavor:

### Subway

Down between the walls of shadow
Where the iron laws insist,
    The hunger voices mock.
The worn wayfaring men
With the hunched and humble shoulders,
    Throw their laughter into toil.

From his daily experiences with those less fortunate, Sandburg could see that there was also a good side to the city of the big, cruel shoulders, the noisy town that so often crushed and bent its victims:

### A Teamster's Farewell
### Sobs en Route to a Penitentiary

Good-by now to the streets and the clash of wheels and locking hubs,
The sun coming on the brass buckles and harness knobs,
The muscles of the horses sliding under their heavy haunches,
Good-by now to the traffic policeman and his whistle,
The smash of the iron hoof on the stones,
All the crazy wonderful slamming roar of the street—
O God, there's noises I'm going to be hungry for.

And Sandburg did find some happiness existing in Chicago, finding the bitter with the sweet. Almost regularly, it appears, he swung on the pendulum from tears to laughter. What was to remain most in his heart, only he could know.

### Happiness

I asked professors who teach the meaning of life to tell me what is happiness.
And I went to famous executives who boss the work of thousands of men.
They all shook their heads and gave me a smile as though I was trying to fool
    with them.
And then one Sunday afternoon I wandered out along the Desplaines river
And I saw a crowd of Hungarians under the trees with their women and
    children and a keg of beer and an accordian.

In 1913 Carl left *System*. For a short time he worked on the *National Hardware Journal*, then he went back to *The Day Book* for $25 a week. The tiny Scripps paper was only eight by ten inches, carried no advertising, and usually consisted of twelve pages. Among the events Sandburg covered was the fifteen-week strike of the Amalgamated Clothing Workers' Union, led by Sidney Hillman, who, during the struggle, was ill in bed most of the time. Sandburg visited him frequently and felt the strong influence of this active union leader. He dug up and printed many examples of workers who were adversely affected by the business practices at that time, and he solidified his attitude against abuse of the lowly.

It was during this time that Carl Sandburg wrote one of his most quoted poems. It contained only twenty-two words, but they carry a world of meaning. Carl wrote the poem while sitting in the anteroom of a juvenile-court judge, waiting for an interview:

Fog

The fog comes
on little cat feet.

It sits looking
over harbor and city
on silent haunches
and then moves on.

Here was something everyone could understand. It was short and simple, like the lives of the simple people of America. It was plain and moving, yet fleeting. It was the inner melody in a new poetic symphony by Sandburg.

In a way the poem was Sandburg himself—active, shifting, then going on to something new yet ever old. In it there was a freedom like that of working on the newspaper that carried no advertising—writing what he wanted to write without regard to the sacred cows of the common journalistic media. He wrote, for example, about how two girl clerks in a large department store in Chicago were arrested for stealing food. Sandburg went behind the story to show that these girls, like many of their kind, could not sustain themselves on their meager salaries and were reduced by hunger to take what they needed.

A momentous event occurred in 1916. Sandburg's salary was raised to $27.50 a week. But this affluence was short-lived. The next year, *The Day Book* closed down because of World War I, but not before Sandburg had

written an astute editorial on the role of the Negro in race riots, in which he foresaw many aspects of racism that would continue in later years. Always he showed a warm and sympathetic understanding of the condition of the colored people, just as he did those of less fortunate whites.

For three weeks, Sandburg worked for the National Labor Defense League, whose purpose was to help striking union members protect their rights. Then he made a trip to Omaha, during which he wrote the poem of that name about its raw midwestern atmosphere. Back in Chicago, the roving writer received a call from the editor of the *Evening American*, William Curly, who explained that it and the other Hearst newspapers had tried to hire Professor Charles E. Merriam of the University of Chicago, a civic reformer, as an editorial writer. He had refused the offer saying, "Carl Sandburg can do a better job than I can." With this promising introduction, Sandburg went to work for Hearst for $100 a week, but he stayed only three weeks because he felt he did not fit in.

The next step in his ever-growing variation of endeavors probably marked the real start in his journalistic career. He joined the staff of the *Chicago Daily News*. Here he seemed to have found his niche at last, a welcome haven after long, hard years of wandering about our rugged hinterland. Harry Hansen, an associate on this newspaper, remembered that the newcomer had the same unruly shock of hair over his forehead, the same attitude of leaning forward to catch a significant remark, and the same deliberate manner of winding up a sentence with an explosive laugh that Sandburg retained until the end of his long life. When Hansen first met him, he was greeted with the remark, "My name's Sandburg. What kind of Scandihoovian are you?"

Hansen observed:

> The warmth that Carl had for people was something that you never forgot. He was from the beginning a newspaperman and he had the qualities of a newspaperman. He had awareness. A newspaperman somehow knows what is going on around him. He doesn't live in isolation. Carl had a keen sense of justice. He hated injustice and it runs all through his career, runs in his poems. Carl also had a great sense of proportion. He enjoyed humor. He found all sorts of amusing things in clippings and his pockets were always full of clippings in those days at the *Chicago Daily News* and at any time, he would take one out and read it and expect you to chuckle just as much as he did.[4]

Hansen remembered that as book editor he came close on one occasion to falling out with Sandburg. "He gave me something which had nothing to

do with book reviewing," Hansen said, "and I didn't want it, and he came in one day and said:

> "Are you going to run that piece I gave you?"
> "Well, we've only got this much space and I don't think I'll run it," Hansen replied.
> "If you want to lose a good friend, then don't run it," snapped Sandburg.

Hansen did not run the article, but fortunately he did not lose the good friend. He added:

> Carl was always noseying in to see me because I got the books for review, and he used to filter through these to see if there was something he was interested in and that is how we got more or less in contact—through books. Once he left a little note on my table, which read something like this: "Harry, why are you never in? Why are you always out? We shuffle in. We shuffle out. Why do we never find you in and yet never find you out?"[5]

Hansen may have been "out" at times, but the poetry of his friend was beginning to be "in." Knowing Chicago itself, the editor was profoundly affected by the poem of that name. "I had found expressed something I had dimly apprehended," Hansen replied. "As a statement of the fact of existence, the basic impulses of a vast, confusing city, *Chicago* is incomparable. It made a tremendous impact on my emotions. It made me hear the hootings of tugs on the river, the grinding wheels of the elevated trains, the slam-bang of trolley trucks on the streets."

While Sandburg's poetry dealt with the city in general, his reporting for the newspaper was mainly about labor activities. He would attend a convention and stay there for days because he was given a fair amount of leeway in his schedule. He worked directly with the news editor, Henry Justin Smith, who was called the "principal of the Chicago school of writers," which included Ben Hecht, John Gunther, and Lloyd Lewis. Smith encouraged Sandburg in his writing of poetry and thus had a helpful influence on his artistic development.

Thus Carl Sandburg entered the field of significant professional writing. His poetry first made him widely known and his prose was later to augment his literary reputation. But in his writings, whatever the form, poetry always ran through them.

From about 1910 until World War I there was considerable labor trouble in Chicago. One of the unions actively involved was the Amalgamated Clothing Workers. Bessie Abramowitz and three other women in this

union, whose pay had been less than four cents an hour, began a strike that eventually included 30,000 workers. A picket was shot and killed. Clarence Darrow and Harold Ickes were hired by Hull House to represent the strikers. In 1915 the clothing workers again struck, under the leadership of their president, Sidney Hillman, who married Bessie Abramowitz. Carl Sandburg, a friend of Hillman, who wrote about the strike for his newspaper, went to the union offices and Clarence Darrow's and sang songs to cheer them up. On October 2, 1917, Sandburg published an interview in the *Chicago Daily News* with "Big Bill" Haywood, the Chicago leader of the Industrial Workers of the World. After Clarence Darrow had read Sandburg's *Chicago Poems*, he wrote him a note saying, "Dear Carl: Please do not step out of my life."[6] He didn't.

Although the article was sympathetic toward the IWW, a week later Sandburg made it clear in a story that he disagreed with the efforts of the Socialists to sabotage the war effort. He and Paula, as he now called Lilian, believed that once America was committed to conflict, the citizens were bound to strive for victory. So they left the Socialist Party, which they had staunchly supported for a decade. They saw no way out but for America to join the Allies.

Bruce Weirick, later a professor at the University of Illinois and author of *From Whitman to Sandburg in American Poetry*, called on Carl. Carl told Weirick that his salary of $2,500 a year from the *Daily News* did not go far enough to support his family, and his poetry only brought in a few hundred dollars a year in royalties. "Thus his ballad and guitar business to lighten up his readings," Weirick stated, "had been of great help in getting engagements. People wanted to see a poet, though they didn't want much to hear poetry just naked for a whole evening."

Weirick described Sandburg as being "an enormous worker and an untiring traveler on trains, a real trouper who never gets tired. Yet he is never in a hurry, but gives the impression of careless ease, in his walk, in his slow measured cadences of speech in the unhurried timing of his pauses.... His speech, indeed, is a kind of singing; quite indescribable, with its strong and seemingly accidental stresses on odd syllables.... There is depth to it and richness and overtones. But this is only part of his talk. There is his laughter, genial, radiant, all inclusive ... always, somehow gentle, even at its most boisterous moments. To hear it is inescapably to share it.[7]

Carl's editor on the *Chicago Daily News*, Henry Justin Smith, had hired Carl on the recommendation of Ben Hecht, the sparkling, multitalented

reporter and author of such sprightly plays as *The Front Page* (in which I once appeared as the inimitable Hildy Johnson). Smith himself was author of a novel about the newspaper business entitled *Deadlines*. In it there appears the following lines:

> Gentlemen, should you see a stalwart person walking the streets bareheaded and glowing with mysterious ecstasy, will you kindly bring him back to the office? That is Our Poet. The Old Man wants to see him. And if you meet The Poet himself on the street, with his gaze fixed on the rooftops and his very footsteps proclaiming his indifference to time and space, will you please bring him back to the office? The Old Man wants him. Besides, he belongs here.[8]

These lines were written about Carl Sandburg.

In 1918 Carl Sandburg began to think seriously about Abraham Lincoln. He would mention to Hansen or some of the other writers discoveries he had made about Lincoln, some information from a book or documents he had seen in the great collection of Oliver Barrett in Chicago. When Sandburg went to other cities to lecture, he would look at local Lincoln collections and talk with men who had firsthand knowledge of the martyred President. Hansen said: "Carl dealt in specific incidents, not abstractions. This trait came into full use in the final volumes of the Lincoln Biography. The heaping up of incident, the use of anecdote and the casual remark as a key to inner motives, sidelights out of a letter—the use of all this material as illustration is characteristic of Carl's biographical manner. It is also characteristic of his intense interest in all phases of human behavior."

Harry Hansen believed that industry, persistence, and patience played a large part in the flowering of Carl Sandburg's genius. "No matter how hard he had to work," Hansen commented, "there was always a singing inside of him. When he wrote poems he expressed the emotional side of American social history. When he sang folk songs, he demonstrated the oral tradition by which simple events are recalled. In small talk, he put things in a new way. I have known him to have plenty of time for talk and because he has worked hard, he has always had something to say."[9]

In the middle of 1918, Sandburg went to New York City to cover a labor convention. The war fever was at its peak, and in this day of cooperation between government and labor, led by Woodrow Wilson and Samuel Gompers, the gathering appeared rather tame and lacking in news interest. Down at the Hudson River piers, however, the ever-curious Carl saw a big troop ship about to leave for Europe, filled with noisy "doughboys."

His heart went out to them, in the typical fashion of a veteran who, having served in the Spanish-American War, was always to retain that peculiar camaraderie that military men experience in their common service.

It was also a time of celebration in New York. The country had not yet learned the horrors of war firsthand. So we were facing a glorious adventure. Here was a romantic challenge: a fracas far overseas that demanded our help. And whether or not it demanded it, we wanted to go in, most of us, and get into the thick of things. Thousands of bright American flags flew across Manhattan and bands played patriotic songs as the young recruits paraded down Fifth Avenue and along lower Broadway. Girls lined the sidewalks, leaning over to kiss their heroes, who were going off to make the world "safe for democracy."

Carl wanted to go, too. At forty, he was old for military service, but he wanted to write about the war. It so happened that the Newspaper Enterprise Association, a feature organization serving 350 newspapers, had decided that Sandburg would be a good correspondent in Scandinavia. In a letter to Sandburg dated July 11, 1918, S. T. Hughes asked Carl to join the organization as a correspondent in Sweden:

> As you know, Stockholm is next door to both Germany and Russia. The very latest and best German news gets to Stockholm faster and better than it gets to either Berne or Amsterdam. . . . I am convinced that the Russian news is going to be just as important, if not more important than from any other part of the world. I know you are better fitted than most newspapermen, mentally, temperamentally and otherwise, to cover this particular place and that section of the world. Of course I am not offering you the Stockholm thing as a temporary assignment. I want you to be a regular and fixed member of the Scripps institution. You know our ways and our ideals. We know you and we like you. We would not look at you merely from the standpoint of exploiting your brains. We are in sympathy with men of your kind. When the war ends, or when this Stockholm assignment ends so far as you are concerned, we want you in the office here.

To this Sandburg immediately replied: "It is a go. On hearing from you that you can finance the stunt, I will begin packing for Stockholm, and looking up Chicago ends that have connections in Europe. I was more than glad to get your letter. It goes both ways."

The two wishes were joined and in mid-October 1918, the new foreign correspondent sailed to Europe, his specific assignment being to interview people who were leaving for the war zone, especially if they came out of Russia. Sandburg remained in Stockholm for five months. His knowledge

of the Swedish language was a help to him, but he found that the whole project turned out to be less important than he had expected. People back home wanted to read war stories rather than background articles, and he had arrived too late in the conflict for that, even if he had gone into the fighting sectors.

There was something going on, however, that did interest Sandburg. This was the collectivist movement of the Bolsheviks. Being not far from Russia, he talked a great deal to Michael Borodin, a Lenin agent in Stockholm who lived in Chicago when Sandburg did. From him, Carl derived interesting information but concluded he liked neither Bolsheviks or their opponents, both of whom espoused violence. Borodin almost got Sandburg in trouble by giving him $10,000 to give to a Finnish agent in the United States. As a result, when he landed in New York, Carl was questioned sharply by government officials, who were suspicious of where the money was going and how it was to be used. Carl turned it over to them and after some delay and irritation, he was exonerated of any wrongdoing.

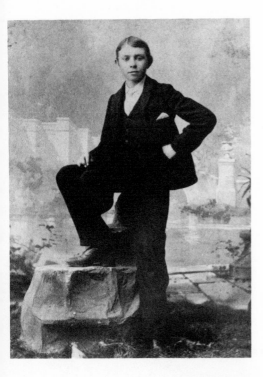

Carl Sandburg at the age of
fourteen, when he worked
as a shoeshine boy in Gales-
burg, Illinois. Courtesy Uni-
versity of Illinois.

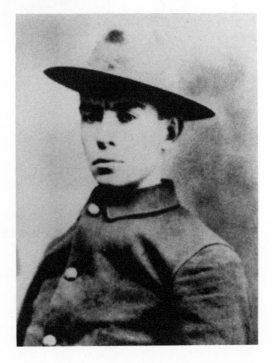

Sandburg as a private in
the Spanish-American War.
Courtesy University of Illi-
nois.

Sandburg at twenty-three, when he attended Lombard College in Galesburg. Here he started his serious writing. Courtesy University of Illinois Library.

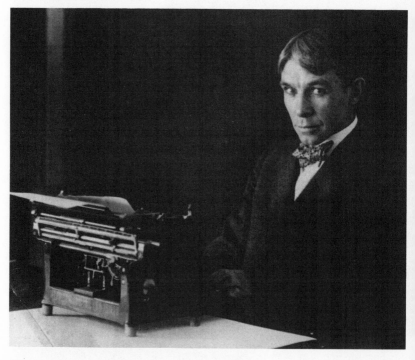

Carl Sandburg in 1922, when he was writing children's stories. Courtesy *Vanity Fair*, © Condé Nast Publications, Inc.

Carl Sandburg in a pensive mood in middle age.

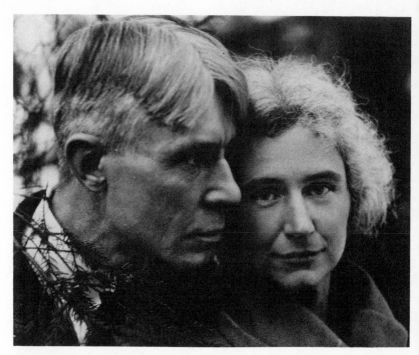

Carl and Paula in Elmhurst, Illinois, 1923. Photograph by Edward Steichen, reprinted with permission of Joanna T. Steichen.

Helga, Janet, and Margaret Sandburg with their parents. Photograph by Edward Steichen, reprinted with permission of Joanna T. Steichen.

# 6

# From Deadlines to Verse Lines

Back in Chicago, Carl Sandburg oversaw the operations of the Newspaper Enterprise Association for a short time, but the work did not suit him, so he returned, in May 1919, to the editorial fold of the *Daily News*. Here he was to remain for thirteen years. And why not? He was allowed to pick his own writing assignments, most of which turned out to be labor stories and interviews. Some he wrote without even seeing the persons concerned, because he knew them so well. After writing the story, he would telephone the person and read it to him for approval. Sandburg, of course, met all kinds of people, especially those from the harsher side of life. He was at home with bums, job-seekers, starving men, and members of the IWW, as well as with contrasting figures in the better economic brackets.

In the meantime, Sandburg was to meet a man who was to play a vital part in the future of his literary output. He was Alfred Harcourt, a book salesman for Henry Holt & Company of New York, who had read in *Poetry* magazine some of Sandburg's poems, which "stirred" him greatly. The next time Harcourt was in Chicago he tried to find Sandburg, but without success. He did find Alice Corbin, assistant to Harriet Monroe, editor of

*Poetry*, and asked her to steer Sandburg his way when he had enough poems for a book.

In the fall of 1915 Miss Corbin took to Henry Holt & Company a manuscript entitled *Chicago Poems*. Harcourt saw at once that it was of first importance and quality, but his colleagues were not so perspicacious. They felt, because of the somewhat conservative traditions of the firm, that the poems, with their midwestern flavor and their strong subject matter, were too raw for their imprint. But Harcourt would not relent, and finally Henry Holt himself agreed that they should publish the book.

*Chicago Poems* was published the next year, and Carl Sandburg went to New York and met Alfred Harcourt, the start of a long literary and personal friendship. The new book received considerable attention from critics, and Holt & Company soon became proud of its discovery. Harcourt later recalled that for almost ten years after that his association with Sandburg was mainly by correspondence:

> . . . and what correspondence! Every letter he wrote, even of humdrum details, seemed to sing. Everything Carl writes is music and full of wisdom. He had a regular job on the *Chicago Daily News* so he couldn't get to New York, and when in 1919 I started my own firm, Harcourt, Brace & Company, I was too busy to get to Chicago. I did drop in on him once in Elmhurst where he lived. I found Eugene Debs there, just freed from a federal penitentiary where he had been serving a sentence for trying to keep the United States out of the First World War. Debs was recovering his health and spirits in the warmth of the Sandburg home. I then heard Carl sing for the first time. Debs had been teaching him some of the songs he had heard his fellow prisoners sing.[1]

Meanwhile, on November 24, 1918, another daughter was born to the Sandburgs. Paula wrote to Harriet Monroe that "we have a husky little newborn baby girl—as colorful and clamorous as you could wish." The infant was first named Mary, but her name was later changed to Helga. This time the father had wished more than ever for a boy, had even suggested a masculine name in his letters to Paula. But he received the news gracefully and was ever devoted to three feminine progeny.

Sandburg was always the friend of the downtrodden, and these of course included the Negroes. In Chicago, after World War I, returning white soldiers found many of their jobs filled by southern Negroes who had come to the city during their absence. Apparently this group of migrants had become so numerous that the political bosses and many white residents came to fear their growing strength.

The race riots in Chicago started during the last week of July 1919, on a Sunday at a bathing beach. A Negro boy swam across an imaginary segregation line and some white boys were said to have thrown rocks at him and knocked him off a raft. He was drowned. Colored people rushed to a policeman and asked them to arrest the boys, but the policeman refused. More rocks were thrown on both sides, fighting spread to the Black Belt of the city, and at the end of three days, twenty Negroes and fourteen white men were dead and several Negro houses had been burned.

Sandburg did a series of sympathetic articles on the subject for the *Daily News*. The articles were published as a paperback on the first list of the newly formed Harcourt, Brace in the autumn of 1919. Significantly, on page 2, Sandburg mentions the Emancipation Proclamation of Abraham Lincoln.[2]

Three conditions marked this violence, according to Sandburg: First, the Black Belt population of Chicago, which had been 50,000, already overcrowded in the slum district, doubled during the war, but no new houses or tenements were built to take care of the great increase. Second, the Black Belt wielded considerable political power, connected directly with a city administration that refused to draw the color line and a mayor whose opponents failed to defeat him even by circulating the name of "nigger lover." This was the Chicago to which the black soldiers returned from France and cantonment camps. Third, thousands of Negroes and whites cooperated during the riots, and officials of the Stockyard Labor Council issued statements asking the public to take note that they were shaking hands as brothers and could not be counted on as sharing in the mob exploits. Poles, Negroes, Lithuanians, Italians, Irish, Germans, Slovaks, Russians, Mexicans, English, and Scotsmen proclaimed unprecedented and organized opposition to violence between union whites and blacks.

In any American city where the race situation is critical, Sandburg perspicaciously observed, the radical and active factors probably are housing, politics, war psychology, and organization of labor.

Barbershops, cigar stores, and haberdashery windows ironically displayed helmets, rifles, cartridges, canteens, and haversacks, as well as photographs of Negro regiments that served in France. Sandburg walked around the Black Belt and found that the folks felt they had made the supreme sacrifice and they needed no work-or-fight laws.

Blacks in Chicago had the largest single Protestant church membership in North America in the Olivet Baptist Church at South Park Avenue and East 31st Street, with more than 8,500 members. The local of the Meat

Cutters and Butcher Workmen's Union claimed more than 10,000 black members. Chicago then had the reputation of being the most liberal city in the nation in this respect and the constitution of Illinois, the most liberal of all state constitutions, according to Sandburg.

But for the black families that came from the South, the problems of adjustment were formidable. Five families, for example, lived in a big brownstone house on Wabash Avenue. All were from Alabama. At first they were said to have thrown their dinner leavings from the back porch. Next, they sat on the front steps and ate watermelon and threw the rinds into the street. Soon, said the Sandburg account, they learned what garbage cans were for, under the local urgings that anything they did might discredit their whole race and therefore they should be careful.

Leaders of the black community reminded Sandburg that the greatest source for a new power in labor was the 12 million Negro workers. They stated spiritedly that when orders for goods came from France and Belgium and Central Europe and South America and Africa to American factories, it did not matter an iota what was the color of the skin of the man whose hand or brain produced the product.

But many Negroes still found it difficult to obtain employment in Chicago, Sandburg revealed. Some of the returned men of the 8th Infantry Regiment tried to get places as Pullman car porters but found they would have to pay an initial fee of $35 for uniforms. They did not have the money. On the other hand, the People's Gas Company broke a precedent by employing four black meter inspectors at salaries of $100 per month and four special meter readers, boys sixteen years old, at salaries of $55 a month. The gas company's experiment proved so successful that the Commonwealth Edison Company soon followed suit by hiring six blacks in its meter-installation department.

Hundreds of letters, it was learned, written to the newspaper the *Chicago Defender* and the Urban League, gave certain causes for the migration of individual Negroes from the South to the North. Charles Johnson, an investigator for the Carnegie Foundation and formerly a lieutenant with overseas service in the 803rd Infantry, found the principal motive was economic.

> There were several ways of arriving at a conclusion regarding the economic forces behind the movement of the colored race northward. The factors might be determined by the amount of unemployment or the extent of poverty. These facts are important, but may or may not account for individual action. Except in a few localities of the South, there was no actual misery

or starvation. . . . A striking feature of the Northern migration was its individualism. Motives prompting the thousands of Negroes were not always the same, not even in the case of close neighbors. The economic motive was foremost, a desire simply to improve their living standards when opportunity beckoned.[3]

During the influx of blacks from the South, Sandburg reported, the Chicago Urban League issued a creed of cleanliness aimed especially at women:

> For me! I am an American citizen. I am proud of our boys 'over there,' who have contributed soldier service. I desire to render citizen service. I realize that our soldiers have learned new habits of self-respect and cleanliness. I desire to help bring about a new order of living in this community. I will attend to the neatness of my personal appearance on the street or when sitting in the front doorway. I will refrain from wearing dustcaps, bungalow aprons, house clothing and bedroom shoes when out of doors. I will arrange my toilet within doors and not on the front porch. I will insist upon the use of rear entrances for coal dealers and hucksters. I will refrain from loud talking and objectionable deportment on street cars and in public places. I will do my best to prevent defacement of property, either by children or adults.[4]

According to editors on the *Daily News*, Sandburg's articles on the racial problems were generally considered his best reporting. This was in-depth, investigative reporting of the highest order. Perhaps it was a harbinger of the intensive research that Sandburg was to do on his biography of Abraham Lincoln. But it was not to go without a challenge. From Austin, Texas, came a strong letter from John A. Lomax, the noted collector of folk songs. He wrote:

> You speak of Negroes locating south of the Mason-Dixon Line, "where neither a world war for democracy, etc., assures them the right to vote or to have their votes counted." I know about such matters in Texas. When I came to the University in 1896 there were five or six Negroes who had seats in the legislature. Negroes still vote, many of them at the University box where I cast my ballot; but Negroes and whites and Mexicans alike now have to meet an educational qualification that does deprive more Negro adults than white adults of the ballot. . . . I built my home in a Negro section of Austin. I have many Negro neighbors. One of them brought me a bushel of potatoes for a Christmas present and I got no present I appreciated more for they were the real sweet yams. I respect him and he respects me. We are genuinely fond of each other. There couldn't be any race question between us.

In a later letter to Sandburg, Lomax added, "You live in a big city surrounded by the problems of a big city; you are apt to attempt to interpret these problems as the biggest ones of the nation. Please bear in mind that there are a lot of folks practically untouched by them. In fact—and I thank God for it—these people constitute the greater majority of the American nation."[5]

Wrote Sandburg to Lomax:

> I am sure that no other white man in recent years did so much for me to help me get at the inside interiors of the Negro human soul as you did. . . . I believe that prejudice runs deeper and wider down south than up north and that this is the basic reason why the southern business interests have completely failed in their endeavors to induce movements of Negro population from northern points back south again. . . . Whatever reflections I may have cast on the south, however, was merely incidental and cursory as compared with the direct indictment of the intelligence of my own home town for its lack of plan in housing, its economic discrimination, its collusion of police and gamblers by which Negro crap joints exploit the Negro workman by wholesale.[6]

Sandburg's duties on the newspaper soon turned to a lighter side. When the movie critic for the *Daily News*, W. K. Hollander, resigned, the versatile Carl was asked to take his place. At first it seemed a frivolous assignment, but I can testify from a similar experience, it had its interesting side. In fact, the job of movie critic proved to be a propitious one. It gave him the time to do research and writing. He worked out a schedule so that he left his suburban home on Sunday mornings, saw three new movies, and then went to the newspaper office and wrote his reviews. He would then stay overnight in Chicago, see three more new movies the next day, and write his criticism of them, as well as a column, "Thoughts for Saturday." By Monday night, his work week was finished and he had Tuesday through Saturday to work at home.

As John Justin Smith stated, "He was free to browse for Lincoln information, free to lecture, free to walk the streets and shake hands with Chicago, a bulging city of newcomers. He could gaze at rooftops or listen to the sounds of many tongues, Swedes along Belmont Avenue, Irish in Bridgeport and Brighton Park, Bohemians along 26th street, Jews on Roosevelt Road, Poles out along Milwaukee Avenue and, here and there, Germans, Italians, Austrians and Hungarians."[7]

Sandburg's movie criticism turned out to be a disorderly hodgepodge of lectures to the public, observations on the state of the times, admonitions

about social conditions—a regular soapbox presentation of Sandburgisms tied loosely to the peg of comment on the cinema.

The new movie critic spent many evenings at the Dill Pickle Club. Jack Jones, an auto repairman, was president of the club. He once described it as a meeting place for "Irish revolutionists, labor leaders, artists, sculptors, poets, writers, and assorted nuts." Besides Sandburg, Ben Hecht, Charles MacArthur, Sherwood Anderson, Robert Frost, Vachel Lindsay, and Sinclair Lewis would drop by when they were in town.[8]

E. D. Akers, former news editor of the *Daily News*, said that Sandburg "was a gentleman and very kind. He said hello to everybody and treated all with great kindness." However, James Gilruth, a former member of the news staff, on his ninety-second birthday, said that "Carl Sandburg was a pest. He was always writing poems and trying to buttonhole people to read his latest brainchild to them. We figured we had better and more important things to do."

On the other hand, Henry Justin Smith remarked, "It does us good to gather around his desk and hear him talk. There is nearly always a knot of young reporters listening to his wisdom." Ben Hecht must have been a good listener to the words of Carl Sandburg. Said he, "I remember his as the finest voice I ever heard. It was a voice of pause and undercurrents with a hint of anger always in it and a lift of defiance in its quiet tones. It was a voice that made words sound fresh and clothed the simplest sentences with mysteries."[9]

Asked to fill out a form for keeping his name on a payroll, Sandburg submitted the following:

THE CHICAGO DAILY NEWS COMPANY

Order to Cashier for Entering Name on Pay Roll
Date: Saturday, Ruck & Rayner's

To the Cashier:      Please put on the *Egghead* department.
Pay Roll beginning *Discreetly*      Re-employed *Frequently*
Name *Carl Hjalmar Sandburg*      Address *courteous*
Employed in capacity *of 145 pounds*      Salary $ *medium*      Age *pliocene*
Married? *Experimentally*      Schooling—where and how
     long? *Dill Pickle Club—Miss Starrett's Academy*
Where last employed? *not yet ascertained*
What Capacity? *More than two fingers daily*
What salary? *Piece Work*      Why Disengaged? *the word is inadequate*
References and remarks:
References: *Amy Lowell, H. L. Mencken, Christian Science*

*Monitor, Michael Kenna, Arthur Burrage Farwell,*
*U.S. State Dept., J. B. Forgan, Barney Bertsche, God*
*Almighty*
Remarks: *See this author's poem "The Space Killer"*

It did not seem so humorous to Sandburg, however, when his name became confused with that of another Chicago resident. In a memorandum to a fellow newsman, Charles J. Finger, Carl explained it this way:

> There are two men in Chicago with names alike. One is Dr. Karl F. Sandberg, author of "The Money Trust" and member of the communist labor party. The other is Carl Sandburg, a newspaper man, author of "Chicago Poems", "The Chicago Race Riots", etc., an independent in politics and member of no party. Karl F. Sandberg is under conviction for violation of the criminal syndicalist laws of Illinois but has not yet served time behind the bars. Carl Sandburg once served a jail sentence in Pittsburgh, having been convicted of riding on a railroad train without a pass, but is not at the present moment in the status of either a martyr or a malefactor of the law. The two Sandb..rgs are both jailbirds, one prospective, the other retrospective. The mail and telephone calls of the two often get mixed.[10]

Carl received a raise in salary from $50 to $75 a week, which was a great help. He and Paula had begun to call each other "Buddy," a carryover from World War I days and a popular song by that name. "They would use the mutual term all of their days," recalls Helga. "It took on romantic connotations." Perhaps even more romantic in a material way was the move of the family from Maywood to the Chicago suburb of Elmhurst. Now they had a house on York Street, which was more like a home. Carl wrote to Edward Steichen, "Great times moving from Maywood to Elmhurst. Paula is having the time of her young life. Be ready to look over some live branches of nieces of yours when you come this way."[11]

Although the house was one of the oldest buildings in Elmhurst, it was attractive and substantial. The wooden structure had sixty-five windows and thirty-seven doors. Carl's desk was on the second floor and stood in front of a double window overlooking the summer kitchen. The Sandburgs called it "Happiness House." Helga remembers that it had a quiet and homey quality, traditional of homes in that day. "The young ones of the family cavorted in a style that showed them to be quite happy, reflecting both the mother's busy attentiveness to them and the childlike nature of their father." Here they were to spend virtually a decade of pleasant years, marked by wifely and motherly devotion and creative industry on the part of the husband and father. Meanwhile Carl shared the Poetry

Society of America prize with Margaret Widdemer. He was soon to share a similar prize with Stephen Vincent Benét.

Fanny Butcher, prominent women's editor of the *Chicago Tribune* and a friend of Sandburg's, recounted a visit to their home, where she met for the first time

> the gentle, quiet Lilian Sandburg and the bouncing little girls. I remember their father, with a great sardonic laugh, referring to the little girls as "the heiresses" as he pulled out of his pocket scraps of paper on which were notes, ideas, bits of half-written and finished poems. As he read some of them aloud and added them to the little pile on the table he ruefully but gleefully said, "These are what I will have to leave them—just pieces of paper, they'll be heiresses of scraps of paper," and the idea seemed up-roarously funny to him. . . . But from those scraps of paper there grew such a fortune as can be counted only in the wealth of immortality.[12]

But into this domestic felicity was to come a sad happening. In November 1921 Margaret had the first indications of nocturnal epilepsy. She fell asleep in class and at the age of ten was taken out of school. She and her mother hurried to the Battle Creek Sanitarium for treatment. Carl, who was away, wrote her: "Dear Margaret: This is only a little letter from your daddy to say he thinks about you hours and hours and he knows there was never a princess or a fairy worth so much love. We are starting on a long journey and a hard fight—you and mother and daddy—and we are going to go on slowly, quietly, hand in hand, the three of us, never giving up. And so we are going to win. Slowly, quietly, never giving up, we are going to win. Daddy."[13] Carl urged her to have patience, exercise her strong will, listen to her mother and she would win the battle. She did, and today is active, animated, and intensely interested in anything about her family.

Another ill person, Eugene V. Debs, came to live in Elmhurst. He was sixty-six and became a patient at a sanitarium only three blocks from the Sandburgs. His last four years were made happy by the affectionate attention of that family, who visited him regularly at the sanitarium, brought him flowers, and sang songs. After Debs's death in 1926, Sandburg included ballads about him in his *American Songbag*.

Sandburg soon gave a lecture-recital at Cornell College, Mount Vernon, Iowa, where he astonished and mystified his hosts by his unconventional delay at dinner and his appearance on the platform. Regardless, his reputation as a poet was growing to the extent that he did not have to pay strict attention to ordinary customs and social amenities.

# 7

## The Poetry

In whatever literary direction Carl Sandburg moved, he always followed the guiding light of his muse. Although there were a considerable number of readers who felt that instead of writing poetry he assembled a disorderly collection of prosaic sentences, he never wavered from his innate conviction that he was essentially a poet.

The lean years of pegging away at various jobs had toughened him and penetrated Sandburg's poetry. His rare contact with a raw world had never eliminated his use of word tones, especially in the writing he did outside his regular working hours. We have seen how he dabbled in poetry in college, how he was called a poet during his newspaper reporting days, and how he finally began to take his poetic writing seriously and hoped that others would too.

The moment came.

In January 1916 Sandburg received a letter from Henry Holt & Company, starting with the words: "We like your *Chicago Poems* and want to publish them. We would propose a royalty of 10% of the published price on sales up to 5,000 and 15% on sales thereafter." This was a little better than the standard contract. The letter was signed by Alfred Harcourt, who

had tried to reach Sandburg in Chicago a year before, and who was later to become Sandburg's editor and publisher and, at times, benefactor. The letter continued, "We believe you can arrange a volume which will have, if smaller, a much better commercial chance and which would mean 'you' at your best more thoroughly. It is rare to have a manuscript in the shop which interests us as much as yours, and we think, too, it has a good chance of interesting the public."[1]

This good news brought joy not only to Carl but to Paula, who had been trying to sell his poems, when Alice Corbin, Harriet Monroe's assistant at *Poetry* magazine, intervened.

The ice of publication had been broken—and by a major publisher. It seemed that the lean years were over. Carl was inspired to write in *Poetry* magazine of February 1916: "People write poetry because they want to. It functions in them as air in the nostrils of an athlete in sprint. Moods, thoughts, emotions, surge over writers as they do over inventors and politicians. It is a dark stuff of life that comes and goes."

*Chicago Poems* was published in the spring of 1916, thanks to Harcourt's strong effort. In *Poetry* magazine, Harriet Monroe praised the power and honesty of these poems, some of which had appeared first in her publication. "It was verse of massive gait," she wrote, "whether you call it poetry or not." She thought it was poetry. In agreement with her was Amy Lowell, who in the *New York Times* stated:

> *Chicago Poems* is one of the most original books this age produced. The impression one gets on reading this book is of a heavy steel grey sky rent open here and there, and through the rents, shining pools of clear pale blue. It is a rare and beautiful combination which we find in this volume, under whatsoever simile we describe it. Seldom does such virility go with such tenderness. . . . Try as he will, Mr. Sandburg cannot help feeling that virtue resides with the people who earn their daily bread with their hands rather than with those who do so with their brains.[2]

*Poetry Review* commented that "Carl Sandburg has shaped poetry that is like a statue by Rodin." However, *The Dial* stated that Sandburg was "gross, simple-minded, sentimental, and sensual." *The Boston Transcript*, while acknowledging that the poems had "tenderness and visual strength," concluded that they were "ill-regulated speech that has neither verse nor prose rhythms."

Carl Sandburg was never one to take such blows lying down. Said he in response, "Here is the difference between Dante, Milton and me. They

wrote about hell and never saw the place. I wrote about Chicago after looking the town over for years and years."

Edgar Lee Masters disagreed with Sandburg's vision of Chicago, saying it was too narrow and unfair to the city itself. Theodore Dreiser objected to Sandburg's crusade for social change. He could not understand why Sandburg, who was so bold otherwise, "shied away from the explicit in the exciting matter of sex, which was a fact to be faced in art in this newly frank post-Victorian time." Yet Dreiser had developed such an admiration for Sandburg that he had tried to find a New York publisher for him. He felt that Sandburg had "the rare secret of elegance amidst the commonplace, the ability to choose the precise word and put it in the right place, though the word might be vulgar in the eyes of the traditionalists."[3]

Oscar Cargill, author and critic, believed that " 'Chicago' and similar poems were a simple matter of delight, although radical. An obvious music is discoverable here, although less than those of Frost. Sandburg, however, was never again to be as brash as in *Chicago Poems*."[4]

In *Chicago Poems*, Gay Wilson Allen saw the longing of ordinary people for the beauty and happiness they have never known:

> This clutching of dreams was not a creation of Sandburg's fantasy, but a social phenomenon which he accurately observed.... A more cheerful theme is the laughter and joy workmen manage to find in spite of their toil and poverty. The face of the Jewish fish crier on Maxwell Street is the face "of a man terribly glad to be selling fish, terribly glad that God made fish, and customers to whom he may call his wares from a pushcart." The poet searches for happiness and finds it one Sunday afternoon on the banks of the Desplaines River in "a crowd of Hungarians under the trees with their women and children and a keg of beer and an accordion."[5]

More recently Professor Louis D. Rubin, Jr., commented that the *Chicago Poems* is the type of poetry one finds in a high school or college survey course in American literature, as exemplifying the Chicago Renaissance, the overthrow of the Genteel Tradition, the first important use of modern urban experience and vernacular speech in our national letters, and also the renewal, in a new century, of the muse of Walt Whitman. In substantiation he quotes a textbook anthology discussing the *Chicago Poems*: "The lines are not without strength, and Sandburg was one of the first after Whitman to catch, in poetry, something of the brute reality of the emerging American city. But, typical of Sandburg, the poem reflects Whit-

man's wordiness without his sensitivity to the delicately exact image, Whitman's uncoiling line without his grace of movement."[6]

Rubin concentrates on a short lyric entitled "Limited" from the *Chicago Poems*:

I am riding on a limited express, one of the crack trains of the nation.
Hurtling across the prairie into blue haze and dark air go fifteen all-steel
    coaches holding a thousand people.
(All the coaches shall be scrap and rust and all the men and women laughing in
    the diners and sleepers shall pass to ashes.)
I ask a man in the smoker where he is going and he answers: "Omaha."[7]

This critic feels that the name *Omaha* "sounds more than a little like 'Nowhere,' " that Sandburg is saying Omaha is as worth traveling to as anywhere else.

Amy Lowell, in the printed program of one reading, remarked: "No one hearing him can fail to see that Sandburg is one of the most important poets in America today. Something of the Whitman who loved to catalogue people and places, something of O. Henry who loved colloquial America, and something of the homely outlook and gesture of that other Illinoisian, Lincoln, each plays its phrase in the tune of Sandburg."[8]

Louis Untermeyer characterized Sandburg as "an inheritance of Swedish mysticism fused with an American idealism, a mixture of gigantic, youthful personality, and an older, active will." Sandburg has "the ability to make language live, to make words on the printed page sing, dance, bleed, rage, and suffer, with the aroused reader." His poetry is "rough hewn and stolid; perhaps a bit too conscious of its biceps... but going on, on gladly, doggedly with a kind of large and casual ecstasy."[9]

Carl Sandburg was "to walk with kings," but he never lost the common touch. He had associated with prominent Chicagoans, but he could treat with equal deference an obscure editor of a little railroad magazine whose views he admired or even a nameless workman just doing his job:

### Child of the Romans

The dago shovelman sits by the railroad track
    Eating a noon meal of bread and bologna.
A train whirls by, and men and women at tables
Alive with red roses and yellow jonquils,
        Eat steaks running with brown gravy,

> Strawberries and cream, eclairs and coffee.
> The dago shovelman finishes the dry bread and bologna,
> Washes it down with a dipper from the water-boy,
> And goes back to the second half of a ten-hour day's work
> Keeping the road-bed so the roses and jonquils
>       Shake hardly at all in the cut glass vases
>       Standing slender on the tables in the dining cars.[10]

Sandburg had developed an aversion to the flamboyant evangelist Billy Sunday, a dynamic "reformed" professional baseball player who electrified audiences by his gymnastic antics in the pulpit. Sandburg thought Sunday was a bombastic imposter who preyed more than he prayed, misleading the people through fervent, high-pressure appeal to their emotions. That most Americans did not agree but felt that Sunday was a benign and needed influence did not deter Sandburg. So in the *Chicago Poems* was included "To A Contemporary Bunkshooter":

> You come along ... tearing your shirt ... yelling about Jesus.
>       Where do you get that stuff?
>       What do you know about Jesus?
>
> . . . . . . . . . . . . . . . . . . . . . . . . . . . . . .
>
> I've read Jesus' words. I know what he said. You don't
>       throw any scare into me. I've got your number. I know
>       how much you know about Jesus.... [11]

In this connection, Sandburg wrote to Alfred Harcourt: "The only other American figure that might compare with Sunday is Hearst. Both dabble in treacheries of the primitive, invoke terrors of the unknown, try to throw a scare into their listeners, with Hearst the same antithesis to Tom Jefferson that Billy Sunday is to Jesus of Nazareth. Sunday is the crowd-faker preeminent. He is a ball-player and acrobat with a sales manager's gift for organizing neurotic and physic effects about him to gain certain results."[12]

Billy Sunday struck back, writing from Chattanooga on the stationery of the First Baptist Church to Allan Sheldon of Leonia, New Jersey: "It is evident to me that the fellow who wrote that poem of bunk was giving his own views, for no fair honest man can ever say he heard any such slush from me. I do not remember of having ever met a man named Sandburg.... It is my opinion, formed after reading what you sent me, that the author is a Communist, a Socialist and a follower of Karl Marx and Nietzsche. I do not want or expect the endorsement of that Godless, Christless, anti-Bible, anti-American gang."[13]

Meanwhile Sandburg received different words from Theodore Dreiser about his poems: "They are beautiful. There is a fine, hard, able paganism about them that delights me—and they are tender and wistful as only the lonely, wistful, dreaming pagan can be. Do I need to congratulate you? Let me envy you instead. I would I could do things as lovely."

But Robert Frost did not agree. He began criticizing Sandburg adversely in the early 1920s. In one comment Frost said, "His affectations have almost buried him out of sight. He is probably the most artificial and studied ruffian the world has had." On the other hand, William Allen White told Sandburg that "you have put more of America in your verses than any modern poet."

Professor Allen Walker Read of Columbia University has expertly analyzed the evocative power of place names in the poetry of Sandburg. He points out that the name *Illinois*, with its liquid sound, had a special appeal to the poet, and of course it being his native state added to the attraction. Indian names were favorites, such as "The Blackhawks ran on moccasins ... between Kaskaskia, Peoria, Kankakee and Chicago." In another poem, Sandburg used the word *Chillicothe* three times in four lines. We have seen how he emphasized *Omaha*, which clearly called up a variety of images to Sandburg, as did to a lesser extent, *Kalamazoo*. These were euphonious words that Sandburg delighted in putting down on paper, and he literally rolled them over on his tongue when he was speaking in that resonant voice that held so many listeners in rapt attention.

On May 3, 1918, Sandburg wrote Alfred Harcourt about his new book of poems, *Cornhuskers*. "The book will be a real and honest singing book and is a bigger conceived and all round better worked-out book than *Chicago Poems*." The book was published at the end of 1918, when Sandburg was still abroad, and it was received with not so much controversy as its predecessor. Probably readers had become more accustomed to the free verse of this poet. It was not so brash and shocking. Sandburg had now in his virile fancy turned away from the noise and bustle of the big city and returned to the prairie he had known as a boy. One only has to drive through this far-reaching expanse of level land that stretches relentlessly to a far horizon to realize the awesome vastness of this midwestern landscape. As Professor Richard Crowder described *Cornhuskers*, "An autumnal nostalgia haunted almost every page, due in part to his vague Scandinavian heritage of mysticism and in part to the fact that he was no longer a young man, forty years old. The buoyance was still present, but it was tempered by an obviously increasing awareness of the passing of time and

by other sobering thoughts.... He was still an American poet, and his pieces were about America and her people; but he was outgrowing any tendency to provincialism."[14]

An excerpt from "Prairie" gives the essence of *Cornhuskers*, a harking back, a nostalgic embrace of the American heartland that first nourished and sustained Sandburg through his early struggles.

### Prairie

I was born on the prairie and the milk of its wheat, the red of its clover, the eyes of its women, gave me a song and a slogan.

The prairie sings to me in the forenoon and I know in the night I rest easy in the prairie arms, on the prairie heart. A thousand red men cried and went away to new places for corn and women: a million white men came and put up skyscrapers, threw out rails and wires, feelers to the salt sea: now the smokestacks bit the skyline with stub teeth.

Sandburg was like a sturdy stalk of wheat or corn that had grown in the prairie and survived because of the strength of its roots, fed by a strong rich soil. Sandburg once told a friend that he could do what he did in the way of accomplishment only because of his strong Swedish heritage. "Prairie" adds to this strength the lasting support of a nurture that the pristine reaches of the Midwest gave him and remained with him through almost nine decades of achievement.

"Prairie" evinces Sandburg's fascination with American history, particularly that of the west. The Indians, he felt, were driven from their native habitats and forced ever westward, fighting the white men sporadically but inevitably losing. He does not recognize that they were often their own worst enemies. The coming of the skyscrapers, structures that always caught his poetic fancy and gave him a common interest with his friend Frank Lloyd Wright, Sandburg held as towering symbols of the change from rural to urban America:

I speak of new cities and new people,
I tell you the past is a bucket of ashes.
I tell you yesterday is a wind gone down,
    a sun dropped in the west.
I tell you there is nothing in the world
    only an ocean of tomorrows,
    a sky of tomorrows.
I am a brother of the cornhuskers who say
    at sundown:
        Tomorrow is a day.

In this poem Sandburg expresses his lasting faith in the future of mankind. Despite his verbal attacks on Chicago, he hails new editions of municipal life as hopeful and promising of ultimate happiness. Reluctantly he takes leave of the past in order to welcome the future. He dares not hold out hope for fear mankind will lose it, as he himself came close to doing at times. But as he reminds us of the past and looks upward to the future, he determinedly retains his own brotherhood with the common man, the cornhuskers.

The poet's conception of death is vividly brought out in his oft-quoted lines about the cool tombs:

### Cool Tombs

When Abraham Lincoln was shoveled into the tombs, he forgot the copperheads and the assassin . . . in the dust, in the cool tombs.[15]

With this vision of the afterlife, he connects the father figure of Abraham Lincoln, the one who was to exert a forceful mastery over the remaining life of the poet-biographer-historian. Sandburg's original contribution to the visualization of a tomb seems to lie in his unique description of one as dusty and cool. As to immortality, it is still a question in his mind.

Of course there were different reactions to these poems. One came from eighteen-year-old Richard C. Wood of Memphis, Tennessee, who apparently felt a kinship with Sandburg because he had also carried newspapers. Wood also wrote poetry, but he admitted, "it is not much good." His letter stated, "I just laid down a copy of *Cornhuskers* and it gave me a 'song and a slogan.'"[16]

In another poem from *Cornhuskers*, "Prayers of Steel," Sandburg seems to be praying for divine guidance:

Lay me on an anvil, O God.
Beat me and hammer me into a crowbar.
Let me pry loose old walls.
Let me lift and loosen old foundations.[17]

Louis D. Rubin, Jr., has observed that in this poem "the conventional language of prayer is combined with that of vernacular denotation. I would venture that few poems in English which contain the invocation 'Oh God' also refer to crowbars."[18]

In reading other poems in *Cornhuskers*, one is struck by three lines from "Slants of Buffalo, New York":

Boys play marbles in the cinders.
The boys hands need washing.
The boys are glad; they fight among each other.

If this is poetry, it is beyond my definition. Bernard Duffey also has taken a critical look at these lines and comments generally on Sandburg's poetical writing:

> The poetry is indubitably there, on the map of American literature, and yet it is hard to call to mind any criticism of it that has succeeded in giving it major character, in raising itself, that is, to encompass sympathetically and memorably a body of writing which has continued to hold the interest and affection of some generations of readers.... Perhaps Sandburg seems distinct from his contemporaries most plainly by reason of his own willingness to build whole sections of his poetry *on* action. The characteristics of our times, however, has been a contrary one seeking decision for the poet rather *in* action, his action as a poet.[19]

Carl Sandburg reaches a height of vividness in "Grass":

> Pile the bodies high at Austerlitz and Waterloo.
> Shovel them under and let me work—
>         I am the grass; I cover all.
>
> And pile them high at Gettysburg
> And pile them high at Ypres and Verdun.
> Shovel them under and let me work
> Two years, ten years, and passengers ask the conductor:
>         What place is this?
>         Where are we now?
>
>         I am the grass.
>         Let me work.[20]

Throughout his life, and especially in his writings after World War I, Sandburg repeatedly revealed his horror of war and its consequences. Although not a pacifist in his maturing years, he exposed with rare and graphic language the carnage of martial conflict. Nor did he hesitate to use description that many times was not for the faint of heart. As we shall see, he carried this realistic attitude into the evening of his life, when he made it a prophecy. Probably the clearest evidence of this viewpoint emerges in his lengthy poem "The Four Brothers." In it he describes France, Russia, Britain, and America as fighting to defeat the Kaiser. Richard Crowder, somewhat singularly, takes a rather dim view of this eloquent poem:

The limitations of Sandburg's vision are evident in this poem, and echoes of his early interest in Populism reverberate. The poem had the narrow view of a professional patriot in wartime. The armies of the allies represent the "People." No notion is present that God might also be the God of the German people. The idea that the true enemy is Kaiser Wilhelm may be sound enough, but the unconsidered concept is that the Allied armies are fighting the common people of the other side, who also swear *Gott mit uns*.[21]

According to an early biographer, Karl Detzer, Sandburg's "verse now stirred minor tempests in academic teacups from coast to coast. Defenders and detractors broke inky lances on the pages of the book supplements. Admirers proclaimed him a latter-day Walt Whitman. Objectors cried that their six-year-old daughters could write better poetry."[22]

Such adverse judgment was hardly borne out when Sandburg shared with Margaret Widdemer the $500 prize of the Poetry Society of America for 1919 for *Cornhuskers*.

His next book of poems, *Smoke and Steel*, published in 1920, received mixed reaction. Maxwell Bodenheim wrote to Sandburg: "I've just read *Smoke and Steel*. I had an argument with Ben Hecht once about your work—he defended it while I attacked. I said then that you often flirted with platitudes and redundancy and that you were too fond of shouting over mud pies. I say now with equal honesty that I consider *Smoke and Steel* to be ten hundred and ninety-three miles above your other books. It is like a dirty giant tearing a sunset into strips and patching the rents in his clothes. He shouts without having forgotten how to whisper and his gropings are like a mountain motion."

The poet occasionally waxes lyrical, as in this poem about his wife, entitled "Paula":

Nothing else in this song—only your face.
Nothing else here—only your drinking, night-gray eyes . . .

Your hands are sweeter than nut-brown bread when you touch me.
Your shoulder touches my arm—a southwest wind crosses the pier.

Sandburg never ceased praising his helpmate. He not only put her into his verse, but he recognized her exceptional ability as a scholar and domestic administrator. His poetic figures of speech often held a feminine aspect, seemingly with Paula in mind. For example, in the lines from "Night Stuff":

> Listen awhile, the moon is a lovely woman, a lonely woman,
> lost in a silver dress, lost in a circus rider's silver dress.

In the poem "For You," the last line is:

> Yes, the peace of great phantoms be for you.

In many of his letters to individuals and especially to friends, Sandburg ends the messages with these same lines.

The essence of *Smoke and Steel*, which contains poems of roughly vivid realism about men who worked in the fields and factories, is set forth in the following poem:

> Smoke of the fields in spring is one,
> Smoke of the leaves in autumn another.
> Smoke of a steel-mill roof or a battleship funnel,
> They all go up in a line with a smokestack,
> Or they twist . . . in the slow twist . . . of the wind.
> . . . . . . . . . . . . . . . . . .
> A bar of steel—it is only
> Smoke at the heart of it, smoke and the blood of a man.
> A runner of fire ran in it, ran out, ran somewhere else,
> And left—smoke and the blood of a man
> And the finished steel, chilled and blue.
>
> So fire runs in, runs out, runs somewhere else again,
> And the bar of steel is a gun, a wheel, a nail, a shovel,
> A rudder under the sea, a steering-gear in the sky;
> And always dark in the heart and through it,
>     Smoke and the blood of a man.
> Pittsburgh, Youngstown, Gary—they make their steel
>     with men.[23]

Sandburg is as fascinated with smoke as he has been with fog. Even as he is concerned with the hard work of men and their making of steel, he lifts his eyes upward and sees the smoke reaching the sky. It is a symbol of his hope for the uplifting of man. Although the bar of steel is made with the blood of man, this material result can extend beyond their toilsome lot to a better existence.

Louis D. Rubin, Jr., has examined the poem "Good Night" in *Smoke and Steel* and feels that Sandburg had exhausted "the supply of subjects about which he feels strongly as a poet, and he substitutes rhetoric and repetition." The poem deals with "many ways to spell good night." It gives as

examples Fourth of July fireworks, railroad trains at night, and steamboats turning a curve in the Mississippi.[24]

In contrast to the subject of smoke and steel is "Peach Blossoms":

> What cry of peach blossoms
> let loose on the air today
> I heard with my face thrown
> in the pink-white of it all?
> in the red whisper of it all?
>
> What man I heard saying:
> Christ, these are beautiful!
>
> And Christ and Christ was in his mouth
> over these peach blossoms?

John and Margaret Knoepfle have analyzed this poem and comment that if Sandburg had used only the first three lines and the seventh line, "he would have written a very fine imagist poem. But he does not, he gives us that totally unexpected last stanza, that line with the stunning double Christ in it."[25]

Analyzing Sandburg's poems is often difficult, for if one does not know what Sandburg meant at times, it is well to remember that he himself did not always remember the meaning of some of his poems.

*Smoke and Steel* was noticed abroad, the name of Carl Sandburg having now become better known in foreign literary circles. The *London Times Literary Supplement* found that the book was dominated by a reckless determination to be American. But the critic admitted that the energy in the lines was impressive and that the poems succeeded in accomplishing what they had set out to do. The British reviewer ended by posing the frequent question: Do these poems rightfully deserve to be called art?

Still, Karl Detzer, while agreeing that all of Sandburg's poetry was not pretty, added "It does not twinkle. It isn't sweet. It is hardy, he-man poetry, vigorous and resonant, with the flavor of the prairie soil and the robust cadences of winter winds."[26]

*Slabs of the Sunburnt West* appeared in 1922 and covers a broader panorama than the earlier books. He appears to have come to view the past more in the light of a pageant of history than in the sharp stabs of its individual parts. From what was apparently a study of the westward movement, the poet turns to the shaping of the people's character by this movement and its significance to our whole civilization. Perhaps showing the effects of the theory propounded by Frederick Jackson Turner, Sand-

burg interprets broadly the experience the western pioneers underwent in their struggle with the elements. They were tried in the crucible of the frontier and came out for the most part as conquerors of their environment. The people moved and with them went old customs and traditions that were soon caught up in new conditions and problems. Out of it all came a new type of American—and none was more typical of this new type than Carl Sandburg himself.

He even took a closer and longer look at his city of Chicago. Now he chose not simply to castigate it like a fond parent spanking a child, but to go back into the past and trace the growth of the windy city from its beginnings. Having understood this development better, he was able to express a deeper understanding of the forces at work in a new nation.

Early in "The Windy City" are lines that give a vivid and pungent description:

> Early the red men gave a name to a river
>    the place of the skunk,
>    the river of the wild onion smell,
>    Shee-caw-go.

More pleasantly, Sandburg adds the lines:

> Every day the people sleep and the city dies;
>    every day the people shake loose, awake and—
>    build the city again.

But later in the poem a paragraph appears that is more like the lead of a newspaper story than poetry, and there is alliteration at the end:

> Mention a carload of shorthorns taken off the valleys of
>    Wyoming last week, arriving yesterday, knocked in the
>    head, stripped, quartered, hung in ice boxes today,
>    mention the daily melodrama of this hum-drum rhythms of
>    heads, hides, heels, hoofs hung up.[27]

Within this book is a long poem, "And So Today," in which Sandburg returns to his theme of lament for the war dead. Since he had experienced war only as a recruit in the Spanish-American War and in this, only desultory duty, it is not easy to comprehend the depth of the poet's feelings about the horrors of war. Of course he had been exposed to the atmosphere of World War I, but not as a combat soldier. The explanation seems

to be that as he had in other fields, he psychologically immersed himself in the subject. Here with eloquence he expresses it:

> And so today—they lay him away—
> the boy nobody knows the name of—
> the buck private—the unknown soldier—
> the doughboy who dug under and died
> when they told him to—that's him.[28]

The next book of Sandburg poems was published six years later by the same publisher, Harcourt, Brace, and was entitled *Good Morning America*. From Hollywood, his friend C. S. Dunning wrote about this work: "Your use of the American lingo appeals to me but the work does not strike home. 'Many Hats,' though intoxicates me. At points there is a physical reaction as I read. It centers in the corners of my eyes, in my throat. I re-read the exciting lines but I can find no reason in them for my reaction."[29] Although the poem is touching, it is not intoxicating.

> When the scrapers of the
> deep winds were done, and
> the haulers of the tall
> waters had finished, this
> was the accomplishment.
>
> The drums of the sun never
> get tired, and first off
> every morning, the drums of
> the sun perform an intro-
> duction of the dawn here.[30]

A more enthusiastic opinion came from Joseph Warren Beach. He even waxed poetic about it himself. Wrote he to Sandburg,

> *Good Morning America* is a good book.
> It is not a perfect book.
> But then, you never wrote a perfect book.
> And I don't know anybody that did.
> And the most perfect books are not those one likes the best.[31]

On January 20, 1935, Sandburg wrote to Malcolm Cowley: "The longer I live the more difficulty I find about answering letters, partly on account of time and partly because writing letters too is writing. Then too, the past

month I have been rewriting the longest piece of verse I have ever done, a ballad pamphlet harangue sonata and fugue titled, 'The People, Yes.'"[32]

Willard Thorp called this "one of the great American books. Whatever may be the name you put to it, a foreigner will find more of America in *The People, Yes* than in any other book we can give him. But he will have to spell it out slowly." There is no doubt that by the mid-1930s Carl Sandburg had, with this publication, reached his poetic peak. He had lived now for half a century and had experienced more than three average men. From the days when the United States was expanding to a world power, through the halcyon span of almost two decades of peace and prosperity, he had come full-blown through the reaction of the 1920s and smack into the Great Depression. As Hazel Durnell said: "Into *The People, Yes* went the failure and the strength, the chaos and the achievement, the mediocrity and the ambition, the good and the bad that make up America. Sandburg has been among the men of character whom Emerson would designate as the conscience of the society to which they belong; as such, he understands why America is what she is and at the same time, as the prophets of old, he reminds her of her true role in the context of her past history."[33]

Several excerpts from *The People, Yes* indicate the background, the philosophy, and the hope of Carl Sandburg. The variation in form and content speaks for itself.

> Hope is a tattered flag and a dream out of time.
> Hope is a heartspun word, the rainbow, and the
>     shadblow in white,
> The evening star inviolable over the coal mines,
> The shimmer of northern lights across a bitter winter night
> The blue hills beyond the smoke of the steel works.

The people, yes, the people,
Until the people are taken care of one way or another,
Until the people are solved somehow for the day and hour,
Until then one hears, "Yes but the people what about the people?"

> Nothing more certain than death
> and nothing more uncertain than the hour . . .

And let me put one bug in your ear; inside information helps; how many
    fortunes came
from a tip, from being around on the ground first, from hearing
a piece of news, from fast riding, early buying, quick selling,
or plain dumb luck?

... Money buys food, clothes, houses, land,
guns, jewels, men, women, time to be lazy and listen
to music.
    Money buys everything except love, personality,
freedom, immortality, silence, peace.

... Six feet of earth make us all of one size.
The oldest man that ever lived died at last.
The turnip looked big till the pumpkin walked in.
The dime looked different when the dollar arrived.

... Three things you can't nurse: an old woman, a hen
and a sheep.
Three who have their own way: a mule, a pig, and a miser.
Three to stay away from: a snake, a man with an oily tongue
and a loose woman.
Three things dear to have: fresh eggs, hickory smoked ham,
and old women's praise.

... Tomorrow the people say Yes or No by one question:
    "What else can be done?"
In the drive of faiths on the wind today the people know:
"We have come far and we are going farther yet."

... Man is a long time coming
    Man will yet win.

In the darkness with a great bundle of grief
    the people march.
In the night, and overhead a shovel of stars for
    keeps, the people march:
        "Where to? What next?"

    Gay Wilson Allen has taken a mixed view of *The People, Yes*: "An amal-
gam of folk wisdom and wit, verbal cliches, tall tales, preaching, slangy
conversation, cracker-barrel philosophy, and Carl Sandburg cheerfulness,
the book served its purpose, as Steinbeck's *Grapes of Wrath* did in another
manner. It was wildly praised by people who liked Sandburg, and mostly
ignored by those who did not."[34]
    Allen's colleague at New York University, Oscar Cargill, was more gen-
erous. "Diffuse, occasionally rambling and sometimes long-winded, *The
People, Yes* is still a splendid organic growth. Nowhere else in poetry is
there such a survey of the people's businesses, their routine affairs, their
employments, their concern."

Carl Sandburg was not unaware of such criticism. In a letter to Robin Lampson, he wrote: "I am quite sure *The People, Yes* would have gone to a larger audience had it been cast in a form indicating it had no relation to poetry. The existing prejudices and quirks regarding poetry, the aversion to it in wide circles, has a basis of a certain sort that is justifiable. Part of it connects with the contradictions, quarrels, pallors, pretenses, sicklinesses, snobberies, temperaments, isolations, poverties, of the poets themselves —while the critics in the main inhabit a pathetic lost world."[35]

Sandburg's opinion of his critics is remindful of that of Maxwell Anderson, who termed the drama critics "The Jukes Family of Journalism." But there was much favorable comment. Irwin Shaw wrote Sandburg: "I have never written any author to tell him that I liked his book, but I have just finished *The People, Yes* and I am moved to tell you that it is a fine book. American authors especially should be grateful for this book, for it is a kind of dictionary of the American spirit, in which a writing man may look and find the exact word for an attitude, a shape, a longing, native to America, mixed with the soil of its farms and the dust of its cities."[36]

The Boston Arts Festival gave the poet an award as representative "of the American affirmation whose reply to doubt, depression, and the failure of heart of those who dared no longer trust the people." The award was signed by Mayor John B. Hynes and by Nelson W. Aldrich, chairman of the festival. A poignant letter came from a navy lieutenant, Kane Zelle, who told of crossing from Tokyo to Seattle with four other Navy men in October 1945. "I had brought with me," wrote the lieutenant, "a copy of *The People, Yes*. We read the book and it was a great source of reassurance. We were able to feel a sense of inclusion, of participation in a heritage which we had come close to forgetting while we were supposed to be fighting for it."[37]

Years later, Daniel Hoffman, Consultant in Poetry at the Library of Congress, remarked about *The People, Yes*: "Nobody in America could have written those lines but Carl Sandburg. They have the thumbprint of his personality, his ear for a good yarn, his sense of the revealing detail, his empathy with the folk wisdom, his unique ability to transform the raw materials of common speech into a lyricism with a swing and rhythm recognizably his own."[38]

In his preface to the handsome *Complete Poems*, published in 1950, Sandburg quotes Thomas Babington Macaulay as saying, "Perhaps no person can be a poet or can enjoy poetry without a certain unsoundness of mind." Sandburg may have regarded this comment as appropriate, but

more likely he was poking fun at a historian whose knowledge of poetry was, to say the least, perfunctory. At any rate, the poet and his publisher performed a valuable service by bringing together in one volume virtually all of the verse he had written.

Although this book was a climax to his career and won him a Pulitzer Prize, it did not receive as much high praise as some of his prose works. Most of the reviews of *Complete Poems* still seemed to visualize Sandburg as the Chicago poet of old. Some of the poems were new and were regarded by a few critics as among his best. Professor Bernard Duffey observed: "The *Complete Poems*, from beginning to end, is studded with observations of place that, across their breadth, can best be characterized negatively, as the absence of the romantic in nature of the sort which bespeaks as an Emersonian feel for spirit.[39]

William Carlos Williams reviewed *Complete Poems* in *Poetry* magazine and excoriated it. But taking a strong opposite view was Elmer Gertz of Chicago, who wrote the magazine's editor that he was astonished at such a negative viewpoint as expressed by Williams. "Each nation seeks its own distinctive mode of self-expression, its peculiar idiom," Gertz wrote. "That is what we mean by a national literature. . . . Sandburg's accents have been real, and they have been in tune with the voice of a masculine America. Sandburg has captured the sounds, the sense, the bearings of the U.S.A. That is why he not only sings the people but is sung by them."[40]

In 1963, when he was eighty-five, Sandburg produced a new volume of poetry entitled *Honey and Salt*. In this there appears again much of the emotion Sandburg showed when he was young. For example, he sees buds on an elm tree as "mice of early spring air."

Then in 1978, the 100th anniversary of his birth, the last book of his poems was published, edited by his daughter, Margaret, and entitled *Breathing Tokens*. It consists of some unpublished poems and is a flavorful epilogue to an eminent career. One poem, "Dixie Flyer," holds a warm, nostalgic interest for me because it describes some of my home country.

> On the path of the Dixie Flyer
> Along two hundred miles on a Sunday afternoon
> Wild azalea sprang up and sang, sat up with its
>     soft pink leaves
>
> The path of the Dixie Flyer
> Took three curves in Tennessee, in Alabama,
>     in Georgia—
> The wild azalea was always there.

Buttercups were a yellow rain,
Johnny-jump-ups a blue mist—
The wild azalea sprang a low cry
. . . . . . . . . . . . . . . . . . . . . . .
Lookout Mountain lays a long shadow across Chattanooga.
Places where men lay lost, lay in wounds in rain.
    lay calling for mothers, water, Christ, lay
    in salt and blood—
Places where trees were born and the spears of grass
    were a splatter of red—
Lookout Mountain lays a long shadow across Chattanooga.[41]

For Ralph McGill, a friend on the *Atlanta Journal and Constitution*, Sandburg wrote "Shenandoah Journey":

I shall be in the Shenandoah some day.
    (The time is not told in the almanacs)
And I shall not go again to the tomb
    of Robert E. Lee in white recumbent marble.
Nor to the hill again where Sheridan counted
    A circle of twenty-two burning barns
Nor repeat the days when any wise crow
    Carried its own rations . . .[42]

In the same year, 1953, another journalist paid tribute to the poet in poetry. Louise D. Gunn wrote in the *New York Herald-Tribune*, October 10, 1953:

Who is Carl Sandburg?
You'd know him if you saw him.
You'd know him if you heard him speak;
He is a singer of songs,
With a shock of white hair,
And a singing guitar.
I heard him speak once and I've never
Stopped hearing him since.
. . . . . . . . . . . . . . . . . . . .
And so Carl Sandburg sang,
And so we sing with him, now, today:
"I have one remember, two
remembers, ten remembers:
I have a little handkerchief
bundle of remembers—of Carl Sandburg.

Carl Sandburg lives on in the minds of public figures, as has been noted in the speeches of President Ronald Reagan.

Sandburg seemed at times to have a fascination with death, but not the morbid concern that Hemingway did. He also pays more respect to religion, though in his own individual and unorthodox way. E. Gustav Johnson has pointed out that

> Sandburg is not a propagandist for or against religious beliefs. He certainly has no system to propose in his poetry, no dogmas to defend, no strictly religious ideals to inculcate; but neither does he engage in the activity of the iconoclast; he has a profound respect for the sincere opinions of the people. . . . He feels that any personality, however outcast or poor, is something sacred, a divine thing. That the human personality suffers from the buffeting of a world which has become a wilderness though it is naturally disposed to be a paradise. . . . Death to him is no curse, no token of divine anger, no fruit of human sin; it is the gateway to a wonderland, the beginning of a great adventure for which man ever yearns, the opening of the possibility through which the ultimate destiny of the soul will be attained.[43]

Whether it is about religious aspects or any other, there has been no lack of appraisal of Sandburg's poems. "Mr. Carl Sandburg's poetry has always, it seems to me," said Professor William A. Sutton, "had this particular merit, that he could take what was odd and angular in the world around us, the things that didn't fit, and the things that often didn't even really seem to belong and can show us through transforming them by his art, that we are really a bigger family than we thought we were." Professor Bruce Weirich, a friend of Sandburg's, waxed pedagogical about the poet's educational qualifications. "I am not sure, but I question his passion for Keats' *Odes*," wrote Weirich. "I fear he would rate a 'C' there. And he takes a dour look at Milton's Puritanism, and doesn't go much beyond that admittedly grim anachronism to listen to the golden trumpet of his music. I am afraid I should give him a charitable 'D' on Milton. I have hesitated in trying to convert him—not having him in one of my classes." Robert Frost said he did not like to be put in the same category as Sandburg when it came to poetry. Said he: "We're entirely different in our work. He has a good heart. He says in his poetry that the people say yes. I saw the people say yes and no."[44]

Vachel Lindsay was consoling, especially regarding the diversity of criticism. He wrote to his friend Carl: "I do not take to the poetry scraps a bit. They are all nonsense to me when you consider that there are one hundred million good Americans who do not know there is even an Amy Lowell. Not till we have reached the Harold Bell Wright circulation will there by any excuse for a battle of the giants."[45]

There does not appear to have been much reaction from blacks to Sandburg's writings, despite his championing of their cause. An exception to this is a poem written by Langston Hughes, noted black poet, and inscribed "For Carl Sandburg—the American poet whom I most admire."

Thomas H. Johnson believed that Walt Whitman's knowledge of the nation was less surely grounded than that of Sandburg's. Sandburg was an "articulate champion of all classes, regions and races of the United States, and everything he wrote expressed his belief in the collective wisdom of the people." Llewellyn Jones felt that Sandburg was "rough and ready, empirical, singing in free verse because that comes most natural." Paul Rosenfeld described the poet's idealism as "the magnetic pole of the spirit. . . . It is because he has the ability to find his way to folks."

Professor James Hurt told the Illinois Heritage Conference that "Carl Sandburg's personification of the city as a high-shouldered youth echoes the mystic embodiment of the prairie frontiersman of a half-century before." Mark Van Doren, in his introduction to *Harvest Poems*, stated: "Carl Sandburg, like all of the other American poets who came into prominence with him, brought something back to poetry that had been sadly missing in the early years of this century. It was humor, the indispensable ingredient of art as it is of life . . . a proof that reality is held in honor and in love."

From beyond our borders came various comment. For example, from Professor Royall Snow of Queens University in Kingston, Ontario, in connection with Sandburg's appearance there: "Your reading here has done a world of good. It represented the first invasion of modern poetry into Canadian universities; somewhat earthquake-like in its effects, but a lot of crystalized opinion has been cracked."[46]

It is not so much the words of others that we are concerned with here but those of Carl Sandburg himself. In explaining and defending the form of his poetry, he said that in reality, "free verse is the oldest way. Go back to the Egyptians, the Chaldeans. The ancient Chinese were writers of free verse. . . . Read the orations of Moses, the Proverbs and Ecclesiastes for free verse. The Sermon on the Mount is one of the highest examples." The poet explained that "the kind of poem most congenial to me is neither the etching nor the symbolic poem of industrialism, but a kind of condensed fable, a snapshot of some scene or action, so written as to set in motion in my reader's mind some train of reflection; I like very much to invest the single incident with cosmic significance." "There are plenty of people who say I am not a poet at all," said Sandburg. "I think they may be right." To

the women's City Club at Berkeley, California, he said, "Maybe what I write ain't poetry—maybe it's history." He described poetry as "where the moon gets the best of you, and you try to understand frogs by being a frog." He told the graduating class of Crane College, in May 1930: "Beware of respectable people. Don't be afraid of your dreams. Remember all original work is laughed at to begin with. And the time will never come when man's fate on the earth will not be mostly concentrated in the word: Struggle! Also it was said long ago that silence is a gift."[47]

For many years, when he was able to spare the time and energy, Carl Sandburg gave helpful advice to those who aspired to become poets. He pulled no punches, as shown by a letter he wrote to a Mrs. Cox:

> The market for poetry is peculiar. I doubt whether there are five poets in the country who are deriving an income of $100. a month from the sale of poetry—and perhaps I should add that my own income from verse since my first book of verse was published would probably not average as much as $40. per month.... The only procedure by which you can find out whether you have salable poetry is to type it neatly and send it to all editors of periodicals and publishers of books whom you think might possibly be interested. This is the only practical suggestion I can make as to the very practical problem you present. Considering the time I have given to the writing of verse I have received in payment of a wage per hour considerably less than a CWA worker and therefore do not qualify as an advisor from the practical viewpoint.[48]

At Bowdoin College, Sandburg told a story about his first book: He went into a Chicago bookstore, and without telling who he was asked how his book was selling. The clerk could not find it in the poetry section but looked around and found a dozen copies under "Hardware." In defense of his free verse, the poet told the story of two English sailors, the first of whom sang, "In the Bay of Bengal I lost my all." The second sang, "In the Bay of Bengal I lost my shirt." "Bah!" said the first, "that's not poetry. It doesn't rhyme." "Bah! It tells the truth and that's more than yours does," was the answer. Sandburg also told of a Swedish maid in New York who had written a successful novel and was asked if she had ever tried writing poetry. She said, "Yes I tried it; but I found that it's just a kind of sickness that you have to get over."[49]

Charles H. Compton of the St. Louis Public Library some years ago made a study of who read Carl Sandburg. The results were tabulated into various categories of people:

To the stenographer: "By day the skyscraper looms in the sun and has a soul. . . . It is the men and women, boys and girls, so poured in and out all day, that give the building a soul of dreams and thoughts and memories."

To the typist: "Smiles and tears of each office girl go into the soul of the building, just the same as the master-men who rule the building."

To the Negro reader: "I am the nigger. Singer of songs, Dancer. . . . Softer than fluff of cotton. . . . Harder than dark earth Roads beaten in the sun By the bare feet of slaves."

To the minister: "Lay me on the anvil, O God. Beat me and hammer me into a crowbar. Let me pry loose old walls. Let me lift and loosen old foundations."

To the newspaper reporter: "Speak softly—the sacred cows may hear. Speak easy—the sacred cows must be fed."

To the police clerk: "Out of the whirling womb of time come millions of men and their feet crowd the earth and they cut one another's throats for room to stand and among them all are two thumbs alike."

To the musician: "A man saw the whole world as a grinning skull and cross bones. . . . Then he went to a Mischa Elman concert. . . . Music washed something or other inside him. Music broke down and rebuilt something or other in his head and heart. . . . He was the same man in the world as before. Only there was a singing fire and a climb of roses everlastingly over the world he looked on."

To the waitress: Shake back your hair, O red-headed girl. Let go your laughter and keep your two proud freckles on your chin."

To the manager of a beauty parlor: "The woman named Tomorrow sits with a hairpin in her teeth and takes her time and does her hair in the way she wants it and fastens at last the last braid and coil and put the hairpin where it belongs and turns and drawls: Well, what of it? My grandmother, Yesterday, is gone. What of it? Let the dead be dead."

To the book agent: "This is a good book? Yes? Throw it at the moon—Let her go—Spang—This book for the moon. . . . Yes? And then—other books, good books, even the best books—shoot 'em with a long twist at the moon—Yes?"

To the man who puts himself down a laborer: "Men who sunk the pilings and mixed the mortar are laid in graves where the wind whistles a wild song without words."

The librarian also found that a similar study of readers of William James indicated that much the same classes of people were reading him as read Sandburg. Probably the most eloquent reaction came from a fourteen-year-old high-school student, who wrote, "I do love his poetry but I can scarcely say whether or not his poetry will live. Perhaps I should say, it shall live—in me."[50]

Many perceptive appraisals have been given of Carl Sandburg's poetry,

but none seems to excel that of Hugh Mearns in his introduction to the Sandburg section of *The Pamphlet Poets*:

> These poems are the distillation of a rich American Experience. Sandburg was nearing forty when the publication of *Chicago* brought him sudden world-fame. The confident sureness of his line startled us then, as it does now, until we began to know that back of all his writing is an astonishing life among men and things. Before a verse of his had been touched by type he had served his days and nights at the trades of men. . . . His theme is this present moving life of yours and mine: its puzzling contradictions, the snare of nature and the trap of circumstance; the beauty that we know of and the beauty that we pass by; the exaltations of self, the pride of place, the glory that is pinchbeck; royalty in the eyes of serf and drab; life's secret purpose, life's irrevocable end; man's comic strut in the infinite cosmos.
>
> All this, and more, he touches with no borrowed language of books. His is the common speech of the common man, twisted always, to be sure, into something ruggedly uncommon; so he startles the academic as did Whitman, whose right son he is. There are those who still deny his genius, seeing only the rough words, the pictures of pathetic low life, the sweat of labor, who hear only the vulgar cries of the illiterate, the dazed mumble of the inarticulate. Sandburg is the voice of the brother of men, tearful with their tears, glad with their gladness, unashamed of their shame; and because it is a brother spirit that speaks to them, his language has, to those not completely alien, the compelling power of accustomed speech.[51]

Whether it is poetry or some other form of expression, the poetic writing of Carl Sandburg is an eloquent testimony to a unique life that flared across America in its most formative years. His shining contributions to our lives, so vividly set forth, will live, in my opinion, when other less original ones have passed.

# 8

# To the Children and Chickaming

Although Sandburg's interest in poetry began to diminish in the 1920s, he would keep an active connection. In 1904, when he was twenty-six, Sandburg had gone to Camden, New Jersey, to visit the old house of Walt Whitman and to bring a tributary rose to his tomb.

In 1921 Sandburg was asked to write an introduction to an edition of *Leaves of Grass*. In it he waxed lyrical. He described the book as "America's most classic advertisement of itself as having purpose, destiny, banners, and beacon-fires," as "the most widely keyed solemn oath that America means something and is going somewhere that has ever been written." He called Whitman "the only distinguished epic poet of America" and his great poem of mourning for Abraham Lincoln, " 'When Lilacs Last in the Dooryard Bloom'd,' probably the most majestic threnody to death in the English language." Throughout Sandburg's long encounter with Lincoln, Whitman is a third man, standing apart from the pulling and hauling, but present nonetheless.[1]

Solidly beneath all the newspaper reporting, writing of advertisements, criticizing of motion pictures, penning of poems, lecturing and music, Sandburg maintained a steadfast interest in Abraham Lincoln. He wrote to

Louis Untermeyer: "I aim to write a trilogy about Lincoln one day, to break down all this sentimentalizing about him. It's curious the company Lincoln keeps these days. I find his picture on the walls of politicians and big businessmen who do not understand him and probably would not approve of him if they did."

This was to come later, but in the meantime Sandburg in his spare time was putting on paper some of the stories he had told to his children. These materialized in his first book for children, *Rootabaga Stories*, published by Harcourt, Brace in 1922. "I do not know whether Sandburg's *Rootabaga Stories* are well known, and often read by those professionally concerned with children's literature," said Daniel Hoffman. "If they are not well known, they ought to be. For these tales are a minor classic, a successful attempt to make for American children stories conceived in pure delight. Sandburg, who wrote them for his own daughters, made up several dozen tales that are cadenzas upon the child's pleasure in names, in the sounds of words, in the setting loose of fantasy in a village as wide as the sight in a child's eye.... Sandburg's fables offer the child a sunny, cheerful world of pure pleasure, with few shadows and no menacing monsters."[2]

These delightful stories demonstrate perhaps more than anything else the originality and remarkable versatility of Carl Sandburg. Here was a man who could change from the heavy rhythms of Walt Whitman and the tragic story of Abraham Lincoln to a whimsical never-never land of children. The *Rootabaga Stories* appear to be simple and easily written, and yet Sandburg himself said they represented the hardest work he ever did. One can describe the stories as beautiful simplicity; but they were carved out of the hard rock of sweat and toil.

Sandburg had read the fairy tales of Hans Christian Andersen but said he could find no equivalent in American literature. "I wanted something more in the American lingo," he explained. "I was tired of princes and princesses and I sought the American equivalent of elves and gnomes. I knew that American children would respond, so I wrote some nonsense tales with American fooling in them."[3]

The following are excerpts from *Rootabaga Stories*, *Rootabaga Pigeons*, *New Stories*, and *Early Moon*, along with my comments (in italics).

### Rootabaga Stories
(How They Broke Away To Go To The Rootabaga Country)

Gimme the Ax lived in a house where everything else is the same as it always was.

"The chimney sits on top of the house and lets the smoke out," said Gimme the Ax. "The doorknobs open the doors. The windows are always either open or shut. We are always either upstairs or downstairs in this house. Everything is always the same as it always was."

So he decided to let the children name themselves.

"The first words they speak as soon as they learn to make words shall be their names," he said. "They shall name themselves."

When the first boy came to the house of Gimme the Ax, he was named Please Gimme. When the first girl came she was named Ax Me No Questions.

*(Delightful fancy, appealing names, and tinged with humor and slices of life. Is it for children or grown-ups, or both?)*

The clown rubbed his eyes, opened his mouth, twisted his neck, wiggled his toes, jumped away from the fence and began turning handsprings, cartwheels, somersaults and flipflops in the sawdust ring near the fence.

The next we come to is the Rootabaga Country where the big city is the Village of Liver-and-Onions," said Gimme the Ax, looking again in his pocket to be sure he had the long slick yellow leather slab ticket with a blue spanch across it."

. . . And so if you are going to the Rootabaga Country you will know when you get there because the railroads change from straight to zigzag, the pigs have bibs on and it is the fathers and mothers who fix it.

*(Remindful of* Alice in Wonderland *and* The Wizard of Oz *and faintly suggestive of Swift's* Gulliver's Travels, *but without the biting satire.)*

"The Wedding Procession Of The Rag Doll And The Broom Handle And
Who Was In It"

The Rag Doll had many friends. The Whisk Broom, the Furnace Shovel, the Coffee Pot, they all liked the Rag Doll very much.

But when the Rag Doll married, it was the Broom Handle she picked because the Broom Handle fixed her eyes.

*(Captivating personification of such ordinary household items to the point where the reader can see them in humanlike action.)*

The music was furnished mostly by the Musical Soup Eaters. They marched with big bowls of soup in front of them and big spoons for eating the soup. They whistled and chuzzled and snozzled the soup and the noise they made could be heard far up at the head of the procession where the Spoon Lickers were marching. So they dipped their soup and looked around and dipped their soup again.

*(Hilarious take-off on bad manners.)*

"The White Horse Girl And The Blue Wind Boy"

When the dishes are washed at nighttime and the cool of the evening has come in summer or the lamps and fires are lit for the night in winter, then the fathers and mothers in the Rootabaga Country sometimes tell the young people the story of the White Horse Girl and the Blue Wind Boy.

*(Like the lead of a newspaper story—only better than most—this sets the stage for a cozy, homey tale to warm the hearts of children.)*

There was a blue wind of daytime, starting sometimes at six o'clock on a summer morning or eight o'clock on a winter morning. And there was a night wind with blue of summer stars in summer and blue of winter stars in winter. And there was yet another, a blue wind of the times between night and day, a blue dawn and evening wind.

*(Shows the fascination of Sandburg with imaginary color, especially blue.)*

### Rootabaga Pigeons

"Slipfoot And How He Nearly Always Never Gets What He Goes After"

Blixie Bimper flipped out of the kitchen one morning, first saying good-bye to the dish towel for wiping dishes.

*(Use of common household things, plus a fairy figure.)*

"How Bozo The Button Buster Busted All His Buttons When A Mouse Came"

One summer evening the stars in the summer sky seemed to be moving with fishes, cats and rabbits.

It was that summer evening three girls came to the shanty of Hatrack the Horse. He asked each one, "What is your name?" And they answered, first "Me? my name is Deep Red Roses"; second, "Me? My name is The Beans are Burning"; and last of all, "Me? My name is Sweeter than the Bees Humming."

"Tell us about Bozo the Button Buster," said the girls. . . .

"So people said, 'Isn't it queer how buttons fly loose when Bozo fills his lungs with wind to go on speaking? After awhile everybody called him Bozo the Button Buster.'"

*(Appealing take-off on human foibles and habits.)*

"How Deep Red Roses Goes Back And Forth Between The Clock And The Looking Glass"

One morning when big white clouds were shouldering each other's shoulders, rolling on the rollers of a big blue sky, Blixie Bimber came along where the Potato Face Blind Man sat shining the brass bickerjiggers on his accordion.

*(Delightful nonsense including rhythmic words and words of tone color.)*

*New Stories*

"The Five Marvelous Pretzels"
(To be read aloud)

Five nights before Christmas, five pretzels sit looking out of a grocery window lighted by five candles. And outside they see snow falling, big white snowflakes coming down cool and quiet. And they see a man come along and stop in front of the window and he looks in while they look out. They see his right hand brush off snow from his left shoulder and his left hand brush off snow from his right shoulder. And they see him shake off snow from his hat and put his hat back on his head. But they don't hear the man saying, "Well, well, here are five pretzels. And how many children is it I have at home running around upstairs and downstairs, in and out of the corners? One, two, three, four, five, one for each pretzel."

*(Sandburg leaves the reader in suspense while he diverges into a circus scene before revealing the ending.)*

*Early Moon*

*(A book of poems for young people)*

In his preface, Sandburg writes,

Should children write poetry? Yes, whenever they feel like it. If nothing else happens they will find it a training for writing and speaking in other fields of human work and play. No novelist has been a worse writer for having practiced poetry. Many a playwright, historian, essayist, editorial writer, could have improved his form by experimenting with poetry.

*(Is Sandburg expressing a viewpoint based upon his own experience? Does the answer not depend also on whether a person has written good poetry or something that can't be called poetry at all?)*

From Frank Lloyd Wright came a letter of praise for the *Rootabaga Stories*:

I read your fairy tales nearly every night before I go to bed. They fill a long felt want—poetry. . . . O man! the beauty of the White Horse Girl and the Blue Wind Boy. And the fairies dancing on the wind-swept corn. The Wedding Procession of the Broomstick and the Rag Doll—the Skyscrapers that decided to have a child. All the children that will be born in the Middle West during the next hundred years are peeping at you now, Carl—between little pink fingers—smiling, knowing that in this Beauty they have found a friend.

In the heart of Rootabaga Country sits the wise blind man, Potato Face, with his accordion. He peers over the top of his glasses and tells Blixie

Bimber, "Tomorrow will never catch up with yesterday because yesterday started sooner." This kind man loves the precious things that are cheap, such as the stars, the wind, pleasant words, the time to be lazy, and fools. He realizes that young people are young no matter how many years they live, and that a young heart keeps young by a certain measure of fooling as the time goes by.

It seems remarkable that Carl Sandburg could write so many kinds of things, this capacity inspiring the comment that he could write anything. Yet he said that his children's stories were harder to do than anything he ever wrote. "If the people who read books don't like these stories there is no joy left in the world," he rightly said. And this work was a relaxation to him, a joy in his own life that many readers shared.

After the appearance of his two Rootabaga books, Sandburg received a letter from his good friend Helen Keller, which he tried to read aloud to his family. He was so touched with the missive that in answering the letter, he said:

> As I got into the last three paragraphs of your letter I knew all of a sudden that if I went on reading it I would be crying, and knowing this, I stopped reading. . . . I have an impression that you are not acquainted with my Potato Face Blind Man. He is the leading character in two books, Rootabaga Stories and Rootabaga Pigeons, which I wrote for young people, meaning by young people those who are children and those grownups who keep something of the child heart. If you do not have these books I should love to send them to you, for there are pages which travel somewhat as my heart and mind would have if I had gone blind, which twice in my life came near happening.[4]

May Massee, a Chicago book editor, wrote Mrs. Sandburg, "Why that old Potato Face Blind Man is as wise as Socrates and a deal more companionable. Carl has never worked so hard on anything; he's been doing them for several years but has only just got them to the point where he's willing to let go."[5]

The author wrote to a Miss Anne Moore a revealing statement: "Some of the *Rootabaga Stories* were not written at all with the idea of reading to children or telling. They were attempts to catch fantasy, accents, pulses, eye flashes, inconceivably rapid and perfect gestures, sudden pantomimic moments, drawls and drolleries, gazing and musings—authoritative poetic instances—knowing that if the whirr of them were caught quickly and simply enough in words the result would be a child lore interesting to child and grownups."[6]

Evidently there was one young person who was unsure as to what he meant in these stories. From Providence, Rhode Island, came the following letter: "Dear Mr. Sandburg, I am a junior at the Lincoln School and as one of our English assignments we are to write on an American author. Since I have chosen you as my subject I feel that I must ask you the following questions. I have been reading your *Rootabaga Stories* for the first time and to be perfectly frank do not really find their point. I see a good deal of satire and feel that it shows peoples' dissatisfaction with what exists in life. Am I correct in assuming this? If this is true then did you intend the *Rootabaga Stories* for adolescents and adults as well as for children? Sincerely, Ann Adams."

At the bottom of this letter in the Sandburg Collection, he wrote in his own handwriting, "And this smart little snob thinks she's going to get an answer."

On the other hand, there was a more favorable, if adult, impression. Henry Justin Smith, then in 1925 assistant to the president of the University of Chicago, wrote Sandburg that he had had a letter from Ben Hecht in which he said, "Last night I read aloud from the sagas of Master Sandburg—the *Rootabaga Stories*—imitating as well as I could his potent inflections and rabinical pauses. And everything charming that I know of Chicago returned to me. It occurs to me, also, that I must have been strangely preoccupied not to have known how rich the *Rootabaga Stories* were when I first looked at them."[7]

On the eve of publication of *Rootabaga Pigeons*, Sandburg went to New York to discuss his next book with Alfred Harcourt. By this time the writer was proud—and rightly so, for it is a happy time in the author-publisher relationship when the next book becomes an automatic assumption. Harcourt was ready and Sandburg was glad of it. Harcourt well knew that for years Sandburg had been collecting material on Abraham Lincoln—whom some had termed "Father Abraham"—a figure as far removed from children as could be imagined, yet the author had been concentrating on juvenile books.

Perhaps these two entities could be combined, the shrewd Harcourt suggested. Perhaps Sandburg could write a "life of Lincoln for young adults." The idea struck a strong, resonant note in the man who, though he had been portraying youthful characters, doubtless knew that they could "grow up," especially in the person of such an appealing real-life person as "Honest Abe."

Sandburg agreed.

He recalled to Harcourt how in his Galesburg days he had always been fascinated with Lincoln and was reminded of him daily when he passed the Lincoln-Douglas debate plaque on his morning milk route.

And so began the epic struggle with depicting a mighty figure, which was to end in a monumental masterpiece.

Carl Sandburg was now in a somewhat better financial position, but he still had to make a living for his family of four. We have seen him take to the road when he could in order to supplement his income from the *Chicago Daily News*. I am grateful that he did move around, for this brought about our first acquaintance. Some examples of his national tours will serve to show the variety, the color, and the effectiveness of his personal appearances.

Going back to his early travels, he stood one night on the platform of the Presbyterian Church in Homer, Michigan, to deliver a lecture on Abraham Lincoln. An informal account by F. Elmer Marshall, his talent manager, states that at that time Sandburg had been given little recognition by either critics or public. His finances were also at a low ebb. As his talk progressed, the audience was unresponsive; there was no applause and a chill seemed to pervade the room. As Marshall and Sandburg walked back to their hotel, Marshall felt depressed, but Sandburg seemed in good spirits. He said cheerfully, "Well, I think I held that audience pretty well tonight, didn't you?" Marshall answered, "On the contrary, Mr. Sandburg, the people were so disappointed that I shall have to send them another speaker later to satisfy the committee." There was dead silence for a minute, and then Sandburg changed the subject.[8]

Most public appearances, however, were successful, particularly as Sandburg became better known and appreciated. Norman L. Ritchie of the *Chicago Daily News*, in an introductory letter to W. L. Lockwood of Saratoga Springs, New York, commented that "Carl has a supreme depth to him that no one will plumb in a first meeting. But you will find him a lovable soul even at first meeting. He is a man's man. No truer advocate of real democracy, imbibed through living intimately with and among men of every class, and a profound study of them in all their vagaries—no truer democrat, I venture to say, ever lived." In like manner, Lew R. Sarett, one-time member of the English Department of the University of Illinois, described his friend thus: "Sandburg has a great big burning message in his poetry—one that the people ought to hear. Personally he is a big, virile

he-man with a spine and he can put his work across, I believe. There is none of the effeminate pussywillow spirit that marks some poets in him. He's a regular guy, and the audiences will sense him, and respect him."[9]

Professor S. D. Stephens of Rutgers University has recalled that in the spring of 1925 he was chairman of a dinner meeting of high-school teachers in Milwaukee. Carl Sandburg was a substitute speaker for the occasion at a fee of $25 and was late in arriving. He was told that dinner was waiting for him, but he seemed in no hurry, although it was already 7 P.M. Instead, he asked to eat some "lunch" at a counter in the railroad station. "He quizzed the waitress about the pastries," recalls Stephens. "She assured him that they were good for what ailed him, with a look as if she wondered what did ail this queer codger with the Windsor tie and guitar. He chose two pastries and when the waitress appeared, he surprised her by taking both. Finally, I got him to the lobby of the banquet room."

There Sandburg decided he wanted to telephone a local woman poet—her name is not recalled—whom he had known when he lived in Milwaukee. She was not at home and, after wondering at length why she was not, he made a second try. He next asked a lobby attendant for a drink of water and was told there was water on the speaker's table.

"But," said Sandburg, "you wouldn't want me to drink in front of all that audience, would you?"

"Would you like me to bring it to you?" replied the attendant.

"I'd be very happy if you would," was the response.

So the attendant did.

During this time, sporadic handclapping could be heard in the dining room, and now and then a guest was seen to depart.

"Do you think, Mr. Stephens," asked Sandburg, "that that applause is for us?"

"Yes, Mr. Sandburg, I'm afraid it is."

"Well," he replied, "we'll just let them wait. That's one thing the American public hasn't learned, to wait."

So they waited.

At last, Stephens got Sandburg to the speaker's table and he was duly introduced. Stephens recalls:

> There were all the handicaps a speaker could have. He was a substitute for the advertised speaker, he was late, he was at that time little known to a general audience. He sang some songs from the material which he had

collected for the *Songbag*, he read the fable of the two skyscrapers who produced in marriage the transcontinental express train, he did all sorts of things which made his hearers wonder when to laugh. I was interested in the audience, which I had to live with, and when after fifteen minutes they were sitting forward in their seats, and when after an hour and fifteen minutes they applauded him loudly, I realized that he had overcome all his handicaps.[10]

Walter Yust, writing in *The Bookman*, described Sandburg in this way: "When he talks, there is no jabber or gesticulation or studied modulation in his voice, and when his eyes burn out their black fire, your attention is gripped by that same honest, man-to-man sincerity which he is able to put into the grinding, crashing, angular words of his verses." *The Harvard Crimson* commented: "Mr. Sandburg has achieved novelty, vitality, truth to modern life. He has introduced themes which have seldom, perhaps never, been treated before." A writer in *The Minnesota Star* stated, "It's his voice, I think, which is his most poetic quality. It is unforgettable and accompanied by a nervous intake of breath like a tenor's when he is reaching for a high C. . . . He is himself a piece of music. His body flows with his songs and his voice vibrates like a harp string." Stuart P. Sherman in the *Rail Review* said, "Carl Sandburg is violent but he does not destroy the beauty of the world which he explores. There is bitterness in his comment but there is also health and passionate gusto. He expresses his love for elemental things in a large elemental way."[11]

Once when he was reciting his poems at Indiana State University in Terre Haute, a city then known as a "second Pittsburgh" because of its smog, dust, and smoke, many people in the audience were coughing. Finally Sandburg laid his musical instrument down and glared at them.

"When you people stop barking, I will proceed," he said.

Another vivid description: "With his brown-clad ankles and his black-clad feet dangling easily over the edge of a table, his banjo across his knees, and coffee of long coldness and creamless blackness at his elbow, Carl Sandburg on his recent visit to the University of Oregon, sat up and talked to a group of students and faculty members. He sat from twelve o'clock Friday night until a foggy seven o'clock Saturday morning."[12]

On one occasion, when Sandburg was introduced, his service in the Spanish-American War was mentioned. He began his remarks with the following statement: "The Chairman in the introduction failed to state that the 6th Illinois Volunteers in which I was enlisted in 1898 was the first to land on the Island of Puerto Rico and make that a part of America, so that

all residents there are American citizens, and I have done my share toward repopulating New York with a half million."

In his railroad travels on the lecture circuit, Carl Sandburg, instead of trying to find other writers and performers, preferred to spend his time in the smoking car with traveling salesmen and businessmen. As was the custom among such individuals, he was often asked what his line was, and when he answered "Poetry," he drew laughter all around. Eventually, because this answer was not taken seriously, he would reply, "I am chairman of the board and president of the North American Pawpaw Growers Association." This seemed to satisfy his listeners. He even had cards printed with this hilarious title on them.

His favorite state for lecturing was naturally his birthplace, Illinois. He often spoke there for a smaller fee than he received elsewhere. At Millikin University in Decatur, he talked about the age of the atom and its awful possibilities. According to the *Decatur Herald and Review*, "He seemed tall and lean, knobby and rough-hewn as he stood there in his black suit and black bow tie. His white hair was combed from a middle part, straight down to both sides, in that manner which is almost a Sandburg trademark. As he spoke, he swayed slowly and slightly, back and forth, and he spoke in a whisper. He spoke in a whisper, but what he said was a shout, a cry. It was a cry in time of crisis, he said. For this is a time of crisis, he said, a time of crisis every bit as much as the time of the Lincoln-Douglas debates."

Before the University Club in Cleveland in 1934, Sandburg talked for forty-five minutes about Lincoln, then remembered his announced topic and said that if anyone asked members of the audience what his talk was entitled, they should say, "Aspects of Romance and Realism in Art and Literature" and let it go at that, on the ground what people didn't know wouldn't hurt them.[13]

Professor William A. Sutton, in his research on Sandburg's travels, received the following letter from Robert A. Harbach of Sarasota, Florida:

> As you may know, Mr. Sandburg's brilliant personality had a few unfortunate facets. He was hungry for the dollar, and had a very tight grip on every penny. One evening my father and Mr. Sandburg were holding a symposium on the theatre, journalism, poetry, etc., when an admiring young man, about 18, asked Mr. Sandburg for his autograph. The poet turned purple, exploded with rage and gave the now reddening student a tongue lashing in front of the assembled group, that lasted at least a minute.
>
> "I'm sick and tired of being used."
>
> "All you people only want my autograph to sell."

"Go buy one of my books and I'll sign it."
The evening ended on a sad note.

As he grew older and his long periods of research and writing were
taking their toll, Carl Sandburg did not and could not pay attention to
every small request made by his many admirers. For instance, when he
appeared at the Civil Round Table of New York to accept an award, the late
Benjamin Barondess, vice-president of the organization, told the secretary,
Arnold Gates, that he was very much disturbed because Sandburg closed
his eyes and appeared to go to sleep while Barondess was talking to him.
"What can you say," Barondess asked, "of a man who goes to sleep while
you are talking to him?" I was present at the time and answered that
Sandburg probably was bored. This instance is remindful of Lord North in
the English Parliament, who would close his eyes as if in sleep but who
was entirely aware of everything going on. A playwright found that Sand-
burg had fallen asleep during a performance. How could he criticize the
play if he fell asleep? Sandburg replied that sleep was a form of criticism.
He quoted Bill Nye as saying, "You know they say the music of this fellow
Wagner is better than it sounds."[14]
    In twenty years, Sandburg traveled from coast to coast a dozen times.
Included in his itinerary was the Poetry Society of South Carolina in
Charleston, and he appeared before audiences in all the former Confeder-
ate states except Florida. As he stood before the students of Washington
and Lee University, he had solemn thoughts of Robert E. Lee, a founder,
whose tomb is nearby. In San Antonio, Texas, the troubadour was pre-
sented with a $200 bond of that state after it had left the Union. When
Sandburg showed up in Athens, Georgia, he was presented with a check
signed by Alexander H. Stephens, Vice-President of the Confederacy, by
the latter's niece. In Colorado Springs, he met the granddaughter of Jeffer-
son Davis, and at Chicago, he met a son of Gideon Welles. A great-niece of
General Abner Doubleday drew a charcoal sketch of Sandburg at Ben-
nington College. While he was in a newspaper office in Palm Springs,
California, he met a lady whose grandfather had played with the sons of
Abraham Lincoln in the White House, and on the same visit he also met a
niece of Stephen A. Douglas. On a plantation in South Carolina, Julia
Peterkin showed Sandburg the descendants of slaves.
    As far as lecture fees were concerned, by 1956 Sandburg had come a
long way. An organization in New York City, "Folk Festival, Inc." was
presenting a series of performances that included Paul Draper and Richard

Dyer-Bennett. The Pearson and Eaton Lecture Management company was asked if Sandburg would participate and give some form of Lincoln tribute for a fee of $1,000. At the bottom of the letter of invitation, Sandburg has written with his heavy, stubby pencil, "NO."

In regard to his political leanings, as we have seen, Carl Sandburg was liberal and in his early days, even radical. But as the years and prosperity increased, he became more moderate. This was apparent regarding a letter he received at the *Chicago Daily News*, dated August 29, 1932. It was in behalf of the Communist candidates in the national election campaign, William Z. Foster and James W. Ford. The letter stated:

> We feel that it is essential at this time for all American intellectuals to express their strong dissatisfaction with conditions as they are, and to give impetus to the only group of workers in the American labor movement who are intelligent and brave enough to fight militantly the powers in control.
> The two major parties, we all agree, are hopeless. The Socialist Party, with its present leadership of small businessmen, lawyers, and nice people in general, does not symbolize change, or a leadership feared by the in-trenched class. And the Socialists' persistent attacks on the Soviet Union, during its present bitterest years of struggle, deserve sharp rebuke and repudiation. We may not all agree with all the ideas of Communism, but the Communist Party is the only party today feared by the ruling class, and the only party we can vote for that will *effectively* register our protest against the present economic and political regime. "Will you join us?"[15]

According to the copy in the University of Illinois Library, the letter was signed by Sherwood Anderson, Malcolm Cowley, Professor H. W. L. Dana, John Dos Passos, Theodore Dreiser, Waldo Frank, Prof. Sidney Hook, Langston Hughes, Matthew Josephson, and Edmund Wilson.

Apparently Sandburg did not join in this movement. Instead, as he had told Romain Rolland, "I belong to everything and nothing. If I must characterize the element I am most often active with, I would say I am with all rebels everywhere all the time as against all people who are satisfied. I am for any and all immediate measures that will curb the insanity of any person or institution that is cursed with a thirst for more things, utilities and properties than he, she or it is able to use, occupy and employ to the advantage of the race."[16]

Regardless of such apparent political and economic independence, Sandburg tended to be a Democrat. He voted for President Franklin D. Roosevelt, holding that "he is a momentous historic character more thoroughly aware of where he is going than most of the commentators. The

SEC, TVA, NLRB and much else deserve continuation." Not content to express himself to others along this line, Sandburg wrote the President directly:

> Having written for ten years now on "Abraham Lincoln: the War Years," starting this year [1935] on the fourth and final volume, I have my eyes and ears in two eras and cannot help drawing parallels. One runs to the effect that you are the best light of democracy that has occupied the White House since Lincoln. You have set in motion trends that to many are banners of dawn. This may be praise to your face but it is also a recording of a hope and a prayer that you go on as steadfast as you have in loyalty to the whole people, that in your difficult war with their exploiters your cunning may increase.[17]

The Great Depression weighed upon Carl Sandburg as it did all who were affected by it—and that was just about everybody. He was rising in his professions—for he had more than one—and had less reason to complain than most, but his closeness to the people, his warm empathy with them, was shown in his attitude and in his expressed philosophy. He told Oliver Barrett, the Chicago lawyer and collector of Lincoln documents who was to be so much help to him, that he was not sure he had "put down the element of true history and valid memoranda" in his writings. "True democracy," he continued, "is as difficult and as mystic in its operations as true religion or true art.... The masses of people have gone wrong often in the past and will again in the future. But in the main, their direction is right. I have had a deepening melancholy about the masters of finance and industry of America. How seldom is there one like Julius Rosenwald [head of Sears-Roebuck] who could say to Governor Henry Horner under a special circumstance, 'I'm ashamed to have so much money.' "[18]

Sandburg seemed to appreciate what Henry Ford had done in paying his employees higher wages and improving their working conditions; but he had the veteran reporter's instinct that Ford was doing all this for publicity and good public relations, and was therefore "a commercial demagogue."

On the lighter side, the music of Carl Sandburg helped him through the struggles of his life. Morris Fishbein gave a dinner for Sinclair Lewis in 1925, just after Lewis had returned from England, where he was offered a baronetcy and turned it down. Carl Sandburg was present and asked to sing. He arose and rendered with a borrowed guitar "The Buffalo Skinners." This song is about starvation, blood, fleas, hides, entrails, thirst, and

bad Indians. When Carl had finished, Sinclair Lewis, tears streaming down his face, probably mixed with drink, cried out, "That's the America I came home to. That's it."

Lloyd Lewis described Sandburg as, "not a great singer, but his singing is great. The man's voice is heavy and untrained ... and all his accompaniments on the guitar sound alike, but for every song he sings, there comes a mood, a character, an emotion. He just stands there, swaying a little like a tree, and sings, and you see farmhands wailing their lonely ballads, hillbillies lamenting over drowned girls, levee hands in the throes of the blues, cowboys singing down their herds, bar-room loafers howling for sweeter women, Irish section hands wanting to go home, hoboes making fun of Jay Gould's daughter. The characters are real as life, only more lyric than life ever quite gets to be."[19]

Arthur E. Sutherland of Cambridge, Massachusetts, who helped Sandburg collect folk songs, told William A. Sutton that he thought Sandburg was a self-taught guitarist. "With six or eight chords, a few runs on a guitar clamp to change keys, and a feeling for songs, he had all the apparatus he needed. Sandburg got the most out of this level of skill. He would draw five lines in pencil on a sheet of paper and sketch in the notes well enough to remind him of the tune which he had heard sung. He would scribble in the words and so add another piece to his repertoire."[20]

Sandburg may have been self-taught, but he sought the help of the eminent guitarist Andrés Segovia, who found the folksinger more of a poet than a musician. Commented Segovia, "His fingers labor heavily on the strings and he asked for my help in disciplining them. I found that this precocious, grown-up boy of 74 deserved to be taught. There has long existed a brotherly affection between us, thus I accepted him as my pupil." Although this acceptance was more figurative than real, it showed how other famous people were attracted to the many-faceted Sandburg.

One of the most appealing aspects of Sandburg's musical performances was his competent imitation of those represented in his songs. For instance, W. W. Ball, dean of the school of journalism of the University of South Carolina, wrote Sandburg that he had received a letter from a seventy-nine-year-old woman who was born and brought up on a South Carolina plantation. She wrote, "The record of Sandburg's spiritual you sent us is the best imitation of the real Negro voice that I have heard. The Fiske quartet are Negro voices, but trained Negro voices. Robeson's is unusually well trained, but Sandburg's is the natural cornfield Negro voice as I have heard it."

So it was natural that a book would be published containing the songs that Sandburg had collected, especially since he was already an established author. It was *The American Songbag*, published in 1927 by Broadcast Music Inc. of New York, of which Carl Haverlin was president. He was already a friend of Sandburg and had collected all of his books. "I suggested that it be written, and our company published it," Haverlin reminisced. "It has long been recognized that Sandburg is the father of the current interest in American Folk music." Sandburg went to New York to help with the musical volume, and Haverlin recalled to me how Sandburg worked alone in a big room at a long table covered with notes, manuscripts, and photostats. In his mouth he held a stub of an unsmoked cigar, a frequent custom, and an old cap adorned the back of his shaggy head. Now and then he would lean back, close his eyes, and twang a bit on his guitar as he recalled from memory the songs he would try to put down on paper.[21]

The volume contained the words and music of about three hundred ballads, accompanied by Sandburg's own explanation of the nature of his selections.

Of the *American Songbag*, its author states:

> The book begins with a series of Dramas and Portraits rich with the human diversity of the United States. There are Love Tales Told in Song, or Colonial Revolutionary Antique, some of them have the feel of the black walnut, of knickerbockers, silver shoebuckles, and the earliest colonial civilization. Out of the selection of Pioneer Memories, one may sing with the human waves that swept across the Alleghenies and settled the Middle West, later taking the Great Plains, the Rocky Mountains, the West Coast. The notable distinctive American institution, the black-faced minstrel, stands forth in a separate section. Mexican border songs give the breath of the people above and below the Rio Grande. One section contains ballads chiefly from the southern mountains.[22]

It became time to seek a new home for the family. The Sandburgs had been reasonably happy in the Chicago suburb of Elmhurst. But regardless of where they lived, the family was apparently content. According to Margaret, in a statement of years later, "I don't know anyone who has been happier all these years. My father would go off on trips, but he felt they were necessary to make money to support his growing family. When one in his place was offered so much for a lecture, it was hard to turn it down. Contrary to some impressions, he did not just go off and wander around

aimlessly. That was before he was married and when he roamed around with hoboes."

Encouraged by his success and motivated by the desire for a more serene place suitable for serious writing, Sandburg, in 1928, moved his family to Harbert, Michigan, beside the dunes across the lake. This did not mean that he was to leave his job on the *Daily News*, for he would commute into the city for the next four years. He was now fifty and just on the threshold of his great career.

Harbert was to be their home for the next seventeen years, which in some ways was the most productive period in Sandburg's life. It was to be eventful also for other members of the family. Appropriately, it was a picturesque place. Karl Detzer was lyrical about the new location: "There is a stretch of sandy beach where every northwest storm leaves its grey tribute of driftwood, old logs and timbers of long-dead ships. The beach is wide, with sand grasses and tufts of wild pears growing inshore, close to the shelter of the woods. Sometimes on clear winter nights across Lake Michigan loomed the lights of Milwaukee and Chicago, beckoning lanterns to the man who loved them both." Sandburg himself described it as "a blue inland sea; immeasurably blue with incessantly changing blues; then haze; a grand gamut of hazes; and baffling transitions of mood from walking rain of summer to the galumphing grizzly white blizzards of winter; never forgetting the quiet hover of the northern lights."[23]

The new domicile had a dual purpose. Of course the most important one was to provide a fitting site for literary composition; the other, and almost as vital for a time, was to be a little farm on which Mrs. Sandburg and the children would raise blooded goats. They named it "Chikaming," a euphonious Indian name that could have come out of one of the father's poems. Now that he was fully launched into the great project of his life, Sandburg found that he had fifty cases of research material on Abraham Lincoln, which he moved into the garret room that was to be his study in the toilsome years to come. Every item, every volume, every note, every sheet of paper, even pencils and typewriter ribbon, was in its exact place. The stage was set for momentous things.

# 9

## The Prairie Years

Carl Sandburg once said that he had studied monotony and that whatever he died of "it would not be monotony." This was a masterful understatement and was strikingly brought out in the variety of his life and work.

When he was writing the *Rootabaga Stories* for children, he got to thinking about the many biographies he had read in grade school. It occurred to him that in the libraries nearby there was no such book about Abraham Lincoln. Twenty years earlier he had read all of the Ida Tarbell articles on Lincoln in *McClure's Magazine*, followed by Herndon's life of Lincoln, and then the Nicolay and Hay life of Lincoln as serialized in *Century Magazine*. So he had young people in mind in the early chapters of his book, *Abraham Lincoln: The Prairie Years*.

This interest in the martyred President certainly came naturally, for Sandburg had been collecting information on him for years, mostly written on slips of paper with a soft blunt pencil, the handwriting being surprisingly legible even to this day. Later he catalogued the data in envelopes according to subject matter and added newspaper and magazine clippings. Sandburg's travels served a triple purpose—one of collecting

Lincoln material, "listening to old men's reminiscences, walking the paths that Lincoln walked," communicating with Lincoln collectors, and scouring secondhand bookstores and purchasing books. From some of those he tore out the appropriate pages and threw away what he did not want. The second object was to make some money from his lectures, and the third, to meet and be with people, something that gave him a valuable and lasting empathy with them.

Of course there were moments of doubt, one of which was when Sandburg learned that former Senator Albert J. Beveridge, biographer of John Marshall, was also working on a biography of Lincoln. But Sandburg rightly concluded that Beveridge's biography would be different from his. Allan Nevins was later to say that Beveridge's biography was not vivid like Sandburg's.

As he went along, Sandburg was encouraged in his undertaking, and he certainly needed it. One friend, Negley D. Cochran of Washington, D.C., wrote:

> Glad you have been reading Lincoln. Good thing we have him to read about. He always appealed to me more than Washington. I never got much of a thrill out of visits to Mount Vernon. One day down there somebody remarked about the extent of the lawn and what an expense it would be to keep it properly manicured. I replied that George was rich enough to have slaves enough to get down on their knees and mow the lawn with their teeth. . . . Go on with Lincoln. He is about all we have left that's worth a shrine in this country. When I think of Warren Gamaliel Harding as President of the United States, I shudder and get goose-pimply with apprehension for the future of the race.[1]

As Karl Detzer has pointed out, this was a time of intense labor for Sandburg, who had to exert tremendous effort night and day in digging for the facts, putting them on paper, and checking them against other facts. Besides his work for the *Daily News*, his occasional writing of more poetry, and trying to keep his files up to date, he found time to rush off on trips for lectures and songs. "Lincoln and Sandburg had similar prairie boyhoods," Detzer observed. "They both had known the same hard poverty, the same hard labor, the same hard winters, and the same soft spring winds. . . . Sandburg was inside Lincoln looking out through Lincoln's eyes, seeing the world as Lincoln saw it, saying the things Lincoln would have said."[2]

What Sandburg was undertaking can be compared to a journalistic assignment in which a reporter is asked to do, instead of a straight, factual account, a feature story. The feature writer relates the same story but

embellishes it with colorful touches, additional decorations, and even imaginative flourishes. Carl Sandburg wrote a feature story about Abraham Lincoln.

In his first years of research, Sandburg went through more than a thousand books for source material on Lincoln. After he marked the pages he wanted copied, he passed the books along to his wife or daughters. As prosperity increased he at times employed two secretaries working at typewriters. His files were systematic, but of course there were times when some item was misplaced. More often than not, it was Paula who located the missing data. Envelopes were filled until each became the basis for a chapter. Books were everywhere, some in cases, others stacked in handy spots. Carl's workroom contained a wood-burning stove, a cot, bookcases, and filing cabinets. Whether for practical or whimsical reasons, he placed his typewriter on a wooden crate instead of a desk. He was never fastidious about such furnishings, and he fancifully compared the crate with the cracker barrel from which, for a time, General Grant conducted the Civil War. Outside this attic room was a wide sun deck, where on nice warm days from spring to autumn Sandburg worked. A second-floor room was known as the Lincoln Room. After the books in it were used, they were moved to the barn for storage.

The Sandburg house sat atop a huge dune, about a mile from the Harbert post office. On the land side the three-story structure, with the top deck open, was blessed with the sun on pretty days and swept by the snow in winter. From the porch the family could see along ten miles of beach dotted by tall pines. One visitor noticed that the attic workshop had a bare, unpainted floor and no ornaments except a life mask of Lincoln. Rows of books stood on open shelves made from rough timber around the four sides of the room, while other volumes lay in piles on boxes and tables or in bins and cases. From the wood stove in the center of the room, a stovepipe zigzagged to the roof. Nearby was a worn woodbox with kindling beside it. Just in case, a fire extinguisher reposed near the top of the stairway.

Regarding his Michigan retreat, Sandburg wrote to a friend in 1935 that when he "went away in February, they decided a goat herd, hens, ducks, geese and rabbits were not enough, and took on a horse. When I left in April for ten days they took on two pigs. The horse can live on what the goats reject. And the pigs get by on leavings no others will touch, though like very ancient farmers we cannot begin to get God's intention in curling the tails of pigs."

Mrs. Sandburg reared the children with the impression that their father was a genius with unique faculties. Still under this impression after she had learned to type, Helga began to type manuscripts, and worked especially hard when they lived on Lake Michigan. When Sandburg was working, his wife would admonish the children to be quiet—sometimes he added to this with his own stentorian voice from upstairs—and when he was sleeping, often at odd times, the same directions were given. He would usually arise in late morning and work until dawn. This schedule considerably hampered the household work, when the women were busy at such chores as cleaning and cooking, trying meanwhile to keep the ordinary noises at a minimum.

Paula, a fancier of goats, in some barns behind the rambling house on the dune, began to raise blooded dairy Nubians. But this was not just a hobby. She became one of the leading goat raisers in the country and regularly marketed them at state fairs. This brought in needed money too. Alfred Harcourt felt that Carl could not have written his books without the help of his wife. Sandburg himself praised her as being more able than he in several ways, including artistic talents and good business sense. She was ever to be his faithful and understanding helpmate.

Paula's devotion was a constant. There is little doubt that her encouragement helped him keep to his task of writing, and she was a competent listener to his work as well as an affectionate friend. When he did not show up for dinner, she did not complain as some women would have done; she felt he had a reason to be absent, that he had secreted himself in order to work out some part of his writing or to brood over a poem or visit some working man's home.

A congressman from Illinois, Paul Simon, said that "some have commented that comparing Sandburg and other Lincoln writers is like comparing Homer with Herodotus, and it is an apt analogy for Herodotus, the father of modern history, laid out the facts while Homer, the more widely read of the two, combined poetry and history, taking liberties with both." However, the scholarly congressman, who studied under Allan Nevins, added: "For the person working with some portion of the Lincoln life, Sandburg provides the mood, the sight, the smell, the feel and the panorama. For the reader who wishes to capture the spirit of the times and the hero, Sandburg is excellent. For that relatively small number of people who want to be sure about data, quotes, and complete reliability of every detail, Carl Sandburg is not the source."[3]

To professor William E. Dodd of the University of Chicago, Sandburg

sent several chapters of his Lincoln biography for criticism. The answer was, "The manuscript is truly Sandburgian. You have caught the spirit of Lincoln and his time and the more I read the clearer this became."

When the manuscript of *The Prairie Years* was finished, Sandburg journeyed to New York to discuss with Frederick Hill Meserve, an outstanding authority on photographs of the Civil War, the illustrations he would need for his new book. "I can hear him now," Meserve later recalled, "reading from the manuscript to show the kind of thing he was doing on Lincoln's early life—something never before done, poetry and history together, a marvelous blending of his own. I can hear the extraordinary voice, now whispering soft, now booming loud, slowed down almost to stopping one moment, words mouthed and rolled on the tongue and lingered over, then suddenly rippling and tripping forth in a heart-jumping change of pace."[4]

Sandburg told Alfred Harcourt that in the manuscript he had brought Lincoln to his departure from Illinois in February 1861. It was "the end of the smooth-faced Lincoln, of the man whose time and ways of life belong somewhat to himself." From that time on, Lincoln was no longer a private citizen but a public man. "I was going to write you," he told Harcourt, "that I had been throwing drops, outdrops, slow straight balls and wild pitches, and the last innings of the book would have to cross the pace into spitballs and high inshoots near the chin. But the last innings will have to wait. A man can't write the Gettysburg speech and the Second Inaugural, and make the portraits of Lee, Stephens, Sherman, without tears, wet or dry."[5]

Van Wyck Brooks, at the time a consultant to Harcourt, Brace, suggested that the title be *Abraham Lincoln: The Prairie Years*. This proposal may have been a coincidence, for Sandburg had earlier mentioned that he and Sherwood Anderson had discussed the same title sometime before the manuscript had gone to the publisher. Now followed proofreading, changes in the copy, and even the addition of new material. The book was published in a two-volume set in 1926 on Lincoln's birthday.

The book begins with a brief tracing of the ancestry of Abraham Lincoln but soon comes to the morning of February 12, 1809, when a granny and Nancy and Tom Lincoln welcomed into the world a new child, a boy, whom they appropriately named Abraham. The young fellow had a struggle from his early age onward. He later described himself as being large for his age and having an ax put into his hands as soon as he could handle it. He seemed to be "almost constantly handling that most useful instrument." Even though it is legendary, Abe evidently read all the books he

could lay his hands on. These included the family Bible, which was the only book in the family cabin, and borrowed copies of *Aesop's Fables*, *Pilgrim's Progress*, *Robinson Crusoe*, Grimshaw's *History of the United States*, and Parson Weems's *The Life of George Washington*. These volumes of history and biography are of the same nature as those in Sandburg's childhood home; in both cases, books were scarce and there was little choice.

The biography relates with some emphasis Lincoln's voyage down the Mississippi River to New Orleans in 1821. There he saw advertisements of traders offering for sale black girls from the ages of ten to twenty-five to become slaves. Lincoln's abhorrence at this pitiable spectacle set the stage for perhaps the most meaningful theme of his life. It also aroused in Carl Sandburg a similar revulsion against servitude of all kinds.

From the first to a much later stage in life, Sandburg shows Lincoln as a loser in his political quests. Starting with a local election in New Salem, Illinois, where he was living, Lincoln was to lose several elections before he became a congressman. But like Sandburg, another son of the prairie, he had the stuff of rare persistence. With little education but physically lithe and strong, he thought of becoming a blacksmith. When he first considered studying law, he felt discouraged because of his lack of education. Later he learned that success in this profession often comes more from personal sagacity than from book learning. Like the young George Washington, whom Lincoln greatly admired, he for awhile became a surveyor. His surveys were so respected for their care and accuracy that he was often called on to settle boundary disputes. Meanwhile, he kept up his political contacts, and some saw him as a rising young man who someday might be governor or a senator; others looked upon him as an awkward, homely giant whose moods alternated between telling droll stories and lapsing into long-faced silence. In describing these characteristics, Sandburg showed a warm familiarity and a striking rapport with his appealing subject. His poetic but down-to-earth approach was to show brightly that he had hold of a monumental subject about which too much could hardly be said, and he acted accordingly. His object was to convey the image of Lincoln from innumerable angles, and in this he greatly succeeded.

*The Prairie Years* naturally contained errors, and many were corrected in later editions. Sandburg noted that the Lincoln family had neither a cow nor a horse when they moved from Kentucky to Indiana. Later scholarly research revealed that they had both horses and cows. Although this was

not a crucial point, it shows that the early Sandburg method was not as meticulous as it might have been, indeed not as careful as it was later.

The critics picked up on such errors. For example, placing Crawfordsville, Indiana, on the Wabash River; locating the shipwreck in which the poet Shelley was drowned on an Italian lake rather than on the Ligurian Sea; attributing a quotation of Montesquieu to de Toqueville; and citing a letter of Lincoln to his wife as hitherto unpublished when this was not the case. All these slips were grist for their mill. But despite such revelations, the biography stood up more than well. Sandburg accomplished what he set out to do—to present the unique figure of Abraham Lincoln during the years when he was ripening for the presidency, set against the unprecedented background of his rough and seemingly patternless environment. This setting included so much of national significance that the figure of one man, even that of Lincoln, could have but little import compared to the problems of a new nation bursting out at its western seams—nurturing pioneer settlements that tested the mettle of humans who dared to plant them, and embracing the still greater problems of the drastic agricultural revolution, the coming of industry, which even in its primary stages was pregnant with the issues of today, and the economic growth that was to start our modern Hamiltonian nation on its way to bigness never even dreamed of by its founders.

Whenever there is an awkward gap in his narrative, Sandburg fills it with a diverting anecdote. He uses these anecdotes frequently to set forth not only the philosophy of Lincoln but his own as well. For example, Bill Greene, a lawyer friend of Lincoln's, when once asked on the witness stand who were the principal citizens of New Salem, had replied, "In New Salem every man is a principal citizen." But Sandburg takes pains to point out, as in the case of the idealized Nancy Hanks Lincoln, that some of the stories are apocryphal. Even so, he evidently felt they were significant and entertaining enough to be included and, like the cherry-tree story about George Washington, were characteristic of their subjects. The author does not spend much time in interpretation. Rather, he is content to present the facts and let the readers find their own way by the light of his new information. Still, by his choice of the facts, by the vividness of their presentation and the emphasis he places upon some of them, he makes clear what he believes about the life of Lincoln and his place in our history.

Running through the early pages is a manifest sympathy with Lincoln, who, like Sandburg, as a poor boy, grew up in the prairies and lived to

conquer his environment. The social life was hard, with sorrow mixed with pleasure. Sandburg rightly attributes Lincoln's humor to the need at times to escape the severe realities of the frontier. Later, when he was in the White House, Lincoln explained that if he did not laugh he would have to weep.

Sandburg notes that Lincoln was a clipper of newspaper items. This habit may have inspired Sandburg in his own practice, which he followed most of his life. With careful scissoring, Lincoln cut out his own speeches and those of Douglas in the 1858 senatorial campaign—his own from the friendly *Chicago Press* and the *Tribune*, and those of Douglas from the *Chicago Times*—which later he neatly compiled for publication as a book.

If Sandburg was not the first to discover the sources of Lincoln's growth, he was a masterful interpreter of the concept that the wellsprings were peculiarly American. He realized that Lincoln was a product of influences and forces that make America what it is. True, others had seen this; but Sandburg did the outstanding job of translating it. He saw Lincoln as sensitive to the words and ways of occupations, songs and sayings, portrayed in that continual transition that accompanies pioneer life. They were the backdrop of the life of Lincoln.

Now that he had extensive material and the helpful comments of others, he took a less idealized approach toward Ann Rutledge. In *The Prairie Years*, he carefully speculates that "there seems to have been an understanding between them." Lincoln had his work, Ann had her domestic problems. When she became ill, Lincoln went to see her, but it is not known what passed between them on this last visit. "Few words were spoken, probably, and he might have gone so far as to let his bony right hand and gnarled fingers lie softly on a small white hand while he tried for a few monosyllables of bright hope."[6] Ann died on August 25, 1835. Then there arose a lasting rumor that Lincoln went out of his head and wandered in the woods, mumbling and crazy, and had to be locked up. Here Sandburg seems to set at rest this fanciful story.

Lincoln later married Mary Todd, after a strange, off-and-on-courtship that held a premonition of troubled years ahead in his married life. Mary Lincoln alternatively brought happiness and grief to her husband and was an enigma that is still unsolved.

As Sandburg wrote of Mary Todd:

> When Mary Todd, twenty-one years old, came in 1839 to live with her sister, Mrs. Ninian W. Edwards (Elizabeth Todd), she was counted an addition to

the social flourish of Springfield. They spoke in those days of "belles" and Mary was one. Her sister told how she looked. "Mary had clear blue eyes, long lashes, light brown hair with a glint of bronze and a lovely complexion. Her figure was beautiful and no Old Master ever modeled a more perfect arm and hand." Whatever of excess there may be in this sisterly sketch, it seems certain that Mary Todd had gifts, attractions and was among those always invited to the dances and parties of the dominant social circle. Her sister's husband once remarked as to her style, audacity or wit, "Mary could make a bishop forget his prayers."

Such was the woman Lincoln gathered in his arms some time in 1840 when they spoke pledges to marry and take each other for weal or woe through life. For two years Mary Todd haunted Lincoln, racked him, drove him to despair and philosophy, sent him searching deep into himself as to what manner of man he was. Some time in 1840, probably toward the end of the year, Lincoln promised to marry Miss Todd and she was pledged to take him. It was a betrothal. They were engaged to stand up and take vows at a wedding. She was to be a bride; he was to be a groom. It was explicit.

As a lawyer in Springfield, Lincoln is described by Sandburg as follows:

His head surmounting a group was gaunt and strange, onlookers remembering the high cheekbones, deep eye sockets, the coarse black bushy hair and tangled, the nose large and well-shaped, the wide full-lipped mouth of many subtle changes from straight face to wide beaming smile. He was loose-jointed and comic with appeals in street-corner slang and dialect from the public square hitching posts; yet at moments he was as strange and far-off as the last dark sands of a red sunset, solemn as naked facts of hunger and death. He was a seeker. Among others and deep in his own inner self, he was a seeker.

An important element in the Lincoln biography was its poetical description of the man and his time:

The umbrella with the name "Abraham Lincoln" stitched in, faded and drab from many rains and regular travels, looked sleepy and murmuring. Sometime we shall have all the sleep we want; we shall turn the law office over to the spiders and cobwebs; and we shall all quit politics for keeps.... There could have been times when children and dreamers looked at Abraham Lincoln and lazily drew their eyelids half shut and let their hearts roam about him—and they half-believed him to be a tall horse chestnut tree or a rangy horse or a big wagon or a long barn full of new-mown hay—something else or more than a man, a lawyer, a Republican candidate with principles, a prominent citizen—something spreading, elusive and mysterious—the Strange Friend and the Friendly Stranger.[7]

After his election as President, Lincoln was described as a Springfield man, sometimes a shy and furtive figure, who had been picked to carry the banner. He seemed to want the job and he also seemed not to want it. He knew that terrible days were ahead. He could contemplate an old proverb, "The horse thinks one thing, he that saddles him another." A banner at an Alabama mass meeting stated, "Resistance to Lincoln is Obedience to God." Of the 1,108 officers of the Regular Army, 387 were preparing resignations, many having already joined the Confederacy. Lincoln told some friends privately (and perhaps mistakenly) that the forts seized by the Confederacy would have to be retaken. As he left Springfield for Washington, he said, "I now leave not knowing when or whether ever, I may return, with a task before me greater than that which rested upon Washington. Without the assistance of that Divine Being, who attended him, I cannot succeed. With that assistance I cannot fail."[8]

"Scholars were startled by the unique technique of Sandburg's *Prairie Years* when he first ventured into Lincoln biography," said Benjamin P. Thomas, author of several books on Lincoln. "But most of those who scoffed then, honor him now, realizing at last that none of those who used traditional methods had been able to recapture the true feeling of Lincoln and bygone days with the power that Carl commands."[9]

It was soon discovered that the rewards of writing a book are often not confined to its publication. An excellent magazine for women, entitled *The Pictorial Review*, wanted to excerpt parts of the manuscript. But the editors offered only $3,500. Alfred Harcourt, already full of enthusiasm for the project, was not satisfied. He informed the editors that he felt *The Prairie Years* would rank as one of the greatest biographies in the English language and indicated that about ten times their offer would be more suitable to him. They were taken aback but finally agreed to pay $30,000. Carl Sandburg was in Texas on one of his lecture tours. Harcourt telegraphed him the good news, and the reply was:

Dear Alfred:

This is the first time I've understood something about the emotions of holding the lucky ticket in a lottery. Professor Armstrong of Baylor College at Waco wired your telegram to me at Commerce, saying, "I have received the following telegram. Does it mean anything to you?" I replied "Thank you for sending a telegram with news equivalent to falling heir to a farm."

Carl

Professor Robert W. Johannsen of the University of Illinois noted the critical reaction to *The Prairie Years*. "There has never been biography quite like this before," wrote one reviewer, the professor said. More than "a picture of the mind and the soul of Abraham Lincoln," commented another, Sandburg's work presented "a sweep of background that takes in the whole world." "A vividly human portrait of Lincoln with a richly peopled background," declared still another. And to a fourth, Sandburg had not only realized the figure of Lincoln more perfectly than had ever been done before but he had also written "a comprehensive survey of the development . . . of middle western America, with Illinois as the centre of the action." It was not unlikely that Sandburg had given the world its "first great American epic." Professor Johannsen cited the *New York Times Book Review*, *The Bookman*, *North American Review*, and the *Saturday Review*.[10]

No previous biographer had devoted so much space or amassed so many facts dealing with Lincoln's early life. Close friends of Sandburg praised the book highly, among them, William E. Dodd and, later on, Allan Nevins, Carl Becker, and James G. Randall. Paul Angle, then executive secretary of the Lincoln Centennial Association, took a mixed view. While he believed that *The Prairie Years* would occupy an enduring place in American literature, as biography he felt "it cannot take high rank." Biographer William E. Barton expressed a similar opinion, decrying Sandburg's reliance on earlier and unreliable writers, thus subordinating critical scholarship to poetic fancy. Wrote Barton in the *American Historical Review*, the work was "literature not history, poetry not biography." Milo Milton Quaife stated in the *Mississippi Valley Historical Review* that Sandburg possessed neither the conceptions nor the training that was essential to the writing of history. He called the book a "literary grab bag, a hodge podge of miscellaneous information."[11] Some said that when Sandburg did not have the facts he improvised.

But if Sandburg's historical imagination left some unimpressed, it did not the noted historian Carl Becker. "I rarely read the professional historians," he wrote, "unless I have to, because so much of their work is antiquarian—they have a love for exact information for its own sake, which I have not. They are inclined to object to your *Lincoln*, and for the very reason that I find it interesting—you inject a good deal of imagination into it, you cannot prove all you say by reference to documents.[12]

Many of the errors in *The Prairie Years* were corrected in later printings. These included the less elaborate and more accurate version of the Ann

Rutledge story, which Sandburg had overidealized in his first version. The most vicious attack on the book came from the often acerbic critic Edmund Wilson. This terror of Greenwich Village had lambasted Sandburg's poetry in the 1920s. Dipping his pen in acid, Wilson wrote, "There are moments when one is tempted to feel that the cruellest thing that has happened to Lincoln since he was shot by Booth has been to fall into the hands of Carl Sandburg." Particularly did the critic zero in on Sandburg's description of the thoughts of Nancy Hanks Lincoln as she nursed her son. And of Sandburg's Lincoln and Ann Rutledge: "A trembling took his body and dark waves ran through him sometimes when she spoke so simple a thing as, 'The corn is getting high, isn't it?' " To which Wilson commented, "The corn is getting high indeed!"[13]

*The Prairie Years* was both praised and attacked when it appeared in 1926, but on the whole the book was hailed as a major literary event. Some academic historians felt that it was unscholarly because it lacked footnotes and other critical apparatus. No one doubted, however, Sandburg's familiarity with his material. The general agreement was that the book captured the spirit of Lincoln and the land.

Often Sandburg stacked brief incidents quickly one on another, sometimes without much coherence, but the total effect was convincing for most readers. Sandburg was not out to settle disputed points. He selected and arranged his material in such a way that the end result was the truth as he saw it, but not the whole truth. He was not writing history for the classroom. As Richard Crowder stated: "*The Prairie Years*, in spite of its many shortcomings as history, biography, and imaginative literature, is a universality built of thousands of particularities. It proves that prairie society was not special, but typical of pioneers anywhere on the continent; for most of the United States was still rural, its people all one people. . . . the times, the country, and the man were of such a complex nature that this method of accumulation was appropriate to the subject."[14]

Vachel Lindsay felt that the work was "prose poetry, the best free verse Carl Sandburg has ever written." Christopher Morley thought it was a fine thing "to turn loose a poet on the job of biography." Nearly all of the reviewers agreed that the book was a work of poetic art, and some said that despite its informal nature *The Prairie Years* was history. Professor Robert W. Johannsen posed the question, "But cannot such a work also be a work of history? Of course it can and in Sandburg's case it was."[15]

One reviewer said that the book "is a poem of America, the America of humble folk and rough pioneers, of crude settlements, of communities

gradually shaping themselves into order as the frontiers receded; a poem of physical America, of the corn lands and broad prairies, the rivers and mountains; a poem of the human spirit, not Lincoln's spirit only." Gamaliel Bradford wrote to Sandburg, "Both in the Lincoln and in your poems, you have all the spirit of this vast, dubious, struggling, restless, animal, triumphant America, which Lincoln knew or divined better than any one, and died for."[16]

Professor Johannsen concluded that "Sandburg's work was not simply a testament to America for his own time. It has a relevance to our time as well, for it is a dramatic reminder of the forces, convictions and ideals which made America and which, God willing, we will never fail to understand and appreciate."[17]

Although Sandburg's research was not that of a scholar, it was painstakingly thorough, as befits the trained newspaperman who learns to check all angles of a story before it goes to press. He found the *Official Records of the Union and Confederate Armies*, all 133 volumes, invaluable, as well as the files of the *Congressional Globe*. Said he about these valuable sources: "In these two wildernesses of words, I have picked my way carefully, sometimes drearily and with hope and patience, or again fascinated and enthralled by the basic stuff of indisputable great human action in play before my eyes."

*The Prairie Years* showed a vivid parallel between the lives of Abraham Lincoln and Carl Sandburg, especially in their boyhood days. Although many critics found flaws in the facts presented and complained of the elaborate description, they did admit that here was a picture of a man being tested by the growing pains of a new nation, and through the great mass of detail, the earlier life of Lincoln emerged from a fog of sentiment and legend into that of a real human being. Writing in the *New York Times*, Robert E. Sherwood, the renowned playwright who was later to bring Lincoln so dynamically to the stage, said: "In *The Prairie Years*, with fewer documents and many more myths at his disposal, Mr. Sandburg gave greater play to his own lyrical imagination. Anyone can indulge in guesswork about the raw young giant who emerged from the mists of Kentucky, and Indiana, and Sangamon County, Illinois, and Mr. Sandburg's guesses were far better than most."[18]

Sandburg had been gathering information about Lincoln from all over the United States—the first time this had been done so diligently by a single biographer—and filtering it through his spirit and poetic imagination. All his writings are inevitably a part of his own distinctive personality.

The story of Lincoln's growing up was so heavy with details that at times it appears to be simply a catalogue of facts, as indeed some of it is. Not only did Sandburg compile myriad names of things, but he reveled in their vividness and euphony. Sandburg's great mass of information and legends sometimes overwhelms the reader, but it also impresses and, like the repetition of a melody, finally embeds itself in the consciousness.

Sandburg has been likened to Lincoln in appearance, as a tall, gaunt man, stooped from hard work in his young days and from bending over a typewriter. Sandburg's face was lined and wrinkly and his expression kind and quickly humorous. He had two unruly locks of stiff, white hair which he constantly pushed back and which just as often fell forward again. When he worked, he wore thick glasses and in his teeth clutched a small cigar, usually cold and unsmoked.

The *New York Times* found *The Prairie Years* "as full of facts as Jack Horner's pie was full of plums." Mark Van Doren remarked in *The Nation*, "Here is God's plenty indeed." The *New Statesman* considered it "a masterpiece which suits its subject," and *The Bookman* regarded it as a "veritable mine of human treasure from which to read aloud or to pore over by oneself." John Drinkwater, the Lincoln dramatist, had already read a dozen Lincoln books and never thought anyone could get him to read another thousand pages about Lincoln. But he did read *The Prairie Years* and found it "a quite sincere and cumulatively very touching reversion of a mind, closely disciplined in an almost savage candor, to a natural grace and leniency of sentiment."

Sandburg himself said: "Among the biographers, I am a first-rate poet. And among the poets, a good biographer; among singers, I'm a good collector of songs and among song collectors a good judge of pipes." But always the poet shone through his writings. As Allan Nevins said, "He was always primarily a poet, even when he was writing prose, and always something of an evangelist, even when his utterances were apparently tinged by cynicism. He had a vein of deep religious feeling which he concealed rather than paraded. As a newspaperman, he was highly skilled, and as an historian, he showed fine artistry. But whether he was writing a review of a movie or an account of an election or a characterization of Lincoln, he was, above all, a poet with a strong sense of the values of democracy."

In describing the Mexican War in the book, Sandburg drew on his brief experience in the Spanish-American War to good advantage and affords a colorful picture of the conflict. He depicts the war in Kansas fairly but

vividly and sets the violent forces off against each other in a novel manner. Although he shows sympathy for Harriet Beecher Stowe and her part in moving against slavery, he shows her faults as well as virtues and relates Lincoln's reaction to her propaganda in an analytical rather than an emotional way. He accuses her of playing up a "black Christ" and describing this country as divided into two parts, one desecrated and the other sacred. For John Brown, Sandburg showed little sympathy, pointing out through Lincoln's reaction that no matter what the cause, law and order should be observed.

Throughout the book, Sandburg tried to keep Lincoln the central and overriding figure. In the main he succeeds. Out of the immense amount of relevant material and anecdote, as well as some that is irrelevant, the gaunt and mystical figure of Abraham Lincoln emerges clearly. The President is pictured as the product of the Midwest, which at that time constituted mainly our extreme western borders. His character, as Frederick Jackson Turner has contended about Americans as a whole, was molded by his environment more than anything else. It grew from the soil and its people, the raw problems and hard challenges that most people have met but from which many have recoiled. From the struggle with the climate and the forces of nature, there emerged the characters not only of Lincoln but of his biographer as well. That they survived their environment and rose far above it, whereas many were flattened by it and passed into oblivion, is a tribute to their strength of will. Why these two gathered strength and rose to fame in a somewhat similar manner has still an element of mystery about it. Sandburg in his first book on Lincoln strives hard to explain the phenomenon. He has come closer than anyone else, but the mystery of the Civil War President remains.

The biographer has shown the development of the young Lincoln, who showed no obvious promise of becoming a dedicated genius in the White House during a fratricidal conflict. Sandburg hoped to make it clear that the raw material was here, and from this the reader could judge for himself what was to come and why and how. Awkward and bashful as he was, Lincoln nevertheless made a tremendous impact on those with whom he came in contact, whether favorable or not. What this impact was to amount to was not for his contemporaries to judge; nor can it be judged from Sandburg's narrative, unless one chooses to read hindsight into the story. Lincoln was almost without formal education, yet he had an innate wisdom, which might have come from the fountain of knowledge he found in his few books. The Emancipator remains simple and natural

throughout; but one is led to believe that behind this disarming facade of rural plainness is a mystic power that is only awaiting its destined opportunity to mount onto Olympus.

As humble as Lincoln is pictured in our histories as well as in the Sandburg biography, he came from respectable stock. Virginia gentry, Pennsylvania Quakers, and Massachusetts Puritans all go into the making of this unique man. But despite this, Sandburg, who was of common stock himself, chooses mainly to ignore hereditary factors and associates Lincoln with the stark forces of his raw environment. The circumstances of Lincoln's early years would have discouraged men of lesser determination from trying to get even a rudimentary education. But the force that Sandburg considered to be driving Lincoln toward his great place in history impelled him forward into a kind of self-education that at least fitted him for the halls of government.

Lincoln grew familiar with Aesop and John Bunyan's immortal *Pilgrim's Progress*, which, along with the dictionary and the Bible, were the pioneer's indispensable books. Like Sandburg, he even wrote verse, although most of it has disappeared. He was discerning enough to recognize even then the greatness of the orations of Daniel Webster, and perhaps knowledgeable enough to distinguish between Webster's greatness and his sad weaknesses. He analyzed the sources of Webster's brilliance, and although he never became an eloquent orator in the sense of Burke, Webster, Clay, and Calhoun, he absorbed their gems of expression and used them in his own quieter but effective way.

More than these early American orators and statesmen, Lincoln was close to the people. He reveled in the daily contact with the common man and drew from that fellowship something that Sandburg recognized and fused into his own personal philosophy. "To walk with kings, yet have the common touch" was a bond between subject and biographer that shows throughout Sandburg's writings.

In his biography Sandburg shows that while Lincoln sought the respectability of polite society, he also enjoyed an off-color story, and Sandburg did too. In some of his informal moments, Sandburg told yarns with four-letter words, and one of his favorite private expressions was "son-of-a-bitch." But the stories told by both Lincoln and Sandburg in these "closed sessions" were clever and therefore perhaps could be justified as entertainment.

Abraham Lincoln, as Sandburg so well shows, was a living paradox of the gregarious and the lonely. He was a companionable man, yet when he was

alone, he often fell into a dreadful melancholy. He naturally had a long face, and he enhanced the solemnity of his physiognomy with an intense preoccupation with personal and world problems. Often he burst into tears to relieve the painfulness. Yet Lincoln, like Sandburg, yearned for distinction. They both courted the public favor. And they both had an ambition possessed by few notable figures in all our history, and each brought this ambition to fruition in an overwhelming way.

In *The Prairie Years*, Carl Sandburg shows a Lincoln who was sometimes a clown—devoting whole chapters to anecdotes, true and otherwise—and at the same time he portrays a profound philosopher who must have sprung full-blown from the brow of one of the Greek pundits. Wise, humane, and attuned to the lowly in life, Lincoln fashioned himself into an image of the downtrodden and a defender of the faithful poor. He tried to raise the lowly to higher places, yet, despite all of his fine philosophy and achievements, Lincoln was always the commoner. Sandburg himself chose to remain a commoner, even after he had become affluent.

In the book, Lincoln emerges as a constant contradiction, simple and yet wise in the ways of the world and even beyond. He seemed to hear innately the beat of the distant drum of humanity, as though from some mystic inner source that leaves us yet marveling. Why was he so solicitous about his fellow man? Why did he have little compunction about the lowly status of the slaves, then later cry out against the inhumanity of slavery? No doubt he grew in stature, especially later when he occupied the White House. But Sandburg shows that something more than political ambition motivated him. Part of it may have been a strange, enigmatic identity with the fate of man as the young rail-splitter understood it.

Sandburg does not depict Lincoln as unblemished. Lincoln is described as the self-serving lawyer who would not hesitate to use legal tricks when necessary, although he was generally ethical. When he entered politics, he knew it was an opportunistic game, and he was willing to play it. When he did not choose to answer a question directly, he always seemed to have a good, down-to-earth story to counter the questioner. Lincoln, like his discerning biographer, was shrewd. Only seldom did the President-to-be waver from his course, although he was repeatedly beaten at the polls until he came almost to the last big contest.

Yet with all his enterprise, Lincoln is portrayed as he really was, at heart a conservative, but one who was willing to take liberal chances. He was a believer in the democratic principles of the nineteenth century but adapted himself to the growing consolidation of the country. His was not

only a voice crying in the wilderness; it was a clarion call to those within the wasteland to move in the right direction.

Professor Alan Swanson stated:

> The Lincoln that remained clearest to Sandburg was the human, the common side of the man, the side that laughed because if he did not, he would weep. Sandburg greatly admired Lincoln's use of language and was one of the first to demonstrate the care Lincoln put into his public utterance. He tried also to show the warts and blemishes, but clearly, Lincoln was an heroic figure and Sandburg does not attempt to explain in more than mechanical terms how a poor lad from Illinois could get into the White House and rise to steer the government in its most dangerous days.[19]

Professor Stephen B. Oates, a historian at the University of Massachusetts, was critical of *The Prairie Years* as true biography. He felt that Sandburg captured the Lincoln of mythology more vividly and consistently than any previous biographer. However, he points out that nowhere in *The Prairie Years* do we find the literate young Lincoln who became estranged from his father and left a rural world of toil, never to return. Also, nowhere do we glimpse the self-made attorney who had such superior legal talent that he became "a lawyer's lawyer," who did his most important and influential work not among country folks but in the Supreme Court of Illinois; nowhere do we find the Lincoln who disliked the nickname of "Abe," or who had no farmers among his Springfield friends or had any interest in farming.

Professor Oates also argues that "nowhere in *The Prairie Years* do we see the eloquent and visionary politician who extolled America's experiment in popular government more eloquently than anybody of his generation; nor do we see the Lincoln who wanted a seat in the national Senate even more than the Presidency itself, because in that august body he could defend the containment of slavery and have his speeches preserved for posterity in the *Congressional Globe*." Be this as it may, these observations reflect an astute viewpoint.[20]

Carl Sandburg was pleased with the accolades that came to him and his publisher. From one who not only knew the prairie country but wrote brilliantly about it, William Allen White of *The Emporia Gazette* of Kansas: "I am reading your 'Lincoln' with great joy. And I am going to review it for *The New York World*. It is a wonderful book. I am proud of you. Mondays, Wednesdays, Fridays and Sundays, I think you are a better poet than a

historian; and Tuesdays, Thursdays, and Saturdays I think you are a better historian than a poet. But you are a great man—nothing off for cash."[21]

A patron of the Illinois Central Railroad, Lee A. Stone, wrote to its president, C. H. Markham, urging him to read *Abraham Lincoln: The Prairie Years*. "Sandburg's Lincoln is a very human document," he said. "So human is it that those perusing its pages have to love Mr. Lincoln, not for his saintly attributes, (of which he had none), but for his ability to mingle on a mortal plane with those whom he believed to be just what he was, an ordinary mortal filled to overflowing with frailties of the flesh. Mr. Sandburg's book will do much to eliminate any feeling that Mr. Lincoln was prejudiced against the South and was working for its undoing. It is a book all Southerners should read."

The radical Lincoln Steffens, then in Italy, wrote Sandburg: "It is beautiful. Beautiful men, those two I say as I read Sandburg and Abe Lincoln. And you find in us, your readers, what is akin to you and him. Maybe you and he are not so exceptional. Maybe it is not A. Lincoln but his spirit that is always with us; and maybe it is not only in you that it lives always in us."[22]

Then when bright April shook out her "sun-drenched wings" there came perhaps the most glowing tribute to *The Prairie Years*. Sandburg's good friend, the eminent historian Professor J. G. Randall of the University of Illinois, wrote him: "You have given us Lincoln as no one else has done. Other books are dull or stupid by comparison. It is in your pages that we have the breathing life, the scenes, the pictures, and the thoughts of the times."

# 10

## Lincoln by the Lake

For the first four years after the family had moved to Michigan, Sandburg continued his regular job with the *Chicago Daily News*. Although the income from his freelance writing was now considerable, he knew from hard experience that it could be uncertain and risky for the support of his family. But if he were to finish the monumental task of the Lincoln biography, it was evident that he must work on it full-time.

So in 1932, Carl said farewell to his editors and friends at the newspaper, of which he had become such an affectionately regarded appendage over the years. Now he could virtually hibernate in his attic high above the lake and endeavor to bring to life that mystic, tragic figure who had gone from Sandburg's prairies to Washington and martyrdom.

Meanwhile, Sandburg had been working with Paul M. Angle on a smaller volume, *Mary Lincoln—Wife and Widow*, which was published by Harcourt, Brace in 1932. It begins with a favorite literary device: "In the year of 1881 there was a woman in Springfield, Illinois, who sat in a widow's mourning dress, who sat in a room of shadows where a single candle burned. Outside, the sun was shining and spring winds roamed the blue sky. For her that outside world was something else again—it was a world she had turned her back on."

Sandburg defended this strange woman and tried to explain her peculiar actions and sometimes stormy relationship with her husband. She is described as being pretty but with a sharp and at times offending wit. Mary Lincoln had a "broad, white forehead, eyebrows delicately marked, a straight nose, short upper lip and expressive mouth with dimples and long-lashed blue eyes." Lincoln had courted her, became engaged, then broke the engagement and resumed it. They were married in 1842. He was lean and lank, she was chubby; he was of the lower, she was of the upper class. Despite her violent temper and bad headaches, "she wifed him."[1]

From a personal standpoint, this was not to be entirely a banner year for Sandburg. On September 14, 1932, his daughter Janet was knocked down by a motorcar in Three Oaks. She suffered a gash on her head and ear that required several stitches. "She has had no food in 36 hours and could only be forced to take three spoonfuls of water in that time," Sandburg reported. "The doctors say all indications are favorable for recovery, however; she won't be disfigured. Paula, as usual, is managing superbly."[2]

This unfortunate accident was to have a lasting effect upon Janet and her family. But with the transition and change in his work routine, Carl was too busy to be permitted much time for family troubles. He was also tired. He wrote to his friend Sherwood Anderson, who was running two newspapers in Marion, Virginia, that a neighbor of Sandburg's in the Michigan sandhills "has ordered me to sleep a lot and the last year I have slept more than in any two years of my life previously." The author estimated that finishing the life of Lincoln would require five or six years. "Lincoln ran the war," Sandburg wrote a friend. "That is, it is almost universally conceded that the South could have won a peace and achieve some form of independence had it not been for Lincoln and his ways of running the war. Therefore, the war and its personalities must have presentation."[3]

No matter where he was or what he was engaged in, Carl Sandburg seemed always to have time for more than one activity. During the years he was writing his biography of Lincoln, he was also playing an active part in the political life of the country. The New Deal of President Franklin D. Roosevelt gave him a sparkling opportunity for at least an expression of his sentiments. According to Louis D. Rubin, Jr., Sandburg overdid it:

> For the remainder of his days Sandburg regularly indulged in grandiloquent Yea-Saying and celebrating of the *Volksgeist*, becoming and remaining a kind of professional Prophet of Democracy, demonstrating (so far as I am concerned) impeccable political attitudes and insufferable intellectual allegiances. He participated in all the claptrap of midcentury middlebrow

liberalism, blending invocations to democracy, pseudopopulist jargon, and commercialized aesthetics in a soufflé heavily flavored with cliché. He cosied up to each succeeding Democratic president and presidential nominee in turn; and he was doubtless deeply chagrined when Frost and not he, was John F. Kennedy's choice as ceremonial bard for the 1960 inauguration."[4]

Sandburg was to support the cause of labor and liberal candidates into the 1940s and 1950s. John L. Lewis and the United Mine Workers considered running him for President against Roosevelt in 1940, but Sandburg supported Roosevelt. Archibald MacLeish suggested to the Michigan United Auto Workers that they support Sandburg for Congress from the Fourth District of Michigan, but Sandburg refused. He supported Harry S. Truman, especially in his veto of the Taft-Hartley Bill, and Sandburg supported enthusiastically his fellow Illinoisian, Adlai Stevenson, against Dwight Eisenhower because of what Sandburg felt was Ike's antilabor policies. Said Sandburg about Eisenhower, "With him [Eisenhower] the words 'socialist' and 'socialism' are dirty words. . . . But ever since he left the creamery of Abilene, Kansas, he never bought a suit of clothes or a meal, he never was out of work a day. . . . He lived in a welfare state ever since . . . West Point."[5]

The foregoing statement about Ike never having bought a suit of clothes or a meal after West Point is incorrect. U.S. Army officers are required not only to pay for their expensive uniforms, which can amount to a substantial sum for Regular officers, who wear different types of clothing for various routine and social occasions, but they also must pay for their meals and quarters, although such are furnished at reasonable rates. Sandburg must have been thinking of his days as an enlisted private in the Spanish-American War.

Adlai Stevenson was fond of Sandburg, and the feeling was mutual. Their acquaintance extended over many years. "Among my most pleasant recollections," wrote Stevenson, "are parties in Chicago in the twenties and thirties where I listened to him sing from his songbag to the inimitable accompaniment of his guitar, and happy evenings with him and the late Lloyd Lewis, where anecdotes, Lincoln and music took us far into the night."

For his part, Sandburg, in speaking at Stevenson's inauguration as governor of Illinois on January 10, 1949, said, "The incoming governor knows well that predictions as to what will happen across his four-year term are not wanted so much as good wishes, good will and prayers."[6]

Sandburg was liberal but not left-wing. When he went to extremes in his

expressed attitudes, he usually tempered them with an explanation. For example, he told Oliver Barrett that, "Merely to say, 'I have found the general run of labor leaders having about the same mixture of honesty and crookedness as the general run of business and industrial leaders,' is considered improper. The stress is supposed to be laid on the labor racketeers, on the few small-time rakeoffs of Con Shea or Tim Murphy, rather than the merciless twelve-hour workday which went on in the U.S. Steel Co. plants until the fantastic NRA arrived."

All was not work at the Chikaming Farm. The family liked visitors, and Carl always enjoyed being with people when he could spare the time, which was not often. In the spring of 1933, the Chicago World's Fair was in progress not many miles away, and it proved to be one of the most festive such events ever presented. Sandburg wrote to his friend, the novelist Julia Peterkin:

> Please let me know at about what time you are coming to the Chicago Fair this summer. I am going to be away about two weeks during the summer and I am praying that I will not be away when you come north. You will have quiet, no callers unless you wish, no parties unless impromptu, and you will find the Dune country has something all its own as truly as Lang Syne. Also there will be deep love and a lot of understanding. I love the human spirit of you and I adore the sagacity and the fine intuitions that guide you. As the feller said of the whiskey with swamp root in it: it is good for whatever ails you and if nothing ails you it is good for that.

Martha Moorman, the housekeeper for the Sandburgs for eleven years at Harbert, was honored in a recent edition of the *Chronicle-Tribune Magazine* of Marion, Indiana. She told City Editor Ed Breen that she helped to protect Carl when "so many people wanted to see him. He had to have his privacy, and there were always people who wanted to come and talk to him about something." Mrs. Moorman, who lives on an 80-acre farm near Marion, which was bought largely "from money I earned from Mr. Sandburg," was fond of the family and they of her, and remembers Carl quoting a sea captain telling his crew, "All that I want from you is silence and damned little of that!"

Carl and Lilian Sandburg had always been politically liberal, but as war clouds began to gather over Europe, they declared themselves firmly for the Allies and this country. The development of the America First committee, although led by some able men, irritated Sandburg and drew from him considerable criticism of the movement. He focused particularly on

Charles Lindbergh, who had praised some of the military aspects of Nazi Germany. Regardless of the issue, Sandburg was now assailing one of America's greatest heroes. This brought strong retorts from Lindy's defenders, including one Wylie G. Atkenson, a Chicago furniture dealer, who wrote to Sandburg:

> This letter is being written by a person who has thought enough of your works to buy them. I do enjoy reading your poetry, but I must confess great disappointment at your attitude toward America and her destiny to herself. We Americans can live independently of the rest of the world more easily than any other nation, and we do not have to declare war on Europe just because the English Empire is losing to Germany. Here in this country of ours, enjoying the blessings of a Republican form of government, we can stay out of the wars that afflict Europe and Asia, if we so desire.
>
> When you malign Charles Lindbergh by saying in your metaphorical poetical way that he has ice in his veins, you do a great disservice to a man who is vitally interested in American lives, and heartily opposed to the slaughter of American men in Europe's wars. It is you who may well have ice in your veins when you callously argue that our American boys must go to fight in Europe against the English Empire's enemy.[7]

Another Chicagoan, Clifford Ernest, expressed a similar sentiment:

> I have never been an admirer of Charles Lindbergh's peculiar temperamental personality and I do not stand for the same things for which he stands. We differ widely. But I could not bring myself to talk about a great American as you did about Mr. Lindbergh. I shall always read 'The People, Yes,' feeling that its author died and that the book is a posthumous work of art. I believe the Carl Sandburg of yesteryear would have been able to have analyzed the undemocratic forces that are at work in our country, pushing us into action to rescue an Empire whose corrupted aristocracy and subservient masses have betrayed every trust of civilization.[8]

From another direction came comments of a different nature. After Sandburg had spoken before a meeting of the Joint Anti-Fascist Refugee Committee, an organization that supported the Loyalists in Spain, Helen R. Bryan, the executive secretary, told him that he was "without doubt a great American, a great man, great because you see so clearly the hopes, the dreams, the aspirations of mankind and because in identifying yourself with man and his dreams you are able, as no other American I know is able, to make every one who hears you want to make those dreams and hopes come true for all men."[9]

As always, there was a lighter side to Carl Sandburg, who enjoyed telling

anecdotes. Some of them seem to have been original, others not. But Sandburg must have thought the following one was funny when he related it to a friend, Kenneth M. Dodson:

> King Arthur and his knights you have heard of, a good king he was and his knights bold and having what it takes, you might say. And one of the knights was short. They had to pile three Webster's Unabridged Dictionaries on a chair for him when he sat at the table with other knights. Instead of a horse he rode a dog. One evening when it was snow and sleet and it grew darker and the winds howled, the midget knight on his dog got lost in the storm. They rassled their way through tall timber and mean underbrush and came suddenly to a house with candlelights gleaming from every window. The midget got off his dog, knocked on the door, and said to the lord of the manor:
> "Wouldst thou be so kind as to yield to a knight the hospitality of thy manor?"
> The lord of the manor took a look at the midget and a look at the dog with a hanging tongue and all tuckered out, completely petered, you might say. Then the lord of the manor laughed till his innards shook and busted out:
> "Come in, shortboy, you and your dog, I couldn't think of throwing a knight out on a dog like this."[10]

Helga Sandburg, the daughter who showed promising literary talent, recalls that their father's jokes did not seem funny to the family at first. He would sit and tell one of his "long jokes" and they would sit obediently and listen. For example, how Pat and Mike were at a wake when they grew thirsty and decided to carry the corpse across the street to a saloon and prop it between them. There they left the stiff for a few moments at the bar in care of an innocent customer. Sandburg described minutely how the customer tried to become friendly with the corpse, until finally, in anger, he knocked it over. Then came the familiar ending: Pat and Mike rushed over and sobbed, "You've killed him!" And then the retort, "I had to. The son-of-a-bitch pulled a knife on me!"

Bernard Hoffman, a photographer for *Life* magazine for some years, visited Sandburg at his Michigan home to do a story. The weather was so cold that the goats were virtually freezing outside, recalls Hoffman. Whereupon Sandburg called them into the house and about fifteen of the shivering animals crowded into one of the rooms. Sandburg's hospitality did not stop here. He took up his guitar and played for his guests. Said Hoffman, "They listened politely."

Like his friend Douglas Southall Freeman, biographer of George Wash-

ington, Sandburg had written a monumental biography of a great man; both knew the value of time and used it accordingly; both men had been newspapermen (Freeman the editor of the *Richmond News Leader*), and both received acclaim for their prodigious work, which, coming later in life, was all the richer and more appreciated.

Sandburg wrote to Freeman on September 27, 1953:

> You don't have to be modest—yet it is inconceivable that you could be anything but humble.... Lee was not a Union man—and he was. Lincoln didn't love the South—and he did. The paradoxes are terrific. Much of that war runs into the imponderable and the inarticulate. From the way you delineate Lee as an executive, I would judge you handle men on your staff much as did my old chief, Henry Justin Smith on the *Chicago Daily News.*... I am now doing the last chapter of the only American biography equaling yours in length (though not footnoted with the fine fidelity that goes with yours) so perhaps we should meet as the only two biographers in the Western Hemisphere who have written a million-word portrait.

In his turn, Freeman said, upon presenting Sandburg with the Gold Medal for History and Biography awarded by the Academy of Arts and Letters on May 28, 1952: "Carl Sandburg embodies something happily identifiable and gratefully cherished in American life. He is more than a poet or musician or biographer or philosopher or historian. He is all of these combined in the second generation of the living Lincoln tradition. His is the happy fortune without a single imitative touch to personify the spirit of the man of whom his greatest prose work was written."

In his commemorative address about Freeman exactly two years later, Sandburg said, "He could have said, had there been time, 'So this is you, Mr. Death. I've been walking and talking for years with men and women well acquainted and familiar with you, Sir. You are no stranger, and since you say so, I'll go with you.' "

Freeman believed that the first requisite of a successful biography was "choosing a large subject," and Sandburg had done just that. Making the huge project come alive was up to him. Sandburg figuratively chained himself to his cracker box and struggled with the greatest task of his life. He was fifty when he began *Abraham Lincoln: The War Years* and he realized it was to be his biggest challenge. Indeed in some ways it was perhaps the biggest that any American writer had faced, this highly ambitious life of the man who had been most dramatic in the history of the United States, a martyr and a mystic figure who had perplexed the best historians and confounded others. And after all, who was Carl Sandburg to

presume to write the definitive biography of Abraham Lincoln? Like him, I am a son of the prairie, Sandburg reasoned, a poor boy who wandered over the land to find himself and his mission in life.

He would do the gigantic task at night, when the world was quiet and the wind sang more musically, and when his devoted women were asleep. Lincoln would come back to him then as he would not in the daytime; the records would read better and shape up better as his own. So he wrote from midnight until dawn, retiring only when the sun looked over the lake to find the inhabitants of the Sandburg home still in slumber. It is not known when Sandburg's thick hair first turned white, probably it did gradually, but the strain of night work, one can readily surmise, did much to hasten this process.

Books, journals, letters, diaries, documents, and especially newspapers came under his scowling scrutiny. He had the orderly but sharply inquiring sense of the reporter, and from this viewpoint he sifted out the fact, as he saw it, from fancy, trying to separate the man from the myth. The style of the material he found doubtless influenced him, made him more careful in his own writing, and inspired him with its somber quality. From all the bits and pieces, he fashioned his own style—lucid, simple, poetic, at times even staccato. But so were the events. At times the style appears to be a patchwork. But so was much of the life of Lincoln. As the writing progressed, Carl Sandburg became, on paper, more and more Abraham Lincoln.

No one could stand the pace of such a task for twelve months a year. Sandburg, knowing that he did not have to hurry, did not do so. He was already a successful writer and knew that his publisher would not let him starve. So he added to the diversity of his program by taking off a few months each year for a routine he loved, as did those who were more and more numerously becoming a part of it. He now owned six guitars, none of which he could play very well, but he periodically grabbed up one and took to the road again. The money helped too, and he now received good fees.

These traveling intervals also rested Sandburg's eyes. Straining over the Lincoln materials in his attic, some of it dimly written or printed, was especially fatiguing for a fifty-year-old man who had already used his eyes for reading and writing much more than the average person. In addition to writing his manuscript, he had to carry on an extensive correspondence in order to bolster, supplement, and correct his research. This rigid requirement sometimes led to an antipathy at answering his mail and telegrams.

Once when I was visiting Sandburg, he received a telegram asking why he had not replied to a letter sent some time before. Squeezing the telegram in his big hand, he grinned impishly and commented, "Hell, I didn't ask him to write the damned letter in the first place!"

Meanwhile, *Selected Poems of Carl Sandburg*, edited by Rebecca West, was published in New York and London. In her preface to the British edition, Miss West wrote, "His revolutionary passion so often betrays him, for poem after poem is ruined by a coarsely intruding line that turns it from poetry to propaganda." Soon afterward, *The American Songbag* was published, but this propitious event was saddened by the death of Sandburg's mother.

Carl had little time to mourn. In 1928 he was invited to read as the Phi Beta Kappa poet at Harvard University. He took occasion to tease Paula, who was already a member of this renowned fraternity, saying that if he could not get in by the front door, he had gone in by the side. In the same year, a volume of his poetry, *Good Morning America*, was published. Sandburg received an honorary degree from Lombard College, and Knox College soon followed with a similar degree. Sandburg was understandably proud to receive these honors from his hometown. Northwestern University followed suit with academic honors.

Sandburg had always been an admirer of the work of his famous brother-in-law, Edward Steichen, who had done most of his work in Europe. In 1929 *Steichen the Photographer* was published. The book contained forty-nine photographs by Steichen, reproduced by a new process. Sandburg stated in his Foreword that this was not an attempt at a formal biography:

> Biographies of contemporaries are difficult. Years of the mellowing tests of time are an advantage in doing a full-length book portrait of any individual. There are opinions, judgments, facts, surmises, secrets, that look better in print fifty years after the subject has gone where the woodbine twineth and the lizards sleep on the idle slabs in the lazy sunlight. Yet there are men whose contemporaries can't keep still. Out of love and fun, sometimes hate and ill will, they must write—and out of such writings is laid the basis for later biographies worthwhile. I told friends of Steichen, that he throws a long shadow and ranks close to Ben Franklin and Leonardo da Vinci when it comes to versatility.[11]

Sandburg may have had time, although evidently not much, to do light reading, for he wrote to Sherwood Anderson about his newspaper in Marion, Virginia, "Send the paper to Harbert, Michigan. I am there with my

family most of the year now. It is as lonely as your own hills. I am starting work on *Abraham Lincoln: The War Years*. You will have to tell me a little about why Virginia went into the war, why men fight, and what were some of the innermost thoughts of Robert E. Lee and Stonewall Jackson. You will be asked about these things when I get down there. You will not have to answer anymore than if I asked you, how do seeds and eggs pass life on?"[12]

Anderson and Sandburg had experienced a personal and journalistic fellowship ever since their newspaper days together. Anderson had written in *The Bookman*: "There is a sensitive, naive, hesitating Carl Sandburg that hears the voice of the wind over the roofs of houses at night, a Sandburg that wanders alone through grim city streets on winter nights, a Sandburg that knows and understands the voiceless cry in the heart of the farm girl of the plains when she comes to the kitchen door to see for the first time the beauty of our prairie country."[13]

Carl was now coming up in the world. He received a telephone call from Los Angeles from filmmaker D. W. Griffith, offering him $10,000 to spend a week with the director going over a movie script. "I thought it over," said Carl, "and wired him the next day it would not be fair to him nor me nor the picture; that I would take on the job for $30,000. . . . That was the last of it."

But these diverse activities were minor compared with the real task at hand—the portrait of the lank and looming figure of Abraham Lincoln, who seemed to Sandburg to speak to him from on high. Karl Detzer has commented, "Carl Sandburg knows Lincoln better than any other man knew him, better even than those who were closest to him in life, because Sandburg's advantage was the perspective of eighty years."

Other encouragement had come from Walter Yust, who stated that "Sandburg has acquired his taste for words that rage and storm and bleed during a lifetime of vigorous experience." Paul Rosenfeld described Sandburg as "a man filled with the warm, great love for men and women, a warm, intense, almost animal desire, not to be saved alone, not to go alone, but to go with other men and women, to be saved together with them or not at all."[14]

Sandburg's work on *The War Years* went on apace. He turned in chapters to Alfred Harcourt as they were completed. *Redbook* contracted to publish portions of the book in eight issues. Four appeared in 1936, one each in 1937 and 1938, and the final two in March and May 1939. Harcourt, Brace was excited about the forthcoming book. The publisher even went so far as to imprint on all its metered mail the arresting words, "The War

Years Are Coming." This worked until complaints began to arrive, pointing out that the situation in Europe in the late 1930s made the message all too poignant. The slogan was discontinued, but the outbreak of war in Europe made it prophetic.

Charles A. "Cap" Pearce, later the editor-partner in the publishing firm of Duell, Sloan and Pearce, was then managing editor of Harcourt, Brace. He recalled that Sandburg came to New York occasionally and was under a great strain while writing *The War Years*. Sandburg would drop around to the office and Pearce would send out and get a pint of liquor, which diverted the biographer and relaxed him.

"Sandburg always felt for the essence of things," related Pearce. "He tried to evoke the ghost of Lincoln, who, like him, was a melancholy dreamer of the Midwest, which meant that they believed in no El Dorados but just hard work. So Sandburg drank hard liquor, smoked too many stogies, and did not take very good care of his health in those days." Once Pearce invited Sandburg to his home in Tarrytown, New York. The guest had a cold, which he tried to cure by smoking and drinking.

"He reveled in the local scene of Washington Irving," Pearce said, "and he also was grimly amused by the fact that in the local cemetery, Andrew Carnegie and Samuel Gompers are buried near each other. Sandburg was very interested in the remains of the redoubt on the Hudson River there, from which the American patriots had shelled British ships during the Revolution. He enjoyed such history more than the local residents. But now and then, Mrs. Pearce had to open the windows of our house to let out his cigar smoke."15

On April 6, 1937, Sandburg received a letter from President Franklin D. Roosevelt. FDR thanked Sandburg for his letter, invited him to the White House, and said that he had long wanted to talk to him about Lincoln and other things. "You have reconstructed so well the picture of the executive duties and life in Lincoln's day that perhaps you will be interested in seeing at least the same relative problems at firsthand in these days," the Chief Executive added.

Three years later, FDR wrote Sandburg, thanking him for making a radio broadcast in behalf of his candidacy. "You are such an understanding soul," he said, "and can make allowances with such fairness for the weaknesses and frailties of human nature that you are one of the few people who can truly understand the perplexities, the complications, the failures and the successes of what goes on in Washington."

As the publication date of *The War Years* approached, Sandburg stayed

in New York to be near the scene of operations. He worked with the editors in selecting and arranging the illustrations for the ponderous work, and during part of the summer and fall of 1939 lived in the Brooklyn house of the copyeditor, where he read the galleys and page proofs. Each day a batch of proofs was sent to the publisher in Manhattan, thence to the printer in New Jersey. Copies of the book, as soon as they came off the press, were wrapped in gold paper and sent to reviewers. Now the book had grown, counting *The Prairie Years* and *The War Years*, into six bulky volumes of about 650 pages each.

Said Sandburg to Harcourt: "This has grown into a scroll, a chronicle. There's one thing we can say for it: it is probably the only book ever written by a man whose father couldn't write his name, about a man whose mother couldn't write hers."

Alfred Harcourt at once ordered 15,000 sets printed. Sandburg happened to be in the office and learned of this. "Fifteen thousand sets?" he exclaimed to the publisher in disbelief. "You mean sixty thousand books?"

That is what Harcourt did mean. In fact, when he saw the advance orders, he directed that an additional 14,000 sets be printed for Christmas and Lincoln's birthday. All 29,000 sets of *The War Years* sold out within a few months at twenty dollars a set. Harcourt was presented with a gold-paper crown by his staff "in recognition of the crowning point of his publishing career." In appreciation of the excellent job the printers had done, Sandburg himself made a visit to their Rahway, New Jersey, plant and gave the personnel samples of his songs and readings "in token and appreciation of their fellowship, craftsmanship, anxiety and zeal in connection with the making of *The War Years* from a manuscript of 3,400 typewritten pages into the finished book of four boxed volumes that has had from everywhere high praise as to typography, presswork, illustrations, binding." Sandburg referred in addition to "the ancient and natural partnership that exists between authors and printers, how neither can effectively get along without the other."

The theme of his *Lincoln* might be summarized in his earlier lines from *The People, Yes*:

> He was a mystery in smoke and flags
> saying yes to the smoke, yes to the flags,
> yes to the paradoxes of democracy,
> yes to the hopes of government
> of the people, by its people, for the people.

With the completion of this monumental work, Carl Sandburg gained a permanent place in American historical biography. So closely did he live with Lincoln in the years of hard and continual writing that he achieved a tapestry of detail in some ways unparalleled. Here was not only the story of a great man but the account of a free people in a new democracy, struggling to remain free.

America viewed Sandburg as an integral part of this new land and its people. As Lincoln was in a special sense a rare representative of his age in America, so was Sandburg a symbol of the twentieth century in its more traditional form. Both Lincoln and Sandburg were products of early hardships, and both spoke to the people in the people's voice. In these voices which sounded some 75 years apart, there was hardness, there was earthliness, and there was pathos. In so embodying the man in a lasting, verbal framework, Sandburg became no less than the Lincoln of our literature.

" WHAT DO THEY KNOW OF INDIA WHO ONLY OLIVE ST. KNOW ?"

Cartoon of Sandburg as a newspaperman, by Daniel Fitzpatrick. The caption apparently is a humorous reference to the "special knowledge" held by reporters of esoteric things. Courtesy University of Illinois.

Carl and Paula at a dinner in honor of his seventy-fifth birthday in Chicago, 1952. Some 500 notables attended the lavish occasion. United Press photo. Courtesy University of Illinois.

Sandburg addresses Congress on February 12, 1959, to commemorate Lincoln's birthday. Facing the speaker on the right front row are U.S. Supreme Court justices, left to right, Potter Stewart, Charles E. Whittaker, William J. Brennan, Jr., and John Marshall Harlan. Associated Press wirephoto. Courtesy University of Illinois.

A bust of Lincoln with the artist who helped to immortalize him in words. The bust is in the Chicago Historical Society. Courtesy University of Illinois.

Sandburg and the author, Dr. North Callahan, president of the Civil War Round Table of New York, 1954.

Sandburg in his study at Connemara, where he spent much time in his later years. The study was usually not as neat as it appears here. Courtesy University of Illinois.

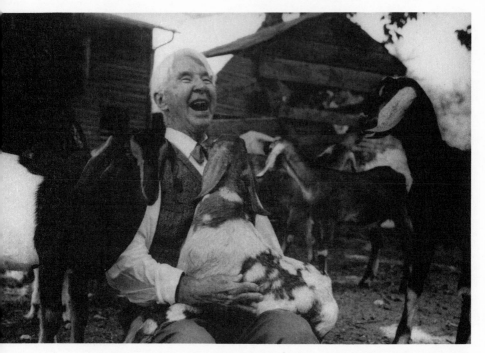

Sandburg and some of his "close friends" at Connemara. Photograph courtesy Dan McCoy, Black Star.

Portrait of Sandburg on the U.S. thirteen-cent commemorative postage stamp issued on January 6, 1978, the 100th anniversary of his birth. (Portrait by William A. Smith).

# 11

## The War Years

At last it was finished. What was probably the most prodigious and monumental single-handed production in American historical literature finally came to an end. It was the four-volume *Abraham Lincoln: The War Years*, by Carl Sandburg. There were times when Sandburg prayed to God that He would sustain him until he had finished the book. Only a man of the strongest nature could have accomplished this gigantic feat. And even Carl Sandburg was weary at the end of the ambitious road he had chosen to travel. *The War Years* contains about 1,175,000 words, more than in all of Lincoln's printed speeches and writings, more than in the Bible, including the Apocrypha, and more than in the complete works of Shakespeare.

The manuscript was so long that its author began to wonder if anyone would wade through it. But they did. His friend Lloyd Lewis of the *Chicago Daily News* read the first draft of the manuscript and was highly enthusiastic. He made only a few suggestions. Lewis was particularly impressed by the closing chapters about the assassination and the consequent national mourning. Here Sandburg had gone beyond reporting and had written a kind of grand and tragic symphony.

In 1938 a little volume was published by the Holiday Press in Chicago entitled *Lincoln and Whitman Miscellany* by Carl Sandburg, who did some of his best writing in this prelude to *The War Years*, some of which later appeared in the biography itself. Two especially beautiful passages in the smaller work deserve inclusion here:

> Spring comes quietly to Washington. In early March the green of the grass brightens, the magnolia softens. Elm and chestnut burgeon. The lovemaking and mating go on in many sunny corners no matter what the plans or who the personages behind the discreet bureau and departmental walls.

> The dew came on the White House lawn and the moonlight spread lace of white film in the night and the syringa and the bridal wreath blossomed and the birds fluttered in the bushes and nested in the sycamore and the veery thrush fluted with never a weariness. The war drums rolled and the telegraph clicked off mortality lists, now a thousand, now ten thousand a day. Yet there were moments when the processes of men seemed to be only an avid dream and justice lay in deeper transitions than those wrought by men dedicated to kill or be killed.

In the words of Benjamin P. Thomas, "Sandburg has become so intimate with Lincoln through long study that the man and his era come alive in his mind. Sandburg recaptures the past.... It is panorama through minutiae. Interpretation comes through subtle suggestion. Some of his passages are almost poetry. It is a unique way to write history, but a powerfully effective one."[1]

Of Lincoln, Sandburg said: "His salient characteristics were his sadness and his humor—a sadness born of sympathy and understanding, and a humor which ran from the finest threads of irony to the courseness of the livery stable. He came from a breed and a region where the language of Shakespeare still persisted, and he knew the value of obsolete words and did not hesitate to use them. He developed a style which was the result of natural feeling, deep thought, and his early environment. He had a poet's sense of rhythm."

Sandburg's original plan was not to follow his first work by this huge successor. He said himself that after finishing *The Prairie Years* he would attempt to cover the rest of Lincoln's life by the device of an introduction. He even went so far as to write a suggested preface, which fortunately has been preserved. It seems fitting to quote the first paragraph: "In the time of the April lilacs in the year 1865, a man in the City of Washington, D.C.,

trusted a guard to watch at a door, and the guard was careless, left the door, and the man was shot, lingered a night, passed away, was laid in a box, and carried north and west a thousand miles; bells sobbed; cities wore crepe; people stood with hats off as the railroad burial car came past at midnight, dawn or noon."[2]

The early part of *The War Years* is a distillation of conventional history, which, if enlightening to uninformed or forgetful laymen, is repetition to the historian. Of course it is well known that Lincoln chose to reinforce Fort Sumter. The question is: If he had allowed it to be lost, would this have pacified the South enough to prevent or postpone the Civil War? Probably not, but we shall never know, for he did send reinforcements, knowing full well that the hot-headed South Carolinians would explode.

Through all the strain and tumult, Lincoln kept his wry sense of humor. "The President liked to tell of a seedy fellow asking Seward for a consulate in Berlin, then Paris, then Liverpool, coming down to a clerkship in the State Department. Hearing these places were all filled, he said, 'Well then, will you lend me five dollars?' "[3]

To Sandburg, the White House gave a feeling of time. It was easy to imagine the nearby statue of Thomas Jefferson and the serenity of the grounds during Lincoln's first year. "Yet hidden in the shrubbery were armed men and in a basement room troops of muskets and bayonets. Two riflemen in bushes stood ready to cover the movements of any person walking from the main gate to the building entry."

Secretary of State Seward wrote to his wife that at first Lincoln proposed to do all his work. But that did not last long. He learned to assign routine work to others. John Nicolay, Lincoln's secretary, who was later to co-author a valuable biography of the President, said that Lincoln exclaimed one chaotic day, "I'll do the very best I can, the very best I know how. And I mean to keep doing so until the end. If the end brings me out all right what is said against me won't amount to anything. If the end brings me out wrong, then angels swearing I was right would make no difference."

In a surge of poetic flair, Lincoln said softly:

> How sleep the brave who sink to rest
> By all their country's wishes blest.[4]

How well can anyone appraise Lincoln's record as a country lawyer, crisscrossing the prairies in pursuit of his practice; his shrewd understand-

ing of human nature as evinced by his homely anecdotes and speeches; his unsuccessful course as a political candidate in his earlier career; his record as state legislator and congressman; and his transformation into a sort of genius when he became President and Commander of the Armed Forces of the United States during its most excruciating war? Carl Sandburg could not relive these phases of Lincoln's life. But he has come closer to it than anyone else.

James G. Randall said, "One must put together the statements of men all over America to have even the beginning of an appraisal of what Sandburg means in poetry, in the journalism of reporting, in the journalism of the column, in history, in biography, and in the vibrant world of American song. There occasionally arises among us one who embodies the fulfill-ment of American democracy, while at the same time he is the spokesman of democracy. Such a man was Lincoln, and such a man was Sandburg. In his life and achievement he stands as the proof, the very certificate of democracy."[5]

Praise from reviewers included the eloquent one from Robert E. Sher-wood, himself a magnificent dramatic writer about Lincoln: "In *The War Years*, Sandburg sticks to the documentary evidence, gathered from a fabulous number of sources.... Mr. Sandburg writes with the poetic pas-sion and the somber eloquence of the great masters of tragedy."[6]

Lloyd Lewis writing in the *New York Herald-Tribune Books* said: "There has probably never been such a summoning of witnesses before in Ameri-can literature or law, no such marshaling of incident, such sifting of rumor, such collecting of evidence, eye-witness and hearsay, as the author here produces.... It is all here, as detailed as Dostoevsky, as American as Mark Twain."[7]

Allan Nevins, in customary generous evaluation, told of the vague re-ports that had come to the world of history about the task in progress in Harbert, Michigan:

> Everyone who knew of Sandburg's rich, if unconventional equipment for his task—his poetic insights, his mastery of human nature, his power of selecting the vital human details from a mass of arid facts, his command of phrase and imagery, and above all his feeling for the mingled humor, pathos, shoddiness and grandeur of democracy—expected a remarkable work. To history he brought just the faculty that the *London Spectator* had detected in Lincoln himself, "a mind at once singularly representative and singularly personal." No one, however was prepared for the particular kind of masterwork that he laid before the country.[8]

When Sandburg was not focusing on Lincoln, he discussed the strutting but well-meaning General Winfield Scott; John Pope, who could not make good all of his boasts; the colorful and enigmatic John C. Fremont; the obstreperous and bothersome Ben Butler; the eccentric but able Stanton; the ambitious but generally judicious Salmon P. Chase; the obdurate and egotistical Charles Sumner; a great soldier but vulnerable political leader, Ulysses Simpson Grant; the effective but cruelly relentless William Tecumseh Sherman; the courageous David Glasgow Farragut; the cautious but still-admired George Brinton McClellan; the tardy but generally competent George Gordon Meade; the sharply observing reporter and author Noah Brooks of the *Sacramento Union*. Or when he was not concentrating on some other prominent figure, his subject was bound to be the plain people who milled around the President, for they were the ones both the martyred leader and this biographer loved best.

Nevins liked the book when it first appeared. Twelve years later, he read it again and still liked it. "We can see that while seemingly unsystematic, the tremendous narrative really has a careful underlying plan. It is a presentation of all that touched Lincoln immediately or remotely in 1861– 1865, set down chiefly as he saw or heard of it, and so arranged as to depict these years with the greatest possible verisimilitude."[9]

The decade of the thirties was timely for Sandburg's project. The world was seeing a resurgence of interest in Lincoln and the Civil War. Sandburg knew this. As a newspaperman, he was conscious of timing, of deadlines, of getting out the story at the proper time for people to read it. Most of the information for a great new version of Lincoln had been assembled. Ida Tarbell, who had given us such a vivid, if one-sided, account of the Standard Oil Company, had turned her vast energy to Abraham Lincoln in her series of articles in *McClure's Magazine*. For four decades a flow of studies about Lincoln's fascinating but elusive character had been produced: The *Diary of Gideon Welles*, the *Letters of John Hay*, the *Diary of Orville H. Browning*, as well as that of *Edward Bates*, the letters collected by Gilbert A. Tracy and Paul M. Angle, and many others. So the time for Sandburg's book was ripe.

"The most distinctive qualities of the Sandburg work," said Nevins, are those of "a great historian who is also a finished artist."[10] Such qualities are revealed in the mosaic of details gathered from long, patient search, pieced together into an awesomely impressive whole. From this, readers gain the correct impression of a difficult, chaotic era, the one in which Lincoln lived, and hardly less, Sandburg's too. Yet the book is not charac-

terized by hero-worship, for it often shows Lincoln's lack of organization, errors of judgment, his indecisiveness, and especially his fits of melancholy, which at times appear to be almost pathological. To achieve victory he had to become a kind of dictator, at times exercising almost tyrannical powers and at other times stooping to low politics to attain his ends. Some of the vital decisions during the war required the talents of a genius, but Lincoln often felt himself inadequate. Yet out of the chaos and confusion, out of the indecision and disloyalties, the wartime leader fashioned a great military machine, which was finally turned over to men who could run it successfully.

This was "Mr. Lincoln's War" in so many ways that Sandburg found himself becoming a military historian as well as biographer. However, he wisely withheld judgment on military strategy and tactics, confining himself mainly to the part that Lincoln played, his almost mystic guidance of the principal currents when they seemed to falter in their flow, and the effects the war had upon Lincoln himself. His story turned out to be an Olympian drama unsurpassed in history.

A lesser man than Lincoln would have become embittered at the South instead of sadly impatient; and a lesser biographer than Sandburg might well have stressed the victory of the Union generals at the expense of the Southern leaders. But Sandburg gave due credit to Lee and Jackson just as to Grant and Sherman and their associates. In this he seems to have some of Lincoln's magnanimity. The President is shown to be "for the ages" as much as for his own time.

So Sandburg had the conflict of his narrative cut out for him. No Greek drama had a more consistently ascending line of action, no more dramatic crescendo and climax, and then the quiet like that of "the cool tombs" which came in the tragic aftermath. Here is a miniature drama of American life played out against its most tragic background. Although civil war had been predicted by some of our Founding Fathers and the country had been warned by later prophets that conflict, particularly because of the slavery problem, was inevitable, the fact remained that for some seventy years of the existence of the new republic, no real armed disruption of the national life had yet occurred. George Washington and Andrew Jackson, especially, had seen to that.

Yet with all the terrible tragedy in the unfolded story, there is as much comic relief as in a Shakespearean play or a Sandburg platform recital. Humor graced the sad heart of Lincoln and burst forth when he was most disheartened. Sandburg recalled a story about Abraham Lincoln when the

President was visiting a military hospital during the Civil War. Also with him were Kate Chase Sprague, daughter of the Secretary of the Treasury, and some friends. While Mrs. Sprague was at one end of the ward of wounded men, she noticed that Lincoln was at the other end talking animatedly to a soldier lying in a bed. When Lincoln rejoined the party, she asked him what he had found so interesting about the patient that made him look solemn and then laugh intermittently. The President looked at her intently, then said with a chuckle, "Mrs. Sprague, if you had been standing in the position that soldier was when he was wounded, you would have not even been hit." Such vignettes dot the pages like small stars.

Probably the two greatest elements in the biography are Lincoln and the people. The people were there in the turmoil of conflict. Lincoln was there, leader of most of them, though never actually President of all the United States—someone has called them "the disunited states." Being so much one of the common people, Sandburg was well equipped to tie Lincoln and his environment together. In an extended and rhapsodic way, he is saying, "Lincoln and the People, Yes."

Had Carl Sandburg followed Abraham Lincoln around the White House and elsewhere during his crucial years, he could hardly have had more information than he actually did gather later. Sandburg vividly shows the almost miraculous transformation of Lincoln from an ordinary lawyer and congressman to the remarkable leader he became after he entered the White House. We still wonder just what happened here. But more than any other, Sandburg shows the steps of this transformation and lights the stage from all angles, from inauguration to assassination.

"The tale is not idle," wrote Sandburg. It is a tale like that described by Shakespeare, "full of sound and fury," and accepted in the Sandburgian manner, it can be read aloud and much of it will sound like poetry—as much of it is. While all six volumes of the biography, as well as the condensed one-volume edition, will endure, *The War Years* is probably Sandburg's greatest work. It is biography, history, poetry, drama, and a kind of background music that can be heard by those who have known the author and who appreciate his subject.

Filed in the dusty morgue of the late *New York Herald-Tribune* was a writer's comment: "After its publication, Mr. Sandburg said he would take a rest, but men like Carl Sandburg don't rest. They are too much a part of life and America." In the book section of the same newspaper, Lloyd Lewis had written:

Lincoln was in himself so large a mirror of mankind that every biographer finds in him the thing he admires most, hence lawyers think Lincoln's legal side the thing that made him great, soldiers think his education in handling soldiers the main thing in his fame, preachers say it was his exalted moral sense, and Sandburg the writer, while giving the most catholic of evaluations to date, would seem, by his emphasis, to feel that it was as a user of words that Lincoln shone the brightest. And the evidence goes far to support such a view. To read Sandburg's detailed description of how Lincoln wrote his most renowned papers, speeches and letters, of what was in the air at the moment, is as absorbing as it would be suddenly to come across the revelation of just how Shakespeare wrote *Hamlet*.[11]

Sandburg's friend Stephen Vincent Benét wrote in the *Atlantic Monthly*: "In *The War Years*, Carl Sandburg carries on and completes his life of Lincoln, through the turmoil of Civil War to the burial at Springfield. He has done so on the grand scale—it is a mountain range of a biography."

But Benét's comments are not all applause. He added, "Now and then it is hard to see the wood for the trees; now and then Mr. Sandburg's principles of selection and omission strike one oddly.... There are places where Mr. Sandburg's style touches genuine poetry, there are others where it descends to bathos. And now and then, he permits himself a sort of rhetorical broodiness which is neither poetry nor prose. But when all this is said, the book remains. To chip at it with a hammer is a little like chipping at Stone Mountain."[12]

What about the political viewpoint of the author? Was it sectional?

Charles A. Beard, who could rarely be impartial, said about *The War Years*: "The scene is viewed mainly from the Northern standpoint. The weight of emphasis is on Northern events and personalities, despite the passages on campaigns and battles.... And, although Mr. Sandburg cites freely many adverse Southern judgments on Lincoln, he sees that strange figure in the White House undamaged by the animadversions. After all, what is *the* Southern view of the war years or anything else? Moreover, who, North or South, is fitted to tell the truth, the whole truth and nothing but the truth?"[13]

Perhaps Beard could discern some obscure meaning in the words of Sandburg that pointed to the Northern viewpoint. Although he was born in what is ordinarily thought of as "Yankee Country," Sandburg maintains a fair, middle-of-the-road approach. To present a full picture of the Lincoln saga, Sandburg had to consider well both sides in the Civil War. A good part of his research came from Southern records, and he visited every part of the country in his quest.

What lifts the book above mere stupendous anecdotage is the thoughtful, searching comment of the collector. Each anecdote and incident is fastened to the growing pyramidal monument by the cement of Sandburg's particular feeling for the form of words and of Lincoln's character.

Here one sees Lincoln guiding when he can, biding when he knew that he must do so. He tried everything: coaxing, persuading, even beating on the heartstrings of his people. He is more often disappointed than pleased and is usually shown as harassed and beaten down. Though Lincoln is confused and beset at times, he sticks to his purpose. He is a kindly man who can ease the burdens of the lowly just as he can endure the cruel barbs of the arrogant. Lincoln is depicted as one who hates war yet feels that it is his only means to the big end. He pardons so many accused that one wonders if he overdoes it, giving generously of his power to both friend and enemy. Although he is excoriated and assailed, he is patient and shows, according to his biographer, more tolerance and forgiveness than any other national leader in history.

By word and colorful illustration, Sandburg shows in The War Years that the very face of Lincoln mirrored the hard tragedy of his life, albeit now and then softening over some humorous tidbit. In that fact there was a solemn sensitivity, whether reflecting mirth or melancholy. It was a face lined by the storms of early life on the frontier and now become more wearied by the conflicts with the more cruelly subtle ways of the East and North. Of course the factor that gave it the aspect almost of a death mask was the war itself and its heavy responsibilities. Only the face of Robert E. Lee could be compared to Lincoln's after the battles were over.

Sandburg's aim was to restore Lincoln to the common people, for he belonged to them. Equally important was his objective to show what happens to a democracy when it goes to war. In the words of Allan Nevins, The War Years "is not merely a biography; it is a magnificent piece of history, an epic story of the most stirring period of national life and a narrative which for decades will hearten all believers in the stability of democracy and the potentialities of democratic leadership."[14]

Sandburg never considered limiting his biography to only one volume; he stuck with his objective and saw it through, feeling no doubt the sinewy spirit of his subject helping him. Sandburg had said, "Lay me on an anvil, O God. ... Let me lift and loosen old foundations." Now he had done just that. He had altered the conventional foundations of writing biography. From the sweat of the harvest fields where he had labored, the cold he had suffered while delivering milk and newspapers in his prairie town, the

handling of heavy cakes of ice, all had brought him physical endurance. And he needed it all, for writing is the hardest and loneliest work in the world. He had been bolstered by his contact with so many people, and his poetic imagination helped him soar above the clouds.

On one of these flights, he glorified, as he had not done before, the Gettysburg Address of Lincoln. But the biographer did not omit the details of the preparation of the memorable speech; he shows that it was not scribbled out on the train en route to the battlefield. Yet, the general on the other side of the battle is also treated sympathetically. Sandburg admired Robert E. Lee, and he wished that Jefferson Davis might have escaped from the country before the Northerners could capture him. Lincoln himself had an affection for the South and did not want his house divided. Long before the war ended, the President had made plans to bind up the wounds of the nation and to care for its widows and orphans. Lincoln, as well as Sandburg, lamented the scorched-earth policy of General Sherman in his cruel march through Georgia, and of Sheridan in his devastating raid through the Shenandoah Valley.

But again Sandburg would turn from such weighty matters to draw upon the President's boundless stock of stories. There is the tale about the man who gets to the theater just as the curtain goes up. So interested is he in what is happening on the stage that he puts his tall silk hat, open side up, on the seat next to him, not noticing that just opposite is standing a very stout and nearsighted woman. She sits down. There is a crunching noise and the owner of the hat reaches for it as the stout woman arises. Then he looks at his hat, and at her: "Madam," he said, "I could have told you that my hat wouldn't fit you before you tried it on!"

One of Sandburg's observations was that the conflict between the states was semantic in nature. "The Civil War," he said, "a bloody time that claimed more than a half-million of the living, actually was fought over a verb. Before the war, this country was referred to in all the treaties as 'The United States is'—and it is still the same now!"[15]

For at least a fourth of his life, Sandburg had lived with his hero, Lincoln, and their association had been perhaps without precedent in the history of a biographer. So saturated was he with this subject that he talked and looked like him, thought like him, and expressed himself on paper much as did the martyred President. This identity Sandburg caught as essential, way back when he began the work. Although it grew on him, as he said, he knew that to reproduce creditably the persona of such an important man, he would have to put himself in the man's place.

After *The War Years* had come off the press and the mountainous burden lifted from his big shoulders, Sandburg was asked what he intended to do next. "I must first find out who this man Carl Sandburg is," he replied, with more meaning than even he must have known. For it was hard for him to lose his identification with Lincoln; and in fact, he never really did. Nor did he want to.

Lloyd Lewis, after setting the stage for describing the remarkably dramatic Gettysburg Address, observed that Lincoln had not had time to give much of a speech, even for the five minutes allotted for the Chief Executive of the United States. Most attention had been paid to the preparations for the main speaker, Edward Everett, president of Harvard University and the most renowned speaker in the country. Yet in two minutes he did what Everett could not do in two eloquent hours.

Like Carlyle, Sandburg dealt more with the men who made the history than he did with the events, and like Macaulay, when the generals advanced to the front, he retreated to the rear to write about the people who made it all happen. But Sandburg, unlike his English predecessors, preferred to concentrate on the private soldiers rather than the officers.

From early 1863 to August 1864, "the darkest month of the war," Lincoln's party moved to replace him with another candidate. This Sandburg handles with immense sympathy. Appropriate too is the comparison here with the tragic-minded Nathaniel Hawthorne, who at the time of his death seemed to despair of our nation and his own part in it and was ready to accept spiritual defeat as the price of having existed in such chaotic times. Then came Lincoln's temporary triumph, his reelection, and his brief moment again in the sun. And then the darkness.

Max Lerner observed that the surprising thing about Sandburg's work on Lincoln was that here was the writing of a democrat, a poet and storyteller, an earthy midwesterner and singer of the people, who has written about another democrat who was also something of a poet in his way, a storyteller and an earthy midwesterner and a product of the popular masses. It is itself a battlefield, a sprawling panorama of people and issues and conflicts held together by Sandburg's absorption with the central figure.

Emanuel Hertz, who also had written about Lincoln, noted that John Hay and John G. Nicolay, private secretaries of Lincoln, had access to materials that up to that time had been used by no one else. Seven and a half of their ten volumes were devoted to the war years and constituted about 920,000 words, while Sandburg covered the same period in four huge volumes

containing almost twice as many words. Sandburg gathered material that disclosed every aspect of this complex man. Not only the biographies of Lincoln, but every book, speech, sermon, or address on Lincoln which contained a pertinent idea or fact engaged his attention. The items of Lincolniana amounted to more than 9,000 books, magazine articles, and pamphlets, beside the recorded lives of his contemporaries—Confederate leaders, federal generals, naval officers—and of soldiers and citizens who came in contact with Lincoln. Added to this were innumerable contemporary newspapers, as well as the accumulated files of the *Congressional Globe*. Hertz counted 170 anecdotes and an equal number of interviews and descriptions of the battles in both the North and South, as well as 150 photographs, besides the cartoons. Taken as a whole, *The War Years* forms a foundation as secure as the eternal hills of the Dakotas, upon which rests Gutzon Borglum's great stone face of Lincoln in its sublimity.

When the life of Lincoln was later condensed, omitted from it was a story that proved catchy in *The Prairie Years*. It concerned an apocryphal letter Lincoln was supposed to have received from a New York firm inquiring about the financial standing of a Springfield, Illinois, man. His answer was brief: "Yours of the 10th received. First of all, he has a wife and a baby; together they ought to be worth $500,000 to any man. Secondly, he has an office in which there is a table worth $1.50 and three chairs worth, say $1.00. Last of all, there is in one corner a large rat-hole which will bear looking into. Respectfully, A. Lincoln."

On one aspect of the voluminous work, virtually everyone agreed: it was different. Charles A. Beard believed that there never yet had been a history or biography like that of Sandburg's. "When specialists have finished dissecting, scraping, refining, dissenting and adding," wrote Beard, "I suspect that Mr. Sandburg's work will remain for long years to come as a noble monument of American literature."

Sandburg examines John Wilkes Booth in clinical detail. Apparently he tries to place himself within the eerie mind of Booth and finds this next to impossible. But Sandburg does not dismiss the man who shot Lincoln with a short and simple explanation. He shows that Booth had been influenced by prominent men who regarded Lincoln as a villain, a liar, and a deadly warmonger, thus his crime was more than an individual one. Sandburg came to the generous conclusion that Booth was insane, like his father.

"Sandburg was the right man at the right time from the right place concerned with the right subject to meet with consummate success," said Richard Crowder.[16] "I know no other work on nineteenth century Ameri-

can history that can surpass it for its depiction of the times and its delineation of Lincoln," said Louis D. Rubin, Jr. "I read it through again recently and was more than ever convinced of its magisterial stature. Sandburg's biography of Abraham Lincoln is a classic of our language; it puts the other biographies of the man in the shade."

It appears that nearly all the critics were in agreement over the pattern that Sandburg used. Professor Stephen B. Oates, who has written a recent, excellent biography of Lincoln, concluded that "the Lincoln of *The War Years* is an observed hero, filtered to us through the vision and sensibilities of hundreds of witnesses who called at his White House office, from generals and politicians and office seekers to the infirm, the destitute, and the ordinary."[17]

Not only was Sandburg familiar with the vast stretches of prairie that so distinguish and impress the visitor to the Middle West, but he knew the politicians too. He stated, "It has been said that in my rather long chapter in the Lincoln book dealing with him and office-seekers, I have shown some familiarity with that tribe. This is partly the result of firsthand experience with the hundreds who came to a new party taking over a municipal government. I got to know every variety of office-seekers, their wiles and stratagems. There are as many varieties of them as there are fish. You could fry some and they would be full of bones. Some are just suckers, others are catfish, once in a while you find a big trout or muskellunge."

Karl Detzer observed that only a good newspaperman could have written certain passages of *The War Years*. "The account of Lincoln's death is as superb a job of reporting as one finds in American literature, without a single useless word or unneeded phrase, wholly without emotion, but packed with the meticulous detail that makes great reporting. It is scholarly journalism." Sandburg said, "I search for picture words such as the Indians and Chinese have." In the four volumes are 107 poems.[18]

By now Carl Sandburg really had arrived. *Newsweek* ran his picture on the cover with the description, "Sandburg's life itself symbolizes for many that peculiarly American dream of great achievement from humble beginnings."

It is difficult to conceive of any significant things being omitted from this colossal biography. Yet Callan T. Tansill, writing in the publication *Thought*, charged that General Giuseppe Garibaldi, the Italian patriot leader whose exploits in South America as well as Italy had made his name a household word, is not mentioned in *The War Years*. Tansill points out that Lincoln's

officials, with his tacit approval, urged Garibaldi to come over and help the Union.

Sandburg may have been examining himself when he wrote about Lincoln Steffens (perhaps his first name added to this interest), the American journalist and editor: "He never lets up on those fishing expeditions into his swarmingly alive mind.... He can now get out of his grooves of thought, be free, and see the world anew."[19]

Reverend Constant R. Johnson, pastor of the Trinity Lutheran Church in Galesburg, stated at the 100th anniversary of the birth of Sandburg that "it is immediately apparent in reading Sandburg's autobiography that ties with the church and the faith were greatly influential in shaping the writer.... Biblical and church allusions are frequent in his poetry. There is no theme that is more cogently repeated in Sandburg's poetry than death—its inevitability, its democracy, its finality, and to some degree, a hope beyond it."

Encomiums continued to pour in. From Malcolm Cowley: "By God you pulled it off. Your *Lincoln* is good; it belongs with *Moby Dick* and *Leaves of Grass* and *Huckleberry Finn*; It's the best piece of American prose which has been written in the last ____ years. Fill in the blank yourself, but use at least two figures." Supreme Court Justice Felix Frankfurter wrote, "There is no individual I feel I know more intimately than I have known these many years, Abraham Lincoln. I have a little of that sort of feeling about you. And now that I have laid eyes on you only once, I feel I have known you these many years."[20]

James G. Randall, reviewing *The War Years* in the *American Historical Review*, stated, "To a task of heroic proportions, Carl Sandburg has brought his own type of fitness. This fitness is to be assessed in terms of a rare feeling for Lincoln.... By word-count Sandburg's six volumes, *The Prairie Years* with *The War Years*, are considerably longer than Nicolay and Hay's ten volumes. What we have before us is the world's longest life of Lincoln."

There is one observation in the Randall review that I have not discovered anywhere else: "that the whole work would have gained much and have lost little if it had been reduced to one-half of its present length.... Much of the work is not about Lincoln."[21]

Apparently Randall was highly regarded concerning his ability to judge Sandburg's work. Professor W. B. Hesseltine of the University of Wisconsin and a former teacher of mine, sent Randall a copy of his review of *The War Years* for *The New Leader*. "No one expected Sandburg to be a historian;

one had only a right to hope that he was a poet of power and insight. The documents, as every historian knows, were full, complete—and inadequate. Everyone knows what had happened to Lincoln: one needed a poet's interpretation of what happened in him. The publication of *Abraham Lincoln: The War Years* brought disillusion. Four great volumes set forth a succession of anecdotes. Here were stories about Lincoln—stories that Lincoln told, the words that men remembered, the words that Lincoln wrote—but nowhere any insight into the soul of the wartime President."[22]

Emanuel Hertz was more favorable. He believed that "there is only one other effort—that of Nicolay and Hay with which this book need be compared. . . . But as to lives of Lincoln there are no other that move in the same orbit. Too long? No, not long enough, if Sandburg has any other material which was not included. If I had the power I would legislate these books into every American home. . . . The most important omission is the fact that we have no final appraisal of Lincoln by Sandburg. This should have been added even if it had taken more years to do so."[23]

Sandburg later wrote to his friend Allan Nevins about the latter's multi-volume book, *The Emergence of Lincoln*. Said he, "It companions my *War Years*. They interweave. There are passages and chapters where you seem to have said, 'Having soaked myself in the materials, having walked so soaked, having gone to bed and been kept awake by what I was soaked with, now I shall write it and I hope it will look like good writing and if it is good writing it will be good history.' "[24]

Virtually unanimous acclaim was heaped upon Sandburg's classical description of Abraham Lincoln's death. After the assassination, the biography concludes:

> The last breath was drawn at 21 minutes and 55 seconds past 7A.M. and the last heart beat flickered at 22 minutes and 10 seconds past the hour on Saturday, April 15, 1865. Dr. Barne's finger was over the carotid artery, Dr. Leale's finger was on the right wrist pulse, and Dr. Taft's hand was over the cardium when the great heart made its final contraction. The Pale Horse had come. To a deep river, to a far country, to a by-and-by whence no man returns, had gone the child of Nancy Hanks and Tom Lincoln, the wilderness boy who found far lights and tall rainbows to live by, whose name even before he died had become a legend inwoven with men's struggle for freedom the world over.[25]

A friend of Carl Sandburg, writing from his upstate New York farm, Professor Louis C. Jones, penned a lyrical and conclusive panegyric. "I

have tried to be slow in coming to my judgment," he said. "I have tried to apply to it every known test at my command—as one who is interested in research, and in the literature whose material and expression come from America. The judgment is simple: *The War Years* is the greatest biography in the English language."[26]

# 12

## An Abundant Aftermath

In the war which Carl Sandburg had fought on paper, he had now come out the victor, so he enjoyed the spoils. The initial sales of the book were better than any expectations, and the money eased the financial problems of the Sandburg family.

In addition to the material rewards, honors were heaped upon the author. He was awarded the Order of the North Star by the King of Sweden. Then came in 1940 the most coveted American award. It was the Pulitzer Prize for history, the judges having extended their concept to recognize *The War Years* as history as well as biography. If this were not enough, the same year, Sandburg was elected to membership in the American Academy of Arts and Letters. On top of this came honorary degrees from Harvard and Yale, an unusual distinction, and others as well—from New York University, Wesleyan University, Syracuse University, Dartmouth College, Lafayette College, and Rollins College.

Sandburg had presented copies of his Lincoln biography to President Harry S. Truman, and he was proud to receive a letter from the President, which stated in part:

I am indeed grateful to you for that set of the six Lincoln volumes because not in my day will there be produced another study of the great Civil War President which will supersede them or, I venture to say, even approach them as the definitive work on this outstanding American.

I appreciate, too, more than I can say, the profound sentiments which you embody in the inscriptions on the flyleaves of Volume I of THE PRAIRIE YEARS and THE WAR YEARS. I like to think that my own Kentucky forebears, who were contemporaries of the Lincolns, represent that responsibility, honesty and common sense which have been the glory of the citizens of the Bluegrass State and of the Nation through all the generations from our beginnings onward to this day. When I read THE WAR YEARS in haunts made holy by memories of Lincoln, I shall often be reminded of the 'White House loneliness and laughter' which you mention with such feeling.[1]

Many men would have rested on their laurels, but not Carl Sandburg. He began writing a weekly newspaper column for the *Chicago Times Syndicate*, which was to continue for several years and was to keep his hand in writing, always a helpful habit for one who authors bigger things.

By 1941 war clouds had begun to gather over Europe and the United States, and many prominent writers became involved in aiding our military preparations. Sandburg helped with some Hollywood hoopla for the defense effort by narrating a short government film depicting the highlights of the Martin B–26 bomber. Said the *Hollywood Reporter*: "It ranks with the finest documentary films ever made. The impact of the picture was tremendous and it should have a terrific effect in awakening America to the great importance of the national defense program. It is completely absorbing and dynamic, made more so by the vivid narration written by Carl Sandburg which stresses power and certainty in its poetic composition. His words bear ominous import, yet are inspiring in their revelation of America's gathering strength."[2]

Sandburg also did some foreign broadcasts for the Office of War Information and wrote captions for a visual presentation, *Road to Victory*, for the Museum of Modern Art in New York. It was obvious that he had little time to celebrate, but no doubt he was elated at the birth of his first grandchildren, John Carl and Karlen Paula, born to his daughter Helga and her first husband.

In 1943 Sandburg published *Home Front Memo*, part of which was broadcast on "America's Town Meeting of the Air." In it he asked, "What is humanity's greatest need today?" He answered by saying that "the greatest need of mankind today is a combination of freedom and discipline holding sway over the earth of all nations and individuals. That sounds like

something. But it doesn't mean a thing. Not unless first of all we come to a common agreement about what we mean by freedom and discipline. Lincoln saw this in his time when he said in 1864 that 'the sheep and the wolf are not agreed upon a definition of the word liberty.' "

Later in this little book, Sandburg spoke of freedom: "Either the Four Freedoms are going to work over this modern world where each continent listens to the others day and night and man flys across oceans every day—or else the Family of Man over the globe can hope and expect nothing more than one world war for each generation. . . . Responsibility—how often Lincoln lingered over that word. And the word Duty—how Robert E. Lee put it among the highest. Freedom, yes. But we can't have it without chastening periods when we get our shoulders under heavy loads of responsibility and duty."[3]

There was one person who did care what Sandburg was not saying. It was Martha Dodd, who apparently had asked him for a blurb to accompany a book she was writing. Evidently Sandburg had not complied with her request, for she wrote him, saying:

> Honesty and simple human virtues seem to have, ironically enough, lost their meaning to a man who has devoted a large part of his life to the study of Abraham Lincoln. A man who resides on Mt. Olympus, I suppose, considers himself above the struggle. . . . It is sad to me that during the last two years I have had to revise many opinions I had held about you. You seem to have lost touch with the people upon whose hopes, needs and backs, literally, you arose. Without those people, the blood and marrow of your poetry, your greatness cannot be real. They are being betrayed. Surely you cannot stand by and applaud. If I were naive, I would expect an apologia. Not being naive, I expect your continued silence.[4]

As the months went by and our country was drawn closer to involvement in World War II, Sandburg was approached by more and more organizations to help stir up sentiment and assistance for the Allies. Prominent among these was the Committee to Defend America by Aiding the Allies, headed by William Allen White. Other friends of Sandburg's active in the committee were Robert E. Sherwood, Tallulah Bankhead, Van Wyck Brooks, and Christopher La Farge. In an urgent letter of appeal, the committee wrote:

> The risk of war is inherent in every move this country makes toward the major objective of defending herself by aiding England and her Allies. The risk of war is much greater in any contrary policy which lets England fail. It

is the duty of the writers of America to inform the people, continually, and
by every form of publication, platform speech or radio, that the risk of war,
or that war itself, should come, is of less importance than the survival of our
institutions.... Unlike 1914, wars today are not waged by armies alone.... 
The question is, shall we aid England now, or prepare to spend the rest of
our lives in arms?[5]

If words could have won the war, this distinguished committee would
have been victorious, for its many members poured out a torrent of letters,
announcements, press releases, and other publications, as well as verbal
eloquence on the platform and radio.

Of course Sandburg responded. He helped by making a broadcast over
Radio Station WBBM, Chicago, and the Columbia Broadcasting System. The
Chicago unit of the committee, headed by Paul H. Douglas, was hearty in
its thanks for the broadcast. The national committee reported to Sandburg
that "no one who has ever spoken for us received as much enthusiastic fan
mail as you did and it is gratifying to know that so many listeners were
inspired by your important message."[6]

Sandburg copied the lines from Longfellow, "Thou, too, sail on, Oh Ship
of State! Sail on, O Union, strong and great!" and sent them with a poem to
President Franklin D. Roosevelt, who was struggling with the great prob-
lems of World War II, then still confined to Europe.

Exactly eight months before the disaster at Pearl Harbor, President Roo-
sevelt wrote to Sandburg:[7]

<div style="text-align: right;">The White House<br>April 7, 1941</div>

Dear Carl Sandburg:

I have received through the kindness of Archie Macleish that copy of your
poem: 'Mr. Longfellow and His Boy' so carefully written out by your own
hand. Your treatment of this inspiring theme is masterly. It reflects deep
poetic sentiment, expressed in lines of singular beauty and sinewy strength.

Naturally the poem makes a strong appeal to me and I need hardly assure
you that this copy in your own handwriting will find a place among the
personal mementos I cherish most. Please accept my heartfelt thanks.

<div style="text-align: right;">Very sincerely yours,<br>Franklin D. Roosevelt</div>

As we have seen, Carl sometimes had his own little wars with individ-
uals. Some criticized his writings, others his viewpoint, and still others his
way of expression. One in the last category was Congressman Clare E.

Hoffman of the Fourth Michigan District. There appeared in the *Washington Post* of September 14, 1941, a column of Sandburg's attacking Hoffman. The column compared him to one-time Congressman Clement L. Vallandigham from Ohio, who in 1863 was court-martialed for a speech he made that was sympathetic to the South. Vallandigham was the most prominent of the Copperheads, who opposed Lincoln's policies.

Congressman Hoffman wrote to Sandburg protesting his inference that he and Congressman Hamilton Fish should be deprived of the right to talk in the House of Representatives "because we think we see danger in some of the New Deal policies and in the President's foreign policy." Hoffman went on to say, "You characterize me as a 'human canary' and charge that, in the House, I speak merely to give my 'tonsils and oral organs a necessary habitual workout for personal relief.'... And by the way, let me interject here the information that my tonsils were removed long ago, so there goes half of your argument.... In any event, let me thank you and point out that if Fish and I are merely talking for publicity, you are helping us in giving us publicity."[8]

Doubtless Sandburg liked the humorous figures of speech in this exchange. Humor was part of his laborious life. For example, he is quoted as answering a question about the definition of an extensive novel in one of his lectures:

> A long novel isn't a folk song but is four lines of verse that compress a long, a long novel.
>
>> Papa loved mama.
>> Mama loved men.
>> Mama's in the graveyard.
>> Papa's in the pen.   (Laughter)
>
> With that verse you don't need to read Faulkner.

The cornucopia continued to pour out its rewarding contents. Allan Nevins wrote from Columbia University asking Carl if he would be willing to go abroad for eight months as Harmsworth Professor of American History at Oxford University. This is an honor prized greatly by academic historians and one that comes to few. Perhaps because of his busy schedule or the chaotic war conditions, Sandburg declined, but it must have been with much reluctance.[9]

Another offer apparently was more attractive. Sandburg had been discussing with Metro-Goldwyn-Mayer Pictures the idea for a full-length novel

and feature film about American life to be called "American Cavalcade." It was to "depict the courage, foresight and fortitude of the people who built up the nation" and those who followed. This was in September 1943, and a little over a year later, Sandburg received a check for $40,000 for the project. "American Cavalcade" was never made, but this was the germination of his big novel, *Remembrance Rock*.

In the fall of 1944, Sandburg went to California to write the novel. Like so many famous writers who had been lured to Hollywood for money and glory, he soon found himself lost in the movie melange. One day Mrs. Lilla Perry, who with her husband, a Los Angeles librarian, were friends of this writer, received a telephone call from Sandburg in Santa Monica. "MGM has got me out here to write a novel which they want to put into a movie," intoned the mellifluous voice, which nevertheless held some anxiety. "I am to meet with them daily till we get the general skeleton worked out. But they've put me up here at this Casa Del Mar at the Studio's expense, and I find I can't write a word. Isn't there a corner for me at your house, Lilla? I've been here three days now in all this elegance and I can't do a lick of work here. I've stared at the walls unable to get a line on paper. I've always been able to work at your house. Can't you find a spot for me?"[10] He stayed with the Perrys for over a month and enjoyed it not only because of fellowship but he was "far from the madding crowd."

Unfortunately, *Remembrance Rock* never was made into a movie, but MGM "continues to share in the author's royalties from the published book."[11]

President Roosevelt's death brought unusual sadness to Sandburg, for he was an admirer and devoted follower of FDR and his administration. Now, true to his Democratic adherence, Sandburg turned to Harry Truman, who was feeling his way uncertainly in his unexpected position as Chief Executive. Always willing to set forth his views and support to those who he felt deserved them, Sandburg wrote to President Truman four months after Roosevelt's death:

> From your public acts and speeches . . . I have come to know you as I have known Lincoln and FDR, from a distance and in the perspective that the People sense a friend in office and high power. And I believe if Lincoln and FDR from the shadowland could be watching you now they would say something like, 'He is of our fellowship, one of us, trying to keep close to the people in what they want done and keeping just a little ahead of them all the time.' You are making your own style and shaping a tradition personal to you. I can reconcile your piety, prayer, profanity, piano playing and

persiflage and it's all of a weave and makes for sanity and sagacity, from my seat in the bleachers. Your sense of timing, your solemnity and brevity, your devotion to duty and capacity for toil, your peculiar grasp of events in moments having no precedent to guide you—it all adds up to something distinctive and superb in our history.

P.S. When in 1897 I was 19 and you were 13, I worked as a railroad section hand at Bean Lake, Missouri, not so far from where you were a 13-year-old kid at Independence, Missouri which I knew then as merely the home town of Jesse James. How tempus shore do fugit![12]

In an interesting coincidence, a next-door neighbor of mine in New York City, C. D. Batchelor, prize-winning editorial cartoonist of the *New York Daily News*, was a friend of Carl Sandburg's. Clear memories still linger of riding around with him in his big old convertible, the wind blowing his shaggy black hair and the city dust collecting on his huge horn-rimmed spectacles. Batchelor was a colorful and unconventional man, just the type who appealed to Sandburg. They corresponded and Sandburg called him "Batch." Undoubtedly the two enjoyed the mutual friendship. Although both have passed from the earthly scene, Batchelor has left in his own large cartoonist handwriting the following bulletin:

Lost: Somewhere in the wilds of North America. One major poet. May have strayed or more likely been stolen: Can be recognized immediately by an incomparable head of recalcitrant white hair or a see gar which is so short the phiz seems to be on fire—and probably is—for the fires of youth still burn brightly. If given half an opportunity will eloquently orate on the kept press or will burn with fervor at injustice and wrong. Is much beloved and honored even while living (most unusual in poets). Finder will be rewarded with the gratitude of a bushy-haired cartoonist in domicile at the Glass House on the tip of the Grand Canyon of the Manhattas, 324 E. 41st St., N.Y. City.[13]

As busy as he was, Sandburg could take time out to read and compliment the work of a younger writer who might catch his fancy, which was not too often. Doubleday published a book by Beth Brown, who was a beginning author. After reading it, Sandburg wrote, "*That's That* is a duck, a darling and a darb of a book. First, because of the way it says what it has to say, second, because of what it has to say, third, because it knows where to stop and say no more."[14]

Back in Harbert, the Sandburgs began to realize that they were getting older and the cold climate of the lake shores was not getting any warmer. So in 1945 they decided to look elsewhere. Paula made a study of weather

conditions throughout the United States and eventually decided that the area around Hendersonville, North Carolina, in the western part of that picturesque state and on the edge of the magnificent Great Smoky Mountains, was the best place. They purchased the former home of Christopher G. Memminger, built in 1836, in the little wooded and quietly residential town of Flat Rock. Memminger was Secretary of the Treasury of the Confederacy under Jefferson Davis. Here was irony indeed. The biographer of Abraham Lincoln, the opponent, if not the enemy, of Davis, moving into a southern domestic stronghold. But such irony appealed to the Sandburg humor. Carl felt it was just the place he had long sought; here was the poet's end of the rainbow, to be his last domicile, a huge house and estate that caused his friend Harry Golden to remark, "Your old Socialist colleagues up in Wisconsin must be turning over in their graves."

Perhaps Memminger was turning over also. As Secretary of the Treasury under Jefferson Davis, he faced a difficult, if not hopeless, task because of inadequate tax laws and military reverses. When the credit of the Southern government collapsed, Memminger was generally held responsible. In 1864 he retired to his Flat Rock home, where he stayed until the war was over. In 1867 he returned to Charleston, where he practiced law.

Before he left Michigan, Carl became acquainted through a Los Angeles friend with Navy Lieutenant Kenneth Dodson, executive officer of an attack transport. The young officer was interested in writing about his wartime experiences and somehow appealed to Sandburg both as a person and a potential writer. Perhaps Carl also saw a source of some good material for the novel he was planning, which was to include the current world war. He asked Dodson for permission to quote his letters to Sandburg in the novel and these were later used. He also helped Dodson find a publisher for his first book, *Away All Boats*.

The fall of 1945 was moving into winter and it was time for the Sandburgs to journey southward. They left their home in Harbert with pleasant memories. Paula said little about it, but she surely felt that the house beside the dunes had been a good home. Helga recalled the glowing sands beside the great lake, the family animals, the fragrant spaghetti sauce and hot cobblers around which the family gathered in the evenings. Always they would remember the father working upstairs and now and then stamping on the floor when noises from below disturbed him in his writing.

Carl was the last to leave. When he did, he must have been in a hurry, for a friend, Thomas I. Starr, a Michigan editor, reported later that when the

Sandburgs were packing to move, he found Carl's quarterly Harcourt, Brace dividend check in a pile of old papers in the garage. His plans for writing and travel were still uncertain. On the morning of November 19, 1945, Paula and Janet and a nephew named Eric drove away in the rain in a station wagon pulling a trailer that held sixteen blue-ribbon Nubian goats. With mixed feelings, Carl watched them go. He was soon to join them, but he was now sixty-seven, the age of George Washington when he died.

# 13

## Connemara: A Confederate Retreat

Moving from one home to another is always a tedious undertaking, but when the paraphernalia of a prolific author is added to the bulk of the family belongings, the task is doubly difficult. So it was with the Sandburgs. Paula had chosen well, and although she had her husband's approval, he, as usual, bowed to her good judgment.

The name of Connemara had been given to Memminger's home in 1900 by a man named Ellington Adder Smyth, an Irish Presbyterian who had come from a part of Ireland described as "a lovely, wild district in western Ireland where a lot of people still use Gaelic as their native tongue."[1] The name was one that Carl liked to roll over on his tongue and pronounce in that sonorous voice of his.

Connemara is a beautiful place with tall trees, wide pasture land, wild-flowers, and a small picturesque lake at the foot of a grassy slope that stretches gently upward to the impressive white wood-frame house. The house is a tall, impressive structure with white pillars in front and steps leading up to a spacious porch with a view of the Blue Ridge Mountains in the distance. When the Sandburgs moved there, horses grazed on the pasture below the house. In the winter these horses pulled a wooden drag

that cleared the occasional snow from the driveway that winds beneath the pine trees to the road below. At the back of the house are tall hemlock trees on the lower part of which were many bird feeders. These attracted large numbers of grosbeaks, purple finches, cardinals, and noisy blue jays. In addition to the Sandburg goats, there were a few cats and dogs and now and then a cow.

Beyond the hemlocks and out of sight but within hearing, Carl had a chair on the granite rock at the edge of the woods. There in the daytime he would usually work through the afternoon, his shirt collar open, taking in the sun and fresh air. By this time he had to watch his health more carefully and besides his eyeshade, he wore in cool weather a scarf around his neck and an afghan over his knees. At times he wore a sweater with the sleeves tied behind to give him more freedom of movement to write.[2]

Not long after arriving at Connemara, Carl wrote his friend Lloyd Lewis that "the health of the Missus, the ancient desire of Helga for a farm and horses, the plight of barn-fed goats who want pasture, these sent us to N.C. I told 'em I'd go any place they picked and it was just an accident that the Memminger place was there at a price near silly." The estate had twenty-four outbuildings, which included a garage, chicken house, pumphouse, springhouse, woodshed, tenant house, gazebo, icehouse, barn pumphouse, barn garage and main barn, horse barn, cow shed, storage shed, silo, and milkhouse, most of them situated along the curving drive behind the house. "We didn't buy a farm," said Paula, "we bought a small village."

Val Lauder, writing in the *New York Times*, March 30, 1975, noted about his visit to the restored Connemara:

> There is a quaint, almost turn-of-the-century simplicity to the work study. Perhaps more than any other room in the house, it looks as if Sandburg had just stepped out. The old black typewriter sits on a wood orange crate. Other upended crates and boxes at the back of the desk hold papers. Research material is spread out on the lid of an old tin stove, its unpainted stovepipe angling up through the ceiling. The papers and notes of the moment fan out on a table to the left of the typewriter, secured by a heavy letter opener—the notes bearing his own shorthand: 'clipps' (for 'clippings'), 'w' (for 'with'). An empty sheet of paper has been rolled into the typewriter . . . and waits."

Paula Steichen, the granddaughter, recalls that the family there consisted of the two elder Sandburgs, the three daughters, Margaret, Janet, and Helga, and the two grandchildren, John Carl and Karlen Paula, who was named after her grandmother. "This wilderness of Connemara," wrote the

younger Paula, "this wild, sweet way of Connemara, would come back to me always after leaving—in the scent of wild blackberries, the nickering of a colt watching its mother being led away to plow, the feel of wet morning grass on bare feet, and the moving of a herd at milking time up the pasture land—a little hurried, anticipating the sweet molasses grain and the company of the herdsmen and my mother, caring for and coaxing them, considerate and firm."[3]

Although the house was impressively set in a picturesque landscape, it needed some changes. For the Sandburgs, the ceilings were too high. So they had these lowered. There were only two bathrooms and these were increased to four. There were virtually no closets, so the Sandburgs had some built in. The bookshelves in Michigan were taken down and moved to Flat Rock, as were some 12,000 books.

On approaching the Sandburg home at Flat Rock, one makes a turn in the tree-lined road through a cool, leafy recess. Suddenly the house appears, high on a hill and framed by towering white pines. The dormer windows offer a view of forty miles to the majestic Smoky Mountains. The squarish house itself sits on an elevation of about 2,500 feet, at the center of a 235-acre plot of woods. Inside on a clear day the sun poured brightly through uncurtained windows, and in one room was a white mantel, beneath which the hearth was filled with various kinds of walking sticks, for there was lots of walking in the Sandburg family. The high bookcases—some of them with eleven shelves—held every type of subject, from the *U.S. Camera Annual* to southern volumes on the Civil War to Swedish, Japanese, Russian, and Chinese literature.

In each room there was a fire extinguisher and a guitar case. On the first floor stood stacks of Sears Roebuck catalogs, in reverential memory of the outbuildings of yesteryear, which were used as footrests when Carl played his guitar. In an upper room, as in Michigan, was the realm of the author himself, a place of orange crates and other such boxes, but now these were close to a chrome-and-leather chair and his typewriter. There he made changes on proofs and wrote poems, some of which remained in his desk drawers for as long as twenty years. Carl usually slept through the early part of the day and worked in the evening hours. Upon arising, he did calisthenics, took walks, and exercised by raising and lowering a heavy oak armchair above his head to keep in shape. Perhaps he would visit the goat pasture in the afternoon or stop at the big moss-topped rock to work for awhile. For a time the Sandburgs were on the prosperous neighbors' guest

lists, but soon they learned that Carl was likely to show up in an old red shirt—that is, when he did not entirely forget the invitation. Finally, the neighbors decided that the Sandburgs were living in "another world."

But the man of Connemara was not entirely aloof to his surroundings. He appeared by request at the local Moore General Hospital and spoke, read, and sang for the patients and personnel. He was introduced as the "greatest living authority on Abraham Lincoln." Sandburg prefaced his recital by saying that "but for certain circumstances, the late war might still be running and have years to run." He referred to the atomic bomb as a weapon that had brought new problems to this country, but he felt that the problems were an acceptable price since the bomb had shortened the war. At one time in his performance, he quoted the proverb, "Nothing is more certain than death, nothing more uncertain than the hour." He added that it applied well to the recent passing of General George S. Patton, and as he lingered upon the saying, there was a feeling that he was also thinking of himself.

When the family gathered, Connemara hummed with activity. Besides the immediate family, Helga's young son and daughter, John Carl and Paula, enlivened the proceedings. Jackson, a shaggy cocker spaniel, also appeared, as did Chula, a fine-looking Siamese cat. Of special importance were the goats. Although Carl spent some time with them, they were really Paula's concern, and she continued her expert interest in them, one that turned to a pretty profit as well. Paula knew every goat by name and its ancestry. Helga put up billboards in the farm office with pictures of the goats.

The father now found that climate was not the only necessity for his well-being. He found at long last that six hours a day was the limit for his writing, four being better. But he also discovered that even with this schedule, he often became so immersed in his research that his companions, "the night stars," soon slipped away, and over the deep blue Smoky Mountains came the sun and "rosy-fingered dawn." Complemented by the boxwood and bamboo that Christopher Memminger himself had planted, this quiet vista must have reminded Sandburg of earlier dawns in Illinois and Michigan of which he had so eloquently written.

The Sandburg women were not to live like ladies of the Old South. They had been too accustomed to hard housework. The few servants they tried turned out to be too town-loving and hour-conscious. So Paula and the daughters settled into their old routine, with the lord and master of the

household now nearly always close at hand, coming into the kitchen or laundry from time to time to pass along a bit of poetry or homely philosophy, often accompanying himself on his "gui-tar."

It was a happy home, probably because it was busy. Paula attended to the goats, and one day as one of the goats nuzzled against her, she explained that the goats would not eat her clothing but added that they were fond of nylon. At a stock show she recalled that a visitor had been standing and talking and not paying any attention to the Sandburg goats. She was wearing a nylon skirt and one of the goats came up behind her and started nibbling. Before the woman knew it, the goat had eaten the back of her skirt.

Mrs. Sandburg could quote production figures, butterfat percentages, and breeding methods. Milk from the goats was sold to a nearby Hendersonville dairy, and many letters regarding the herd were received from different parts of the country. A Cuban wrote that he wanted "to buy some of the goats from the farm of that wonderful biographer of Lincoln."

Asked if she was lonely when her husband was away, Paula told Karl Fleming of the *Asheville Citizen-Times*:

> Dear, no. I look forward to it in a way because it gives me a chance to catch up on my own work. I think it is good for couples to separate occasionally. And Mr. Sandburg always has such interesting things to tell me when he gets home. I have never felt left out. And I have never felt that I had a right to interfere with Mr. Sandburg. When we were first married, I felt that what he was trying to do was wonderful and gave him credit for his wonderful vitality and energy. He was working sixteen hours a day, part of the time at the paper and then at home on the first Lincoln biography. But I think a woman should create interests of her own. It would be a lonely life if a woman didn't get interested in things for herself.

Paula told how she had selected the place, how Asheville did not have the kind of house they were looking for. "The decision came when Mr. Sandburg came down and saw the view from the front porch," she said. As to the house, she added that she did not like the rooms that look like a window in a furniture store, because these windows look so cold and unlived in. Referring to the Sears catalogs and books piled around, she commented, "And if he wants to leave that stack of books there for a month, that is all right with me."

She admitted proofreading the Sandburg copy, saying that she herself usually remained at the farm year-round, except when she visited her brother, Edward Steichen. She said that the two most understanding men

she had ever known were her husband and brother, both of whom she felt had attained greatness. She felt that understanding and greatness go together. "Mr. Sandburg," she said, "is interested in everything and has been interested in every person he ever met. He likes people. I believe this leads to understanding. He is very easygoing. I can put a dish on the table about which I have some doubts and he'll say, 'My dear, I couldn't have gotten a better dish at the finest hotel in New York.'"

Much mail was received at the Flat Rock home. And much of it went unanswered. Sandburg once told me that if he answered all the letters he received, he would not have time to write his books. When people wrote to ask the meaning of some Sandburg poem, Paula would often reply for him in the words of Browning, "When I wrote that poem, God knew what it meant and I knew what it meant. Now only God knows."

But more goats than poems kept popping up at Connemara. Bill Sharpe, a writer for the State News Bureau in Raleigh, noticed that "Nubians, Toggenburgs, and Saanems are fine goats but not literary goats and show little interest in Sandburg and his work." "Just like cows," Helga says, "except they have only two teats and a man with two hands and a willing heart can milk one in a jiffy. A good goat will yield three and one-half gallons a day. The milk is wholesaled to a downtown dairy and is in demand by people all around, especially by hospitals."[4] One goat was named "Felicia Agawam," and she produced her weight in milk.

When he was not working or mixing with the goats, Sandburg sat at a cozy window by the radiator in winter and watched the birds fly by, among them the rosy-breasted purple finches, which took full advantage of the bird feeders behind the house. Carl usually took his daily exercises on the front porch by stretching and turning his body, trying to keep in what he liked to call "baseball trim." Helga recalled how he would open his pocket knife and throw it up in the air, then catch it by the handle with the blade still open, to the consternation of his family.

"Can't you stop him?" she once asked her mother.

"I never tell Carl what to do," was the answer.

Then she asked him what he wanted for supper and he responded that he didn't care, that he had "been a bum all his life."

When they brought him his guitar, he strummed the chords and asked if they wanted to hear "Red Iron Ore." Then he admitted he might have forgotten the words. Instead he asked, "How about 'When the curtains of night are pinned back by the stars, and the beautiful moon swept the sky?'"

Meanwhile, the Michigan neighbors were lamenting his leaving. An As-

sociated Press story stated that Lake Michigan was losing one of the best stone-skippers ever to hurl a piece of shale across its rolling waters.

With the exception of feeling his advancing years, Sandburg liked the South. After all, he had been all over it in his lectures, he had written about its Confederate leaders and had tasted its hospitality. He said, "If anything, I've found the colleges and universities and teaching here even more liberal than in the North. Tolerance is here in great measure today." He added that he never let a day go by without doing some writing. "You know, you've got to let the hook down and float a sinker to see what's going on in the old bean.... For many centuries, it has been taught that mankind is one blood and the family of man is a unity. And now the airplane, radar, and above all, the atomic bomb, tell us we must change our habits and think in terms of global humanity. Otherwise, the two world wars we have seen will each look like a pleasant picnic compared to what can and may come."

In 1947 Sandburg and the James G. Randalls, among others, went to Washington for the opening of the papers that had been deposited in the Library of Congress by Lincoln's son, Robert Todd Lincoln, who had specified in his will that these documents were not to be opened until twenty-one years after his death. Randall prepared an article on the event for the *New York Times*, Sandburg for the *Washington Post*. The date was to be 26 July, so those concerned gathered in the library at midnight of the preceding night. As the clock struck, Dr. C. Percy Powell of the library staff twirled the knob of a big safe and its door swung open. There, where they had been lying for many years, were the manuscripts. Sandburg and the Randalls took over, and, amidst lights and the click of press cameras, worked away at the papers until four o'clock in the morning.

At first glance, the collection did not seem to the two Lincoln experts to be anything exciting. Sandburg left Washington, but the Randalls stayed on for months. He returned in a matter of weeks, however, and spent half a month going over the documents more carefully. He and the Randalls worked at one of the big tables in the Manuscript Division, and when either of the men found what he considered to be a choice item, he would signal the other. At noon they went out to one of the few nearby restaurants and discussed their research. After lunch, they would walk until Sandburg gave the word that they would have to return: "Back to the salt mines!"

Sandburg and Randall commented that working in these "new" Lincoln papers made them feel like preachers attending a theological convention:

they returned home refreshed in spirit. Although the contents of the papers were not sensational, they did contain many letters to President Lincoln from ordinary citizens involved in the Civil War, telling him their vivid impressions of the conflict. This of course Sandburg liked. After dinner, the researchers would often walk past the majestic Capitol building, lighted at its dome with a brilliance that always inspired Sandburg. It made him feel poetic and reminded him of Lincoln. He spoke of this to his friends and they well understood.

Professor Randall reported that "when the Lincoln searchers that night in the Library of Congress plunged into the papers—dashing from volumes to index and back to volumes—(some of us with the uneasy realization that we would have to do a radio broadcast that afternoon) when all this was happening, it was Carl with his rich humor and his booming laugh who was the life and soul of the party. When in the afternoon ceremony Carl was presented to the audience, he received an immediate ovation that was rousing, spontaneous, and soul warming. We who know Carl can understand why all America loves him."

All too soon September came and the friends parted. James Randall saw Carl Sandburg off at Union Station and that night wrote in his diary, "Gosh, how we will miss him." A few years later, it was Sandburg's turn. Randall had developed leukemia and Sandburg went to see him in Urbana, Illinois. The pale, thin face of the popular professor lighted up when he saw his old friend for the last time. On this occasion, Sandburg spoke movingly of Randall's last volume of *Lincoln the President*, describing it as a lovable book. For his part, Randall said, "We need our poets. They are our eyes, our ears, our voices and a good deal more. In Carl we have a great American poet. Sometimes he is whimsical, sometimes in dead earnest when aroused by social injustice, but always he is Sandburg and that is enough. He has given us our own America. He has given us Lincoln. There are three great words that belong together: America, Lincoln and Sandburg."

Meanwhile, the nation was beginning to prepare a lasting tribute to the poet who had sung of its many moods. In Galesburg, a restoration of his birthplace had been undertaken. First there was a search for the house and it was finally found near the railroad yards, in a dilapidated condition and owned by an Italian woman. Over her protest, a plaque about Sandburg was hung by the front door and a large rock was placed on the terrace. Sometimes the indifferent woman would hide the plaque and try to remove the stone. When she died, her son sold the house to the Carl Sand-

burg Association, which was formed to receive donations, and the restoration project was incorporated as a nonprofit educational institution. A fund-raising campaign to purchase the house was launched and the price was raised within sixty days. Work on the birthplace was begun in the early spring of 1945, as sums small and large came in from all sections of the country, including the pennies and nickels of school children.

The siding, plaster, and lath underneath had deteriorated, and these were duly restored. A fence of split hickory pickets was erected around the yard, an old wooden pump of the 1870s was installed, and shrubs were set in proper places around the yard. The original walls had consisted of wide interior boards standing upright and papered repeatedly, but lath, plaster, and siding were used in the restoration.

From the Sandburg family came the Bible that had been used when Carl was a boy, some old wooden chairs, and dishes and cooking utensils. On view also is the stereopticon Sandburg used when he sold similar instruments during his summer vacations as a student at Lombard (now Knox) College. Old families around Galesburg contributed rope and trundle beds with handwoven coverlets harking back to bygone days. On the walls hang pictures of the parents, of their children and grandchildren, and some photographs by Edward Steichen. Conspicuous in the collection are three of the earliest works of Sandburg, written while he was in college: *Incidentals*, *The Plaint of a Rose*, and *In Reckless Ecstasy*.

Adding a touch of realism in the little bedroom is a radiophonograph with recordings by Sandburg, including selections from his songs and his poem *The People, Yes*. Here, too, is a venerable typewriter on which he wrote some of his Lincoln biography and his children's stories. Other items on view include deeds to a home the family owned later on which the father had made his "mark" in 1894, not being able to write his name.

Perhaps the outstanding room in the Sandburg birthplace in Galesburg is fittingly called the Lincoln Room and is the result of donations of friends. Its walls are of knotty pine, and the bricks in the chimney came from an old Galesburg house that had been a stopping place for the "underground railroad," secreting slaves on their way out of the country in Civil War times. On the mantel is a picture of Lincoln, given by the widow of the artist N. C. Wyeth. Beside the fireplace are a pitcher and platter that Lincoln presented to his friends Elizabeth Burner and Isaac Gulliher on the day of their wedding in New Salem in 1831, donated by local descendants of that couple. Beside a wall is a pine desk taken from the Bishop Hill Swedish

community, and on this is a model of a covered wagon by Earnest Elmo Calkins. A rifle of pioneer times reposes over the collection. An iron grease lamp that hangs beside the fireplace is said to have been presented by the Lincolns to their neighbors when the Lincolns moved from Indiana to Illinois. Just before he died, the collector Oliver R. Barrett sent an original copy of an 1863 call for additional troops from Massachusetts, which was signed by Lincoln.

The Carl Sandburg birthplace was dedicated on October 7, 1946, the anniversary of the Lincoln-Douglas debate in Galesburg. Speakers paid tribute to the man who had made the town famous. The main address was by Marshall Field, the noted Chicago merchant. From the *Chicago Tribune* had come Fanny Butcher to talk on the appearance of Sandburg's *Chicago Poems* and his subsequent rewards. Quincy Wright, Harry Hansen, the Reverend Alan Jenkins, and Ralph G. Newman paid warm tributes to Sandburg. Inside the cottage may be found these words by Stephen Vincent Benét: "He came to us from the people whom Lincoln loved because there were so many of them, and through all of his life, in verse and prose, he has spoken of and for the people. A great American, we have just reason to be proud that he has lived and written in our time."

So this three-room birthplace, though restored, breathes warmly of the earliest days of the poet-biographer. Here Carl Sandburg lived until he was three years old, while his father worked as a blacksmith in the nearby C. B. & Q. railroad shops for nine dollars a week. Those in charge of the home do not pretend that it is all authentic. In fact, only three chairs in the living room, the washstand, and two wall whatnots in the bedroom are from the original birthplace. The rest of the picturesque furniture was selected as representative of that used in small homes of people with small means in the days when Sandburg was born.

At the rear of the tiny house is a large stone called "Remembrance Rock" after Sandburg's novel of that name. Dedicated on June 4, 1966, it was used the next year to shelter the ashes of Sandburg himself, which were placed there by his widow during memorial services for him on October 1, 1967. Surrounding the sturdy stone and its buried treasure is a small park that has been planted with dogwood, white pine, and red maple trees— brought here, along with soil, from Connemara.

Credit for the restoration goes to the late Mrs. Adda George, a former English teacher and widow of a professor at Northwestern University who had retired to Galesburg and became interested in bringing to public view

the Sandburg birthplace. When Mrs. George was unable to carry on the restoration work, her place was taken by Mrs. Juanita Bednar, who served actively as head of the project until her death in early 1968.

Lauren W. Goff, a retired transportation official, and his wife, Mary, acted as hosts and showed a dedicated interest in Sandburg, as well as in his birthplace. Goff liked to reminisce about the days of the poet and is impressed by the belief that Sandburg was strongly influenced by the writer of "Little Drops of Water," Julia Carney, about whom he wrote, "She has a tiny, quaint niche in the history of American literature."

Goff recalled animatedly the occasion when Sandburg came to the restored home in 1958 for the observance of the centennial of the local Lincoln-Douglas debates at Knox College. When he first visited the cottage, Sandburg at first seemed embarrassed, Goff recalled. Someone asked him if he had actually slept in the bed in the bedroom. Sandburg paused a moment, then lay down on the bed and closed his eyes. Rising, he said, "Now you can say that I slept in it."[5]

When someone really appealed to Carl Sandburg, it usually became a long-lasting association. Such was the case of Navy Lieutenant Kenneth Dodson, some of whose letters Sandburg was using in his big novel, *Remembrance Rock*. On June 6, 1947, he wrote to Dodson that he had just read a dozen of his letters and found them deeply moving. He told Dodson that the letters had given him

> a lift to go on in the final shapings of this long book that curiously and inevitably has gone on so much longer than originally planned. It may be that I shall have presented, across a timesweep running back to England in 1608, parts of an American testament. Perhaps the gist of it is in your sentence on the U.S.S. *Pierce*, January 14, 1945: 'Nothing seems sure and there is little to hang on to but faith.' The time of my west coast trip now depends on when a hardworn editor returns from a vacation. Before I start for the conference at MGM I will mail to you, in confidence, the entire manuscript of the book. . . . Perhaps I told you of Steichen on the *Lexington*. A disabled plane hit the flight deck with its engine slewing off to kill two men and cripple five others, its whirling propeller knocking off Steichen's cap! So when we meet, call him "The Phantom." And I'll call you the same.[6]

Just why Sandburg placed so much weight on the literary judgment of a Navy lieutenant in analyzing a huge, wide-ranging historical novel is not easy to determine. But there again, he had faith in the young officer, and to Sandburg that probably meant more than anything else. Learning that

Dodson was getting advice about his writing from professors and others, Sandburg wrote him:

> I doubt whether any of them can help you. Your genius at times is that of a prophet, a preacher, a spokesman, a wayshewer, a sailor, a commander, a mariner, a strong man with a great heart never lacking hopes and visions. The people you have met and know, the ports you have seen, the memories of gardens and battles, the books and sermons you have read and heard that you still keep pondering on—I don't see how any counselor could go much farther than saying: You have been places and touched people. You are a man of a thousand stories. Find a framework. Then write it. Then overwrite it and cut it down. Let no day pass without writing it. When the going is good with you, your sentences march and hammer and sing low and what is called style is there in a simple perfection. . . . What of the excellent novelists who have said, "My characters run away from me and become other than I first imagined them." I have known newspaper staffs where a saying ran, "The way to be a Star Reporter is to break all the rules." I heard Steinbeck say regarding *Of Mice and Men*, "I began with an equation and after that the story wrote itself." Paganini had a formula: toil, solitude, prayer. Steichen, after World War I put in a year making a thousand photographs of a cup and saucer.[7]

The Sandburgs settled down in their new home, but that did not mean everything was always serene. Asheville newspaper editor Don Shoemaker met Sandburg soon after he arrived at Connemara and with typical humor presented the editor with half a cigar. It happened that not long afterward, his doctor ordered Sandburg to stop smoking. Shoemaker described to me how he helped Sandburg fend off those who tried to take advantage of him, especially the bores and the gushers. "No man of course was ever larger in these parts," Shoemaker reminisced, "including Thomas Wolfe. The conventions that came to town, the celebrity-sight-seeing politicians that drifted in, the jack leg literateurs, all tried to put a hand on Carl. He was a quick man on the withdraw. No politician could capture him intact. He was a loner who could say 'No' with tenderness and grace or with brutal finality; but publicly he would never acknowledge any idols. But he had his heroes, the living ones."[8]

Sandburg enjoyed good company, but like so many who have attained eminence and financial independence, he did not have the time or energy to spend with many persons outside of his own circles. Yes, he loved people, but by now his three-score-years-and-ten had slowed him down.

There was one question he was repeatedly asked and to which he usually gave the same answer: Why did you spend so much time with Mr.

Lincoln? The answer: "Because he was such good company, and I sort of lived with him off and on for forty years and more, and he still has laughter and tears that are good for a fellow. He was also the first humorist to occupy the White House, the first man of humor. He was pre-eminently a laughing man, and he used to say that a good story was 'medicine.' "[9]

Sometime after moving to Flat Rock, Sandburg told his friend Ralph McGill, "A man must find time for himself. Time is what we spend our lives with. If we are not careful we find others spending it for us.... It is necessary now and then for a man to go away by himself and experience loneliness; to sit on a rock in the forest and to ask of himself, 'Who am I, and where have I been, and where am I going?' ... If one is not careful, one allows diversions to take up one's time—the stuff of life."[10]

One only has to hear the rhythmic name of Connemara or see the serene home itself to realize that here was a fitting place for the waning days of its occupant. To Carl Sandburg, it was truly a "haven of rest" and to me, a lasting symbol of greatness blended with beautiful simplicity.

# 14

## Remembrance Rock

William Herndon, Lincoln's law partner and biographer once said: "Mr. Lincoln thought too much and did too much . . . to be crowded into an epigram or shot off with a single rocket." It has been said that these words could also be applied to Carl Sandburg.

It seems that virtually every writer wants to do a novel and Sandburg was no exception. He had been working on his historical novel, *Remembrance Rock*, and in March 1948 had about finished it. He revealed that the manuscript was 1,480 pages long, containing 673,000 words with 152 chapters. This did not include the preface. Here was an author in his seventieth year trying his hand for the first time at writing fiction. While appearing at the University of Alabama a few months later, he visited the creative-writing class of Hudson Strode and briefly outlined the book. As he described it, the novel opens in Washington, D.C., in 1943, and then, using the familiar flashback device, takes the reader back to Shakespeare in 1608. Next come plans by religious groups to leave England for America, a section on the American Revolution, through the Civil War, and back again to modern times.[1]

The novel received a mixed reception. There is a prologue, a series of

three parts, and an epilogue. The prologue is set in Washington, where a former justice of the Supreme Court is spending the period of World War II with his daughter-in-law and grandson. In his front yard is a large stone called "Remembrance Rock," under which is buried earth from Plymouth, Valley Forge, Gettysburg, and the Argonne Forest. The judge resembles the author himself—generous, well versed in American history, and often sentimental. The first story is set in 1608 in Scrooby, England, whence the Pilgrims embarked for America. Here a woodcarver fashions a little plaque of bronze on which he inscribes the four stumbling blocks to truth as set forth by Roger Bacon. He presents this plaque, hung on a silver cord, to a young woman of the Separatists with whom he is in love, and it becomes a symbol of the theme of the novel.

The second story occurs during the American Revolution and concerns the hero, who is on his way from New York to Boston to see his sons. He runs athwart the feeling between the Whigs and Tories and realizes that there will be two sides to the coming conflict. Military operations and many adventures follow. The third story takes place sixty years later and is about a man who, like earlier characters in the book, has a face half warlike and half peaceful. He marries a promiscuous woman and is caught up in the turmoil and suffering that such a union usually brings, especially in her tendency to continue in the same loose way. The epilogue of the book returns it to Washington in 1945. This is a time of crisis for the country, but the characters know that the country has gone through fire in search of fulfillment of the American dream. So they bury beneath Remembrance Rock gravel from Anzio Beach, sand from Utah Beach in Normandy, and some volcanic ash from Okinawa.

In these pages Sandburg shows the affection he had for his country. He shows that the present is based upon the past, and that without realizing the mistakes made in the past there is little hope for the future. The novel abounds, as does the biography of Lincoln, in songs, proverbs, anecdotes, and folklore. Much of the criticism of the book held that it was unrealistic and that the characters were wooden. Yet Sandburg had gone back into history beyond Lincoln, and beyond the Founding Fathers, presumably to give the book a rich background of realistic detail. He was one of the few who, from his research on the novel, was familiar with Henry Knox, the able artillery leader and first Secretary of War, and he helped me on my biography of Knox, sharing material from his own wide collection and that of Oliver Barrett.

Maxwell Perkins, the noted fiction editor, observed that an author

knows more about his own book than anyone else. So let us note how Sandburg analyzed *Remembrance Rock*:

> We are the most prosperous people in the world, only comparatively speaking, and it wouldn't harm us to tell the world how. Our personal freedom, too, is comparative, as is our acceptance of personal responsibility. Over the generations liberty has kept winning as against excessive and corrupt authority. We have many miles to go. We are, perhaps, more restless, more unfinished, more anxious about goals yet to be won, than any other people on earth. Yet how to tell that to the rest of the world, the plain people, without going literary, without seeming to brag, is no holiday job. To discuss the books that might make 'perfect ambassadors to represent us in foreign countries' would require an essay, a treatise, or a little book I am not now working on. It is a matter of regret that there has not been vast and furious discussion of this large, hazardous and important subject.[2]

*Remembrance Rock* is an extensive fictional chronology of American history. Sandburg plainly felt a distinct empathy for Roger Williams, the founder of Rhode Island. Making his ponderous way through the American Revolution, the author shows admirable delineation between the Patriots and the Tories and deals also with the other third of the people who were neutral in the cause. Of course he is most at home with the Civil War, its leaders and its violent chaos. But he clearly did extensive research on the two world wars, both of which he had lived through.

In the prologue, Sandburg raises some interesting questions:

> "When we say a patriot is one who loves his country," ran the voice of Justice Wisdom, "what kind of love do we mean? A love we can throw on the scales and see how much it weighs? A love we can take apart to see how it ticks? A love where with a yardstick we record how long, high, wide it is? Or is a patriot's love of country a thing invincible, a quality of human shade and breath, beyond all reckoning and measurement? These are questions old as the time of man. And the answers to them we know in part. For we know when a nation goest down and never comes back, when a society or a civilization perishes, one condition may always be found. They forgot where they came from. They lost sight of what brought them along."[3]

In partial answer to these questions, the author points out that in every major crisis our nation has always shown reserves of strength, balances of sanity, and enough wisdom to carry it through. Sandburg describes a Plymouth meetinghouse with its hard benches and its long-winded preacher. He introduces the heroine, Remember Spong, the first of a series of names so odd they are hard to accept. Others include Resolved

Wayfare, Marintha Wilming, Evelyn Trutt, Francis Frame, Locke Winshore, Nack J. Doss, Fred Shamp, Joel Wimbler, Omri Winwold, Alfred Houseworth, and Peter Enders.

There is colorful writing. For example:

> Near noon, Remember Spong came out of this black mood. She washed her face and hands. She combed her hair and studied herself in the polished steel looking-glass, bringing out every wave and gleam of her hair, murmuring, "So should it look framing my pale face on the day they gaze on me before carrying me to Burial Hill. . . . It is dangerous," and Remember stood up with blazing eyes. "It is dangerous to gather flowers that grow on the brink of the pit of hell. You might fall into the pit itself while you think to pick pretty flowers." She waited. No word from him. Then a soft moan as though to herself rather than to him, "A woman should be from her house three times: when she is christened, married—and buried."

Resolved Wayfare wrote out in large, bold script on a small, oblong piece of parchment:

### The Four Stumbling Blocks to Truth

1. The influence of fragile or unworthy authority.
2. Custom.
3. The imperfection of undisciplined senses.
4. Concealment of ignorance by ostentation of seeming wisdom.

"So long as grass grows and rivers run," the heroine declared her fidelity. In some ways the book is similar to *The Scarlet Letter*. Sandburg seems to be fascinated with an inexorable fate. For example, a character named Mim says, "They will not get me, those dooms that reach for me. My strength will be a fine thin cord drawn tight and near breaking but it will hold." And reminiscing about Robert, she says, "There was an hour in a hazel thicket when we stood tiptoe together and plucked stars from the meadows of the sky and that was a memory. There was another hour we snuggled close in a wagon and tried to bring down a ring of brass chains circling the moon." And when her man Robert rides away, she implores in pure Sandburg poetry, "Be lonely for me as I am lonely for you. We must make our loneliness warm with its promises till our spring day. A shining spring with one great day we will have. Keep it tight and keep it sure this one long kiss I send you now."

When he comes to the Civil War, Sandburg shows his great familiarity with the subject. He is remindful of Whitman in his description of the gory

scenes of wounded and dying soldiers. Here he also shows a perhaps incomparable, superb depiction: "A great grief had hung over the land since April 14, the night it was said there was blood on the moon. The tolling of bells, the muffled boom of cannon and minute guns, had marked moments of ceremonial. There had been lashing rains and the red gold of rolling prairie sunsets and great bonfires lighting the sky while crowds stood with uncovered heads to see a coffin pass in the night."

Toward the end of this immense novel, there appears a statement that contains the essence of the book: "Live with these faces out of the past of America and you find lessons. America as a great world power must confront colossal and staggering problems. Reckoning on ever-fresh visions, as in the past, she will come through, she cannot fail."

The critics who liked the previous works of Sandburg were generally favorable in their comments on the novel. Fanny Butcher wrote in the *Chicago Tribune*: "It is the sum of everything Sandburg has written, learned, done." He was grateful to his old friend and responded, "Thank you for affirmations and eloquences. . . . I don't forget a few bright fellowships, such as ours, running thru fair weather and foul, across two world wars."[4]

In *The Nation*, Diana Trilling commented that the novel was not worth reviewing. *The New Yorker* termed it "passing dull." *Time* magazine called it "the sort of novel a distinguished Supreme Court Justice might write," and the *Saturday Review* observed that "Sandburg's portrayals of American life are somehow static." Perry Miller, from his self-erected Harvard heights, pronounced in the *New York Times Book Review*: "*Remembrance Rock* is not really a novel; it is the chant of the antique bard who fills out the beat with stereotypes and repetitions. . . . The effect is to show, unmistakably, some of the things a bard falls short of when he tries to construct a novel out of no more intelligible or dramatic a comprehension of the past than his blind assurance that 'Life goes on.' "[5]

Editors of the *Asheville Citizen-Times* were more generous, stating that Sandburg had written both a novel and history of the dimensions Americans had long waited for in the ultimate American novel. "If *Remembrance Rock* is not that novel, it must anyway be the greatest historical novel so far conceived and written on the scale of this book in what is truly the grand style."[6]

Another local editor, Don Shoemaker, commented to me that "in the ten years I knew Sandburg best, he wrote and completed *Remembrance Rock*, a sprawling novel which never caught fire with the critics but which, I

humbly predict, will be revived in years hence as Americana distinctive of the twentieth century. The cool reception of this novel hurt him."[7]

The *Christian Science Monitor* said that here for the first time was a novel comparable with the greatest one, Tolstoi's *War and Peace*. "*Remembrance Rock* is a rich and perceptive embodiment of the American Dream." Not long after the book was published, Sandburg was present at a reception where an elderly woman asked him for his autograph. He demanded to know if she had read his new book. She had not. He exclaimed, "Well if you didn't take the time to read my book, why should I take the time to write my name in it?"

Sandburg's philosophy shines through not only in his novel but in his speeches as well. When he dedicated the high-school building in Robinsdale, Minnesota, the school preserved his words on a bronze tablet: "Old and tarnished sayings have it, 'Time is a great teacher' and 'Time will tell.'... Always the path of American destiny has been into the unknown. With each new test and crisis it always cost and there were those ready to pay the cost, as an affirming character in *Remembrance Rock* says: 'Man is a changer. God made him a changer.' You may become the witnesses of the finest and brightest era known to Mankind. The nations over the globe shall have music, music instead of murder. It is possible. That is my hope and prayer—for you and for the nations."[8]

From Richmond came thanks from Douglas Southall Freeman for a copy of *Remembrance Rock*. He added that one of the great regrets of his life was that he did not see more of Sandburg. Not far away, Justice Hugo L. Black commented that "the book faithfully portrays the American tradition as I conceive it.... Its appeal should grow as the years go on."[9]

Benjamin Thomas stated: "What a magnificent book *Remembrance Rock* is! To me it seems to give the meaning of our history.... There is comfort in it for facing the Unknown, remembering that others have faced it before us and won through." From Paul De Kruif: "There must be a Providence. I needed *Remembrance Rock* that came day before yesterday. Last night I began reading it, word by word, commas and periods, slowly with the same catch in the throat your big stuff always has given me."[10]

Max Lerner, the New York columnist and critic could be acerbic, but not about *Remembrance Rock*. "Unlike some of your reviewers," he wrote, "who I suspect may have sounded off on the book before they read it, I have waited not only to dip into it but to read most of it. I find the whole of it delightful."[11]

Many in the academic world regarded *Remembrance Rock* with favor. T.

V. Smith of Syracuse University read the book and was about to write the author when he noted the considerable amount of adverse criticism in the press. So he re-read the book, then wrote Sandburg: "What I have decided is this: that when you and I stand together, we are right; and all who stand against us are wrong, albeit the critics make a mighty phalanx. I would allow them this much ground, of a formal sort: your book may not be technically speaking, a perfect 'novel.' But this conclusion I draw from that is: *so much the worse for the norm of the novel.*" Allan Nevins of Columbia University said, "Your sending *Remembrance Rock* touched me greatly, and your affectionate inscription still more. . . . As a historian I greatly envy you your gift of making a society live as a rich, complex, fiercely struggling whole—your talent for making readers see the tremendous variety of human personalities and individual dramas that make up the past." Another friendly critic, Professor J. G. Randall of the University of Illinois, concluded after reading *Remembrance Rock*, "It means many things: American history as no one else has handled it. . . . It is a rugged book and an eloquent one—not a book of heroics, but of momentous periods put before the reader in terms of men and women as they lived and felt."[12]

Carl Sandburg was quite fond of his latter-day Carolinian friend Harry Golden, who had fun associating with the author of the big novel and wrote about it and other things in their mutual association. Wrote Golden, "*Remembrance Rock* may not be the Great American Novel. It is certainly one of the attempts at the Great American Novel. . . . As fiction, it ran counter to post-World War II writing. It did not have the cynicism we associate with the usual war-inspired novel. It did not rage against authority, nor express hatred of discipline."[13]

One letter from a reader seemed to hold even more poignant meaning. Richard Maury of Garrett Park, Maryland wrote, "I am an American. I was born and raised an American. My father was born American and he died fighting that others might continue as Americans. From this standpoint I want to extend to you my most sincere gratitude and appreciation for your book *Remembrance Rock*. . . . You have spoken of the America that lived within the hearts of men before this continent was known."[14]

Thus Carl Sandburg had wondrously run his ambitious literary course. High-school articles, newspaper reports, lectures, poems, children's books, biography, history, and a gigantic novel. He could now rest his weary head and rightly feel that he had at last reaped a rich harvest.

# 15

## Evening Star

Life was pleasant at Connemara, and this was not unusual, for the Sandburg home had always been an agreeable one, even with its ups and downs. Granddaughter Paula remembers sharing the fruit on Carl's tray and watching him eat oranges, peelings and all. Later she was to learn that this was a habit that had come down from his childhood years, when his parents could only afford to give a small bag of candy and a single orange to each of their children at Christmas. As he walked around the new estate, Carl gathered acorns, buckeyes, hickory nuts, and pinecones, which he placed about the house in cigar boxes or crocks. One of the bedroom walls was covered with a billboard, and that was virtually covered with pictures clipped from magazines. Foreign countries and their human and wild-animal inhabitants were pictured on the billboard.

After he got out of bed, Sandburg would turn on the record player and then take his morning exercise. From his window he could see above the boxwood and holly trees, the bamboo grove and the magnolia. Then he would read his mail, which was voluminous and brought from the post office each morning in large wicker baskets. Much of it he did not have

time to answer, and in his evening years his ever-helpful wife did this for him. It was plainly evident that his mild Southern climate and lovely natural surroundings brought much needed restfulness and peace to this veteran literary warrior.

The food at Connemara was simple. It consisted usually of thick soups and freshly baked breads, goats' milk, butter, and cheese from their dairy. Mealtime was enjoyable, and Sandburg praised his wife's cooking as he ate slowly and told the family some of his never-ending stories about his day's work. Paula made spiced springerle cookies with anise and butter. The aroma filled the house and brought warm comment from the grandfather. Gramma, as Paula was called, baked fruitcake in December, mixing currants, white raisins, and nuts in a large stoneware bowl that already held butter, sugar, flour, and molasses. Helga made fresh loaves of bread to be eaten with honey or jam. The only candy was sent by the Hershey Company.[1]

Janet would carry a tray up to her father's bedroom in the mornings and leave it outside his door. On the tray was coffee, goat's milk, some honey, fruit and cheese, and slices of black pumpernickel bread. When he awoke, he would take it inside and eat all or part of it as he worked. In his bedroom was an ancient record player on which he played classical music, often recordings by his friend Andrés Segovia. After his music and exercise, he would descend the stairs, carrying the empty tray, as well as books and papers, and singing in his deep resonant voice. In the sunny living room, when the family had time, they would gather briefly for pleasant chats. On top of a glass and walnut cabinet in the eastern corner stood a framed letter that read: "Will Mr. Rodney do Th. Jefferson the favor to take family soup with him tomorrow?" Some cherished things had been brought from Lake Michigan, such as small carvings of animals, sugar cubes with decorations, axes and stovepipe hats, and bullets from the battlefield of the Civil War.

Meanwhile, another Sandburg book, *The Photographs of Abraham Lincoln*, this one with Frederick Hill Meserve, had been published, as well as *Poems of the Midwest*. In October 1948, Sandburg visited Governor Adlai Stevenson, who greeted his fellow Illinoisian with enthusiasm. Stevenson recalled that Sandburg had visited the governor's father, who introduced him to an ex-governor of the state, "Private Joe" Fifer, who had fought in the Civil War. It seemed that Fifer liked good whiskey and Sandburg, knowing this, took along a pint of rare bourbon. Carl and the governor's

father approached Fifer, expecting him to share it with them. But "Private Joe" placed the bottle on his desk and never mentioned it or offered it to his guests.[2]

At Indiana State Teachers College, a full house was gathered one morning at ten o'clock to hear Sandburg. He failed to appear and the audience finally filed out. At two-thirty in the afternoon, the students were summoned to a special meeting. Sandburg had arrived. Questioned in regard to his belated appearance, he explained that the weather had been so inviting he had decided to hitchhike to the college.

Many authors like to pay tribute to the collections they use in their research. Carl Sandburg went beyond this. He had so utilized the collection of Oliver R. Barrett of Chicago and felt so appreciative of it that he wrote a book about it, which was published by Harcourt, Brace in 1949 and entitled *Lincoln Collector: The Story of Oliver R. Barrett's Great Private Collection*. In it Sandburg pointed out that twenty years after the death of Abraham Lincoln, Barrett, then thirteen years old and living in Pittsfield, Illinois, started what was to become a massive and diversified collection of Lincoln letters, documents, relics, and related source material. Barrett's father had been a member of the Freedman's Aid Society and had an old trunk in which he left about a million used postage stamps that proved to be quite valuable.

"Across the years," Sandburg wrote, "the correspondence of Barrett ranged far and wide. When he heard of a Lincoln letter or a paper or a relic having Lincoln associations, he would write inquiries about it. In the course of time it became widely known that the attorney Barrett welcomed at his office anyone who had material bearing on Lincoln or on actions, events, characters that interwove with the life of Lincoln."[3]

In March of the next year, it became Sandburg's sad privilege to write an obituary for his friend Oliver Barrett. Read by the preacher, the tribute began, "For the journey on which he has gone, Oliver R. Barrett was prepared. He wrote a few weeks ago of the summons at the door, how it might either be 'the postman's knock or the sunset call.' This time it was not one more catalogue at the door. This time it was the sunset call."[4]

It was a time of sadness for Carl Sandburg. His brother, Martin, not long before the family had moved to North Carolina, had died. Now in April 1949, his old friend Lloyd Lewis passed away after having a heart attack. Sandburg wrote to his wife and recalled that her husband had had a rich and crowded lifetime. "I cry over his going," wrote Carl, "but it isn't a bitter crying. He liked that line in Rem Rock: 'To every man, be who he

may, comes a last happiness and a last day.' . . . When the trees are leafed out and the earth is giving with early summer laughter I'll hope to be seeing you and we can talk of rich days that have been and of a lad who is a shining memory."[5]

Soon brighter things were to come. The Swedish community here and abroad honored Sandburg, Augustana College awarding him an honorary degree, and from Uppsala University in Sweden came an honorary Ph.D., a rather unusual designation. In 1950 Harcourt, Brace and Company published Sandburg's *Complete Poems*. The volume was not quite complete, however, for the book omitted his youthful work printed by the Asgard Press. It did contain all of Sandburg's subsequent poems, as well as some new ones. For this volume of poetry, Carl Sandburg was awarded his second Pulitzer Prize.

Of course in participating in these activities of recognition, Sandburg moved around to the large scenes of action. Mrs. Frank Warner remembers that in the fall of 1950 he was in New York and telephoned to say that he would like to get together with them in their Greenwich Village apartment. They heartily agreed. "We didn't know what to expect," Mrs. Warner told me, "before Carl's first visit, from a celebrity of his magnitude. But when he arrived, strong and hearty, the famous lock of white hair over the right eye, we all felt easy. He was real and human, and fun. We remember his booming laugh, his rolling r's and his flat Swedish a's, his habit of stretching out syllables as if reluctant to let a word go: 'Diggin' pota-atoes in her fa-a-ther's ga-a-rden.' He was splendid."[6]

Naturally all the attention that Sandburg was receiving brought him in contact with others of like renown. Norman Rockwell had become such an admirer of the Lincoln volumes that he persuaded the editors of the *Saturday Evening Post* to let him paint a picture called "Tribute to Lincoln." They asked Sandburg to write a poem to accompany the picture, which he did. Rockwell later commented, "The poem was really beautifully written and expressed far better than the picture did just what I wanted to say. Mr. Sandburg, in all his writing, is so truly and sincerely an eloquent voice of the spirit of America."[7]

Allan Nevins, who always seemed to have time to praise others, even with his own voluminous work, wrote Sandburg that the Civil War Round Table in New York was off to a good start, although the initial meeting had one of the poorest speakers Nevins had ever heard. But Douglas Freeman was expected soon and that was to be a first-rate talk—which it was, as I can attest. Nevins recounted that Adlai Stevenson had just been in Chicago

on a Lincoln television program with the actor Raymond Massey. "It broke up with the usual compliments. But Adlai turned to Massey and said 'A great pleasure to appear with Massey—but I hope he won't let himself go as far as Tom Judkins in Galena.' Judkins always prided himself on looking just like Lincoln. He wore rusty clothes and a stovepipe hat like Lincoln; he carried a shawl on his shoulders like Lincoln. He talked like Lincoln. One day some Galena men watched him shambling down the street like Lincoln, and one said: 'There goes old Judkins looking more like Abe than ever. He won't be happy until he's assassinated!' "[8]

Ben Hayes remembers when Sandburg came to Ohio State University to appear before the students. "Sandburg sang for his money," said Hayes. "He looked at a far wall and talked of titles of books of his which were to come. During one of his visits Sandburg mentioned that his next book would be called 'Fun with Fungi,' the next one to be 'Bongoes on the Fungoes.' " According to Hayes, an artist based in Columbus, Emerson Burkhart, induced Sandburg to pose for him in 1951. Sandburg thought the portrait was excellent. It so happened that it was Burkhart's plan to sell this painting to Sandburg himself. "Not that Sandburg was stingy," Hayes went on, "not that Burkhart was stingy. Both liked to acquire money. Well, Sandburg never reached an asking price. As remembered by Mrs. Burkhart, Sandburg said, 'Emerson, it is a great picture. I want you to keep it—and some day it will be worth a lot of money.' "[9]

More rewards were to come. In 1952 Sandburg received the American Academy of Arts and Letters gold medal for history and biography. On the last day of that year, he received a letter from President Truman stating, "It's hard to reconcile reports that you will be seventy-five years old January sixth with those of your ringing participation in the November Democratic Rally at Madison Square Garden. You have my congratulations, however, upon your birthday and my thanks for helping Americans see their forefathers, their cities, their farms and themselves a little more clearly."[10]

On Sandburg's birthday, his partial autobiography, *Always the Young Strangers*, was published. It covers the first twenty-one years of his life, presumably that span of time in which he went from a boy to manhood. The book was widely hailed. John K. Hutchens in the *New York Herald-Tribune* commented that it was "a memorable American autobiography that superbly recaptures the boyhood of the artist that Carl Sandburg became, that fondly and truly paints the portrait of a prairie town in a time long gone." Robert E. Sherwood said in the *New York Times*: "*Always the Young Strangers* is to me the best autobiography ever written by an Ameri-

can. By striving to tell no more than an intensely personal story, Sandburg has achieved the universality of a *Pilgrim's Progress*."

Harvey Breit in the same newspaper described Sandburg as "a bony, fine-looking fellow, with flattened-down, white, symmetrical hair (that can get quite disheveled), enigmatic eyes, a bold nose and mouth." Lewis Nichols saw him "with a laugh so booming as to threaten chandeliers, and an informal manner that would be the envy of a schoolboy. In a warm room, he peels off his coat; in a truly hot room, he probably would peel off his shirt. He does not sit, but slouches."

Richard Crowder felt that "the success of this book rests in the balance Sandburg maintained between the Swedish immigrant's son that he had been and the American poet and historian that he had become. He had got back to the boy who was not yet a poet, but he had maintained sufficient distance to see him as he was and not sentimentally as he might wish him to have been. The result is an authentic condensation of the American Dream, Sandburg's constant theme."[11]

Many people were happy that Carl Sandburg had lived three quarters of a century. So it was very fitting that on the night of his birthday, he and Paula would be in Chicago, "the city of the big shoulders," whose characters had first brought fame to Sandburg's writings. There in the Blackstone Hotel, 550 of his friends, colleagues, and admirers gathered at a testimonial dinner for him. Governor Adlai Stevenson regrettably could not be present but sent the following message: "Carl Sandburg is the one living man whose work and whose life epitomize the American dream. He has the earthiness of the prairie, the majesty of the mountains, the anger of deep inland seas. In him is the restlessness of the seeker, the questioner, the explorer of far horizons, the hunger that is never satisfied. In him also is the tough strength that has never been fully measured, never unleashed, the resiliency of youthfulness which wells from within, and which no aging can destroy."[12]

Besides the celebrities present at the festive dinner, a representative of King Gustavus VI of Sweden was there to bestow upon Carl Sandburg the honor of Swedish Commander of the Order of the Northern Star, designating him as "one of Sweden's prominent sons." Brother-in-law Edward Steichen pronounced: "On the day that God made Carl, He didn't do anything else that day but sit around and feel good." Sandburg arose and with his wife accepted the praise with the words "If I were sixty-five, such an evening would be difficult to take," he said. "If I were fifty-five it would be impossible and if I were forty-five it would be unthinkable. But at

seventy-five you become a trifle mellow and learn to go along with what true friends consider just homage."

The Lincoln biography was popular, but of course not everyone would purchase six big volumes. So plans were made to condense *The Prairie Years* and *The War Years* into one volume. In writing to Alfred Harcourt during the preparation for the book, Sandburg admitted that in the fall of 1953 he had been having some dizzy spells. He had talked it over with his doctor, who told him that six to eight hours of work each day was too much, so he slowed down to three or four hours a day. Sandburg ended his letter with the hope that someday he would write a piece on the advantages of books over television, radio, and movies.[13]

*Abraham Lincoln: The Prairie Years and The War Years* was published in October 1954. Sandburg had compressed more than 1.5 million words into 430,000. "I have been a bracketter. Now I became a deleter.... I did not want to condense, abridge, or make a digest. My purpose was to compress or to distill." He did not wish to write something as some had in capsules. He compared such extreme condensers with a person who pasted the Lord's Prayer at the foot of the bed and when he got up in the morning waved his hand toward it and said, "Lord, there's my sentiments."

As noted in the Foreword, I invited Sandburg to New York City to appear before the Civil War Round Table. Prior to this, he was interviewed and asked about the requirements of being President. He answered that Washington, Jefferson, Jackson, Lincoln, Woodrow Wilson, and both Roosevelts were diabolically cunning or they could not have lasted. The meeting of the Civil War Round Table was held at the New York University Faculty Club. The ornate scroll presented to Sandburg paid tribute to him as a "prime interpreter of the Civil War whose life is a story of rich fulfillment. By his timeless writing and his music of the human heart, he has become the voice of America singing." In answer to further questions, Sandburg, who appeared tired, remarked, "Perhaps I should have some cards printed with mourning crape border reading: "I AM DEAF. WILL YOU SPEAK LOUDER? To be followed by a second card: LOUDER YET! And possibly a third card: COME AGAIN? Old authors never die—they just sign away."[14]

Prodded by reporters for some rules for happiness, Sandburg showed that he was at home with the press. The rules were as follows:

1. To be out of jail.
2. To eat and sleep regularly.
3. To get what I write printed in a free country for free people.

4.  To have a little love in the home and a little affection and esteem outside the home.

The famous case in which Leopold and Loeb were convicted in Chicago for kidnapping and murder came to Sandburg's attention, and he was interested in it for two reasons: first, his old friend Clarence Darrow had defended both of the young men in their trial; and second, because Sandburg was a liberal who favored the underdog. Consequently he wrote to the Illinois State Pardon Board asking for a pardon for Nathan Leopold, who was serving a long sentence in Joliet Prison and had appealed to Sandburg for help. In his letter, Sandburg pointed out that the initiative for the crime was in the hands of Richard Loeb. He added that if he were a member of the board, he would vote for the pardoning of Leopold, that he would be glad to have the young prisoner as a neighbor, and would be pleased to have him as a guest in the Sandburg home. Leopold was later freed and fervently thanked Sandburg for his great help.[15]

The liberality of Sandburg, however, was not unanimously appreciated. He also took the side of Albert Einstein and J. Robert Oppenheimer, who had been accused of Communist leanings. Vincent G. Burns of Annapolis took Sandburg to task for allegedly stating that "when the names of Socrates and Plato are forgotten, the names of Einstein and Oppenheimer will travel on."[16]

Apparently such verbal attacks did little more than ruffle the thick white hair of Carl Sandburg, for not long afterward he assailed television when he spoke at a meeting of the General Federation of Women's Clubs. According to *TV Guide,* "On little gnat's feet, Carl Sandburg crept into [the] meeting . . . and let loose a fog of generalizations about television and television commercials. 'When we reach the stage where all of the people are entertained all of the time, we will be close to having the opiate of the people,' he said. 'More than half the commercials,' said Sandburg, 'are so filled with inanity, asininity, silliness and cheap trickery that to every man and woman who loves children it's a question of what it's doing to these young people.' "[17]

Carl was not averse to appearing on television. Edward R. Murrow, also a North Carolina man, grew fond of Sandburg and interviewed him on his national television program. Once Murrow asked him what he answered when people asked him how he wrote. Sandburg replied:

Much depends on who is asking the question. "How do you write?" I say, "Simple, It's easy. You just sit up to the typewriter and you put down one

word after another. If you try to put down two or three words, you're sunk."
And they take that as very valuable advice. And then there are some nice,
earnest, serious college boys and I try to reduce it to the formula, of say, Ty
Cobb. There were some baseball writers who got around him at the end of
one season and they asked him, "You have eleven different ways of sliding
to second base. Now we'd like to know at what point between first and
second do you decide on which one of those eleven ways you are going to
use?" And Ty said, "I don't think about it. I just slide."

In 1954 Ernest Hemingway was awarded the Nobel Prize for literature.
Later, when questioned about the award, he said that if he had been on the
board he would have voted for Carl Sandburg, whom he considered "a
very dedicated writer." Hemingway added that Sandburg's six-volume
work on Lincoln would have influenced him. When Sandburg was asked in
later years if he ever received the Nobel Prize, he would answer, "Sure, it
was awarded to me in 1954 by Ernest Hemingway." He even wrote to
Ernest and Mary Hemingway, saying, "I know enough of Swedish humor to
believe that some member of the Academy said something like, 'Heming-
way is a Smalander,' referring to the legend of the Lord seeing a Smalander
in a bloody fight with the Devil and ordering an angel to go down and stop
the fight. The angel came back saying he couldn't stop the fight and so cut
off the heads of both of them. The Lord said, 'Go down and put their heads
back as they were.' Which the angel did. But he put the head of the Devil
back on the Smalander which is the reason why today every Smalander has
a little of the Devil in him.' "[18]

Regardless of recognition, there were those already who thought Sand-
burg's life was worthy of a biography. But Carl was not ready for such and
even if so, he wanted to do it himself. He told his friend Alan Jenkins, who
evidently had asked to write a biography, that he had rejected two similar
requests. Such revelation has been of significance to this writer, who wrote
the first Sandburg biography to be published after his death.

Sandburg was known not only to adults but to young people as well, and
not simply as a result of his *Rootabaga Stories*. One day the Superinten-
dent of Schools of Galesburg visited the Douglas Elementary School there.
Having in mind the fifth Lincoln-Douglas debate held in Galesburg in
October 1858, the superintendent asked a fourth-grade class, "Did Abra-
ham Lincoln ever come to this town?" A small hand was raised. "Yes," the
young student answered, "He came to see Carl Sandburg."

Sandburg was in New York to receive the Albert Einstein Commemora-
tive Award. "To make a goal of comfort or happiness has never appealed to

me," giving credit for the thought to Einstein himself. "There is a danger," Sandburg said, "in the deep desire and main goal of Americans to obtain the articles of comfort and happiness at the expense of more important objectives." A version for children of *Always the Young Strangers* was published and entitled *Prairie-Town Boy*. In addition, Sandburg wrote the prologue to *Family of Man*, a volume of photographs selected by Edward Steichen and published by the Museum of Modern Art in New York.

In admirable anticipation of the interests of scholars to come, Sandburg began in 1956 a collection of his books, writings, correspondence, and memorabilia in the University of Illinois Library. Since that time, the able supervisor of the collection, Dr. John Hoffman, has pointed out that the Sandburg family and friends have worked with the university personnel to enlarge and enrich this unrivaled cache of Sandburgiana.

Eventually Professor Bruce Weirick and Leslie W. Dunlap, acting director of the library, were sent to Connemara to inspect the Sandburg library. Weirick reported that he did not know which was "the more overwhelming, the library, or the man it represents, with his running-fire comment on this or that memo, letter, manuscript, and the fifty years of America there revealed." An offer of $30,000 was made to Sandburg and accepted. Back at the university, however, there was considerable opposition from the faculty in American History and Literature. They questioned the value of duplicate books, scattered correspondence, Steichen photographs, and so forth. Despite this, the University of Illinois Foundation approved the purchase.

Apparently there was some misunderstanding as to when the contents of the library would be moved from North Carolina to Illinois. While he was alive, Sandburg retained most of it at Connemara for the sake of his writing. Even in his last few months, as Paula wrote, he spent "most of his time reading and browsing through the library." Since his passing, "members of Sandburg's family," says Dr. Hoffman, "especially his daughter Margaret, have frequently added to the materials previously transferred to the library." Needless to say, this collection is a golden treasure trove for students, researchers, and biographers.[19]

In 1957 *The Sandburg Range*, an anthology of his work, was published. In an introduction, T. K. Whipple said, "The best term that I can find for Carl Sandburg is that of psalmist—not in form only, although his predilection for the form of the Psalms may be significant but in deeper ways. His feeling for the sky, the ocean, the winds, for all the more grandiose aspects of nature, for vastness in time and space, is like that of the Psalms."[20]

In what seemed a colorful paradox, the U.S. Steel Corporation engaged Sandburg to read a poem at a banquet in Chicago in salute to that city's construction industry, as well as the steel business. The *New York Herald Tribune* observed that perhaps this odd combination of poet and "big steel" came about because of the Sandburg poem "Prayers of Steel," which opens with the lines

> Lay me on an anvil, O God
> Beat me and hammer me into a crowbar.

"It's rare for the literary world and the steel industry both to wait expectantly for the same event," the newspaper continued. "Still spry at seventy-nine, Mr. Sandburg is a great talker and speaks with a deep, resonant voice, once described as making 'hello' sound like the opening words of the Gettysburg Address."

Mervin Block has recalled that at the time he was attending a dinner for the Adult Education Council in Chicago, which was held in memory of Justice Oliver Wendell Holmes. Sandburg was a guest of honor and sat next to Mayor Richard J. Daley. A newspaper reporter approached Sandburg and asked him how often he got his hair cut. "That's an impertinent question!" snorted Daley. "He doesn't have to answer that. He's the poet lariat!"

It was during this period that Frankie Sharp, writing for the Associated Press, described Sandburg as follows:

> Now, he's slowing down. His public appearances are rarer, his writing comes more slowly. But there's plenty of pepper in him yet. He says he's living the life of Riley on his farm. Here he pets his goats, strums his guitar, and sings folk songs in the twilight and scribbles notes. He sits on top of his steep hill, joking with friends and newsmen who journey to see him, tossing barbs at modern poetry.... He looks like a proud-backed Indian with hooded eyes and straight, long white hair that falls across his forehead. He walks a bit unsteadily and there are brown age spots on his big hands, but there is nothing old in the shrewd, merry eyes under his green eyeshade.[21]

Asked about the writers of earlier days, Sandburg stated that the contemporary poets "ain't doing so good," adding that Shakespeare, Leonardo da Vinci, Benjamin Franklin, and Abraham Lincoln never saw a movie, heard a radio, or looked at television. "They had conversation and creative soli-

tude. They had loneliness and knew what to do with it. They were not afraid of being lonely because they knew that was when the creative mood in them would work if they could capture it."

Early in 1958, Henry Belk, the blind and astute editor of the Goldsboro, North Carolina, *News-Argus*, suggested to Sam Ragan of the Raleigh *News and Observer* that the state should pay a tribute to the famous writer who had come from Michigan to make his home in the "Tar Heel State." The idea was well received. Ragan discussed it with Governor Luther Hodges and plans were made for a luncheon, with Sandburg as honored guest. Jonathan Daniels, editor of the Raleigh newspaper, telephoned Sandburg and received a hearty acceptance of the invitation to be present at the affair on March 27 in Raleigh. Governor Hodges then issued a proclamation designating "Carl Sandburg Day," in what appears to have been an unprecedented official recognition of an individual by the state. After some 250 persons, including writers, businessmen, politicians, and educators, had accepted the invitation, Daniels thought it wise to contact Sandburg to remind him of the forthcoming day. Mrs. Sandburg answered the telephone, said she knew nothing of such plans, and revealed that Carl was then in Springfield, Illinois. Daniels called Springfield and was told that Sandburg had gone on to Chicago. Again the editor telephoned Mrs. Sandburg and asked whom Carl might be seeing in Chicago. She replied that the only one she could think of was his dentist. A call to the dentist brought forth the information that Sandburg had left Chicago for New York. By this time, the luncheon was only a day and a half away, and it appeared that its guest of honor had forgotten all about it. Again Daniels telephoned Mrs. Sandburg at Flat Rock and inquired whom Carl might be visiting in New York. She pondered a minute, then mentioned that sometimes he stayed there with a friend who played the guitar. Daniels forthwith telephoned Harcourt, Brace and was told that this friend must be Segovia. A call there—and Eureka! Carl Sandburg answered the phone.

Arrangements were made for him to catch a plane for Raleigh the night before the luncheon. He missed two planes but finally arrived at 11 P.M., "feeling fine," according to Sam Ragan, "and ready for a night-long session of drinking and talking." At 4 o'clock the following morning, Sandburg was still at the Daniels', where he was a guest. But he appeared at the luncheon next noon, spry and full of good spirit.

Edwin Gill, state treasurer, had been asked to speak, and he upheld his reputation as an expert at such moments. He intoned:

Our guest of honor, Carl Sandburg, is an *original*—something that has never happened before. Something new under the sun. And how does this come about? Those schooled in science might call it a *mutation!* Those steeped in religion will call it a *miracle.* . . . Surely free-swinging Walt Whitman was his great-uncle and shy, sensitive Emily Dickinson was his great-aunt. Among his distant relatives I find Bret Harte and Mark Twain, while his first cousins could be Vachel Lindsay, Edgar Lee Masters, and Robert Frost, and I would think that among his nephews we might even find our own Thomas Wolfe. But when I come to name his literary father, I hesitate and then go on to say that he could have been that tall, angular man with the stovepipe hat who went to Gettysburg one day and made there a brief, immortal address. And if I were so bold as to attempt to name his spiritual ancestor, I would suggest that patriarch whose gifted hand wrote the book of Job![22]

In this year, when he reached the age of four score, Carl Sandburg received the tribute often given the renowned when they have come to a venerable milestone. He was asked what it was like to be famous. Standing on the bare front porch of his mountain home, he looked out across the hilly horizon and a faraway gaze crept over the pale blue eyes. Then he grinned and wagged his white-thatched head.

"It's like a communicable disease," he replied with relish. "Nothing can be done about it."

After a pause, he continued. "But it's kind of nice. When I walk down a street, people smile toward me as though they know me and like me. I've got accustomed to nodding every so often to a complete stranger as though we were old schoolmates. Plain folks who wouldn't think of bothering you—but they feel they know you and they smile."

Sandburg had been invited to attend a Lincoln Dinner at the University of Redlands in California. His response on February 8, 1949, eloquently and significantly explained his situation:

My responsibility is that evening audience, and I will come out of it sweating as though I had pitched a fourteen inning game in August. I shall have your phone number with me and I expect to phone you on the evening of February 13. On the previous day I will have made a twenty-minute address to a joint session of the Senate, House, Supreme Court, Diplomatic Corps and in the evening will have given the Lincoln address at the Library of Congress, taking a United Air Lines plane at 12 noon the next day, arriving San Francisco 6 o'clock in the evening, Pacific time. At noon February 14 it is rehearsal for giving in the evening with the symphony orchestra, the narration with Aaron Copland's "A Lincoln Portrait."[23]

Some schedule for an eighty-one-year old man!

Carl Sandburg was given the biggest tribute by Congress to a private citizen in nearly a hundred years when he was invited to address a joint session on the 150th anniversary of the birth of Abraham Lincoln, February 12, 1959. Not since George Bancroft, the historian, spoke to Congress following the assassination of Lincoln had an American private citizen been so honored.

Sandburg came up from Flat Rock for the occasion and seemed perfectly at home in the capital as he was escorted to the rostrum, where Vice-President Richard Nixon and Speaker of the House Sam Rayburn were waiting for him. Sandburg was introduced by Rayburn as the man who probably knew more about Lincoln than any other human being. But before he spoke, the House chamber had filled until there was only standing room in the galleries. Northerner and Southerner, Republican and Democrat, sat side by side in a friendly atmosphere. Outside a winter sunlight filtered down on the marble structure and on the statue of General U. S. Grant. A Coast Guard Academy chorus had sung "Dixie" and "The Battle Hymn of the Republic," and Frederic March, the actor, gave a superb reading of Lincoln's Gettysburg Address. Appreciation was expressed by members of the Supreme Court, as well as the diplomatic corps and other luminaries. It was a day of solemn observance.

Peering out from under the thatch of white hair that still fell lank over his temples, Carl Sandburg became for a time the personification of his subject. His face was crisscrossed with the lines of a man of eighty-one; his voice was resonant but becoming softly hoarse at times. His audience was hushed as he began: "Not often in the story of mankind does a man arrive on earth who is both steel and velvet, who is as hard as rock and soft as drifting fog, who holds in his heart and mind the paradox of terrible storm and peace unspeakable and perfect. Here and there across centuries come reports of men alleged to have these contrasts. And the incomparable Abraham Lincoln, born one hundred and fifty years ago this day, is an approach if not a perfect realization of this character."[24]

Sandburg spoke for eighteen minutes. He evoked in his own repeated words the image of a tall, somber man looking at the world with sad eyes, a man who had confined his greatest speech to two minutes.

When Sandburg finished, he stood looking out over the House. His noted audience sat as if under a spell—which it was. Not once did the distinguished personages there interrupt him with applause, for it was not that kind of a speech. Then as they suddenly realized that the Lincoln

tribute was over, the emotion created by his biographer broke into a great thunder of applause. Moving with great dignity, the erstwhile boy from Galesburg, who had been diligent in his ways and now stood before the mighty, stepped down from the congressional dais and strode across the well of the House and out the door. Said Congressman Carl Albert of Oklahoma, his voice choking with emotion, "Never in my life have I ever heard anything like it."

In late spring of the same year, Gene Kelly and Sandburg gave what was termed "a unique television performance," in which the Hollywood star danced to one of the poet's compositions while the latter strummed his guitar. Then in late summer, Sandburg and Steichen went to the Soviet Union as cultural ambassadors to open the "Family of Man" exhibit. Some five hundred pictures had been chosen from millions taken in many countries, and the exhibition portrayed the common brotherhood of humanity in scenes of everyday life, such as loving, praying, weeping, dancing, laughing, and fighting. It had previously been shown at the Museum of Modern Art in New York City, where Steichen was Director of Photography. Although no event of note occurred during the visit of the two Americans to Moscow, the Russians received the pictorial exhibit well. Sandburg thought "Russians in the streets of Moscow hurry more than Americans in New York and Chicago."

En route home, they stopped in Sweden, where Sandburg visited a cousin named Erik Carlsson, as well as some other relatives. Sandburg remembered enough Swedish to be able to chat a bit with his kinfolks and he also sang a few old Swedish songs. While there, he received from King Gustavus VI a special medal for his achievements. The prime minister gave a special dinner for the visitor and at the same time, Upsala College in New Jersey announced the award of an honorary degree to him. He had already received such degrees from Lombard, Northwestern, Lafayette, Wesleyan, Yale, Harvard, Syracuse, Dartmouth, Rollins, Augustana, Uppsala in Sweden, the universities of Illinois, North Carolina, Louisville, and New York University.

Asked by a reporter how he preserved his silvery mane, Sandburg replied, "Every morning, for a wake-up, I give myself a dry shampoo for two to three minutes. Not a massage, a shampoo." Queried as to whether he used any hair lotions, he quipped, "I have no notions about lotions." He revealed that three or four times a year, he gave himself a real shampoo.

Asked if he thought the marriage of Abraham Lincoln to Mary Todd had

been successful, Sandburg responded, "When you have four fine boys in ten years, that marriage ain't a failure."

Successful, too, was the program of dramatic readings that was launched at this time by Bette Davis and her husband, Gary Merrill. She had known the poet-biographer only through "his Lincoln and his 'little cat feet' poem," she said. But she became interested in the script by Norman Corwin, an arrangement of extracts from Sandburg's works, which the radio-television writer had acquired from years of adapting them for broadcasting. Speaking of Sandburg, Miss Davis said, "This man is more vital than anyone I have ever met in my life. He is *au courant*."

"The World of Carl Sandburg" toured the United States for a year with Bette Davis and Gary Merrill and later had a run on Broadway with Miss Davis and Leif Erikson. Then it "came home" to North Carolina and played to some 200,000 high-school students around the state before arriving at the Vagabond Touring Theatre in Flat Rock, where it enjoyed a successful engagement right in the front yard, so to speak, of its original author.

Interviewed in Hollywood, Norman Corwin recalled how he cherished his long friendshp with Sandburg, stating that Sandburg arrived at one time on the West Coast with only one shirt, two pairs of sox and two handkerchiefs. "He had backwoods simplicity," Corwin said, "but he was unspoiled. He was not even a heavy drinker but was first of all a poet. He told me that *The People, Yes* was his best work. Once he met Charles Laughton in the studio and demanded that the actor recite Lincoln's Gettysburg Address on the spot. Laughton did. Sandburg had a scorn for phoneys as Lincoln did. Carl had a distrust of people who liked him only because he was a celebrity."

A master showman himself, it was inevitable that Sandburg would land in Hollywood. The event did not concern Lincoln, or any of Sandburg's books, for that matter. He had seen the movie about Texas entitled *Giant* three times and had sent the director, George Stevens, a copy of his novel, *Remembrance Rock*, autographed with a complimentary note for Mr. Stevens's work on the film. Whether this was pure tribute or also a hint that the novel might be considered as subject for a picture is not known; probably both elements were involved.

At any rate, Stevens was duly impressed, especially as he already had a warm admiration for Carl Sandburg. Correspondence and negotiation ensued and soon a press release from Twentieth-Century-Fox announced that Sandburg was to be a "creative consultant" on the forthcoming movie

production of *The Greatest Story Ever Told*, a life of Jesus Christ, based on the book of that name by the late Fulton Oursler.

The announcement was made in Hollywood style from the picturesque Sandburg home in Flat Rock. Stevens was on hand and was greeted by Sandburg with: "Hello, Boss." Whereupon the producer replied, "Hello, God."

Bantering with reporters, who were numerous, as well as photographers and Twentieth-Century-Fox publicity men, Sandburg quipped, "Why ain't I got a right to write for the movies? That's a header; that's a high dive I haven't made. Why ain't I got a right to take a dive in the Twentieth-Century-Fox lot?"

On posing for the publicity pictures, Sandburg remarked, "It is the grief of those who live for pleasure only." He took occasion to remark about the lake near his home, "The lake belongs to God but He leased it to us." And of motion pictures, he added, "We have to live with it." He recalled that forty years before, when he was motion-picture critic for the *Chicago Daily News*, he had visited Hollywood and apparently did not like all he saw. From the set of an early Cecil B. De Mille biblical film, *The King of Kings*, he wrote: "Today I picked a pink paper carnation from a papier-maché tomb of Jesus."

Sandburg, then eighty-two, duly arrived in Hollywood on July 18, 1960. In an endeavor to forestall cynical comments from people who might think that he was taking advantage of Sandburg's prestige, Stevens issued a statement noting, "There's one thing I wish to make clear. Mr. Sandburg's association will not be merely nominal. He will make complete contribution in all creative areas of the production and will devote his full time working with us from the start to the finish of this dramatic undertaking."

Soon after he had arrived, Sandburg was interviewed for four hours by reporters from newspapers, magazines, radio, and television. He seemed to ignore the rules of the usual Hollywood interviews by saying what he pleased and taunting reporters. He sat back easily in an armchair, his sturdy hands crossed in his lap, with his white mane dropping over his right eye. He took the reporters by surprise by first singing a little song about the apostles of Christ, in order, he explained, to give the meeting the proper spiritual atmosphere. Then he impishly added that he was ready for any cross-examination they might throw at him. Asked to give the major character traits of Jesus, Sandburg quipped, "Go hang out your lawyer shingle!"

To another questioner he answered, "Get my book of poems. Eight

hundred and sixteen poems. $7.50. Less than one cent a poem. Cheaper than tomatoes or onions."

When asked what he was doing on the picture, Sandburg passed this one along to Stevens, who explained that while Ivan Moffatt was writing the screenplay, Sandburg was engaged in basic development and would work on the lineal and visual poetry. The poet himself then commented on movies on religious subjects, saying that as a rule they were less interesting than Sunday School classes.

"Oh, I have had my periods," he went on, "when I have had my cinema drunks. And then very often for months I don't see a movie. I may go to see *Ben Hur* just to see if the chariots are like they were in the hippodrome when I was a boy."

Herbert Mitgang pointed out in the *New York Times* that

> Sandburg overtaxed himself for months while serving as a consultant in Hollywood on the film 'The Greatest Story Ever Told.' He was well paid for lending his name to that forgotten work, and he received much adulation from the Hollywood colony while consulting, but it was valuable time and energy lost during his final years. Surely Sandburg was entitled to relax; he had already produced his major work.... Like so many of the famous, Sandburg was afflicted by what William James called 'our national disease— the bitch-goddess, success.' Still, Sandburg once told me that if readers wanted to know what-happened-next, they could always turn to the book of poetry and prose that was closest to his heart, *The People Yes*."

Sandburg revealed that this was not his first experience with Hollywood. In his newspaper days, he added, he had for awhile done interviews with stars of the silent films, and once D. W. Griffith wanted to produce a movie about Lincoln based on the Sandburg works.

"I told Griffith that I wanted $30,000," Sandburg stated, "and he offered me $10,000. He got Stevie Benét [Stephen Vincent Benét] for the job. Stevie was good. I forget the name of the picture."

In a later interview, he recalled, "In 1944, I was attending a dinner here for Harold Ickes. This was during the Presidential campaign. There was a pretty girl sitting on the other side of Ickes, and after the dinner I was introduced to her. I didn't catch her name and I had to ask her for it." Then he laughed loudly. "That was quite a scandal, to think that I didn't know who Joan Crawford was."

Sandburg admitted that this was his first adventure into dramatic writing, but he quickly added that he had written everything else. Not exactly with modesty but with accuracy, he said, "After all, I have a wider range of

writing than any other American author, living or dead." He reeled off a list of his activities, including newspaper reporter and motion-picture critic; Lincoln biographer ("a million and a half words, longest biography in this hemisphere"); poet ("eight hundred in print and two hundred more I am still playing with"); songster (*The American Songbag* had one hundred songs that have never been printed"); writer of childrens's books; novelist (*Remembrance Rock*). The last named, he said, belonged to Metro-Goldwyn-Mayer but had never been produced.

In his Hollywood interviews, Sandburg supplied incidentally some illuminating facts: "When I wrote *The War Years*, I used to work sixteen, eighteen hours a day, and there were times when pains used to crash through my head and I used to say, 'Jesus could that be the preamble to a brain hemorrhage? pain like that?' And I said an oath like some old-timer in the Old Testament: 'Oh Lord, if thou wilt permit me to finish this task thou canst ha-a-a-ve me.' I was willing to bargain with God: 'Strike me dead when I have read the last page proof of this book!' "

This was remindful of Sandburg's words about his *Complete Poems*: "All my life I have been trying to learn to read, to see and hear, and to write. At sixty-five I began my first novel, and the last five years lacking a month I took to finish it, I was still traveling, still a seeker. I should like to think that as I go on writing there will be sentences truly alive, with verbs quivering, with nouns giving color and echoes. It could be, in the grace of God, I shall live to be eighty-nine, as did Hokusai, and speaking my farewell to earthly scenes, I might paraphrase: If God had let me live five years longer I should have been a writer." He did live exactly that long—eighty-nine.

But for all the well-laid plans for the film on Jesus, Twentieth-Century-Fox in early September of 1961 decided to postpone its production. An obvious reason was that in the preceding year the company had lost $13 million. The sum of $3 million already had been spent on the biblical film, including $170,000 for Carl Sandburg's services. Of course the poet-consultant was disappointed but did not seem discouraged, and neither did George Stevens. Before he left for his Flat Rock home, Sandburg gave an explanation of what happened: "They went on what you might call an economy binge." He blamed the decision to stop production on "Wall Streeters who have been buying heavily in Twentieth-Century-Fox. This picture will be made," he predicted, "and it will be a great all-time picture."

He was at least partially right. *The Greatest Story Ever Told* was later made by United Artists, directed and produced by George Stevens in

Technicolor and Cinerama, in association with Carl Sandburg. It appeared in 1965 and starred, among others, Max von Sydow as Christ, Charlton Heston, Pat Boone, Richard Conte, Jose Ferrer, Van Heflin, Angela Lansbury, Sidney Poitier, Claude Rains, John Wayne, and Ed Wynn. The film ran three hours, forty-one minutes. Critical reaction was mixed.

On March 4, 1961, the centennial of the first inauguration of Abraham Lincoln was reenacted on the east front of the Capitol in Washington before a crowd of 20,000 people. This was twice as many people as witnessed the original event. Referring to its occurrence when the nation was on the brink of the Civil War, Carl Sandburg said: "It was a great day in American history of which we might say it was sunset and dawn, moonrise and noon sun, dry leaves in an autumn wind, and springtime blossoms, dying time and birthing time. Lincoln would have wanted us of the latest generation to remember how he stood amid the terrific toils and turmoils he was under compulsion to face."[25]

Carl's long life was shared by so many that it is easy to overlook that important part of it which related to children. One instance was recalled about this time in connection with Sandburg's brief military service. A descendant of James W. Switzer, bugler of the Spanish-American War unit in which Sandburg served, bragged about it to her classmates. Her name was Linda Lewis, a high-school student in Birmingham, Michigan. Her friends seemed skeptical about her forebear, so she wrote to Sandburg asking him to verify her story. He replied:

> This is to certify that your grandfather, himself and I, myself, have shared hardtack, pork and beans, red horse, on land and sea, and in Puerto Rico we repulsed attacks of mosquitoes who came in heavy night formations, and moreover your grandfather and I were on occasion lousy, infested with blood-suckers in our arm-pits and elsewhere, and all of this as verification you will find in a book *Always the Young Strangers* where James W. Switzer is in the index. The aforesaid Switzer was a good soldier, a man of honor, and beloved by all his comrades, and this deposition you may fling in the faces of your dubious classmates of Birmingham High.[26]

Mrs. Phyllis W. French recalled that during these years, when she was a student at Montclair High School in New Jersey, Sandburg was a guest speaker at one of the school's assemblies. About a thousand students were present when he recited his poetry, sang, and played the guitar. "He so totally mesmerized that young audience that you could hear a pin drop."[27]

His friend Harry Golden, then editor of *The Carolina Israelite*, made a trip to the Middle East and wrote back a customary friendly letter to Carl.

"Dozens of people asked me about you in Israel. I thought of what it would mean to those Israelis if they saw you walking down the streets of Jerusalem. What a wonderful thrill it was to go into a communal farm outside of the city of Haifa and see in the communal library—the only book in English—Carl Sandburg's *Abraham Lincoln*. In Israel the audiences did not ask me, 'What is Jack Paar really like?' but they did ask me, 'What is Carl Sandburg really like?' "[28]

How active Carl remained, Philip H. Cohen remembers. Cohen was advertising director of a New York advertising agency that represented The American Petroleum Institute. This organization planned a national television show on the future of America. "To give the show some dignity," Cohen said, "I got the API to agree to pay Carl Sandburg $5,000 (a substantial sum then) to do a commercial. I sent our producer, Rod Albright, to the Sandburg home in the South to film the commercial. Up to this point, I think Mr. Sandburg had clearly heard of the $5,000 but he was a little vague about exactly who the client was. Sandburg said to Albright, 'Who is this for?' Albright replied, 'The American Petroleum Institute.' Sandburg boomed, 'Robber Barons, all of them!' But of course he did the commercial (which consisted chiefly of reading one of his poems), and pocketed the $5,000."[29]

In delving objectively into the events in the colorful life of Carl Sandburg, one encounters rumors as well as proven facts. The latter included remarks by persons, especially those not favorably inclined toward him, that on his long trips alone, he "played around" with women. Although this writer has not discovered any plain evidence of such activity, a few instances of Sandburg's association with attractive and talented women outside his household are on record. In the late 1950s, he became acquainted with Mrs. Donna E. Workman, a Chicago business executive. At her request, he gave her a letter of tribute to Clarence Darrow and later visited her. There followed some correspondence which shows that he, at least, was very fond of her and considered her "a beautiful woman."

After she had written him from Rome, he answered, saying, "You are beautifully alive—of course you have never before undertaken to guide the conduct and choose the associations of a hard-bitten octogenerian who will go on keeping rowdy company till his cremation day." On the copy of this letter in the archives of Knox College, Mrs. Workman had typed:

> Here I had chided him on his reported 'cutting capers' out there, and I particularly disapproved of the big publicity he had received and held still

for in *Life Magazine*'s photos with little Marilyn Monroe—in his suite at the
Bel Air. I could imagine Marilyn's surprise and possible disappointment,
especially when such a dainty dish was set before the king. Carl LOVED
women. He adored them, and he could come on strong—you had to know
that it was good, not bad, good. That he wasn't a 'dirty old man' he was an
adoring old man, and held a reverence for a good-looking woman, even if it
wasn't from afar.

Carl wrote to her saying, "So often, so incessantly, so continuously with
no let-up, you are in my thoughts—the reality of you and the shadow, the
apparition, haunt me."[30]

Donna Workman presented to Knox College in 1959 a collection of the
books Abraham Lincoln had read. She stated that the inspiration for col-
lecting the books came from Carl Sandburg, in whose honor she made the
presentation.[31]

Another instance that raised some eyebrows was his friendship with
actress Tallulah Bankhead. This writer heard her state in a husky, jubilant
voice at a dinner in New York that Carl had called on her, had drunk two
bottles of Jack Daniels' whiskey, and had then gone steadily down the stairs
singing "I'll be Seeing You." Perhaps this story should be taken with a
grain of salt—or a jigger of bourbon![32]

A television appearance by Sandburg on a CBS program on April 13,
1961, entitled "Carl Sandburg at Gettysburg," attracted wide attention.
Howard K. Smith was the reporter, and the two met on the memorable
battlefield in Pennsylvania. Asked by Smith why people wish to celebrate
so bloody an event, Sandburg replied that it was "a little artificial . . . it's
overdone. . . . War is terrible to look at. Those who are enjoying this Cen-
tennial don't have the imaginations to see the war that was. . . . Lee rode his
horse along roads winding through bright summer landscapes to find
himself looking at the smoke of a battle he had not ordered or planned."

Sandburg further declared in answer to a question that if Lee had com-
manded the Union forces—as he had the opportunity to do—the war
might well have been shorter, but he might also, as a Southerner, have had
some difficulty in handling the Northern troops. As to why Lee continued
to fight after his defeat at Gettysburg, Sandburg felt that it was a matter of
honor. "The South was known for its chivalry, and Mark Twain used to say
that *Ivanhoe* caused the war, the ideas which it gave the South about
chivalry, and a Northern editor said that 'the war was between the shovelry
and the chivalry.' "

In regard to what might have happened had Lee not lost his "right arm,"

Stonewall Jackson, before Gettysburg took place, Sandburg stated that the outcome of that battle could have been different if Jackson had been in command of "Pickett's Charge" instead of its own commander. Sandburg surprised some by saying the battle of Vicksburg was more important than that of Gettysburg, which took place at the same time and received more attention then and since. Unlike Winston Churchill, Sandburg felt it was the American Revolution, not the Civil War, that "was the noblest and least avoidable of wars till that time." Grant was a better general than Lee, Sandburg believed.

From the Civil War to jet airplanes was quite a step, but such fitted right into the variety of Sandburg's life. American Airlines planned the first transcontinental jet passenger flight from New York City to Los Angeles and Carl Sandburg was asked to go along. He was accompanied by Curtiss Anderson, Special Features Editor of *Better Homes & Gardens* magazine. Said Anderson in an interview:

> Carl Sandburg listens and hears the voice of the people. He interprets in the language of the poet and brings poetry in bold and brilliant flashes to everything he writes: biography, history, novel, essay, songs. He is a story-teller with wit and wisdom. He is a reporter too, as vigorous and dedicated to his assignment as a cub writer on his first big story. . . . He is a man of immense joy. He waltzes with life, figuratively and literally. His thoughts move with such delightful and probing curiosity that in the whisk of a second he may turn from the gay troubador to the thoughtful commentator.

Sandburg evidently enjoyed the flight, which was at night, and later recounted:

> When you are riding at nearly 600 miles an hour, 4 miles above the earth, you look out of the window at the waves of dark and light clouds looking like ocean shorelines, and you feel as if you are floating away in this pleasantly moving room, like the basket hanging from the balloon you saw with a visiting circus when you were a boy. . . . You search for words to describe the speed of the flight; you are whisked and streaked, you are gripped and flicked, you are sped, hurtled, flashed, shuttled from an ocean on one side of the continent to an ocean on the opposite side in less time than it has taken the sun to trace a 90-degree arc across the sky.

Sandburg may have searched for descriptive words—but he certainly found them.[33]

He was still able to joke to his friends, as when he told cartoonist Herb Block that Justice Oliver Wendell Holmes said, "The novels of Henry James

should have been written on white paper with white ink." To Kenneth Dodson he commented that he admired Dodson's sentence about Hollywood biblical films: "Sin attractively buried under a syrupy sundae of sex dressed to pass the Hays office, with ten thousand sweating bodies and the Pyramids as a backdrop." However, Sandburg told Paula that the movie on which he had worked had been thoroughly researched from all angles.

The money kept coming in. Howard S. Richmond of Songways Service in New York wrote Carl that he found pleasure after years of forwarding royalty statements from three cents to ninety-two cents, "and having collected a good many of your autographs that way, I find with pleasure that your good old folk song, 'The Wreck of the John B,' seems to be up in three figures this time." Sandburg's agent in New York, Lucy Kroll, informed him that she had just set up a deal for $10,000 for him to appear on the Bell Telephone Hour on February 12, 1960, narrating Aaron Copland's "A Lincoln Portrait." From the Writers Guild of America came a note stating that Sandburg was being paid for his work at Twentieth Century Fox $4,807.69 per week, this to be paid in sums of $25,000 per year for five years.[34]

Sandburg did not forget the children. He was asked by Charles H. Silver of the Board of Education in New York for an inscription to be placed on a bronze tablet in the entrance lobby of a new school on the Lower East Side. Sandburg furnished the following:

> The restless and adventuring human spirit of youth may perform tomorrow with exploits today called visionary and impossible. What the young people want and dream across the next hundred years will shape history more than any other motivation to be named. None shall look on this hour and say we did not have hope and faith in them. The walls of this school might be saying: "Youth when lighted and alive and given a sporting chance is strong for struggle and not afraid of any toils or punishments or dangers or deaths. What shall be the course of society and civilization across the next hundred years? For the answer read if you can the strange and baffling eyes of youth."
> Carl Sandburg 1961 A.D.[35]

Not everyone welcomed Sandburg's concept of Abraham Lincoln. Paul Green, the playwright, wrote from Chapel Hill that although he admired Sandburg's portrayal of Lincoln, he could not agree with all of it. Said Green:

> Yesterday I passed through Salisbury, North Carolina and stopped off and went out to the site of the old Federal prison. The marker there spoke

above a little plot of ground not even an acre big saying "Here 11,700 Federal soldiers lie buried." And they lie there "unknown" buried. Let the imagination x-ray on down a few feet through the ground. What a horror of bones piled yards deep! And now while I am weeping and talking, thinking of the rot and the gangrene and the sobs and the mother-calls through the long night there in that prison a hundred-years-near ago, I say aloud that I hold your idol Abraham Lincoln too one of the tragic participators in and creators of this maelstrom of pain and shame. It was he—sucked along by the party pull and bestrid by the radicals that, like Ikie and the pregnant gentile girl 'couldn't vait' pushed on toward Sumter and the call for volunteers and the blockade and thus drove the border states in cement together with the hard-core cotton group and so on into the blazing holocaust.[36]

Sandburg had many letters inquiring if Lincoln had any religion. He replied that he covered that subject in *The War Years*. He was also asked about his own religion and said in 1962, "At thirteen years of age I was part of a ceremonial called Confirmation and admission as a member of the Swedish Lutheran Church in Galesburg, Illinois. In the course of time I moved toward the Unitarians and the Universalists and belonged there a little more definitely than to any other denomination."[37]

In late October 1962, Carl asked for a report on the sale of his books. Hilda Lindley of Harcourt, Brace and World replied that as of June 30 of that year, the total sales for twenty-four titles came to 818,672 copies, "which is an impressive achievement," she aptly added.[38]

Just before Christmas, Sandburg was invited to be a narrator with the New York Philharmonic Orchestra in Aaron Copland's "A Lincoln Portrait" on May 29 and 30, 1963. Sandburg accepted and gladly told his friend Sophocles Papas, noted guitarist of Washington, D.C., about it. Papas was delighted that Sandburg was being included in such musical company. The guitarist was fond of retelling a joke that Sandburg had told him: "After the deluge, Noah opened the gates of the Ark. As the pairs of animals made their exit, he blessed them with 'Go forth and multiply.' Presently two snakes came along and Noah gave his blessing; they hissed at him. When Noah asked why, they replied, 'We are adders.' "

On a balmy spring night Sandburg appeared at Carnegie Hall to narrate Copland's composition, the orchestra being conducted by André Kostelanetz. The poet-biographer had just had a birthday and was asked by newsman Joseph Wershba what advice he had for people. "Just because I've gone past eighty-five," was the reply, "I don't go around giving people advice on how to live long." His wife, who had accompanied him—an unusual occurrence, for he ordinarily traveled alone—added that when he

was one-hundred-ten he then might be entitled to pass along some advice. By this time, however, Carl was ready with some.

"My advice," he pronounced, "reduces itself to this: watch out about stumbling into a coal hole. And it's always safer to walk upstairs than down."

The rehearsal for the concert had proved to be more than that. As Sandburg walked on to the stage with a big grin, the orchestra arose and applauded him. Paula remarked that this had happened to him all over the country. He tried out the microphone and Teleprompter and nodded to Kostelanetz. Soon the soaring music of the Copland "Portrait" swept up, to be followed by the voice of Sandburg speaking Lincoln's lines in his address to Congress in 1862: "Fellow citizens, we cannot escape history. The fiery trials through which we pass will light us down in honor or dishonor to the latest generation." Again there was applause.

Irving Kolodin wrote about him in the *Saturday Review*: "Sandburg is the least affected, the most eloquent, the closest in identity with the martyred President and his thoughts. Seated though he was, and protected by a robe across his knees from chill of the air-conditioning, Sandburg nevertheless made a towering presence at least equal to the six-feet-four attributed to Lincoln in the text. He was greeted by a standing, applauding audience in tribute to past accomplishments; the equivalent, in greater numbers and louder volume, after his performance, was a testimonial to an achievement equally impressive on its own."[39]

Afterward, at a nearby table, Paula told him, "You were good, buddy, but tomorrow night I want you to wear your lower incisors so that your voice will be clear as a bell." He protested that he could not find them. "I have them right here in my pocket," she replied.

Backstage, I joined the principal performer and reminded him that we had invited him for a little get-together that evening. He remembered and was about to go when a young man approached him and spoke earnestly. Sandburg must have liked the fellow, for he replied, "You stick around and we'll open up a keg of nails." Which must have been some kind of verbal record for Carnegie Hall.

Sandburg joined a small group of us and we went to the Park Avenue home of Mrs. O. O. McIntyre, widow of the late New York columnist. It was a magnificent sixteen-room apartment, and one was reminded of the $150,000 a year McIntyre made when income taxes were low. Mrs. McIntyre was a Christian Scientist, so no liquor was served, but instead, some of the most delicious ice cream and cake her guests had ever tasted.

This writer had "framed up" with Frank Warner, a friend, the folk singer, also a friend of Sandburg, and YMCA executive, to bring along his banjo and try to get Sandburg to play it, although he had said he was through with playing stringed instruments.

So, as Carl sat comfortably in a lounge, Frank went over to him and in seeming innocence showed him the banjo. Sandburg took it, fondled it affectionately, and slowly began to pluck its strings, then to strum it, and this started him humming. Soon Sandburg was playing and singing and his small audience was enthralled. Frank Warner looked at me and winked. "Mission accomplished," he said.

Warner had first met Sandburg when the former had sung at an author's luncheon in New York just after the publication of *The War Years*. He had with him a new banjo of wood, made by a North Carolina mountain friend, and Sandburg became intrigued by it and autographed it. Later, Warner acquired some 150 additional signatures, mostly from celebrities, but he always remembered gratefully the one who first inscribed his name. Warner had a good but not sensational voice, as Sandburg humorously noted when he told him, "It is easy to see your voice has not been ruined by a conservatory." The Warners and Carl had occasionally visited at their apartment in Greenwich Village, which was on the ground floor of an old brownstone, where there were young children, a fire in the fireplace, a cat, a pot of coffee always ready, and a shared interest in people that seemed to mean for Carl an escape from the crowds and adulation that surrounded him elsewhere. "This isn't New York City," he often used to say when he was there. "At first we considered his visits an honor," Mrs. Warner said, "but soon these became just a joy." "One of the reasons Carl Sandburg was able to affirm his faith in people was that he did not look back to another time and wish vainly for it. He made the best of the time he lived in," wrote Harry Golden.[40]

John K. Hutchens agreed with this observation, writing on an occasion that took note of the more than four-score years of Sandburg's sojourn upon this earth: "He is the prairie-haunted bard, the biographer of Lincoln, the teller of stories for children, the guitar-strumming troubadour and song-collector, the novelist invoking the American dream from Plymouth Rock down the years to our time, the memorialist looking back on his youth.... His robust, delicate, throbbing songs of city streets and distant prairies and mighty rivers are still as stirring as they originally had been. ... He is today's America."[41]

But the song was dying down. Life at Connemara during the octogen-

arian years seemed to be mainly a succession of birthdays with more or less celebration, and in between some literary achievement of a modest nature as befitted the evening of the writer's career. He would be asked leading questions such as what would Lincoln have done about dropping the atomic bomb on Japan. "Let us permit our imagination to conceive of Lincoln free of his Springfield tomb and resident in the White House," Sandburg answered, "as Chief Executive in the year 1945, and before him the reports from the War Department on the estimated casualties of 500,000 to be expected in an invasion of Japan. For myself, I believe Lincoln would probably have made the same decision as President Harry Truman."

His eighty-fifth birthday was celebrated in New York City at a literary dinner at the Waldorf-Astoria, which Sandburg himself termed "a beautifully tumultuous evening." The occasion also marked the publication of his new book of seventy-seven poems entitled *Honey and Salt*, and his publisher, Harcourt, Brace & World, had invited scores of other celebrities. When the guest of honor dropped his short cigar and arose to read the title poem of the new book, he remarked that the occasion was so "rare"—a favorite adjective of his—and unforgettable that he could not express his feelings even in a poem. But he declared the evening's fine remembrances "will help me live a little longer—perhaps a year or so." These words were prophetic. After a session of autographing books, he admitted that he felt toward the end "like something the cat drug in." John Steinbeck was there and commented: "Carl, all of us could have learned from you—and a lot of us did." Mark Van Doren read a poem he had composed, "To Carl Sandburg, lover of the long view." A telegram from President Kennedy was read, which stated that Sandburg, "as poet, storyteller, minstrel and biographer, has expressed the many-sided American genius." So Sandburg stood "before kings."

"How does one live to be eighty-five and still be producing poems which are wise and profound, merry and sad, prophetic of phrase and beautiful with imagery?" asked his friend Ralph McGill in his syndicated newspaper column. Then he answered it himself. "Why one lives, of course. This is what Carl Sandburg has done—and still does—he lives."

At his eighty-sixth milestone, January 6, 1964, the sage of Connemara spent a quiet day at home. Now and then he and his devoted wife would look out across the snow-covered fields and woods and reminisce. Of his reliable colleague, he remarked, "We've been married fifty-five years—and we ain't never had one real storm." Paula was now eighty. He went on

to muse, "Life is a series of relinquishments"; to remind people that at forty he gave up baseball; at sixty he stopped bounding up stairs; in his seventies he cut out most of his cherished cigars; and in his eighties he reduced his taking of whiskey to very small amounts.

"I don't like the phrase 'old age,'" said Sandburg. "Frank Lloyd Wright and I agreed that we did some of our best work in our seventies."

"I'm going to make a little address to God," he declared, "thanking Him for the eighty-six years."

And in regard to the race question, he remarked, "The most important thing is that the Negro Slaves were freed in the Emancipation Proclamation, which can never be revoked. It is up to the Negroes to perform now."

His eighty-seventh birthday he celebrated by lifting the same heavy armchair over his head that he had been lifting to keep himself in condition over the years. He also did considerable reading and continued to work on a sequel to his autobiography, *Always the Young Strangers*. By now, he avoided the telephone, and his wife and the two daughters at home, Margaret and Janet, protected him from intruders. "He's a great family man," Harry Golden observed. "They hold hands all the time. And they don't do it for effect. Fantastic."

But by the end of his eighty-eighth year, Sandburg had been slowed down by illness. The year before, he had been bothered by an intestinal inflammation. Since then, he had suffered a fall, and his physical discomfort was increased by gall-bladder trouble. At long last, the marvelous physical machine was forced into low gear. He spent much of the time in bed—reading, eating a steak, and worrying about a transit strike in New York. But seclusion in his picturesque home could not prevent greetings from the low and the mighty. He received well-wishes from Mark Van Doren, Archibald MacLeish, Harry Golden, and Ralph McGill. A telegram from President Lyndon Johnson stated: "You once wrote that 'The People Will Live On'! Thanks to you the people live on with a deeper insight into their nation, their fellow citizens, and their own inherent dignity."

By the time another year had passed, Carl Sandburg was more his old, ebullient self again, though weakened. By now he had given up writing in favor of reading history and poetry. Rarely was he seen tending to the goats, strumming the guitar, or roaming through the hilly countryside. He even stopped granting interviews, but Paula did give one over the telephone. She said her husband usually spent mornings in bed but got up in the afternoons. "He sometimes walks around the house," she said. "And he

likes to watch television, especially news programs." As to his attitude, she added, "He has a wonderful disposition. Some people fight aging, but he doesn't. And he loves everybody. Mr. Sandburg doesn't like sweets and won't eat cake, so there's no sense in baking one."

When spring came again to Connemara, there was a new quietness about it. The dimming eyes of Carl Sandburg looked out on what Professor W. C. Burton called

> a vision of verdure soothing to his aging but ever-keen, blue eyes. . . . He loved [Connemara] better and was more lavishly contented in it than any other place he had ever lived. . . . The barnyard where his goats gathered and where they nuzzled any member of the family, and all visitors in the bargain, to be petted, was so overlaid with a rustic peace that it seemed to exist in another, earlier century. Sandburg's real tower and fortress, however, could not be truly said to have been a place but a person, his devoted wife, Paula, the former Lilian Paula Steichen. She fended him from the world when he wanted fending and let him rove when he wanted to rove. She kept the home fires banked or burning as need be. She sheltered him, encouraged him when courage and faith and admiration were his needs, and walked by his side when he might otherwise have walked alone.[42]

But even such sustaining inspiration has its limits. As the spring wore on, Carl Sandburg became weaker and weaker. In June he suffered what was described as a "heart stroke" and lapsed into semiconsciousness. It was becoming clear that the evening was nigh. As the July days passed, he talked to hardly anyone and it became difficult for him to recognize any-one—anyone, that is, except his beloved wife. She remained in his con-sciousness endlessly, and now and then he would arouse his failing fac-ulties and softly speak her name. Then she would stand beside him until he recognized her. "But his great strength was failing," she noted, and she would be the last to give up.

On Saturday morning, July 22, 1967, as the sun broke brightly over the Great Smoky Mountains, Sandburg awoke but was barely conscious. By eight o'clock, his breathing came with difficulty. The two nurses who were with him applied artificial respiration. Dr. D. I. Campbell King, his attend-ing physician, was quickly summoned. But it was to no avail.

The pale horse had come.

At nine o'clock, Paula Sandburg, close beside him, noted that her hus-band "slowly breathed away." She added, "I thought it was a wonderful way of going. He had a beautiful passing."

Across the nation, obituaries flashed on newspaper pages in vivid prominence. The *New York Times* brought out its full-page tribute, long set in type, as is customary with this newspaper, and gave it a front-page position.

"What does a man care about his obituary?" Sandburg had once asked a reporter who had come to see him to freshen up his paper's own obituary file. People evidently did care about Sandburg's. It was news of the first order for days.

Mrs. Sandburg immediately announced that the body would be cremated and the ashes placed at "Remembrance Rock" in Galesburg.

Known to be one of Sandburg's favorite spots around Flat Rock was a beautiful little early nineteenth-century church known as St. John in the Wilderness. It is an Episcopal church and stands on a knoll, wooded by tall white pines, long-leaf pines, firs, and cedars interspersed with ancient boxwoods and rhododendron, a lovely sylvan setting. Here the funeral services were to be held.

The Sandburg family asked the Thomas Shepherd & Son Funeral Directors of Hendersonville to select a Unitarian minister. They recommended a young man, Reverend George C. B. Tolleson of Charleston, South Carolina, and he and the family quickly agreed on the arrangements. He was also a musician and played drums with the Charleston Symphony Orchestra. "My first awareness of Carl Sandburg began when I was eight years old and my mother sang to us from *The American Songbag*," he revealed. In a conversation with the family, the Reverend Mr. Tolleson learned that there was no need for any sort of ritualistic funeral. "Sandburg's own belief was not in a God of ritual but in a God of reality," he concluded.

It was decided that most of the words to be used in the service were to be Carl Sandburg's own. So on Monday afternoon, a small procession wound down from Connemara to the little church of St. John in the Wilderness. There was Mrs. Sandburg, brave and unassisted, their three daughters, Margaret, Janet, and Helga, and Edward and Mrs. Steichen. The family had wanted private services but said that the church door would not be closed. Two of Sandburg's friends, Ralph McGill, publisher of the *Atlanta Constitution*, and Harry Golden, were among the small gathering.

The funeral service lasted only fifteen minutes. During the organ prelude, Mr. Tolleson's six-year-old daughter broke into tears. When her mother took her outside and asked her why she was crying, the little girl replied: "Because he was such a nice man and he wrote such good stories for children and I didn't get to meet him until he died."

The organ prelude was "John Brown's Body," a favorite of Sandburg's.

Then from one of Sandburg's poems, "Finish," the young minister quoted, "Death comes once, let it be easy."

"We are gathered here on this July afternoon to take note of a landmark," the minister said, "to celebrate a great life and to acknowledge its ending. Death is a gate through which all must pass. Each of us has died a little with the death of Carl Sandburg. This is how it has to be when a man whose voice was our voice has left us."

Edward Steichen entered the church and walked to the coffin carrying a single green pine bough from Connemara. He quietly placed it on the white pall and then took his seat. When the minister had ended his words to the hushed group, the organ again pealed forth. This time it was "All of God's Children." The funeral service was over.

From President Lyndon Johnson came a message: "Carl Sandburg was more than the voice of America, more than the poet of its strength and genius. He was America."

These Presidential words seemed to echo some of Carl Sandburg's own, which were usually the most fitting and meaningful of all:

> I have spent as strenuous a life as any man surviving three wars and two major depressions, but never, not for a moment, did I lose faith in America's future. Time and time again, I saw the faces of her men and women torn and shaken in turmoil, chaos and storm. In each major crisis, I have seen despair on the faces of some of their foremost strugglers, but their ideas always won. Their visions always came through.
>
> I see America, not in the setting sun of a black night of despair ahead of us. I see America in the crimson light of a rising sun fresh from the burning, creative hand of God. I see great days ahead, great days possible to men and women of will and vision.[43]

Connemara was too large for the remaining Sandburg family to take care of, so Paula, Margaret, and Janet moved to nearby Asheville. Helga lived with her second husband, Dr. George Crile, noted heart physician, in Cleveland, Ohio. The family decided to sell the Flat Rock estate to the government, which after some delay, purchased Connemara for $240,000 and made it into the Carl Sandburg Home National Historic Site. It was expertly restored by the National Park Service and was opened to the public on May 11, 1974. Now it is a popular place for the many visitors who view it year-round.

Soon after moving to Asheville, Mrs. Sandburg and her daughters were invited to New York City, where Hallmark Cards was giving a party in honor of Carl Sandburg at its ornate Fifth Avenue store. I was also invited

and enjoyed the festive occasion. A story about the event appeared in the *New York Times*.

Still vivacious but showing too the weight of the passing years, Mrs. Sandburg lived quietly in Asheville until her death on February 19, 1977. Memorial services were held for her in the Asheville Unitarian-Universalist Church, and her remains then joined those of her husband under "Remembrance Rock" in Galesburg. She would have enjoyed the event that took place less than a year later. In January 1978, scholars, poets, educators, journalists, entertainers, and others gathered under the auspices of Knox College to commemorate Sandburg's 100th birthday, the "Carl Sandburg Centenary."

The commemoration was carried out with efficiency, dignity, and friendliness. College officials from the president down worked day and night to make the occasion a resounding success. Sandburg himself would have loved it. In national recognition of the event, the U.S. Postal Service issued a thirteen-cent Carl Sandburg postage stamp, and its first day of issue, January 6, 1978, was at the Galesburg post office. A colorful ceremony in observation of this event took place in the new Sandburg College there, one of the many schools named in his honor. The governor of Illinois proclaimed "Carl Sandburg Day" in the state, and local civic and religious organizations joined in with enthusiasm to make the celebration a sparkling success.

Contributions made by the scholars and writers in their papers and comments during the meetings have been included in the foregoing pages. I was one of the participants and particularly relished and appreciated the rare occasion, gaining new insights into the life and achievements of Carl Sandburg, as well as fresh inspiration for this book.

Herbert Mitgang, Cultural Correspondent of the *New York Times* and author of the highly regarded *Letters of Carl Sandburg*, stated in his paper, "Carl Sandburg, Journalist-Activist," that

> Ben Hecht was one of Sandburg's seatmates at the *Chicago Daily News*. He was a man known for his acerbic wit—but you won't find any Sandburg character in "The Front Page." He and Sandburg liked and respected one another. When I once asked Hecht about Sandburg, he spoke of him with enormous admiration as a "poet in the newsroom." He said the reporters recognized him as a model of what they wanted to do: write creatively and not just chase the felons and fires of Chicago. Reporting worked two ways for Sandburg for he soon shifted away from the remoteness of the editorial page and worked out of the newsroom. There, in Ben Hecht's phrase, he

was regarded as "our Orpheus." On assignment away from the office, he gathered a bottomless file of experiences for his poetry and historical writing.

It was while reporting such stories that Sandburg decided that the most detestable word in the English language was "exclusive" because, he explained, "you shut out a more or less large range of humanity from your mind and heart." Nothing in the human experience was "excluded" from Sandburg's journalism. He recalled interviewing Babe Ruth in 1928. Their conversation went this way:

"I put it to him, 'People come and ask what's your system for hitting home runs—that so?'

" 'Yes,' said the Babe, 'and all I can tell 'em is I pick a good one and sock it. I get back to the dugout and they ask me what it was I hit and I tell 'em I don't know except it looked good.' "

Sandburg returned to newspaper work early in 1941, before America entered the Second World War, writing a weekly column for the *Chicago Times* syndicate for several years. The syndicate had come to Sandburg and said that he had no right to keep silent during a time of world chaos. Sandburg responded by saying that he had a perfect right to keep silent if he so chose—but he did not so choose. Sandburg felt that the place to be when the going got rough was in the newspapers.[44]

In earlier years for *Venture Magazine*, Herbert Mitgang and Sandburg had visited the Knox College Library, which held the books Lincoln had reportedly read. Sandburg singled out a book on higher mathematics and seemed enthralled with a Lincoln who could pursue so vast a range of interests. Later, Sandburg and Mitgang visited the courthouse in Springfield, Illinois, where Sandburg was greeted by a clerk and given some literature advertising the accomplishments of the secretary of state. Sandburg asked heatedly: "He's a Republican, isn't he?"—which the clerk acknowledged, probably to his regret, after Sandburg charged: "What right have you to hand out Republican propaganda in the state house?"[45]

Some of the others who took part in the Sandburg centenary included Gwendolyn Brooks, Poet Laureate of Illinois, who praised Sandburg's poetry; Howard K. Smith, the television commentator who told of his friendship with Sandburg and their journalistic association; performers of the Knox College Theatre, who presented "The World of Carl Sandburg"; Helga Sandburg Crile, who presented a program of "Sweet Music" using her father's guitar; Studs Terkel, Chicago writer, who talked about Sandburg and minorities and his optimistic outlook; folksinger Pete Seeger, who rendered American folk songs; Burl Ives, who filled the college auditorium for his colorful songfest built around Sandburg's music; and

Margaret Sandburg, who described the phenomenal memory of her father—he could remember the names of the men with whom he once worked in the Galesburg Fire Department.

The words with which I ended my address at the Carl Sandburg anniversary seem to be appropriate in the conclusion of this story of his life: "We are here to commemorate him who has taken his last journey to that 'undiscovered country from whose bourn no traveller returns.' But if he were here, it is certain that he would enter into this occasion with bright aplomb, dynamic elan and great, good humor."

# Notes

## Chapter 1

1. Letter from Carl Sandburg to a Mr. Requé, April 14, 1934, in the Carl Sandburg Collection, University of Illinois Library at Urbana-Champaign, Rare Book Room. This valuable collection is hereafter referred to as CSC.

2. Hermann R. Muelder, "The Galesburg Years," paper delivered at the "Carl Sandburg Centenary" at Knox College, Galesburg, Illinois, January 7, 1978.

3. Paula Steichen, *Carl Sandburg Home* (Washington, D.C.: National Park Service, 1982), 30.

4. Carl Sandburg, *Always the Young Strangers* (New York: Harcourt, Brace, 1953), 42.

5. Ibid., 95.

6. Ibid., 115.

7. Ibid., 254.

8. Ibid., 242.

## Chapter 2

1. Hazel Durnell, *The America of Carl Sandburg* (University Press of Washington, D.C., 1965), 10.

2. Richard Crowder, *Carl Sandburg* (New York: Twayne, 1964), 26.

3. Carl Sandburg, *Complete Poems* (New York: Harcourt, Brace & World, 1950), 307–8.

4. "Carl Sandburg: His Early Wanderings," paper delivered by the author at the "Carl Sandburg Centenary" at Knox College, Galesburg, Illinois, January 7, 1978.

## Chapter 3

1. Hermann Muelder, paper delivered at the "Carl Sandburg Centenary."

2. Reprinted in *The Sandburg Range* (New York: Harcourt, Brace, 1957), 269–70.

3. Carl Sandburg, *Ever the Winds of Chance*, edited by Margaret Sandburg and George Hendrick (Champaign: University of Illinois Press, 1983), 1, 12.

4. *Lombard Review*, May 1899, 152. Articles by Carl Sandburg published in the *Lombard Review* have been identified by Professor Hermann Muelder as "Hoback Philosophy," March 1899; "Mrs. Upsum's Cat," May 1899; "E Pluribus Unum," February 1900; "One of Two Things," December 1900; "Sidelights," February 1901; "A Man With Ideals," March 1901; "The Diatribe Frank," September 1901; and "Willie Applecart," December 1901.

5. Joseph Haas and Gene Lovitz, *Carl Sandburg: A Pictorial Biography* (New York: G. P. Putnam's Sons, 1967), 60.

6. *Ever the Winds of Chance*, 23.

7. Ibid., 30.

8. Ibid., 112.

9. Durnell, *The America of Carl Sandburg*, 15.

10. Crowder, *Carl Sandburg*, 35.

11. Quoted in *Ever the Winds of Chance*, 161, 162.

## Chapter 4

1. *Ever the Winds of Chance*, 154.

2. Ibid., 155–56.

3. Carl to his sister, Esther Sandburg, April 5, 1906, quoted in Herbert Mitgang, ed., *The Letters of Carl Sandburg* (New York: Harcourt, Brace & World, 1968), 41.

4. Helga Sandburg, *A Great and Glorious Romance* (New York: Harcourt, Brace, Jovanovich, 1978), 99.

5. William J. Adelman, "Carl Sandburg, Spokesman for Labor," paper delivered at the "Carl Sandburg Centenary."

6. Margaret Sandburg, "The Wisconsin Years," paper delivered at the "Carl Sandburg Centenary."

7. Crowder, *Carl Sandburg*, 41.

8. Margaret Sandburg, "The Wisconsin Years."

9. *The Letters of Carl Sandburg*, 61.

10. Ibid., 63.

11. *A Great and Glorious Romance*, 145.

12. Remarks by Professor Frederick I. Olson of the University of Wisconsin at the "Carl Sandburg Centenary."

13. Remarks by editor Fred W. Emery of the *Galesburg Labor News* at the "Carl Sandburg Centenary."

14. *Milwaukee Social-Democratic Herald*, February 11, 1911.

15. *A Great and Glorious Romance*, 192.

# Chapter 5

1. William J. Adelman paper delivered at the "Carl Sandburg Centenary."

2. *A Great and Glorious Romance*, 193.

3. *Chicago Poems* (New York: Henry Holt & Co., 1916). The other poems in this chapter are from this edition.

4. Interview with Harry Hansen by author, November 12, 1969.

5. Ibid.

6. William J. Adelman, paper delivered at the "Carl Sandburg Centenary."

7. Bruce Weirick, "Poetical Circuit Rider," *Journal of the Illinois State Historical Society* (Winter 1952), 342, 351–52.

8. John Justin Smith, "Sandburg the Popular Spokesman," paper delivered at the "Carl Sandburg Centenary."

9. Harry Hansen, "And the Chicago Daily News," *Journal of the Illinois State Historical Society* (Winter 1952), 324, 325.

# Chapter 6

1. Alfred Harcourt, "Forty Years of Friendship," *Journal of the Illinois State Historical Society* (Winter 1952), 396.

2. *The Chicago Race Riots* (New York: Harcourt, Brace & World, 1919), 27.

3. Ibid., 35.

4. Ibid., 42–43.

5. John A. Lomax, Letters to Carl Sandburg, January 5 and October 25, 1920, in CSC.

6. Sandburg to Lomax, January 9, 1920, in *The Letters of Carl Sandburg*, 175.

7. John Justin Smith, paper delivered at the "Carl Sandburg Centenary."

8. William J. Adelman, paper delivered at the "Carl Sandburg Centenary."

9. John Justin Smith, paper delivered at the "Carl Sandburg Centenary."

10. Memo from Sandburg to Edward Steichen, August 26, 1920, in CSC.

11. Sandburg to Steichen, September 1919, in *The Letters of Carl Sandburg*, 167.

12. Fannie Butcher, "Bright Fellowships," *Journal of the Illinois State Historical Society* (Winter 1952), 388.

13. *A Great and Glorious Romance*, 288–89.

## Chapter 7

1. Harcourt to Sandburg, January 20, 1916, University of Illinois Library, Urbana-Champaign, Rare Book Room.

2. Amy Lowell, *Tendencies in Modern Poetry* (New York: Macmillan, 1917), 216, 217, 221.

3. Crowder, *Carl Sandburg*, 48; F. O. Matthiessen, *Theodore Dreiser* (1951), 210.

4. Oscar Cargill, "Carl Sandburg: Crusader and Mystic," *College English* 2, no. 7 (April 1950): 365.

5. Gay Wilson Allen, "Carl Sandburg," *Pamphlets on American Writers*, no. 101 (Minneapolis: University of Minnesota Press, 1972), 18–19.

6. Louis D. Rubin, Jr., "The Chicago Poet: Thoughts on Carl Sandburg as a Craftsman," paper delivered at the "Carl Sandburg Centenary."

7. *Complete Poems*, 20.

8. Sandburg printed program in the William A. Sutton Collection, Rare Book Room, University of Illinois Library, Urbana-Champaign. Professor Sutton of Ball State University compiled a large amount of valuable material on Sandburg, mostly relating to his lecture schedule. Hereafter referred to as Sutton Collection.

9. *Semi-Weekly Campus*, Southern Methodist University, March 3, 1923, Sutton Collection.

10. *Complete Poems*, 20.

11. Ibid., 29–30.

12. Sandburg to Alfred Harcourt, February 3, 1916, University of Illinois Library, Rare Book Room.

13. Sunday to Allan Sheldon, February 18, 1927, University of Illinois Library, Rare Book Room.

14. Crowder, *Carl Sandburg*, 63.

15. Poems from *The Cornhuskers*, in *The Sandburg Range* (New York: Harcourt, Brace, 1957), 9, 11, 15, and 17.

16. Richard C. Wood to Sandburg, 1942, University of Illinois Library, Rare Book Room.

17. *Complete Poems*, 109–10.

18. Rubin, "The Chicago Poet."

19. Professor Barnard Duffey, "Carl Sandburg and the Undetermined Land," paper delivered at the "Carl Sandburg Centenary."

20. *Complete Poems*, 136.

21. Crowder, *Carl Sandburg*, 68.

22. Karl Detzer, *Carl Sandburg* (New York: Harcourt, Brace, 1941), 142.

23. *Smoke and Steel* (New York: Harcourt, Brace & World, 1920), 3–4.

24. Louis D. Rubin, Jr., paper delivered at the "Carl Sandburg Centenary."

25. John and Margaret Knoepfle, "Commentaries on Four Poems by Carl Sandburg," paper delivered at the "Carl Sandburg Centenary."

26. Detzer, *Carl Sandburg*, 7.

27. *Complete Poems*, 271, 277, and 279.

28. Ibid., 283.

29. C. S. Dunning to Sandburg, January 5, 1929, in CSC.

30. *Complete Poems*, 429.

31. Joseph Warren Beach to Sandburg, undated letter in CSC.

32. Sandburg to Malcolm Cowley, University of Illinois Library, Rare Book Room.

33. Durnell, *The America of Carl Sandburg*, 168.

34. Gay Wilson Allen, "Carl Sandburg," 31.
35. Sandburg to Robin Lampson, December 5, 1936, University of Illinois Library, Rare Book Room.
36. Irwin Shaw to Sandburg, May 12, 1937, University of Illinois Library, Rare Book Room.
37. Kane Zelle to Sandburg, January 20, 1946, University of Illinois Library, Rare Book Room.
38. Daniel Hoffman, lecture at Library of Congress, January 5, 1978.
39. Bernard Duffey, paper delivered at the "Carl Sandburg Centenary."
40. Elmer Gertz to editor of *Poetry*, January 12, 1953.
41. Margaret Sandburg, ed., *Breathing Tokens* (New York: Harcourt, Brace, Jovanovich, 1978), unpaged.
42. *Atlantic Journal & Continental Magazine*, July 26, 1953.
43. E. Gustav Johnson, "Religion in the Poetry of Carl Sandburg," *The Prairie Schooner* (Winter 1950): 194, 200, 205.
44. Sutton Collection, University of Illinois Library, Rare Book Room.
45. Vachel Lindsay to Sandburg, January 13, 1917.
46. Royall Snow to Sandburg, December 27, 1920.
47. Sutton Collection.
48. Sandburg to Mrs. Cox, April 14, 1934, University of Illinois Library, Rare Book Room.
49. Sutton Collection.
50. Charles H. Compton, *The South Atlantic Quarterly* 28 (January-October 1929): 191–92.
51. *The Pamphlet Poets*, Hughes Mearns, ed. (New York: Simon & Schuster, 1926), 5–6.

## Chapter 8

1. Justin Kaplan, "After Whitman," paper delivered at the "Carl Sandburg Centenary."
2. Hoffman lecture at Library of Congress, January 5, 1978.
3. Detzer, *Carl Sandburg*, 155.
4. Sandburg to Helen Keller, October 10, 1929, in CSC.
5. *A Great and Glorious Romance*, 290.
6. Sandburg to Miss Anne Moore, November 20, 1922, in CSC.
7. Henry Justin Smith to Sandburg, September 24, 1925, CSC.
8. F. Elmer Marshall, "Our Paths Will Cross Again, Carl Sandburg," in Sutton Collection.
9. Both letters in CSC.
10. Letter from S. D. Stephens to author, April 10, 1968.
11. These statements are from a 1921 Tour Program of Sandburg's in the Sutton Collection.
12. *Oregon Daily Herald*, February 17, 1923.
13. Sutton Collection.
14. Ibid.

15. Copy of letter from The Foster and Ford Committee, 35 East 12th Street, 9th Floor, New York, to Sandburg, in CSC.

16. Sandburg to Romain Rolland, October 1919, in *Letters of Carl Sandburg*, 217.

17. Sandburg to Franklin Roosevelt, March 29, 1975, CSC.

18. Sandburg to Oliver Barrett, May 9, 1935, CSC.

19. *The Sandburg Range*, 120.

20. Arthur E. Sutherland to William A. Sutton, June 15, 1970, Sutton Collection.

21. *Journal of the Illinois State Historical Society* (Winter 1952), 386–87.

22. Interview with author, October 12, 1967.

23. Sandburg to Dorothy Bell, April 17, 1938.

# Chapter 9

1. Negley D. Cochran to Sandburg, January 6, 1923.

2. Detzer, *Carl Sandburg*, 166, 168.

3. Paul Simon, "Sandburg, Lincoln and the Legislative Years," paper delivered at the "Carl Sandburg Centenary."

4. Frederick H. Meserve, "Thoughts on a Friend," *Journal of the Illinois State Historical Society* (Winter 1952), 337.

5. Robert W. Johannsen, "The Poet as Biographer—Carl Sandburg's Prairie Years," paper delivered at the "Carl Sandburg Centenary."

6. Carl Sandburg, *The Prairie Years*, vol. 1, 186–88.

7. *The Sandburg Range*, 390.

8. Sandburg, *The Prairie Years*, vol. 2, 426.

9. Benjamin P. Thomas, "A Man of Faith in Man," *Journal of the Illinois State Historical Society* (Winter 1952), 339.

10. Professor Robert W. Johannsen, paper delivered at the "Carl Sandburg Centenary."

11. Ibid.

12. Carl Becker to Sandburg, November 10, 1937, CSC.

13. Edmund Wilson, "The Anarchists of Taste—Who First Broke the Rules of Harmony with the Modern World," *Vanity Fair*, November 1920, 65.

14. Crowder, *Carl Sandburg*, 97, 103.

15. Johannsen, "The Poet as Biographer."

16. *The Independent*, February 13, 1926; Gamaliel Bradford to Sandburg, February 3, 1928, CSC.

17. Johannsen, "The Poet as Biographer."

18. The *New York Times*, February 14, 1926.

19. Alan Swanson, "The Achievement of Carl Sandburg," paper delivered at the "Carl Sandburg Centenary."

20. Stephen B. Oates, "Carl Sandburg—Chronicler, Composer, and Poet of the Mythical Lincoln," paper delivered at the "Carl Sandburg Centenary."

21. William Allen White to Sandburg, January 29, 1926, CSC.

22. Lee A. Stone letter, February 16, 1926; Lincoln Steffens letter, April 4, 1926, both in CSC.

# Chapter 10

1. Carl Sandburg, *Mary Lincoln: Wife and Widow* (New York: Harcourt, Brace, 1932), 3.

2. Sandburg to Alfred Harcourt, September 15, 1932, CSC.

3. Sandburg to Charles P. Bissett, May 18, 1929, in *The Letters of Carl Sandburg*, 266.

4. Louis Rubin, Jr., *Sewanee Review* (January-March 1977), 187.

5. William J. Adelman, paper delivered at the "Carl Sandburg Centenary."

6. Adlai Stevenson, "A Friend and Admirer," *Journal of the Illinois State Historical Society* (Winter 1952), 299.

7. Wylie G. Atkenson to Sandburg, June 7, 1941, CSC.

8. Clifford Ernest to Sandburg, December 6, 1941, CSC.

9. Helen R. Bryan to Sandburg, December 6, 1944, CSC.

10. Sandburg to Kenneth M. Dodson, May 26, 1945, CSC.

11. *The Sandburg Range*, 303.

12. Sandburg to Sherwood Anderson, October 11, 1928, in *The Letters of Carl Sandburg*, 261–62.

13. Sherwood Anderson, "Carl Sandburg," *The Bookman*, December 1921, 361.

14. Walter Yust, "Carl Sandburg, Human Being," *The Bookman*, January 1921, 237; Paul Rosenfeld, "Carl Sandburg," *The Bookman*, July 1921, 392.

15. Interview with Charles A. Pearce by the author.

# Chapter 11

1. Benjamin P. Thomas, *Abraham Lincoln* (New York: Knopf, 1952), 528.

2. Carl Sandburg, *A Lincoln Preface* (New York: Harcourt, Brace, 1953), 7. In the Rare Book Room of the New York Public Library.

3. *The Sandburg Range*, 408, 416.

4. Ibid., 433.

5. J. G. Randall, "Carl," *Journal of the Illinois State Historical Society* (Winter 1952), 329.

6. *New York Times Book Review*, December 5, 1939; see also Charles A. Beard, *The Lincoln of Carl Sandburg* (New York: Harcourt, Brace, 1940).

7. *New York Herald Tribune Books*, December 3, 1939.

8. *Journal of the Illinois State Historical Society* (Winter 1952), 361.

9. Ibid., 363.

10. Ibid., 366.

11. *New York Herald-Tribune*, December 5, 1939.

12. Stephen Vincent Benét, "Abraham Lincoln, the War Years," *Atlantic Bookshelf* 164 (December 1939): 22.

13. Charles A. Beard, "The Sandburg Lincoln," *Virginia Quarterly Review* (Winter 1940).

14. Allan Nevins, "Sandburg as a Historian," *A Tribute to Carl Sandburg* (New York: Harcourt Brace & World, 1953), 63.

15. Comment of Sandburg to author.

16. Crowder, *Carl Sandburg*, 131.

17. Stephen B. Oates, paper delivered at the "Carl Sandburg Centenary."

18. Detzer, *Carl Sandburg*, 126, 141.
19. Carl Sandburg, memo in *The Letters of Lincoln Steffens* (New York: Harcourt, Brace, 1938), viii.
20. Felix Frankfurter to Sandburg, December 6, 1939, CSC.
21. *American Historical Review* (July 1940), 917–22.
22. *The New Leader*, November 7, 1942, CSC.
23. *American Autograph Journal* 3 no. 6 (March 1940): 216, 222.
24. Sandburg to Allan Nevins, October 8, 1950, CSC.
25. Carl Sandburg, *Abraham Lincoln: The War Years* (New York: Harcourt, Brace, 1939), vol. 4, 296–97.
26. Louis C. Jones to Sandburg, November 30, 1939.

# Chapter 12

1. Truman to Sandburg, April 14, 1945, The Harry S. Truman Library, Independence, Missouri.
2. *Hollywood Reporter*, October 8 and 10, 1941; copies in CSC.
3. Carl Sandburg, *Home Front Memo* (New York: Harcourt, Brace, 1943), 27, 137, 139.
4. Martha Dodd to Sandburg, November 13, 1940, CSC.
5. Letter from Committee to Defend America by Aiding the Allies to Sandburg, November 18, 1941, CSC.
6. Letter from Chicago Committee to Defend America to Sandburg, September 15, 1941; Committee to Defend America to Sandburg, October 2, 1941, both in CSC.
7. Copy of letter given to author by Sandburg family.
8. Clare E. Hoffman to Sandburg, September 16, 1941, CSC.
9. Allan Nevins to Sandburg, July 24, 1943, CSC.
10. Sutton Collection, File 49–1800, CSC.
11. MGM to Sandburg: several letters dated from September 11, 1943, to October 31, 1944, approved and accepted by Sandburg in his own handwriting, in CSC. Letter from Herbert S. Nusbaum, MGM Assistant General Counsel, to author, May 22, 1984.
12. Sandburg to President Harry Truman, September 15, 1945, CSC.
13. Handwritten memo of C. D. Batchelor, CSC.
14. Undated letter from Sandburg to Doubleday-Doran, CSC.

# Chapter 13

1. Sandburg to Alvin W. Dreir, July 15, 1960, CSC.
2. Paula Steichen, *Carl Sandburg Home* (Washington, D.C.: U.S. Government Printing Office).
3. Paula Steichen, *My Connemara* (Flat Rock, N.C.: Acorn Press, 1969), 13, 28.
4. Press release, North Carolina State News Bureau, July 1948.
5. Memo of J. G. Randall, January 4, 1948, CSC.
6. Paula Steichen, *My Connemara*, 49.

7. Sandburg to Kenneth M. Dodson, June 6, 1947, in *The Letters of Carl Sandburg*, 444–45.

8. Letter of Don Shoemaker to author, March 15, 1968.

9. Sutton Collection, Item No. 2804.

10. *Journal of the Illinois State Historical Society* (Winter 1952), 300–306.

## Chapter 14

1. *Tuscaloosa News*, October 8, 1947.

2. Sandburg Memo, CSC.

3. This and following excerpts are from *Remembrance Rock* (New York: Harcourt, Brace, 1948).

4. *Journal of the Illinois State Historical Society* (Winter 1952), 394.

5. *The New York Times Book Review*, October 10, 1948.

6. *The Asheville Citizen-Times*, August 10, 1959.

7. Don Shoemaker to author, March 15, 1968.

8. Quoted in Harry Golden, *Carl Sandburg* (Cleveland and New York: World Publishing, 1961), 268.

9. Douglas Southall Freeman to Sandburg, September 27, 1948; Hugo L. Black to Sandburg, August 18, 1949, both in CSC.

10. Benjamin Thomas to Sandburg, October 20, 1948; Paul De Kruif to Sandburg, October 26, 1948, both in CSC.

11. Max Lerner to Sandburg, November 18, 1948; CSC.

12. T. V. Smith to Sandburg, November 18, 1948; Allan Nevins to Sandburg, October 31, 1948; James G. Randall to Sandburg, May 2, 1950, all in CSC.

13. Golden, *Carl Sandburg*, 235.

14. Richard Maury to Sandburg, October 16, 1956, CSC.

## Chapter 15

1. Paula Steichen, *My Connemara*, 112–13.

2. *Journal of the Illinois State Historical Society* (Winter 1952), 297.

3. *The Sandburg Range*, 331, 334.

4. Copy of obituary dated March 8, 1950, CSC.

5. *The Letters of Carl Sandburg*, 461.

6. Mrs. Frank Warner to author, April 2, 1984.

7. Norman Rockwell to Miss Margaret Ligon, Pack Memorial Library, Asheville, North Carolina, January 23, 1951, CSC.

8. Allan Nevins to Sandburg, February 10, 1951, CSC.

9. Ben Hayes to author, April 10, 1984.

10. President Harry S. Truman to Sandburg, January 5, 1953, The Harry S. Truman Library, Independence, Missouri.

11. Richard Crowder, *Carl Sandburg*, 29, CSC.

12. Governor Adlai Stevenson in recorded message, January 6, 1953, CSC.

13. Sandburg to Alfred Harcourt, September 24, 1953, CSC.

14. Sandburg to Catherine McCarthy, September 23, 1954, CSC.

15. Copies of correspondence regarding the Loeb-Leopold case are in CSC.

16. Vincent G. Burns to Sandburg, April 24, 1956, CSC.

17. *TV Guide*, July 13–19, 1957.

18. Sandburg to the Hemingways, December 8, 1954, in *The Letters of Carl Sandburg*, 503. Answering my inquiry as to why Sandburg did not receive the prize, Professor Lars Gyllensten of the Swedish Academy replied that such information was not available.

19. John Hoffman, "How the Sandburg Collection Came to Illinois," *Non Solus*, University of Illinois Library Friends, no. 8, 1981, 23–35.

20. *The Sandburg Range* (New York: Harcourt, Brace, 1957), 3.

21. Associated Press dispatch, June 1, 1958.

22. Edwin Gill to author, March 27, 1968.

23. Sandburg to a Mr. Bromberger, February 8, 1959, CSC.

24. United Press International dispatch, February 12, 1959; copy in Rare Book Room, New York Public Library (reprint, Achilles, J. St. Onga, Worcester, Mass. 1959).

25. Associated Press dispatch, March 4, 1961; copy in Rare Book Room, New York Public Library (reprint, Chicago: Black Cat Press, 1961).

26. Sandburg to Linda Lewis, October 3, 1954, CSC.

27. Phyllis French to author, April 2, 1984.

28. Harry Golden to Sandburg, October 13, 1959, CSC.

29. Philip Cohen to author, March 25, 1984.

30. Letters in Knox College Archives, Galesburg, Illinois.

31. *Galesburg Post*, February 20, 1959.

32. Copies of related material in CSC.

33. *Better Homes & Gardens*, April 1959, 56–59.

34. Howard S. Richmond to Sandburg, June 2, 1959; Jane E. Lynch to Lucy Kroll, October 11, 1960; Lucy Kroll to Sandburg, October 20, 1959, all in CSC.

35. Sandburg to Charles H. Silver, September 25, 1961, CSC.

36. Paul Green to Sandburg, April 3, 1961, CSC.

37. Sandburg to George N. Marshall, April 11, 1962, CSC.

38. Hilda Lindley to Sandburg, October 26, 1962, CSC.

39. *Saturday Review*, June 15, 1963.

40. Harry Golden, *New York World-Telegram and Sun*, January 6, 1960.

41. *New York Herald-Tribune*, April 7, 1963.

42. *Greensboro (N.C.) Daily News*, July 30, 1967.

43. *Asheville Citizen-Times*, January 5, 1963.

44. Herbert Mitgang, paper presented at the "Carl Sandburg Centenary."

45. Speech of Curtiss Anderson, editor of *Venture Magazine*, "Prairie Trail to Lincoln," Miami Beach, Florida, January 16, 1955.

# Index